BARRIER REEF
TRAVELLER

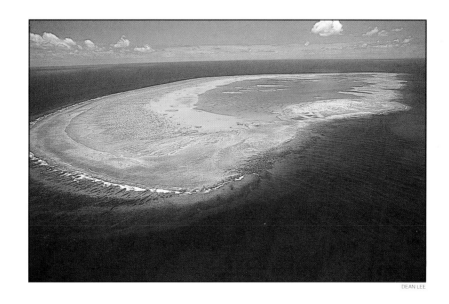

First published in 1989 by
Windward Publications Pty Ltd
RMB 206 Woodhill Mountain Road
Woodhill Mountain, via Berry, NSW 2535
© Copyright David and Carolyn Colfelt 1989

National Library of Australia
 Cataloguing-in-Publication Data

Colfelt, David, 1939– .
 Barrier Reef Traveller
 ISBN 0 9590830 5 7
 1. Great Barrier Reef (Qld)—Description and Travel—Guidebooks.
 I. Colfelt, Carolyn, 1941– . II. Title.
 919.43'04

Produced in Australia by the publisher • Design by Carolyn and David Colfelt • Illustrations and maps by Carolyn Colfelt
• Typeset in Australia by Windward using Ventura® with high-resolution output by Deblaere Typesetting Pty Ltd, Dee Why,
NSW • Printed by Dai Nippon Printing Company (Hong Kong)

BARRIER REEF
TRAVELLER

by
David and Carolyn Colfelt

Illustrated by Carolyn Colfelt

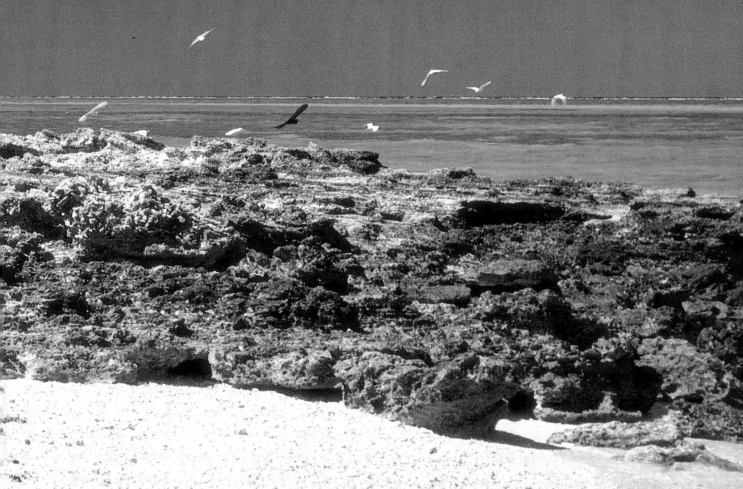

WINDWARD PUBLICATIONS

CONTENTS

Acknowledgements

When we first got down to thinking seriously about producing *Barrier Reef Traveller* we almost decided not to. The support of Ansett Transport Industries, Australian Airlines and Avis made our travel arrangements less daunting. Particular thanks to John McMullen and Jenny Manton of Ansett Holidays, and to Owen French, Lorraine McLennan and Ian Williams of Australian Resorts.

In our travels we have spoken with many people whose lives are more or less bound up in The Barrier Reef, and the whole exercise has been a delightful experience. We have pestered the Great Barrier Reef Marine Park Authority (GBRMPA) solidly for two years, with questions and requests for information and reports, and many people at GBRMPA have 'done the country mile' as far as we are concerned. The Queensland National Parks and Wildlife Service (which is now a part of the Department of Environment and Conservation) has also been extremely helpful. Australians can be pleased that we have, in these two agencies, some very able and dedicated people who are doing their best to take care of The Reef for us.

At GBRMPA we would especially like to thank Don Kinsey, Wendy Craik, and Ray Neale, but there have been many others who have helped, too. At QNPWS, we owe special thanks to David Perkins, Peter Ogilvie, Peter (Bill) Laverack, Steve Domm, Col Limpus and John Hicks.

Every photograph in the book has an individual acknowledgement (except for those on the covers and a few in the early spreads), and we are especially grateful to Gary Bell, Dean Lee and Tony Fontes, and others, too, who have trusted us with their originals so that the best possible results could be achieved. Gary Bell took the shot of the anemone fish on the back cover; Kate Gentle immortalised us on the back cover flap; the remaining unacknowledged photographs are our own. The illustrations are all by Carolyn.

We wish to thank Calvin Tilley for his help with the section on fishing, and Len Zell gave valuable advice about diving. Mike Rowland supplied much information about the original Australians who loved The Barrier Reef before James Cook came along. We also owe much to Professor John Beaglehole for his posthumous guidance and inspiration on matters of Cook, which have come through his magnificent work, *The Journals of Captain James Cook*.

A few other people have exceeded the country mile by a quantum. We are deeply grateful to Wendy Craik and Grant Hawley, and to Rob Henty, for their support and advice, and to Ella Martin for the yeoman's effort she has put in.

David and Carolyn Colfelt
Woodhill Mountain, 1989

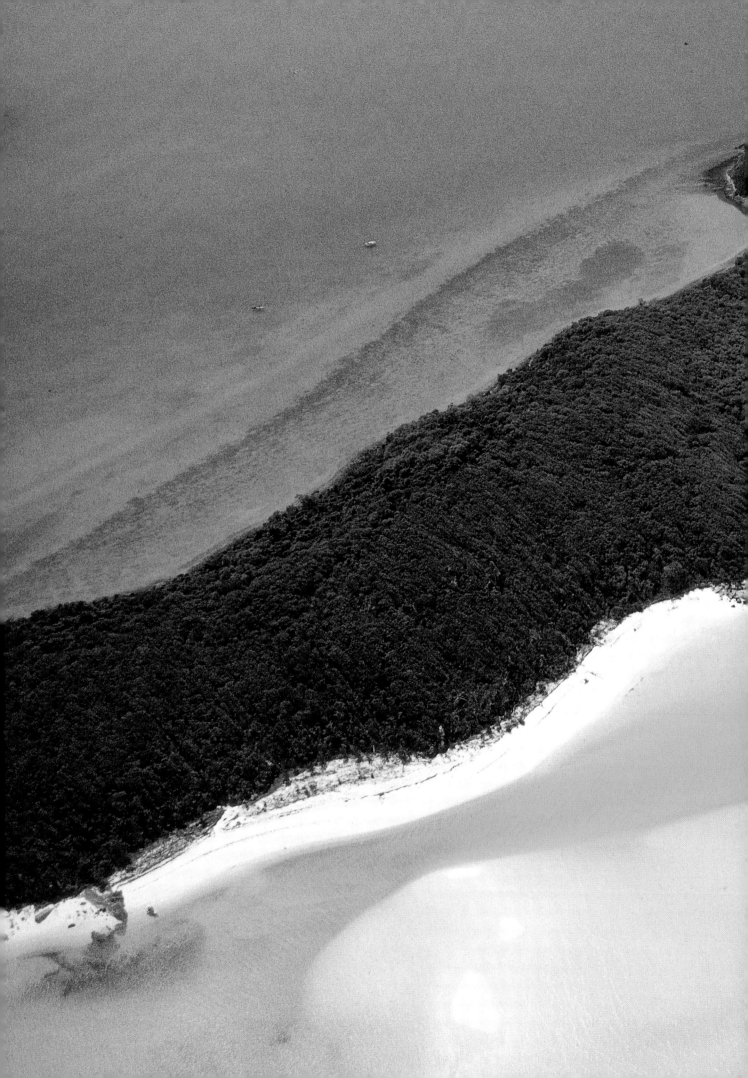

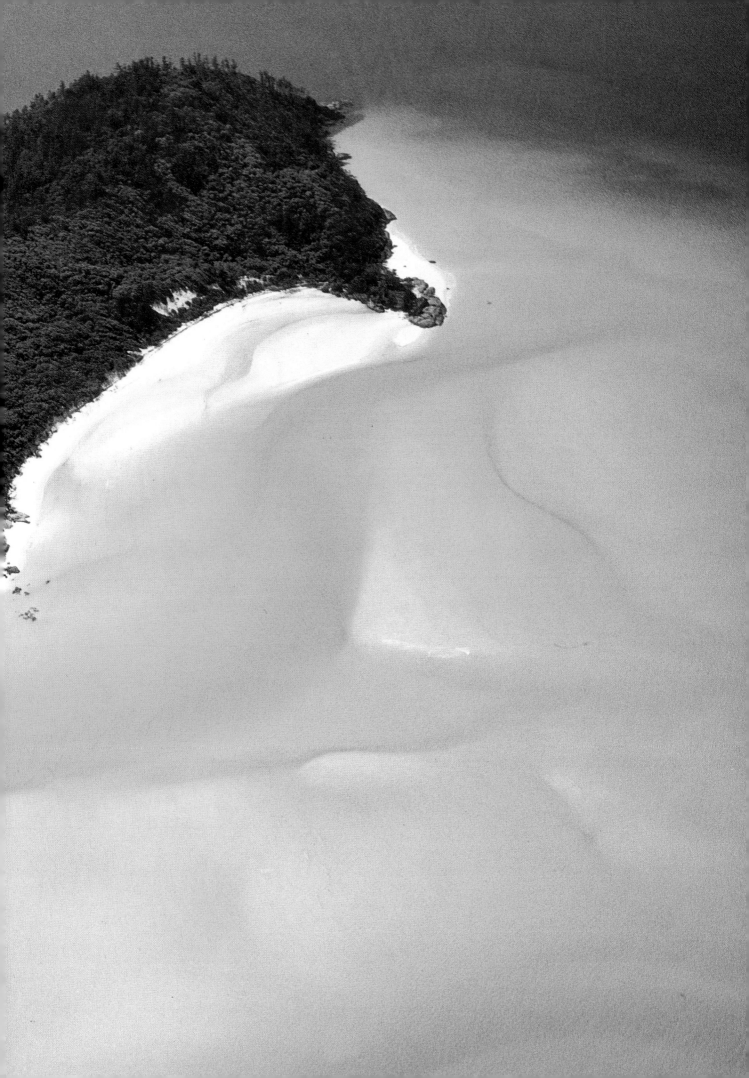

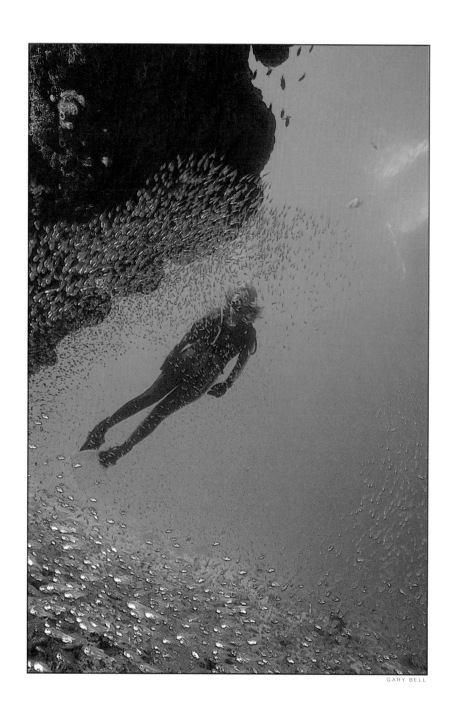

Before setting out…

Barrier Reef Traveller is a book about how to see the Great Barrier Reef—where to go, how to get there, what there is to do when you do get there.

Many books have been written about the Barrier Reef but none specifically for the tourist, whose information almost always comes from those who have a vested interest—the resorts, airlines, the various regional tourist organisations, the magazines which depend upon advertising—and therein lies the rub. How can the uninitiated traveller tell whether the tropical flower that is being held up for inspection is a Queensland orchid or a gilded lily? What answer does one really expect when asking a mother if her son is a nice boy?

This book is a companion for the uncertain traveller, designed to help find the location, the resort, the holiday that fills the bill. It is not a 'yellow pages' or a travel guide. Rather, it takes a snapshot of a large area and provides a summary of the scene, telling what types of Reef experiences are available and how to go about organising them. Because the islands are so often the focal point of Barrier Reef holidays, *Traveller* takes a close look at the island resorts to help you decide whether what they're offering is what you're looking for.

Traveller ignores the top 25% of The Reef, a wild, beautiful, undisturbed area north of Lizard Island, an area which will appeal immensely to the adventurer, the person who wants to escape or to pioneer. The subject of the remaining 75% of The Reef is already too big for one book but, that aside, there is not much developed tourist activity in the far north. It is available for those who seek it out but it is not for the traveller who has a strict timetable or financial constraints. Lizard Island, therefore, seemed to be a convenient place to stop.

Barrier Reef Traveller provides a general introduction to The Reef, we hope enough information to help you to get the most out of your Reef holiday.

David and Carolyn Colfelt
Woodhill Mountain, 1989

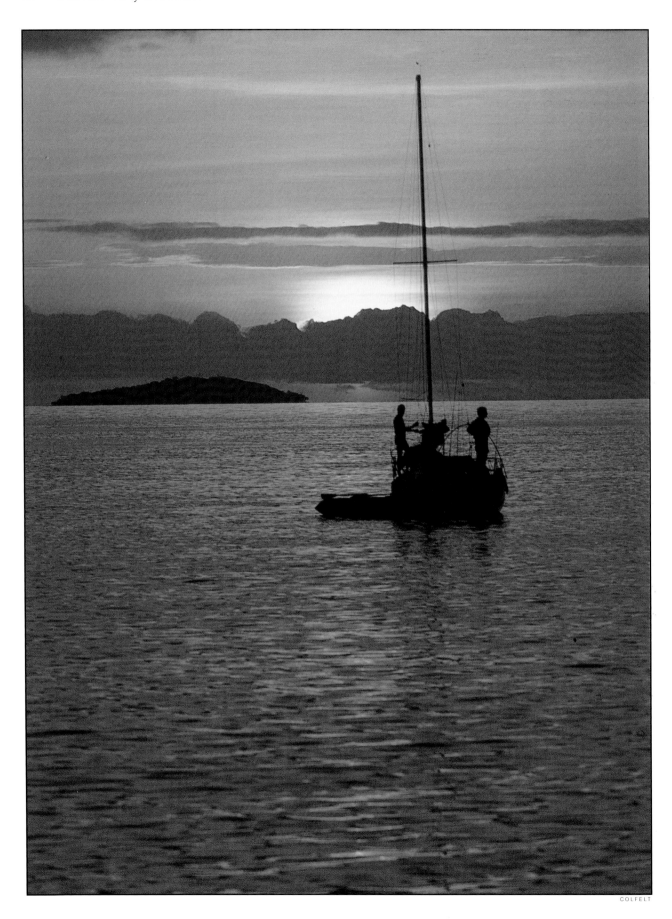

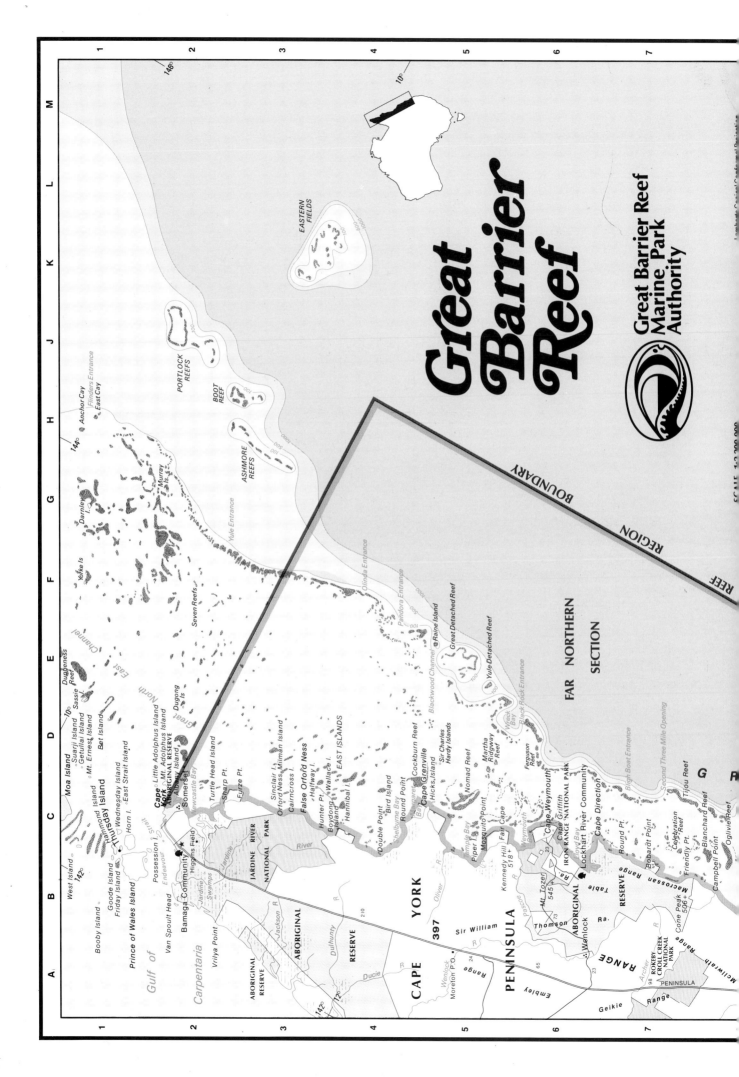

Great Barrier Reef

Great Barrier Reef Marine Park Authority

GREAT BARRIER REEF REGION BOUNDARY

FAR NORTHERN SECTION

EASTERN FIELDS

PORTLOCK REEFS

BOOT REEF

ASHMORE REEFS

Anchor Cay
East Cay
Flinders Entrance
Darnley
Yorke Is
Murray Is.
Yule Entrance
Seven Reefs

Raine Island
Great Detached Reef
Olinda Entrance
Pandora Entrance
Yule Detached Reef
Blackwood Channel
Black Rock Entrance
Wreck Bay
Ferguson Reef
Big Boat Entrance
Second Three Mile Opening

Great North Channel
East Channel
Dugeness Reef
Moa Island
Suarji Island
Getulai Island
Sassie I.
Mt. Ernest Island
Bet Island
Hammond Island
Thursday Island
Wednesday Island
Horn I.
East Strait Island
West Island
Booby Island
Goode Island
Friday Island
Prince of Wales Island
Possession I.
Endeavour Strait

Cape York
Little Adolphus Island
Mt. Adolphus Island
ABORIGINAL RESERVE
Albany Island
Somerset
Newcastle Bay
Dugong Is
Turtle Head Island
Sharp Pt.
Furze Pt.

Sinclair I.
Orford Ness
Milman Island
Cairncross I.
False Orford Ness
Halfway I.
Hunter Pt.
Boydong I.
Wallace I.
Hannibal I.
EAST ISLANDS
Bird Island
Double Point
Round Point
Bayer
Shelburne Bay
Cockburn Reef
Cape Grenville
Hicks Island
Sir Charles Hardy Islands
Nomad Reef
Martha Ridgway Reef

Van Spoult Head
Bamaga Community
Higgins Field
Vrilya Point
Carpentaria
Gulf of

JARDINE RIVER NATIONAL PARK
Jardine River
Jardine R.
Swamps

ABORIGINAL RESERVE
Jackson R.
Ducie R.
Dulhunty R.
Wenlock R.
Moreton P.O.
Oliver R.
Sir William
Range

CAPE YORK PENINSULA 397

Kennedy Hill 518+
Piper
Temple Bay
Mosquito Point
Weymouth
Cape Weymouth
IRON RANGE NATIONAL PARK
Lockhart River Community
Cape Direction
Round Pt.
Bobard Point
Celebration Reef
Friendly Pt.
Blanchard Reef
Campbell Point
Oglivie Reef
Tijou Reef

Mt. Tozer 545+
ABORIGINAL RESERVE
Wenlock Ra.
Table
Thomson R.
Macrossan Range
Cone Peak 506+
Pascoe R.

Embley
Range
Geikie Range
ROKEBY CROLL CREEK NATIONAL PARK
Archer R.
McIlwrath Range
PENINSULA
RANGE

SCALE 1:3,200,000

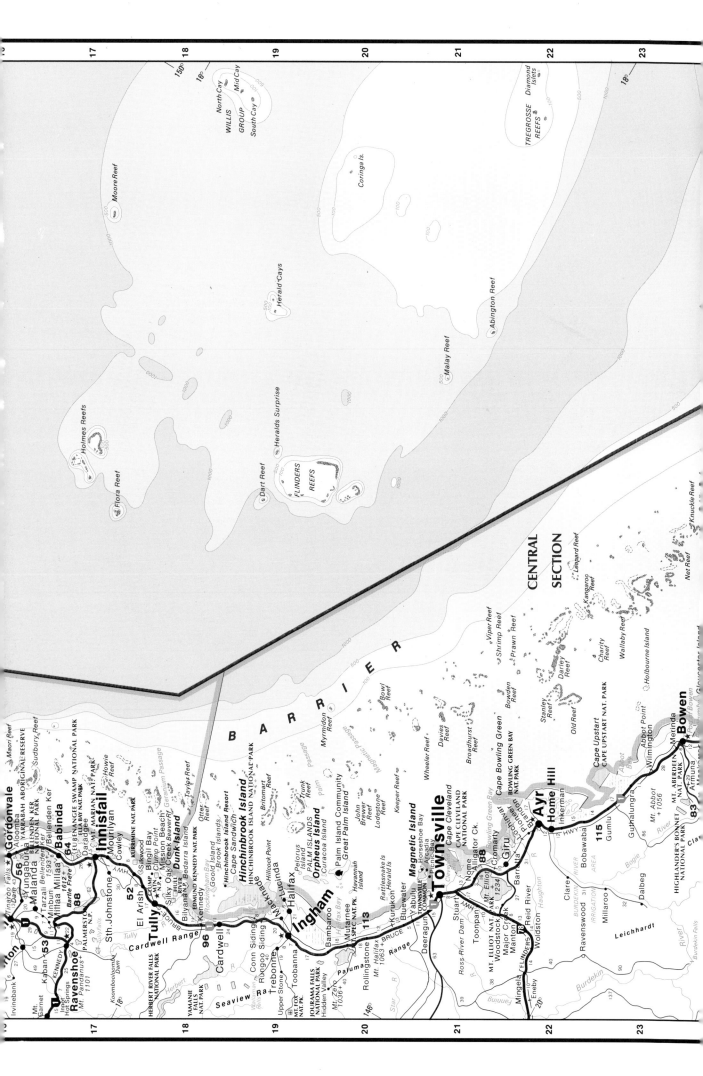

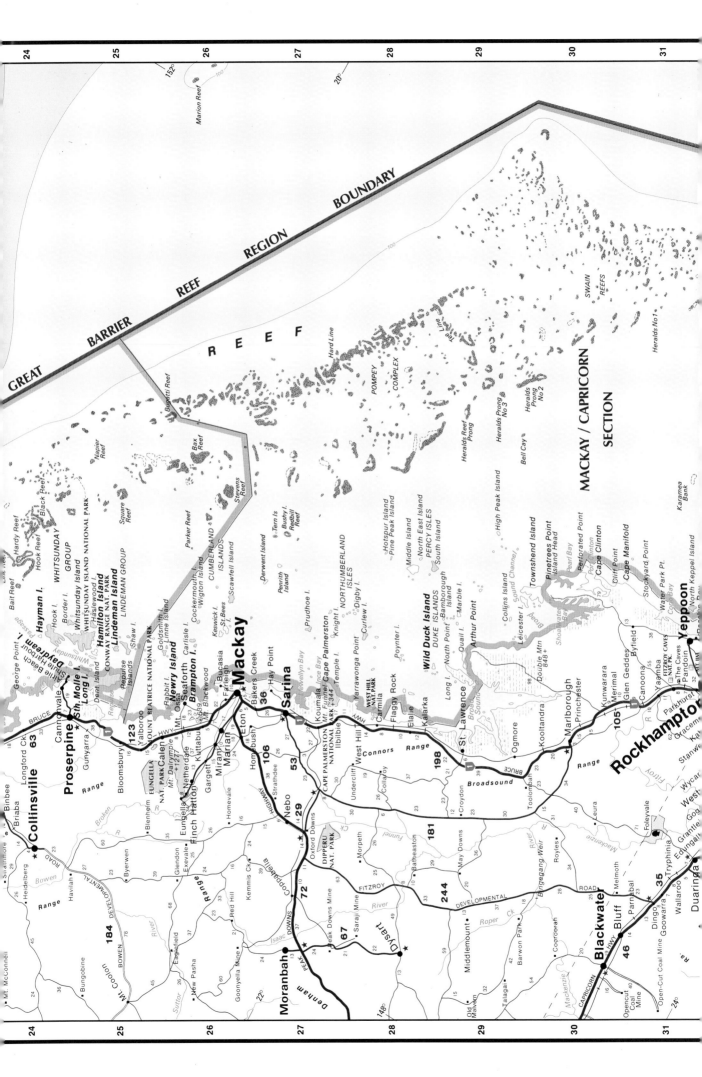

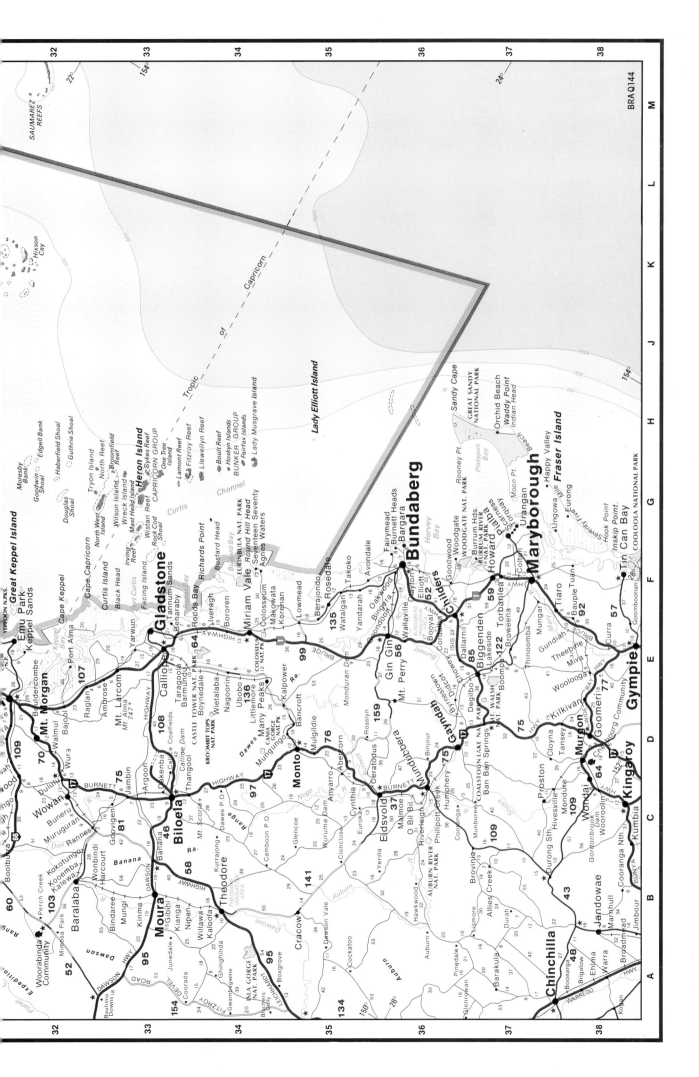

This map is indicative only

LEGEND

	Highways	Coral Reefs and Shoals
	Main Roads	National Parks
	Other Roads	Aboriginal Reserves
	Railways	Perennial Lakes
	Distances (kilometres), intermediate & cumulative	Swamps
sealed unsealed		G.B.R. Marine Park Boundaries
26	National Route Numbers	G.B.R. Region Boundary
5 9 12		As per schedule to the Great Barrier Reef Marine Park Act 1975.
U V		Caves ● Aboriginal Community
∴ Ruins ○ Ghost Towns	Elevations and Depths in metres	

Coral Sea

OSPREY REEF

Bougainville Reef

N

CORMORANT PASS SECTION
No Name Reef
Cormorant Pass
Ribbon Reef No 10
N

GREAT BARRIER

Creech Reef
Rodda Reef
Corbett Reef
Claremont Pt.
Evanson Pt.
Stewart
FLINDERS GROUP
Stanley I.
King I.
Flinders I.
Pipon I.
Bathurst Head
Princess Charlotte Bay
Bathurst Bay
Melville Passage
Cape Melville
MELVILLE NATIONAL PARK
Saints Pauls Hill +418
Marina Plains
Wakooka Outstation
Breeza Plains Outstation
South Warden Reef
Waterwitch Passage
Barrow Point
Red Pt.
HOWICK GROUP
Murdock Point
Jewell Reef
1000
500
Melville Rfs
TURTLE GROUP
Nymph I.
Lizard I.
Lookout Point
Cape Flattery
One Mile Opening
One and a Half Mile Opening
Half Mile Opening
Cook's Passage
Jewell Reef
No 9
No 8
Lark Pass
No 7
No 6
No 5
No 4
No 3
No 2
Ribbon Reef No 1
Cruiser Pass.
Papuan Pass.
St. Crispin Reef
Tongue Reef
Batt Reef
Low I.
Michae-mas Cay
Upolo Cay
Arlington Reef
Green I.
Cape Grafton
Yarrabah Community
GREY PK.
Fitzroy Island
Trinity Opening
Grafton Passage
Cairns Reef

CAIRNS SECTION

Hope Vale Community
Cape Bedford
Noble I.
Nob Point
Archer Point
Williamson Rfs
ENDEAVOUR RIVER NAT.PK.
Cooktown
MT COOK NAT.PK.
82
Rossville
Mt Finnigan 1148+
BLACK MOUNTAIN NAT. PARK
Obree Pt.
Rattlesnake Point
Endeavour Reef
Weary Reef
CAPE TRIBULATION NAT.PARK
Cape Tribulation
Cape Kimberley
Alexandra Bay
DAGMAR RANGE NAT. PARK
Cow Bay
Port Douglas
Clifton Beach
Trinity Beach
AND RESERVE
AND RESERVE

Creek
Jeannie R.
Starcke
STARCKE NATIONAL PARK
Glenrock
Battle Camp
Normanby R.
Laura R.
LAKEFIELD NATIONAL PARK
41
Lakefield
Marina Plains
Breeza Plains
Kennedy R.
Nth Kennedy R.
Hann R.
Morehead R.
317
Jack R.
Laura
Kalinga
Fairview
Fairlight
Maytown
Woods Peak +762
Maitland Downs
Mitchell
Palmer R.
QUINKIN RESERVE
Sussex
Lakeland
Roadhouse
146
CEDAR BAY NATIONAL PARK
Adeline Falls
Thornton Peak 1325+
MOSSMAN RIVER GORGE NATIONAL PARK
Daintree
Miallo
Mossman
Rumula
Kuranda
Koah
Barron Falls
Walkamin
Tolga
Mt. Carbine
Mt. Molloy
Biboohra
Mareeba
MAREEBA-DIMBULAH IRRIGATION AREA
Mutchilba
Dimbulah
Petford
Atherton
Walsh
White Rk.
CAPT. COOK HWY
Newell
Edmonton
Wujal Wujal
Mt. Cook
Developmental
38
35
30
26
20
16
32
29
38
47
54
64
59
46
65
75
39
8
33
35
32
38
65
24
75
146
82

9
10
11
12
13
14
15

12°
14°
16°
18°
14°
146°
148°

MAP OF
THE GREAT BARRIER REEF
MARINE PARK

This fold-out map, which is reproduced with the permission of the Great Barrier Reef Marine Park Authority, gives a good overview of the Great Barrrier Reef Region including the adjacent mainland. It may help to gain perspective on the distances involved in travelling to The Reef as well as in travelling between the principal coastal gateways. The map scale is 1:2 200 000, so:

>1 cm = 22 km (about 12 nautical miles)
>1 in = 56 km (about 30 nautical miles)

In the map margins are letters and numbers which provide grid references. These are cited throughout the text of *Barrier Reef Traveller* to help voyagers find their way.

← → FOLD OUT

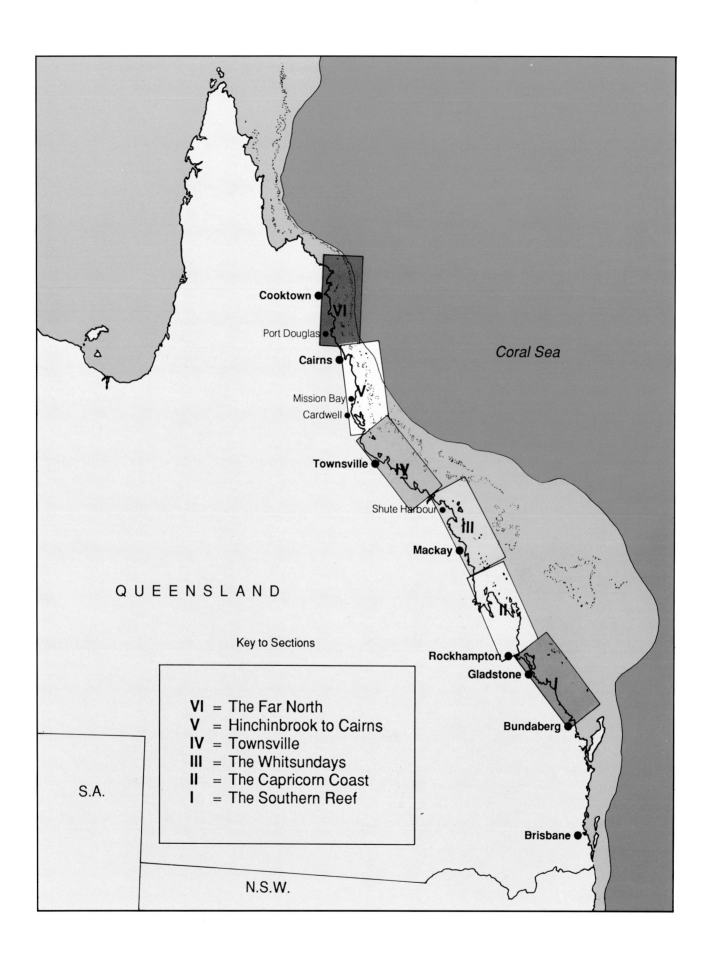

Cooktown

Port Douglas

VI

Coral Sea

Cairns

Mission Bay

Cardwell

Townsville

IV

Shute Harbour

III

Mackay

II

QUEENSLAND

Key to Sections

Rockhampton

Gladstone

I

Bundaberg

VI	= The Far North
V	= Hinchinbrook to Cairns
IV	= Townsville
III	= The Whitsundays
II	= The Capricorn Coast
I	= The Southern Reef

S.A.

Brisbane

N.S.W.

TRAVELLER'S BRIEFING

Using this book; notes on travelling in Australia and to The Reef

The Great Barrier Reef has been variously described as the 'eighth natural wonder of the world' and 'the largest structure on earth made by living creatures', and indeed it stretches some 2000 km along the Queensland coastline, from above Cape York to just north of Bundaberg. Being cloaked in the mystery of the sea, The Reef has always held a certain fascination, but the advent of scuba diving in the 1950s opened up the underwater universe, and tales of the amazing life on and around coral reefs simply heightened the allure. The Reef, however, remained pretty much in the domain of the adventurer because of the relative difficulty of getting there. Travel involved a six- to seven-hour journey, often on a boat that was pitching and rolling violently on seas whipped up by the trade winds. Today, fast motorised catamarans take 'adventurers' of all kinds to The Reef in one to two hours. The day trip has been made possible, and The Reef has become available to those who previously wouldn't have gone. Even those who are not adventurous enough to get into the water can still experience the excitement of The Reef from a glass-bottom boat or a partially submerged coral-viewing 'sub'.

The part of the Great Barrier Reef considered in *Barrier Reef Traveller* is the 1300 km from Lizard Island (latitude 14° 40'S) to Lady Elliot Island (latitude 24° 07'S), where tourist activity is generally well developed. This represents a vast stretch of geography, and The Reef thus still poses one question for the tourist: where to start. In order to provide some focus, this very long piece of coast has been divided into six sections of equal length. Because the majority of travellers either live south or will begin their travels from points south, the book deals with The Reef as it is encountered moving from south to north. Within each section, the book describes the mainland 'gateways' to The Reef, the coastal cities and towns which are the exit points, tells how to get to each, gives a few details of local attractions, and then describes Reef destinations reached from each gateway—islands, resorts, Reef trips and other things that can be done on or around The Reef.

Later in the book there are brief summaries which provide an overview of particular interests, for example, diving, fishing, yachting, and which consider the Reef area from those perspectives. Travellers with a specific bent may find these helpful in deciding where best to go. Likewise, wildlife watchers may find some points of interest in 'Notes for Reef travellers'.

The Great Barrier Reef is not a single, continuous reef as its name suggests but is in fact a system of about three thousand individual coral reefs. Australians, who like to abbreviate, call it simply 'The Reef', and the term has come to be used in a number of different ways. Some people use 'The Reef' to mean anything within the Barrier Reef Region, an area defined by a Federal Act of Parliament which, in 1975, set out to protect The Reef by creating a Marine Park around it. This Region also encompasses numerous continental islands close to the mainland, so called because they are made of the same continental rock as the mainland. They are yesterday's coastal mountains, cut off when the ice melted at the end of the last ice age. Many of them have coral reefs frin-

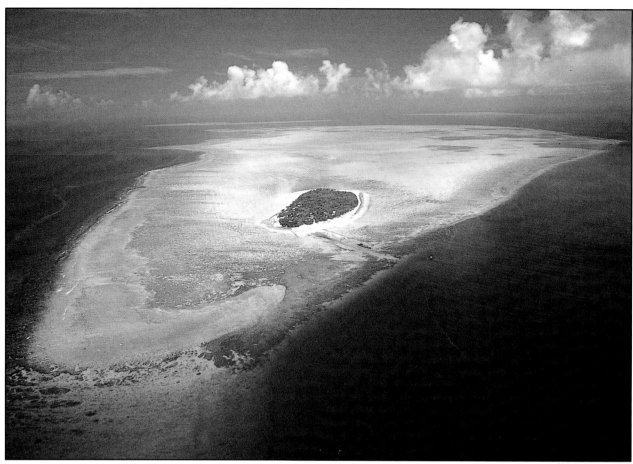

STEVE NUTT – QTTC

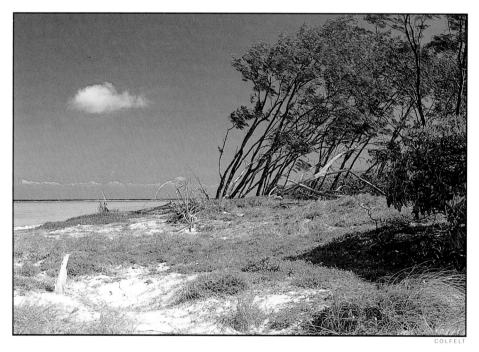

COLFELT

Top: Heron Island is a vegetated coral cay which has grown from the accumulated debris of a platform reef in the southern Reef Region; it is thus a true Barrier Reef island.
Bottom: Coral cays have their own special character and vegetation. Their calcareous sand is made up of fragments of coral, shells and the skeletons of other limestone-secreting animals and plants which are part of a reef community.

COLFELT

COLFELT

Top: Continental islands are made of the same rock as the mainland, being yesterday's
coastal ranges, cut off by the flood at the end of the last ice age. They may have
well-developed fringing coral reefs.
Bottom: The vegetation of continental islands is typical of that on the
adjacent mainland, featuring eucalypts, acacias and hoop pines.

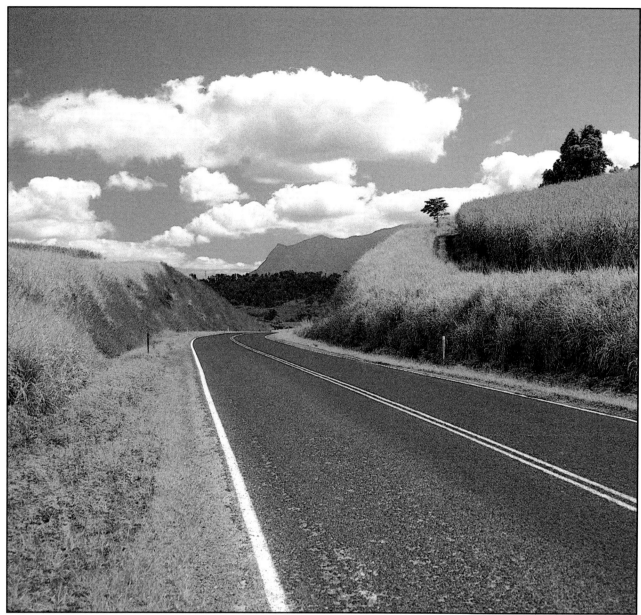

COLFELT

Above:
Fields of tall sugar cane and blue
volcanic mountains characterise much
of the Queensland landscape along the
Bruce Highway between the Barrier
Reef gateway cities.

Right:
Cane fires are a common sight in
Queensland from June to December.
They are deliberately set in preparation
for harvesting.

ging their shores, and some even have coral beaches like those of true coral islands. 'Barrier Reef island' is sometimes used to refer to one of these continental islands, usually by resort operators or advertising copywriters anxious to capitalise on the magic of The Reef, but the term really refers to the true coral islands, ones that are an inherent part of The Reef system and which have unique vegetation and bird life. 'Barrier Reef holiday' means, to some people, simply a trip to a mainland city, adjacent to the Great Barrier Reef Marine Park, from which a lot of Reef activity begins.

The importance of all this is simply to show that terminology is not universal, and it is possible for travellers to get a wrong impression when reading some tourist literature. The prescription for disappointment is to have one's expectations not matched by reality, regardless of how good the reality may be, and from the outset it's best to have a clear picture of what is in store.

Fold-out map of the Great Barrier Reef

Between pages 16 and 17 is a fold-out map of the Great Barrier Reef and the Queensland coast from Cape York to just south of Fraser Island. This map, produced by the Great Barrier Reef Marine Park Authority, helps to put The Reef in geographic perspective and may be of use in planning a holiday. References given after place-names, for example, Gladstone (E 33), are grid references based on letters and numbers in the margins of the fold-out map.

Travel in Australia and to The Reef

Australia is a relatively large country with most of its population scattered around its coastal fringes. It is virtually the same size as the USA. Many visitors from overseas, and even many Australians, fail to appreciate the distances involved in travelling, for example, from one of Australia's southern cities to a Barrier Reef gateway. Some tourists fly into Sydney expecting to 'do' the Sydney Opera House in the morning and then to set foot on The Reef that afternoon.

The whole of the British Isles could rattle around in the area of Queensland; Japan would occupy only a slice. All of Europe, from Spain to the Black Sea, can be accommodated in the Australian island continent. Travelling from Sydney to Cairns one covers the same distance as going from Florida to the Great Lakes.

Travel by road

Australia, with almost as large a land mass as the USA, has a population of only sixteen million. The major cities are dispersed around the coast. The highways connecting these cities are not six-lane super-highways where you can put your foot down and sit right on the speed limit, maintaining an average of 100 to 110 km/h. For example, as the crow flies, the distance between Sydney and Brisbane is 730 km, but the trip takes all of 12 hours by car.

As a rule of thumb, in Queensland it takes four hours, more or less, to get from one major coastal centre to the next. The roads are generally straight and were improved in many sections during the bicentenary road-building programme. Travel by road, if time is available, offers potential savings for a family and is a way to get a feel for the country. The scenery is always striking, the blue silhouettes of volcanic mountains, the red soils of ploughed fields next to vibrant green sugar cane blowing in the wind, the charming houses of Queensland built on

Australia vs. United Kingdom

Australia vs. Japan

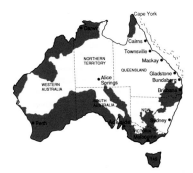

Australia vs. Europe

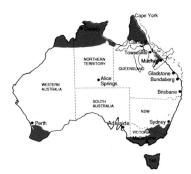

Australia vs. USA

COLFELT

Above:
Air travel in Australia has traditionally been in the hands of virtually two carriers, Ansett and Australian Airlines, although the two-airline policy that brought about this situation is now scheduled for dismantling. A number of small airlines fly to destinations on and around The Reef, such as to Lindeman Island (pictured), which is serviced by Seair Whitsunday from Mackay and Shute Harbour. The trip in a small plane adds an element of excitement to arriving for an island resort holiday.

stilts, with their latticework. The rent-a-car business in Australia is well developed, and you can find an Avis car, for example, in almost any town; one-way rentals are available between major cities for those who wish to drive one way and fly the other.

Five coach lines travel the Brisbane–Cairns route, most providing several daily services. Travel times vary somewhat from company to company depending upon the stops and meal breaks; the total travel time straight through from Brisbane to Cairns is 23 to 27 hours. Coach travel is the least expensive way to go. Smokers should note that most companies do not permit smoking on the bus.

Travel by air

There are international airports in all of Australia's State capital cities, and a few extra ones in Queensland for the benefit of Reef travellers—at Cairns and Townsville, and one or two more under consideration.

Air travel in Australia has for years been governed by a so-called two-airline policy which gave two domestic carriers, Ansett Airlines, which is privately owned, and Australian Airlines, owned by the Federal Government, a virtual monopoly on domestic air travel. The policy has provided Australians with a very good service and (so far) a safety record second to none. Australians complain about the 'high cost' of domestic flying, but we have a small population, we make a fetish of servicing expensive modern aircraft, and it is possible to get flights to even remote centres almost daily. The two airlines' schedules have historically been almost identical—a virtual 'drag race down the

runway'—and this parallel scheduling, as it is euphemistically called, can be blamed to some degree on the fact that air service in Australia is a 'tale of two cities', based on the demands of Sydney and Melbourne, where a large majority of the population lives. Business travellers account for most of the demand, and since most business travellers want to move between the cities in the early morning and late afternoon, all other scheduling follows from this. A range of discount fares is available, such as advance purchase fares, stand-by, flexi-fare, bulk kilometre purchase, with discounts ranging from 20% to 45% of the Economy Class fare. 'Package holidays' effectively give considerable discounts on air fares, and there are special discounts available to visitors from overseas. Children under three travel free; ages 3–14 travel for half fare.

The two-airline policy is scheduled for termination in a few years' time, and the airlines are moving towards the new operating environment. It is now possible for international passengers on Australia's flagship carrier, Qantas, to stay aboard the flight on which they arrive in Australia and, after going through customs and immigration, to proceed on their Qantas flight to other domestic destinations. East West Airlines, a small domestic airline owned by the same company that owns Ansett Airlines, is beginning to appear on Queensland routes between Brisbane and Mackay, and it will be offering services in the southern Barrier Reef area.

Australian airlines offer two basic classes of service, First Class and Economy Class. As a general rule Economy Class is one-third cheaper than First Class. Most flights offer either a full meal or snack service. Flights in the Barrier Reef area are seldom longer than two hours, so Economy Class offers a worthwhile saving. First Class passengers are allowed to check in three pieces of luggage and Economy passengers are allowed one piece*.

Many say that the choice between the two major airlines really comes down to a matter of preference for the type of aircraft, if you are that much of an *aficionado*, or whether you prefer white planes to have their decoration on the fuselage or on both the fuselage and the tail fin. It must be said that Ansett serves the best cup of coffee you'll find other than at home or at a highway diner in America.

Ansett has an interest in the Queensland air operator, Lloyd Air, and Australian Airlines has an interest in Queensland's Sunstate Airlines, and these companies service a number of central and southern coastal gateway cities and islands which are off the main route. Ansett also has a 50% interest in the private airport on Hamilton Island, and it thus provides more services to the Whitsunday area than Australian does. A few other small companies offer a number of Reef tourist services, such as Seair Pacific (Seair Whitsunday), which operates coastal, island and Reef services, and Air Queensland, which flies to Cooktown and Lizard Island (among other destinations) from Cairns.

Travel by train

Train travel in Queensland is certainly not the fastest way to go, but some say it is the only way to go to really appreciate the countryside. The trip from Brisbane to Cairns takes 33 to 35 hours, although electrification of some sections of the track by mid-1989 will see several hours chopped off the trip. The coastal gateways to The Reef between Brisbane and Cairns are serviced by two trains, the Queenslander, a spruced-up tourist service departing once a week from Brisbane (on

**Baggage on planes and trains*
Planes. Each piece of luggage must not exceed 140 cm (55 in) in the sum of its length, width and depth, nor weigh more than 30 kg (66 lbs). Excess baggage may not be able to be put on the same flight and may be charged at 'air freight' rates. Hand luggage permitted is: one briefcase or small overnight bag that will fit under the seat (dimensions not to exceed 48 cm in length, 34 cm in width and 23 cm in depth) and one soft-sided suit-pack (unfolded dimensions not to exceed 114 cm in length, 60 cm in width and 11 cm depth). In addition personal items may be taken as follows, provided their total weight does not exceed 4 kg: one small handbag, one small camera, overcoat, infant's food, toiletries. Hand baggage exceeding these limits may be treated as cargo and may not get onto the same flight. It is worth noting that travel to some island destinations is on small aircraft, and baggage is more severely restricted; for example, passengers to Heron Island are restricted to one bag not exceeding 15 kg, and travellers to Lady Elliot Island are permitted a total of 10 kg.
Trains. Passengers on Queensland rail services are allowed 80 kg of baggage without extra charge.

Australian weather is dominated by a belt of subtropical, uniform high pressure, the axis of which is centred about 30°S in winter. High pressure systems march across the Australian continent from west to east. The isobars on a weather map in winter typically depict a high centred over the southern continent with ridges up the Queensland coast, and the anti-clockwise circulation of air around this high produces the south-east trade winds which blow quite persistently in the Barrier Reef Region from April to September. These often have to be reckoned with in planning activities on The Reef.

In the Australian summer, the subtropical high moves south, the south-east trades abate and easterly to north-westerly winds predominate.

Sunday morning), and the Sunlander, a commuter service which operates five days a week.

The Queenslander has an all-inclusive First Class fare which is slightly less than the cost of an Economy Class plane ticket; it includes all meals in the dining car and your berth, in either a roomette car (single berth compartments with wardrobe, washbasin, and toilet) or twinette car (twin-bed compartments like the singles but without their own toilet); twinette cars themselves have toilet and shower. First Class passengers have the use of the lounge car, with its thick carpet and wood panelling, bar and video; it is open from 10.00 a.m to 10.00 p.m. Economy and concession fares include accommodation in the sitting car (it has 48 reclining seats), and meals are *à la carte.* The train also has a Club Car for snacks, confectionery and cigarettes. If you are travelling to either Townsville or Cairns, the Queenslander offers 'motorail', a piggy-back service for cars and trailers.

The Sunlander is a commuter service which is slightly slower (about two hours longer). A First Class ticket to Cairns on this train costs half as much as an Economy air fare, but all meals are *à la carte.* There are sitting cars, optional sleepers, a Club Car and dining car.

On both trains children 4 to 15 years travel for half fare.

Weather: when is the best time to go?

Australia's seasons are opposite to those in North America and Europe. The Barrier Reef Region, particularly in the north, hardly has seasons at all, the weather merely being relatively hotter and wetter or cooler and drier. Throughout the area the hottest and wettest months are January–March. The coldest month is July (if it ever gets 'cold'; the coldest night on the southernmost cay of The Reef is about 14°C; the temperature drops below this on the mainland. July, August and September are the driest months.

The Reef destinations described in this book span 10° of latitude, some 1111 km, and there is considerable difference in temperature from one end to the other. In the northern areas it is always warm. In southern areas in winter (June–August), if the trade winds are piping, you will need a wind-cheater or sweater when you're out in the wind, but you will be comfortable in a bathing suit lying in the sun. If you're in the water snorkelling for longer than 15 minutes or so, a wet suit will be a comfort, although the water is seldom cooler than 21°C.

Whether there is a 'best' time of year on The Reef is debatable, and it also depends upon how far south or north you are going to go. In general, the winter months (June–August) are driest and delightful to those who do not appreciate humidity; the heat is tempered by the south-east trades. Some say September–October is best, because the trade winds are abating and swinging more to the north, there are increasing days of calms, and the temperature neither too hot nor too cool.

North Americans and Europeans often come to Australia in January to February having cleverly escaped the perils of their winter. They plan to visit The Reef at a time when many Australians would think twice about going to central or northern Queensland—hot, humid, possibly wet, perhaps a cyclone. Some people love the tropical heat, but in any event the prescription for surviving a northern summer is to be sensible about clothes and to relax and enjoy it. Forget about make-up and fashion, and wear loose-fitting clothes made of natural fibres. Synthetics are uncomfortable in the tropics; they are clammy and don't

COLFELT

An example of Queensland architecture, a house in Bowen (D 23–24) with elegant
spindle palms (*Hyophorbe verschaffeltii*) on the front lawn.

COLFELT

Above:

The advent of the fast motorised catamaran revolutionised travel to the Barrier Reef and made day-trips possible for the average tourist. Pictured is the MV *Lady Musgrave*, which visits the coral cay of the same name, departing from the gateway city of Bundaberg.

breathe as well as cotton does.

December–January typically marks the onset of the wet season in the Reef Region (the tropical monsoon), although the weather continues to live up to its reputation of being utterly confounding. Wet seasons, of late, have been fitful ones, arriving late, being equivocal, and sometimes hanging around until June. About the only thing that can really be said for certain these days is that December–March will be quite warm and humid in The Reef Region. In the northern areas February may have some superb days or it can be very hot and humid, 38°C by day, 98% humidity, dropping down to 32°C at night; tile floors feel warm; you take a cold shower because the hot water is just too hot; watch dogs lie down and go to sleep. As the wet season progresses, the weather settles into a pattern where most rain falls at night. The mornings glisten; everything has grown another few centimetres.

As for cyclones, they can come any time from November to May. If they come at all, it is most often in February or March. Queensland has an excellent warning system which gives several days' advance notice of severe storms, so there is little chance of being caught unawares.

Travel to The Reef

The Great Barrier Reef lies on Australia's continental shelf, generally towards its outer margin. The shelf varies in width at different locations along the Queensland coast, being narrower in the north than in the south. It is about 40 km wide just below Lizard Island (14° 40'S), and from there south it gets progressively wider, reaching a maximum of

COLFELT

about 370 km due east of Mackay (21°S). It then narrows again, and opposite Gladstone (23° 50'S), the shelf width is about 100 km. This means simply that The Reef is closer to some coastal gateways than to others, and it tends to be easier to get to in the north than in the south.

Getting to The Reef by definition means a trip over the water which, depending upon the particular destination, may be by boat and/or by aeroplane. The Queensland coast is fanned by south-east trade winds which blow persistently from April to late September. Although the waters behind the Barrier Reef are protected from oceanic swells by The Reef, the trade winds can whip up the local seas. The catamarans of today provide a much faster and more comfortable ride than the slow monohulls of yesterday, and the latest generation of 'wavepiercers' which are beginning to appear have hulls designed to go *through* the seas rather than over them, providing even a more comfortable ride. However, if it is blowing 20 knots or more, the ride to The Reef will be bumpy, particularly if the ship is heading straight into the weather.

There is nothing that can be done about the weather and sea conditions. Sometimes the trip on a boat will be idyllic, sometimes not. If you know you are prone to seasickness and become green and prostrate when waves are a few centimetres high, if an air travel option is available this may be worth your consideration.

What to expect on a Reef trip

A typical day-trip to the Barrier Reef entails a one- to two-hour journey on a large motorised catamaran, or 'cat', usually a double-decker which

Above:
A crew member of a Reef-tripping catamaran keeps an eye on snorkellers while other guests enjoy a visit ashore at Michaelmas Cay, which is reached from the Cairns gateway.

DEAN LEE

Above:
Semi-submerged coral-viewing craft provide a close look at fish life and enable the Reef visitor to see the sides of coral heads as well as beneath coral ledges. These 'subs' and their surface counterparts, glass-bottom boats, provide two quite different perspectives on reef life.

has large enclosed lounges with rows of seats like a wide-bodied jet. Passengers can also sit outside in the fresh air on the sun deck.

On the trip out, those sitting in the lounges can watch video movies about The Reef. The bar is open, and passengers may be invited to sign up for a guided snorkelling tour, conducted by a qualified marine biologist. Underwater cameras are available for hire, and scuba diving is available for qualified divers. A fee is charged for such 'extras'.

There is a sense of anticipation and excitement on arrival, as the reef slowly reveals itself in the surrounding vibrant blue, an almost iridescent hue characteristic of clear oceanic waters over the white coral reef sands. The air is spiced with salt, and swarms of tame fish may swim up and splash impatiently, knowing they will soon be fed.

The catamaran ties up next to a large floating aluminium pontoon anchored in the lee of The Reef, and this, along with the cat, becomes the base for the day's activities. It has a sun deck, shaded tables and benches, a sea-level platform to allow snorkellers and divers easy entry and exit from the water, an underwater viewing chamber, and showers.

There will be trips in glass-bottom boats and the opportunity to have a ride on a reef-viewing 'sub', as they are called, which looks like a submarine but, in fact, is not as it never submerges; it has a below-water-line viewing chamber with rows of benches in front of large glass windows, and it is self-propelled for manoeuvring in and out amongst coral heads and along the edge of the reef. Glass-bottom boats and coral-viewing subs offer two quite different views of a reef, and as they

are included in the price of your trip, it's worth going on both excursions to get two different perspectives. The boat gives a bird's-eye view, while the sub provides a lateral view and allows you to see underneath ledges and down the sides of coral heads. Fishes swim close past the windows (when taking pictures hold the camera right against the glass, particularly if you are using flash, to avoid unwanted reflections).

The very best vantage point from which to really appreciate a coral reef and its marine life is in the water, either snorkelling or diving. (Those who are unskilled at snorkelling should read the summary section on snorkelling and diving later in this book. Those frightened by the thought of sharks shouldn't be, and should assuage their fears by browsing through 'Sharks' in the 'Notes for Reef travellers'.)

If your Reef trip is to a coral cay, you will have the opportunity to go ashore and to experience the beauty of a coral island, with its unique vegetation and sea bird life. Unsure snorkellers may find it more comfortable to practise while standing waist deep in water at a beach rather than diving into deep water from the pontoon. At a few reefs, if the tide conditions are right, you may be able to do some reef-walking. Always wear old shoes or sneakers that you don't mind getting wet. Protective footwear is essential for reef walking (try not to step on live coral—keep to sandy areas or areas which have the appearance of being 'cemented over').

Lunch is served on the catamaran, and there is time afterwards for more reef exploration or perhaps just lying in the sun. You will normally spend about three hours out at The Reef.

On the return trip another movie may be shown, and the marine biologists are available, with books about The Reef, to discuss any amazing creatures you may have seen. You can have a drink from the bar and relax and enjoy the journey.

Trips to The Reef via sea plane or helicopter are available from some gateways and islands. These get you there in about 30 minutes, landing either in a reef lagoon or on a pontoon. It can be a very exciting way to go; depending upon the particular excursion, the price may be 30–100% more than that of a catamaran trip. Such excursions usually allow you two to three hours at The Reef and do not include lunch. For those with limited time to spare, they may be the answer.

Queensland's sun

The 'bronzed Aussie' is a familiar image and it says not only that Australians like the outdoors but also that the sun is very strong. Australian air is relatively unpolluted, and Queensland summer sun is virtually overhead, in the optimal position for frying the human skin. Even if you think you can tolerate massive doses of sun, don't underestimate the strength of Queensland's sun, even in winter-time. A broad-brimmed straw hat and long-sleeve white cotton shirt are extremely useful additions to any Reef traveller's wardrobe. Take plenty of suntan lotion, including a grade 15+ water-resistant sunscreen for use if you do not have a good tan base or to prevent further burning when for when you've overdone it a bit, as you almost inevitably will.

One other item that should be in the traveller's kit is insect repellent. There is just no such thing as the tropics without insects; some of those that bite have also discovered the delights of the best sandy beaches. Some general hints for keeping safe and well may be found in 'Notes for Reef travellers'.

Below:
A trip to The Reef by seaplane can be an exhilarating way to get there, offering a magnificent aerial perspective on the way out. Trips by plane or helicopter are offered from some gateways and can be ideal for those with only a little time to spare.

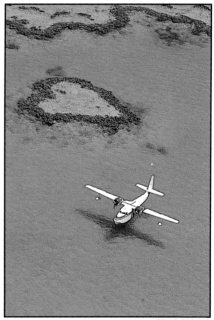

SEAIR PACIFIC

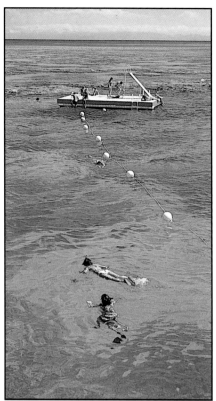

COLFELT

Above:
A pontoon anchored in the lee of Arlington Reef provides a sunning and snorkelling deck for Reef visitors.

Opposite:
Snorkelling is one of the best ways to really enjoy a coral reef, in intimate contact with the coral and marine life.

Approximate metric equivalents

1 hectare (ha) = 2.47 acres
1 metre (m) = 39.37 inches
1 metre = 3.28 feet
1 kilometre (km) = 0.63 statute miles
1 statute mile = 1.62 kilometres
1 nautical mile = 1.85 kilometres
15°C = 59°F
20°C = 68°F
25°C = 77°F
30°C = 86°F
35°C = 95°F

Two rough rules of thumb: to convert temperature from Celsius to Fahrenheit, double the Celsius degrees and add 30; to convert kilometres to statute miles, multiply by six and drop the last digit, e.g. 30 km = 30 x 6 = 18(0), 18 miles

What to wear

Dress in Queensland is informal. Good casual wear for men (evening attire) consists of open-necked short-sleeve shirt, slacks, or shorts with long socks, and, if really dressing up, a jacket, but the notion of a neck-tie is foreign to the tropics, with good reason. Women are most comfortable in a light dress or cotton skirt or slacks and shirt. During the day, just about anything goes.

Notes about Queensland beaches

The beaches of the Queensland coast are generally composed of brown quartz and feldspar sands and have a lovely golden hue rather than the pure white that is common to silica sand beaches. From Gladstone (E 33) north the beaches are behind the Great Barrier Reef and are protected from oceanic swells. This means they can be beautifully quiescent but also that there is no surf to speak of, so if you're after a surfing holiday, bear in mind that the northernmost surf beaches in Queensland are at Round Hill Head (F 34), in the vicinity of the towns of Seventeen Seventy and Agnes Waters.

Australia's mightiest river, the Burdekin, empties into the ocean just south of Ayr (C 22). It is said that 'a farm' passes under the Burdekin Bridge every three minutes in times of flood. The silt-laden waters are turned north by the Coriolis force, and immediately adjacent to the mainland coast from this point northwards the waters are tinted reddy-brown with the good earth borne by the Burdekin and other rivers. Further out, around the islands, the water is clearer.

From around mid-October through late May Queensland's mainland beaches are made potentially hazardous for swimming by the possible presence of marine stingers, namely the box jellyfish (*Chironex fleckeri*). These highly venomous jellyfish pack a potentially lethal wallop, and fatalities have resulted from their stings. Some beaches employ 'stinger nets' in an attempt to screen them out, and it is possible to purchase 'stinger suits' (lightweight full-body-length suits made of 'Lycra') for protection, but if you are contemplating a holiday centred around carefree beach activities and swimming during the October–May period, then you ought to choose an island venue or be prepared to do your swimming in a mainland fresh-water pool. Box jellyfish are a mainland and near-mainland phenomenon (they breed in the mainland river estuaries) and they are not a problem on the islands. For more information about the box jellyfish, see 'Notes for Reef travellers' in the latter pages of this book.

Which holiday?

The Barrier Reef area offers a wide choice of resorts and holidays. The next part of this book is devoted to describing each Reef gateway and its destinations. If you're looking for a resort holiday, the detailed descriptions of island resorts should help you decide which will suit your taste and your budget. Later chapters give brief overviews of diving, snorkelling, camping, fishing, and sailing in the Reef Region.

A note about the metric system

Some travellers may not have come to terms with the metric system, which Australians are bound by law to use. A couple of very rough rules of thumb for making conversions between the metric and imperial measures are given in the box at the left.

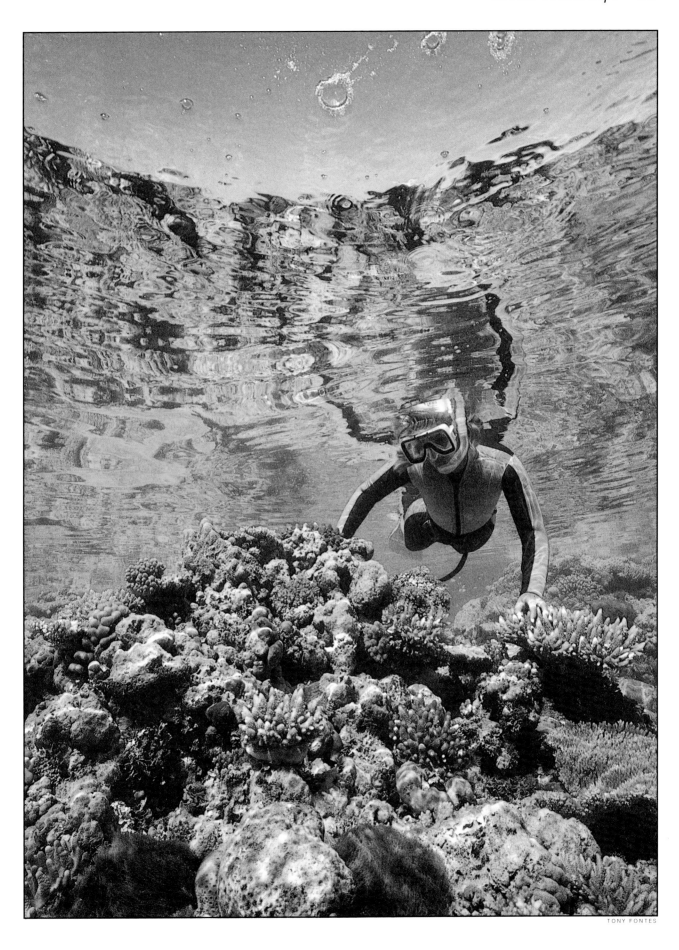

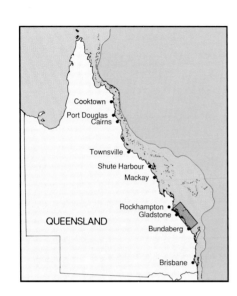

Principal destinations of this section

From Bundaberg
- *Lady Elliot Island*
- *Lady Musgrave Island*

From Gladstone
- *Heron Island*
- *North West Island*
- *Mast Head Island*
- *Tryon Island*
- *Lady Musgrave Island*
- *The Swain Reefs*

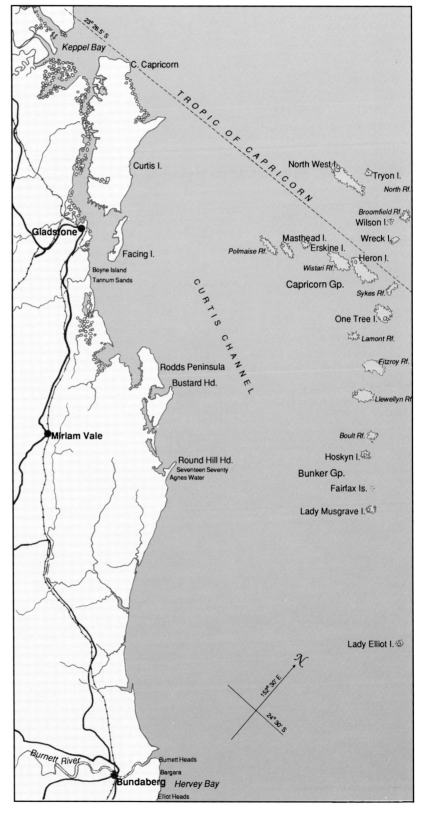

Keppel Bay

C. Capricorn

TROPIC OF CAPRICORN

23° 26.5' S

Curtis I.

North West I.

Tryon I.

North Rf.

Broomfield Rf.

Wilson I.

Masthead I.

Wreck I.

Polmaise Rf.

Erskine I.

Heron I.

Gladstone

Wistari Rf.

Facing I.

Capricorn Gp.

Sykes Rf.

Boyne Island
Tannum Sands

CURTIS CHANNEL

One Tree I.

Lamont Rf.

Fitzroy Rf.

Rodds Peninsula

Bustard Hd.

Llewellyn Rf

Boult Rf.

Mirlam Vale

Round Hill Hd.
Seventeen Seventy
Agnes Water

Hoskyn I.

Bunker Gp.

Fairfax Is.

Lady Musgrave I.

Lady Elliot I.

152° 30' E

24° 30' S

Burnett River

Burnett Heads

Bargara

Bundaberg

Hervey Bay

Elliot Heads

Cooktown

Port Douglas
Cairns

Townsville

Shute Harbour
Mackay

Rockhampton
Gladstone

QUEENSLAND

Bundaberg

Brisbane

SECTION I
THE SOUTHERN REEF

The southern Barrier Reef and its coral islands; the gateway cities of Bundaberg and Gladstone and their Reef destinations

The gateway cities of Bundaberg (F 36) and Gladstone (EF 33) provide the first opportunity to see the southern Great Barrier Reef, which is made up of a series of platform reefs that rise near the eastern edge of the continental shelf. Some of the reefs are just beneath the surface at low tide, while others have upon them islands made of coral sand or shingle, with luxuriant vegetation. They lie in clear waters away from the influence of mainland river systems, and from the air on a sunny day they appear not unlike emeralds strung out beneath the sea.

Some say this is the most beautiful part of the Great Barrier Reef Region, with the most equable climate, mild in summer and in winter. It is one of the significant turtle nesting areas of the world, and its cays (coral islands) are important sea bird rookeries. In late winter and early spring, humpback whales cruise through the Curtis Channel and can be seen breaching and cavorting on their way south to Antarctic feeding grounds. Tourists may observe them while sipping a drink by the pool at Heron Island Resort, or from the beach at Lady Musgrave.

Lady Elliot Island (H 35) represents the extreme south of the Great Barrier Reef. Twenty-two nautical miles (41 km) further north are two groups of coral islands and reefs, the Bunker Group and the Capricorn Group, which are strung out to the north-west for a distance of over 53 nautical miles (98 km). There are 15 coral islands in all, counting the double islands of Hoskyn and Fairfax—all true Barrier Reef islands. They have actually been built on top of reefs by the action of the waves. There are also eight platform reefs, without cays, in this area.

The coral islands of the south

Unlike the continental islands, the coral islands (or cays) of the region have never been part of the mainland. They have existed possibly for only 3000 years, the process of their creation having begun after the sea level stabilised at the end of the last great thaw.

The cays are formed by the action of tides and waves, which pile up coral debris and sand on top of the reef. The prevailing south-easterly trade winds whip up the sea, waves strike the reefs and are refracted around their sides, recurving back and travelling across the surface of the reef to leeward. The redirected waves converge at the nodal point and deposit their suspended sediments. If conditions are favourable, and enough of this sediment remains accumulated above the water at high tide, and if this pile of sand and shingle survives wind changes and storms from one season to the next, sea birds will probably find the fledgling island a convenient resting spot. They will contribute guano (droppings) to the structure—the beginnings of a soil base. Seeds will arrive, by their own adventure over the water, or transported by birds—stuck to their feathers or left in their droppings. Again, if favourable conditions prevail, the first colonising plants—creepers that can withstand the harsh salt environment close to the water—will take root. If all goes well the island will continue to grow. More vegetation will arrive and secure a niche, perhaps on the beach just behind the prostrate vines. The sea birds will continue to fertilise the soil. The new

Below:
North Reef, with its vegetated cay, is located at the top end of the Capricorn Group. The lighthouse was built in 1878 and was unique in Australia, being the only one with the keeper's quarters incorporated in the base. It is now fully automatic. The cay is highly mobile, having moved several hundred metres to the north since the lighthouse was built. The structure was originally placed on the lee side of the reef flat, and it is now completely encircled by the island, which is continuing to move to leeward.

DEAN LEE

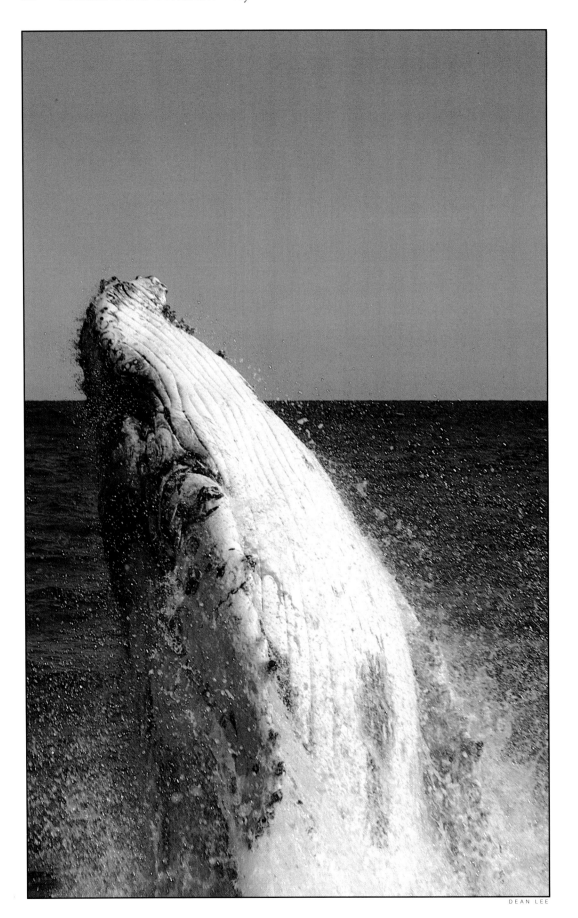

DEAN LEE

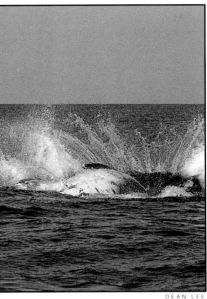

Humpback whales are becoming an increasingly common sight in the southern Barrier Reef as populations build up without pressure of whaling. They can be seen from nearby islands of the Capricorn and Bunker Groups, breaching and cavorting on their way south to Antarctic feeding grounds, and special 'whale watching' charter boats now operate from Hervey Bay (G 36). The tail flukes of humpbacks are highly individualised and are used by whale watchers to identify particular beasts, much as human fingerprints can be used to identify individual human mammals.

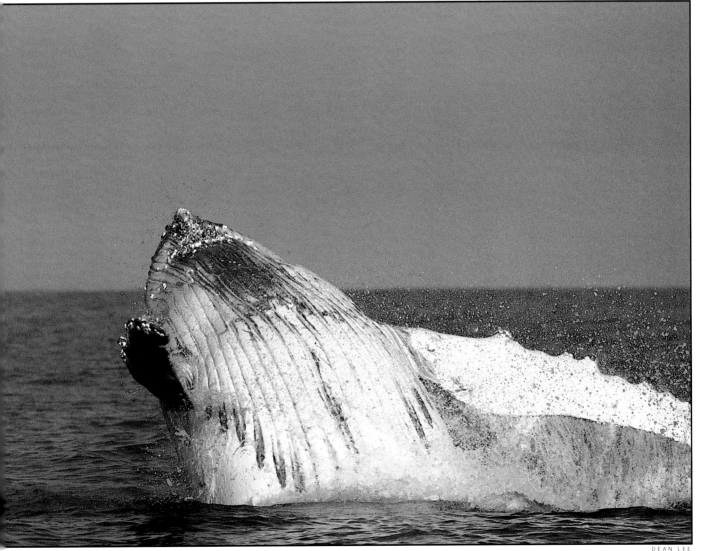

plants may create an environment favourable to yet more floral colonisers, each favouring its particular habitat. The island may soon be able to retain some of the rain that falls on it, and the existence of a 'lens' of fresh water, plus the conditions created by early vegetation, will encourage more growth. Older colonisers may be pushed out by the later arrivals.

Typical of vegetation seen on coral cays of the Capricorn and Bunker Groups are: Goat's-foot convolvulus (*Ipomoea pes-caprae* subsp. *brasiliensis*), a creeper with pretty purplish-pink flowers on the beach edge; hardy shrubs (such as *Argusia argentea*, or octopus bush) which can form an almost impenetrable wind break on the upper rubble of the beach; grasses, such as spinifex on the sand dunes; the graceful *Casuarina equisetifolia* var. *incana* (she-oak) with its fine needle-like branchlets and special roots that allow it to succeed in the salty, sandy soil above the dunes; low herbs; the pandanus (screw pine) with its fibrous leaves used throughout the Pacific to make bed-mats; the pisonia, a relatively tall, soft-wooded, leafy tree that forms dense shady groves in the middle of the islands. The branches of pisonias provide nesting areas for sea birds, such as black noddy terns (*Anous minutus*); mutton birds (*Puffinus pacificus*) will make their burrows in the soft ground among its spongy roots. Other sea birds will nest on the beach just next to the edge of the grass. Still others may find a home in the ready-made 'tents' created by the prop roots of the screw pines. The birds will provide more and more fertiliser to ensure the continued success of the island's flora.

Below:
Fairfax Islands Reef has three associated cays, two of sand and one of shingle (the latter of finger-size coral fragments). The islands have had a troubled history—mined extensively for guano in the 1890s, chewed over by wild goats (which were removed a number of years ago), infested with rats (most have been eradicated), bombed by the Australian Navy during gunnery practice in the 1940s–1960s, and inundated by a cyclone later in that decade. Today, as National Parks above water and Marine Parks below high-tide level, most of these troubles are over, and Fairfax is again an important nesting area for sea birds.

DEAN LEE

Come early summer, sea turtles will congregate around the reef and in the lagoon, and will mate, and the females, on a high tide after dark, will make the exhausting trek up the island beach to bury their eggs deep in the dunes. Six to eight weeks later the hatchlings will explode in unison from the sand during the night and will scramble down the beach to attempt the treacherous journey across the reef to the ocean. Many will not escape the many awaiting predators, and their short life will have served only to nourish the creatures of the surrounding reef; the others will disappear into the ocean, it is presumed to drift in the plankton community, not to be sighted again for several years.

For Reef travellers, coral cays have a very special character, unique among islands. There is a certain smell about them, of coral and shells and sea birds and salt air. Finger-like fragments of coral, piled high on their exposed beaches by the waves, ring like crystal when you walk on them. Beneath the she-oaks and pisonias, the ground is soft and hollow underfoot. The islands are low—only a few metres above sea level—always in intimate contact with the sea. The sound of the surf crashing on the distant reef edge is a constant companion, as is the call of the birds, muted by the trade winds. These islands offer the visitor a real sense of escape, a return to fundamentals, a chance to rediscover the inner person after the trappings of modern civilisation have weathered away under warm sun and the caresses of the breeze.

There are resorts on two of the coral cays reached from the southern gateway cities, on Lady Elliot and Heron Islands, and these offer tourists the opportunity to prolong the magic experience of a true coral

Below:
One Tree Island sits on the weather side of its lagoonal platform reef which glows gem-like beneath Coral Sea waters. Its was named in 1843 when the naturalist Jukes aboard the survey ship HMS *Fly* viewed the island from a distance and mistook a clump of pandanuses for a single tree. The island has been much studied and is currently accessible only to those doing scientific research. The research station there is operated by the University of Sydney.

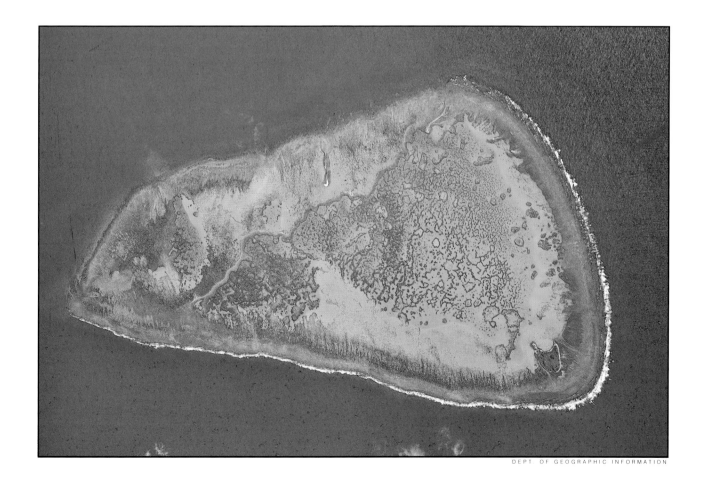

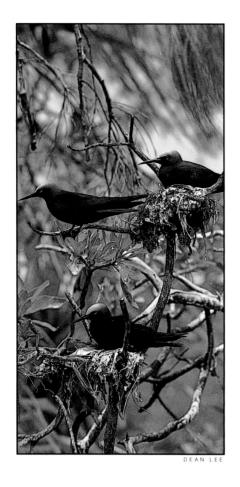

DEAN LEE

Left:
White-capped noddies (*Anous minutus*) in pisonia trees, Heron Island.
Right below:
Lady Musgrave Island, a vegetated coral cay of the Bunker Group.
Bottom:
The sandbank on the north-western end of Broomfield Reef represents a cay in the early stages of development.

COLFELT

DEAN LEE

island (there are only three coral cays with resorts in the whole of the Barrier Reef Region, the other being Green Island, off Cairns). Camping is permitted (with a permit obtained from Queensland National Parks and Wildlife Service) on several of the other cays in the Capricorn and Bunker Groups. And there are Reef trips, departing from Bundaberg and Gladstone, that offer day visitors an opportunity to visit these islands.

To the north-east lie the Swain Reefs (JL 29–32), a complex of small, tightly packed patch reefs on the edge of the continental shelf, remote and relatively unvisited. Although these reefs are more adjacent to the next section of this book 'The Capricorn Coast', Gladstone is the principal gateway to the Swains. They are a favourite destination for divers and reef fishermen.

BUNDABERG

Bundaberg is located on the Burnett River 15 km upstream from Burnett Heads, where the river empties into the Pacific Ocean at the top of Hervey Bay. This is just south of the Great Barrier Reef Marine Park, and Bundaberg is the first gateway to The Reef, its nearest destinations being Lady Elliot Island (80 km to the north north-east) and Lady Musgrave Island (94 km to the north).

Bundaberg to Australians is virtually synonymous with rum and sugar. The district accounts for 20% of Australia's sugar production and it is one of the few places in the world where the whole sugar experience can be seen on one site—cane fires, harvesters moving through fields of tall cane, cane crushing, raw and refined sugar production, the making of molasses and—the ultimate product so far as Australian spirit drinkers are concerned—rum. The Bundaberg Distillery at Millaquin, just across the river from the town centre, produces 85% of Australian brown rum which it packages in the distinctive square-shouldered bottle with bright yellow label.

Viewed from the air the countryside surrounding Bundaberg resembles a quilt, with bright green rectangles of ripening sugar and red-ochre patches of rich volcanic soil ploughed and ready for the next planting. (For more about sugar, see 'Notes for Reef Travellers'.) Bundaberg is a major small-crop growing area, the country's largest grower of tomatoes, a major producer of avocados and other fruit and vegetables. A provincial centre which thrives on agriculture and associated industry, Bundaberg has kept the character of a small, friendly town. Its coastal suburbs, such as Bargara, about 13 km away, are peaceful and serene, with lovely beaches.

Bundaberg used to be the largest scallop port outside of Tasmania; its fleet of 80 trawlers now goes out mostly for prawns and fish.

How to get to Bundaberg

By road. Bundaberg is just over four hours' drive on the Bruce Highway from Brisbane, turning off at the pretty little country town of Childers (EF 36–37). It's about five and a quarter hours by bus.

By air. Bundaberg is on the Queensland coastal routes of two air operators, Sunstate Airlines and Lloyd's Air Services. Each has several flights daily between Brisbane and Bundaberg. Sunstate operates a daily coastal connection linking Bundaberg with cities north to Mackay. The airport is located on the main road 9 km from town.

By rail. It's a four- to five-hour train trip from Brisbane.

COLFELT

Above:
The coastline and countryside in the vicinity of Bundaberg.

Principal Reef destinations reached from Bundaberg

- *Lady Elliot Island*
- *Lady Musgrave Island*

Bundaberg tourist information

The Bundaberg Tourist Information Centre is at the corner of Takalvan and Bourbong Streets, Bundaberg, Qld 4670.Telephone: (071) 72 2406.

Bundaberg weather

Bundaberg residents enjoy one of the most equable climates to be found in Australia.

	Jan.	Apr.	July	Oct.
Avg. Daily High	30°C	28°C	22°C	27°C
Avg. Daily Low	22°C	18°C	10°C	17°C
Days Rain (over 0.2 mm)	12	8	5	7
Normal Rainfall	156 mm	53 mm	30 mm	46 mm
Mean Sea Temp.	26°C	24°C	21°C	22°C
Normal Annual Rainfall = 1137 mm				

Accommodation

Bundaberg and its surrounding beach suburbs offer a wide selection of good to medium-standard motels, cheaper than in many areas along the Australian east coast, the city having a relatively low cost of living. Some twenty motels are found in the city, the majority on the main road into town (Takalvan Street) and on Bourbong Street (which is a continuation of Takalvan Street through the centre of town). The beach suburb of Bargara (13 km from Bundaberg) has a number of motels and a number of establishments offering holiday units on daily or weekly tariff. There are a large number of caravan parks, some in the city and more scattered along the beaches from Burnett Heads to Elliot Heads.

Mon Repos

The sandy mainland beaches north of Bundaberg are used by sea turtles as mainland nesting sites, the height of activity occurring from November to February. Turtle research has shown that the sex of turtle hatchlings is affected by the temperature of incubation, females being produced by relatively warmer sand temperatures. Because of their north-east orientation and the nature of their quartz-feldspar sands, these beaches are relatively warmer and tend to produce relatively more female turtles.

Mon Repos Beach, 15 km north-east of Bundaberg, is the most accessible (to humans) of all nesting sites in the Barrier Reef area, and it is one of the most important mainland rookeries. Ramps have been constructed for easy access to the beach. During the season National Parks personnel are present every night doing turtle research, and they are only too willing to assist tourists with their turtle watching. There is a commercial caravan park and camping area just behind the beach, and Mon Repos, a lovely crescent sand beach for swimming by day, is thus a good spot for an inexpensive, nature-orientated family holiday.

There are basic rules that should be followed in observing turtles nesting or in watching the hatchlings scramble down the beach, and these are discussed under 'Turtles' in 'Notes for Reef Travellers'.

Hinkler House Memorial Museum

Herbert John Louis Hinkler was one of the world's pioneers of aviation. Born in Bundaberg, his fascination with watching ibis in flight resulted in his being one of the early glider aviators, and eight years after the

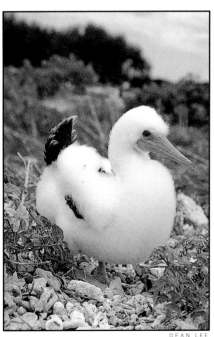

Below:
Brown Booby chick (*Sula leucogaster*). This species nests on only two cays of the southern Barrier Reef. Boobies may be seen on Lady Elliot Island, where they frequently roost.

DEAN LEE

Wright Brothers' successful 'Kitty Hawk' experiments Hinkler made his first glider flights on Mon Repos Beach. There followed a remarkable career in aviation, with a Distinguished Service Medal in the Royal Flying Corps during World War I and a series of record-breaking solo flights all over the world. He became chief test pilot for A.V. Roe and Co., later Avro, which ultimately was to become British Aerospace. Hinkler was killed in the Apennine Mountains in Italy in 1933 while attempting to better the England–Australia solo flight record then held by C.W. Scott. In 1982 Hinkler's house in Southampton, England, where he hatched his plans for his daring flights, was under threat of immediate demolition, and a few citizens of Bundaberg arranged to have it dismantled brick by brick and brought back to Australia. It is now one of the city's proud attractions, located 4 km out from Bundaberg on the road to Gin Gin. The museum is open every day, 10.00 a.m. to 4.00 p.m.

Bundaberg Distillery

Bundaberg Rum has been made in that city since 1888, and the distillery is just across the Burnett River from the centre of town. A sugar crushing mill is located on the same site, and thus it is possible for visitors to have the complete sugar experience, from cane to 'Bundy' Rum. The distillery tour covers all aspects of rum production, beginning with giant 'swimming-pools' full of molasses and progressing through fermentation, distillation and bottling. There are three guided tours a day, Monday to Friday (10.00 a.m., 12.30 p.m., and 2.30 p.m.), public holidays excepted.

The coastal suburbs and beaches; local snorkelling

It is about 13 km from Bundaberg to the coast, where there are a number of peaceful suburbs—Bargara, Innes Park, Elliot Heads—with good surf and bathing beaches. Bargara has an 18-hole golf course. The coast from Burnett Heads to Elliot Heads has fringing coral and near offshore reefs which offer some of the best mainland snorkelling and diving in Queensland. There is a diversity of marine life and some uncommon species of coral, particularly around Barolin Rock. Access is from any number of beaches between Burnett Heads and Elliot Heads.

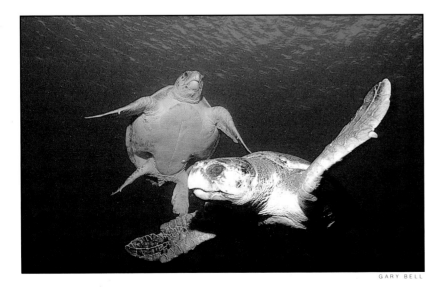

GARY BELL

Left:
Sea turtles nest throughout the southern Barrier Reef Region, on the islands and on mainland beaches. Mon Repos Beach, 15 km north-east of Bundaberg, is, for tourists, an easily accessible mainland nesting site of loggerheads (*Caretta caretta*), Greens (*Chelonia mydas*) and Australia's own flatback turtles (*Chelonia depressa*).

LADY ELLIOT ISLAND

Lady Elliot Island is a coral cay, a true Barrier Reef island and one of only three such coral islands of the Barrier Reef to have a resort. It is a low-key resort, with 'no-frills' accommodation—tents and bungalows situated along and behind the beachfront under a stand of graceful she-oaks. The atmosphere is informal, in tune with nature. It is a place for the family, the diving enthusiast, for snorkellers, reef fossickers and nature lovers, and it will suit those who delight in simple pleasures in simple surroundings. There is no phone, no TV, no contact with the outside world other than that provided by the daily arrival of the plane.

Lady Elliot Island was discovered by Englishmen in June 1816 when Captain Joseph Abbott sailed the 353 tonne *Lady Elliot* on her maiden voyage from India to Sydney. The island was named after the ship (perhaps named after the wife of the then colonial governor of India, Hugh Elliot). Lady Elliot is spelled with one 't', not 'Elliott', as is sometimes seen, a practice that may have begun with a slip of the pen by a shipping clerk.

The island marks the southern extremity of the Great Barrier Reef. It is a platform reef with vegetated shingle cay on its south-western side, the first reef to be encountered when heading north from Fraser Island. A lighthouse was erected on the island over a century ago, in 1873, and was rebuilt in 1928. Over the years Lady Elliot has proved to be a graveyard of the sea, and numerous ships have come to an end there. The light, situated on the cay itself, is almost one nautical mile west of the edge of the reef, and Lady Elliot, a *femme fatale*, traps unwary seafarers who perhaps think they are further away than they actually are (there have been a number of wrecks in recent years, providing a kind of entertainment for guests not offered by many resorts). The resort buildings are embellished with the remains of some wrecks, such as *Thisby*, used to make the bar, and *Apollo I*, Ben Lexcen's second most famous yacht, which was wrecked there in 1980 and which forms the servery in the dining hall.

Lady Elliot, a century and a half ago, was the home of huge colonies of sea birds. The island was mined for guano in 1863–1873 at which time its vegetation was almost totally stripped, along with about one metre of the island's surface, and the sea birds went elsewhere.

Many of the islands of The Reef Region were stocked with goats in the late 19th and early 20th centuries to provide a source of food for shipwrecked sailors, and a large herd on Lady Elliot helped keep the island bleak and windswept for decades; the last of these goats was destroyed about 30 years ago.

Lady Elliot Island is controlled by the Federal Government, the principal lease being held by the Department of Transport for the lighthouse. In 1969 Don Adams acquired a sub-lease for a resort and it was he who constructed the airstrip. Adams did extensive replanting on the island and won a conservation award for his efforts; there is now an attractive stand of *Casuarina equisetifolia* (she-oaks) in the resort area, and the birds are returning in larger numbers each year.

Opposite:
The Fish Pool, on the eastern reef flat of Lady Elliot Island, where both small and fully grown children find delight in hand-feeding the fish.

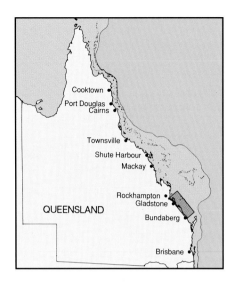

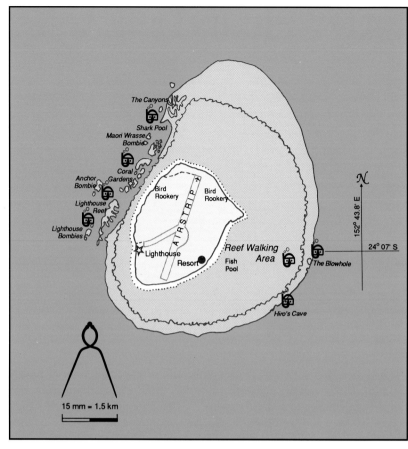

ISLAND SUMMARY
Lady Elliot Island

Location: 24° 07'S 152° 43'E
Gateway: Bundaberg (80 km)
1700 km NNE of Melbourne
1095 km N of Sydney
372 km N of Brisbane
1081 km SE of Cairns

Island and resort details
Vegetated coral shingle cay (54 ha) with associated coral reef (180 ha). Lighthouse.

Access
From Bundaberg, by aeroplane (35 mins). 10 kg baggage limit; nominal charge per kg for excess baggage but no guarantee it will be on the same flight. Children 3 to 14 years half price.

Resort capacity, accommodation, resort facilities
100 guests maximum; the occasional day visitor. **Accommodation:** 24 units in fibro bungalows (18 with private facilities), 10 tents. Units without facilities and tents share toilet/shower units. **Resort facilities:** Dining hall, two small bars, barbecue area, kiosk, small games room. Water by desalination.

Tariff
All inclusive (except alcohol—guests asked not to bring alcohol to the island, as it is available from the bar at reasonable prices). Tent accommodation tariff is about 20% cheaper per night than cabin with facilities. Children under 3 years no charge; children 3 to 14 years half price.

Eating and drinking
In resort dining hall, buffet (7.30 a.m. to 8.30 a.m., 12.30 p.m. to 1.30 p.m., 6.30 p.m. to 7.30 p.m.). Bar open throughout the day until 10.00 p.m.

Activities
Diving, coral viewing and snorkelling, beaches (ranging from coarse shingle to quite fine coral sand), fishing trips (trolling), reef walking, sea bird watching, turtle watching (November to February).

Anchorage
Not a good anchorage, but shelter in SE weather is possible on western side between lighthouse and northern end. Anchor in sand off reef and be careful to avoid dropping anchor in live coral. No fishing.

Lady Elliot Island, Locked Mailbag, via Bundaberg, Qld 4670

In 1985 the Government called for expressions of interest to develop a low-key family-style resort, and the current operators, John and Judith French, were the successful tenderers and now hold the lease.

The resort

Lady Elliot is the epitome of low-key informality. The staff all seem to have several occupations, from porter to dive master, from dive instructor to bar tender, from waitress to hostess. The 10 kg baggage limit on the plane bespeaks the fact that dress requirements are absolutely minimal, and unless you are a scuba diver married to your own weight belt, the baggage limit should be adequate, or you are probably bringing too much with you.

Accommodation

Accommodation at Lady Elliot is either in tents or units in bungalows (built on poles so that they don't get in the way of nesting sea turtles). Eighteen of the 24 bungalow units have their own small private bathroom. Tents and rooms without private bath share communal toilet-shower facilities. The bungalow units are spartan but comfortable, with pine furniture and polished pine floors. The tents, with two double-decker bunks, provide a pleasant place to sleep on a coral island; the screened windows ensure that a breath of fresh air is always circulating, and one is lulled to sleep by the wind sighing through the she-oaks and the sound of surf on the reef.

Eating, drinking and entertainment

The resort offers three good square meals a day (buffet) in the dining hall or on the sundeck. There is good variety and you can eat as much as you please. Catering is for ravenous divers who have been in the water all day. Drinks are available throughout the day till 10.00 p.m.

Lady Elliot is not an island for all-night raging, and most people seem to be sufficiently tired from their day's activities to go to bed fairly early. For evening entertainment there is an occasional slide show about the island and its marine life, there are bush dances, carpet bowls games, bonfires on the beach, 'island nights', and barbecues. The programme is tailored for guests currently in the house. A small games room next to the main bar has a few books, a video screen, and a ping pong table.

Activities

Activities are centred on the coral reef and surrounding waters. The island has several good beaches, particularly that at the northern end, which has lovely fine white coral/shell sand. Walking around the island offers endless beachcomber diversions; there are nesting sea birds, shells, flotsam and jetsam, and you can lose yourself in fantasies inspired by old weathered wrecks in the sand.

The reef on the south-eastern side of the island has a huge flat for fossicking at low tide; staff take guided walks to introduce you to some of the creatures that live there. There is also a glass-bottom boat for coral viewing trips. Or you can just take yourself out onto the reef with mask and snorkel and lie in the shallow pools and watch the marine pantomime of small sea creatures. The fish pool, a tidal pool not far from the beach, is a favourite spot for young and old alike where tame fish come to be fed by hand. Bread for fish-feeding is available from the kitchen.

COLFELT

Above:
Getting ready to dive the Lighthouse Bombies.

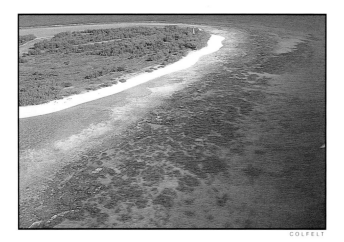

COLFELT

COLFELT

COLFELT

COLFELT

COLFELT

Opposite left top:
All along the western side of Lady Elliot Island are excellent dive sites, accessible directly from the beach.

Opposite left middle:
Tent accommodation at the resort.

Opposite below:
Cabins at Lady Elliot are set along and behind the shore amongst graceful she-oaks.

Left:
The beach at the northern end of the island, with wrecks to provide fantasy for beachcombers.

Below:
Divers entering the water opposite the lighthouse.

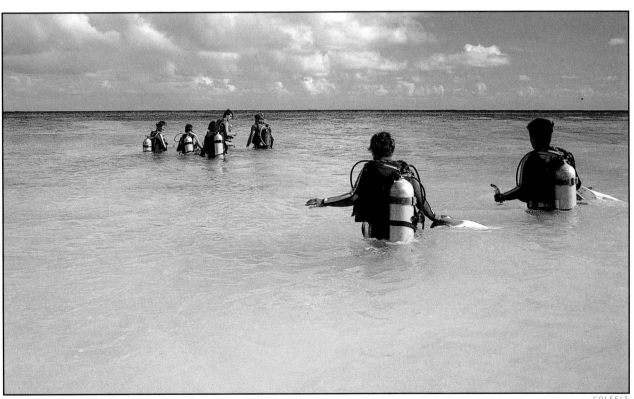

COLFELT

Diving

Lady Elliot offers diving as good as almost anywhere on the Barrier Reef, with a variety of dive sites and an abundance of marine life. A unique feature of Lady Elliot diving is that access, for most dives, is straight from the beach. You pick up your gear at the dive shop next to the airstrip, put it in one of the barrows provided, and wheel it across the airstrip and down to the beach. There are excellent dive sites all along the western (lee) side of the island, from the Lighthouse Bombie to The Canyons.

Water clarity at Lady Elliot is very good, averaging 21–24 metres (70–80 feet) and often it is better than 30 metres (100 feet). Manta rays, leopard sharks, large shovel-nose rays, turtles, large moray eels are commonly encountered, and there is a good variety of coral. Old anchors, chains, timber from early wrecks litter the bottom on the western side of the island. The dive sites from The Canyons to the Lighthouse Bombie offer something for everyone, including good shallow sites for beginners and snorkellers (e.g. the Coral Gardens). There is also some spectacular diving in very clear waters off the eastern side of the reef which is weather dependent because it is on the side of the island exposed to the south-east trades. These dives are done from the boat.

The dive shop offers introductory courses for those who aren't sure if they really want to learn, or you can get your PADI Open Water Diver ticket while you're staying on the island. These courses begin on Mondays and conclude on Saturdays.

All diving and snorkelling gear may be hired. If you plan to dive only a few times it's probably not worth bringing your own gear because hiring won't cost that much. But if you plan to dive continually throughout your stay, you'll save a bit of money by bringing your wet suit, regulator, buoyancy vest, mask, snorkel, fins and boots. Tanks, fills, weights and belts are included in the price of dives.

Fishing

Fishing trips may be arranged. Most of the western side of the island is zoned Marine Park 'B', which means 'look but don't take', so fishing is prohibited there, and excursions usually head away from the island to troll for pelagic species.

Turtle watching

Lady Elliot, like all of the coral cays in the southern Reef area, is a nesting site for sea turtles. During the season (November–February), green and loggerhead turtles come ashore on spring tides to lay their eggs. For more about turtle watching, see 'Turtles' in 'Notes for Reef Travellers'.

Opposite above:
Painted sweetlip (*Plectorhynchus pictus*) and sea perch (or stripeys, *Lutjanus carponotatus*) at the Coral Gardens, Lady Elliot Island.

Opposite below:
Diver with leopard shark (*Stegostoma lasciatum*), a harmless, lethargic shellfish-feeder, at Lady Elliot Island.

Below:
Coral cod (*Cephalopholis miniatus*) at the Anchor Bombie, Lady Elliot Island.

CLINT HEMPSALL

CLINT HEMPSALL

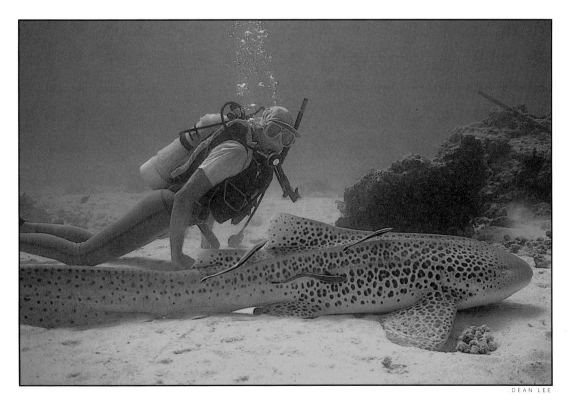

DEAN LEE

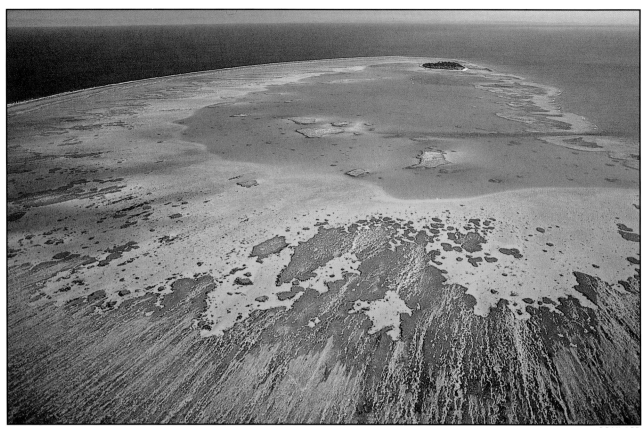

DEAN LEE

LADY MUSGRAVE ISLAND

Above:
The crest of Lady Musgrave's reef is exposed at spring low tide, shutting out the choppy seas, and as the lagoon remains full and there is a break in the reef, it is a good anchorage for yachts. This reef of the Bunker Group has many natural advantages—a lovely wooded cay, beautiful coral and a protected beach. It is a favourite with yachtsmen, divers and campers, and it gives many day-trippers their first experience of a Barrier Reef island.

Location: 23° 55'S 152° 23'E (94 km north of Bundaberg).

Island type: A wooded coral shingle/sand cay about 300 m x 500 m, located on the south-west side of a lagoonal platform reef (1250 ha). National Park.

Access: Easiest and cheapest access is from Bundaberg via motorised catamaran operated by Lady Musgrave Barrier Reef Cruises, 1 Quay St., Bundaberg. (071) 72 9011. They operate seaplane trips too. Access from Gladstone (116 km to the west) is by private charter vessel, such as the barge *Calypso Kristie*. Seaplane flights to Lady Musgrave from the Gold Coast (south of Brisbane) are operated by Seair Pacific, 15 Howard St., Runaway Bay, Gold Coast. Telephone: (075) 37 2855.

Facilities: Two mulch toilets.

Lady Musgrave combines all of the attributes that can be admired in any Barrier Reef Island—a lush, vegetated cay with open shaded areas for camping, a beautiful protected lagoon anchorage for yachts and day visitors and some excellent scuba diving and snorkelling sites. The island is one of the Bunker Group (named after Captain Bunker who discovered them in the early 1800s). When the survey ship HMS *Fly* visited in 1843, the geologist Jukes noted that it was well stocked with birds, particularly black noddies (also called white-capped noddies *Anous minutus*) and shearwaters (mutton birds *Puffinus pacificus*). The island was mined for guano about the end of the last century. Goats were released for the pleasure of the shipwrecked, and by 1928 these were present in 'wall-to-wall' proportions and had devastated the island vegetation. The vegetation recovered after they were removed.

COLFELT

COLFELT

The coral islands of The Reef have a special character which makes them lovely places to camp—the constant sound of the ocean on the reef, the muffled cries of sea birds (perhaps not so muffled during the nesting season), the tinkle of coral shingle underfoot, the smell of salt air spiced with guano. These low islands are in intimate contact with the sea and are a place where it is easy to find escape and enjoyment in simple things.

COLFELT

Lady Musgrave is the first really good coral anchorage for yachtsmen heading north on a Barrier Reef cruise, offering the experience of sheltered anchorage 'mid-ocean' next to a tropic isle. When the tide is high, the seas whipped up by the south-east trades can lap over the crest of the reef, and it becomes an active anchorage, putting both anchor and ground tackle to the test.

The easiest way for tourists to get to the island is from Bundaberg via the motorised catamaran MV *Lady Musgrave*, on a day-trip which is available four days a week (Tuesday, Thursday, Saturday, Sunday). Passengers may join the vessel at the quay in Bundaberg (at 7.30 a.m.), and enjoy the pleasant trip down the river, or at Burnett Heads, where the vessel picks up more passengers and departs for the island at 8.45 a.m. It is a two-and-a-quarter-hour trip to Lady Musgrave. The catamaran ties up next to a pontoon anchored in the lagoon. Snorkelling, scuba diving, coral viewing in a glass-bottom boat or from the underwater chamber in the pontoon are the order of the day. Lunch is served aboard the catamaran, and the crew conduct guided walks on the island. *Lady Musgrave* is back at Burnett Heads by about 5.45 p.m.

Lady Musgrave Cruises operates seaplane flights to the island, on demand, in a seven-seater De Havilland Beaver float plane, at a cost of about double that of the catamaran trip. Seaplane passengers join the catamaran for lunch. Transport by plane may provide an alternative for those who are short of time or who prefer to fly to avoid seasickness when the weather is rough. A minimum of four passengers is required. Seair Pacific has an all-day plane trip from the Gold Coast to the island, joining the *Lady Musgrave* for lunch. This is a fairly expensive trip but is the only such service from the Brisbane–Gold Coast area and may offer an opportunity not otherwise available.

Lady Musgrave is one of four coral islands of the Capricorn-Bunker Groups for which the Queensland National Parks and Wildlife Service (QNPWS) issues permits to camp. It is a magnificent island for camping, with a protected lagoon and some excellent reef for diving and snorkelling. The numbers of campers permitted on the island at any one time is limited to a maximum of 50 (for details about camping permits, see 'Camping on the islands'). Portable generators and air compressors are permitted on Lady Musgrave (which is not so for some other islands). Camping may be undertaken either by individuals or with a commercial camping operation. Transport for campers, their gear and water (there is no reliably accessible, drinkable fresh water on any of these coral islands) is either via the *Lady Musgrave* or by chartered vessel from Gladstone (Calypso Ferry Services).

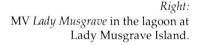

Right:
MV *Lady Musgrave* in the lagoon at Lady Musgrave Island.

DEAN LEE

GLADSTONE

Gladstone (EF 33), currently described in its tourist promotion as the hub of 'Reef Adventureland', is a bustling industrial town of 22 000 located on the coast between Bundaberg and Rockhampton. It is one of the most important Barrier Reef gateways, being the first major jump-off point to be reached from the populous southern cities. It is immediately adjacent to the magnificent Capricorn and Bunker Groups of coral islands and reefs and is the nearest major port to the Swain Reefs.

Gladstone is known as 'aluminium city'. It has the world's largest alumina refinery virtually in the centre of town, converting red bauxite ore into fine white powder which is, in turn, made into the silvery metal. At night the refinery lights up like a Christmas tree, with electricity made in Gladstone by the State's largest power station. Gladstone has one of the largest man-made harbours of Queensland, with one of the largest coal loaders in the southern hemisphere. Port Curtis, as it is called, handles some 200 000 tonnes of cargo each hour—coal, grain, aluminium, alumina, bauxite. In spite of all this, Gladstone does not really give the impression of an industrial town; looking back from the harbour, its factories are eerie presences in a bush setting.

Five years ago Gladstone was unashamedly industrial, and the visitor then might easily have got the impression that tourism was a frivolity that serious folk didn't have time for. The exception to this was perhaps the hard core of professional charter-boat skippers, a salty, seasoned lot who could hardly be described with the usual adjectives of tourism. Today the Gladstone Area Promotion and Development Bureau has dragged the city kicking and screaming into the Australian tourism revolution. Its glossy Reef Adventureland pamphlet melds the ideologies of industry and leisure with a fervour reminiscent of Russians of the post proletarian revolution who gave their children names like 'hydraulic stamping machine' and 'diesel tractor'. Gladstone tourist literature sings of 'silvery rivers of molten aluminium pouring into ingot moulds, huge turbines spinning power across the country, and long trains hauling shining black coal in from vast mines ...' If you, as a tourist, are not inflamed by this, the same pamphlet shows scenes of white sand, pellucid waters, nubile bodies and the glories of Barrier Reef island beaches. Gladstone itself has won the Tidy Towns Award for several years running, but to find Reef adventures or holidays in seclusion that are promised in the literature you have to head out to the coral cays, the nearest of which is 56 km offshore, or south on the mainland to Tannum Sands, Seventeen Seventy and Agnes Waters.

Gladstone has a new multi-million-dollar marina complex which is the launching pad for Reef adventures. It is also the finishing point of the Brisbane–Gladstone Yacht Race, and there is a harbour festival to greet the yachts. A new international touring car facility is planned adjacent to the marina.

How to get to Gladstone

By road. Gladstone is about seven hours' drive from Brisbane, about three from Bundaberg. Turn off the Bruce Highway at Benaraby (E 33). Gladstone is about eight and a half hours from Brisbane by bus; not all companies stop there.

By plane. Gladstone is serviced by Sunstate Airlines and Lloyd Air. Each has several flights daily originating in Brisbane and coming via

Principal Reef destinations reached from Gladstone
- *Heron Island*
- *Camping Islands*
- *The Swain Reefs*

Bundaberg; there are occasional direct flights. The airport is a short (5–10 minutes) taxi ride from the centre of town.

By train. The train trip from Brisbane is about ten hours.

Gladstone tourist information

The tourist information centre is located at 100 Goondoon Street, Gladstone, Qld 4680. Tel. (079) 72 4000. FAX (079) 72 5006.

Gladstone weather

Gladstone has a pleasant climate and is on the fringe of the low rainfall area of the Queensland coast.

	Jan.	Apr.	July	Oct.
Avg. Daily High	31°C	28°C	23°C	28°C
Avg. Daily Low	22°C	20°C	13°C	19°C
Days Rain (over 0.2 mm)	14	6	5	8
Normal Rainfall	124 mm	32 mm	28 mm	48 mm
Mean Sea Temp.	26°C	24°C	21°C	23°C

Accommodation

Gladstone has a number of motels, two in the four-star category (the Country Comfort and Highpoint International, which are central and close to the waterfront) and a range of good-to-medium standard motels. There is a caravan park at Benaraby (EF 33), 21 km south, with 8 hectares of camp and caravan sites, and there is a 100-site caravan park at Tannum Sands (off the Bruce Highway ten km from Benaraby).

Gladstone environs

When Lieutenant James Cook made his epic voyage along the Australian coast in 1770, the place where he first went ashore in Queensland was at Round Hill Head (F 34). There, one of the crew shot a 6.8 kg eastern bustard turkey, which Cook, his officers and the gentlemen of the crew thoroughly enjoyed for dinner that night. It was the best bird they'd eaten since leaving England, and Cook accordingly named the bay in which he anchored Bustard Bay. The town which was originally known as Round Hill is now called Seventeen Seventy in commemoration of the year of Cook's landing. A few kilometres south is Agnes Waters, where the last of Queensland's surf beaches is located, those further north being robbed of oceanic swells by the Great Barrier Reef. Seventeen Seventy and Agnes Waters are well off the beaten track, about 69 km from Miriam Vale (EF 34), which itself is 67 km south of Gladstone. Closer to Gladstone (20 km south) the twin towns of Tannum Sands and Boyne Island (EF 33) are the main beach areas for Gladstone and are good fishing spots. Boyne Island also has Queensland's only aluminium smelter, with buildings a kilometre long, a very clean plant and one where it is possible for tourists to take a conducted tour, perchance to view a silvery river of molten aluminium, before heading out to The Reef. Smelter tours are free and take place Wednesday and Friday mornings; numbers are limited and children under 12 are not allowed; bookings are necessary: (079) 73 0211.

Gladstone harbour

The waters of Gladstone are gold with the suspended sediments which are kept churned up by the considerable tides of this region. On the

COLFELT

Above:
Auckland Creek used to be the principal point of embarkation for Reef trips in Gladstone. The new boat harbour and marina is now the main departure point.

northern side of the harbour is the bottom end of the huge, sandy Curtis Island, the north-east extremity of which Cook named Cape Capricorn because of its proximity to the Tropic. On the southern end of Curtis Island there is a camping area with showers, toilets, shelter sheds, barbecues and picnic tables. The island is a wildlife sanctuary, and turtles, principally Australia's flatback (*Chelonia depressa*), nest there during the season. Facing Island protects the north-east–south-east side of the harbour; its southern tip, Gatcombe Head, was where the transport ship which carried the first colonists for the ill-fated North Australian Colony was wrecked in 1847. Tiny Quoin Island, in the middle of the harbour, has a small resort, and daily ferry excursions go there.

Fishing and diving

Gladstone is the reef fishing capital of Australia (*reef* fishing as distinct from *game* fishing), and Gladstone's charter fleet is probably the largest on the coast. Most boats are engaged primarily in fishing charters but are capable of doing diving as well. Names like *Booby Bird*, *Australiana*, *Fabrina*, *Curtis Ambassador*, *Capricorn Star* are known up and down the Queensland coast, and they operate all year round, with perhaps a couple of weeks off for the annual survey.

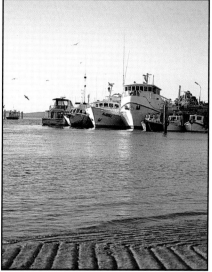

COLFELT

The majority of the fishing charter fleet is 18–24 m (60–80 ft) vessels, with a crew of three and accommodating perhaps 12 passengers. They go out on a Saturday night and return the following Friday. Once in the lee of the reefs they fish either from dories or from the main vessel if it is too rough for dories. And if it's too rough to fish at all, they break out the beer and the 'Bundy'. You never see much advertising for these boats, but they are booked from one year to the next, mostly by word of mouth. They say the skippers can smell coral trout 20 nautical miles away; the boats return with good catches of red emperor, Spanish mackerel and with happy charterers, who will probably come back.

Diving charters from Gladstone operate in the Capricorn and Bunker Groups, the Swains and out in the Coral Sea. Ron Isbel and his *Tropic Rover* are two of the best known names in diving charter, and McGregor's Reef Services' *Calypso Kristie* is expanding its diving business, doing weekend and week-long trips for the budget market. The dive groups come from all over Australia. The reefs of this area have been unaffected by the crown of thorns star fish, the waters are clear. Gladstone at the moment offers no day-trip diving; there are weekend trips, private charters of flexible duration, and week-long trips that may be joined by individuals who are not part of a group.

Information about the activities of individual charter boats is subject to change, and those wishing to book should check with the tourist information centre for the latest details.

Camping

Camping is permitted on four of the coral islands of the Capricorn-Bunker Groups—North West, Lady Musgrave, Mast Head and Tryon. A camping permit issued by QNPWS is required (complete details are found in 'Camping on the islands'). The remoteness of the islands, and the fact that all equipment and water must be taken, has given Gladstone, with its large number of charter vessels, a key position as a camping gateway. Barge-like craft such as *Calypso Kristie* specialise in camper transport, being able to accommodate large numbers, lots of gear, and also being able to land campers right on the beach next to the campsite (subject to tide).

Above:
Gladstone has one of the largest fleets of Reef charter vessels of any gateway city along the Queensland coast. Reef fishing is the principal activity, but diving charters and camper transport are also important to the local charter economy.

HERON ISLAND

Heron Island, Australia's best known Barrier Reef resort, is on a coral island that is part of The Reef itself. It is possibly the resort which offers the best opportunity to really learn something about The Reef. There is good diving, snorkelling, reef walking, or one can just laze about on a white coral sand beach and pretend to be on a 'desert isle'. Heron is a relaxed place for those interested in nature rather than those seeking 'resort life'; it is comfortable, if not luxurious. If you are potentially phobic about birds you ought to avoid Heron Island during the nesting season (October–February) because there are hundreds of thousands of sea birds at that time and they cannot be ignored.

Heron has the magic of a true coral island. With staff and activities oriented towards Reef and wildlife education, a resident Marine Parks Ranger, an information centre, and with the presence of the University of Queensland research station, it is possible for the visitor to become pleasantly saturated with the ethos of The Reef.

Heron Island lies in the middle of a group of coral islands and reefs called the Capricorn Group, the island itself being practically bisected by the Tropic of Capricorn. It thus enjoys a mild, subtropical climate year round. Situated 28 km from the edge of the continental shelf, Heron is an elongated oval pile of white coral sand about 800 m long by 300 m wide, topped with a lush central forest of shady pisonia trees. The geologist Joseph Jukes was travelling with the survey ship HMS *Fly* on her coastal explorations of 1843, and he was impressed by the numbers of reef herons he saw there, which is no doubt how the island got its name.

Heron Island sits almost on the western extremity of its reef, which is a massive 9.3 km long by 4.6 km wide. Just across a deep channel lies Wistari Reef, itself almost 8 km long. There are reefs to the north-west, north, east, and another nine reefs are strung out in a line to the south-east.

Opposite:
A white reef heron (*Egretta sacra*) such as those for which Heron Island was named in 1843.

Below:
White and grey herons interbreed quite happily and produce offspring of either colour. Reef herons congregate in the trees around the beach and await the low tide, and then they go out onto the reef flat to catch small crustaceans, molluscs and fish.

COLFELT

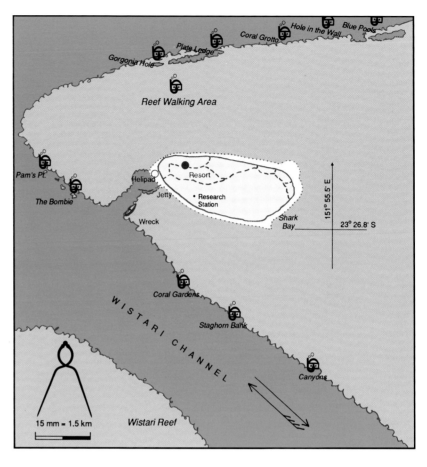

ISLAND SUMMARY
Heron Island

Location: 23° 27'S 151° 55'E
Gateway: Gladstone (81 km)
1737 km NNE of Melbourne
1161 km N of Sydney
459 km NNW of Brisbane
971 km SE of Cairns

Island and resort details

Vegetated coral sand cay (16 ha), about 1.6 km in circumference, with an associated lagoonal platform reef very much bigger (3750 ha). Heron is National Park except for the resort area. There is a research station operated by the University of Queensland.

Access

From Gladstone airport, by helicopter (Lloyd Air at Gladstone airport) (35 mins). Schedule determined by incoming planes. Children half fare. Baggage limit: 1 suitcase approximately 15 kg. Baggage storage is available. Extra baggage may be taken but only as space is available; on return trip, extra baggage must go in advance to insure that it makes connecting transport.
From Gladstone marina, by catamaran *Reef Aventurer II* leaving at 8.00 a.m. and 1.30 p.m. (2 hrs). Children 3 to 14 years, half fare. Catamaran round trip costs about half as much as helicopter round trip.

Capacity, accommodation and resort facilities

300 guests maximum. **Accommodation:** Three levels of accommodation: Heron Suites (41), Reef Suites (32), Lodges (26). Heron and Reef Suites have private bathroom. **Resort facilities:** Dining room; bar; small games room; theatrette; two swimming pools; lighted tennis court; kiosk/boutique; washing/ironing room; dive shop; information centre. Baby sitting available. Water by desalination. Island time is one hour ahead of mainland.

Tariff

Tariff is all inclusive (except alcohol, and activities requiring use of petrol, hire of dive equipment). Children 3 to 14 years, half price; children under 3 years free.

Eating and drinking

Resort dining room (7.45 a.m. to 8.45 a.m., 1.00 p.m. to 2.00 p.m., 6.30 p.m. to 7.00 p.m.). Buffet breakfast and lunch, *à la carte* dinner except on seafood buffet nights. Bar 10.00 a.m. to midnight.

Activities

Diving, coral viewing, snorkelling, reef walking, guided island and reef tours, fishing trips, beaches, tennis, bird watching, turtle watching (November to February), sea bird watching, research station.

Anchorage

It is possible to find anchorage in the lee of Wistari Reef across the channel from the resort. However the island does not normally encourage visiting yachts.

Heron Island Resort, via Gladstone, Qld 4680. Telephone: (079) 78 1488. FAX: (079) 78 1457. Telex: 49455.

Heron has sandy beaches all around, and from late October to early March sea turtles by the hundreds use these as places to bury their eggs. In the early 1920s, when green turtle soup was keenly sought for the tables of epicures around the world, Heron Island had its own turtle soup factory—the Australian Turtle Company—just waiting for the turtles to come ashore.* (There was also a cannery on North West Island at the time, operated by Captain Cristian Poulson, who was later to establish the Heron Island resort.) By the latter 1920s, after years of slaughter, the turtles of one of the world's significant breeding grounds were in a steep decline. The Australian Turtle Company folded in 1927. In 1928 Percy Friend took over the operation, and that year it was necessary to go scouring the beaches of adjacent islands to find enough turtles to feed the factory at Heron. Came the depression, and world markets were less enthusiastic for turtle delicacies.

Cristian Poulson was a keen fisherman and he saw the potential for tourism in these parts where fish were so plentiful that they practically jumped into the boat. He came over from North West Island in the late 1920s and was associated with the waning turtle operation on Heron for several years. In 1932 he acquired the lease from Percy Friend and set about converting the cannery into a fishing resort. Heron became a National Park in 1943.

The channel that leads to the boat harbour of today was apparently always the lowest part of the reef, a natural drainage channel, which was the preferred location in the early days for landing the boats. The wreck (*Protector*) was put alongside the channel in the mid-1940s to act as a breakwater for landing operations, and a cavity was chopped in the edge of the reef so that, at low tide, boats could more easily be pulled over the top with a four-wheel drive vehicle. This accelerated the natural drainage of water as the tide went down, and it began a long term problem of erosion.

*There are no figures on actual production, but the company's prospectus estimated that one year's production would yield, from 2500 turtles, 125 000 one-pound tins of turtle soup; 8000 pounds each of calipee and calipash; 4000 gallons of oil; 200 tons of fertiliser (Ogilvie, 1977).

Calipee, in Queensland, was the term for the flesh from the flippers, and calipash the yellow meat on the lower side of the body. Outside Queensland calipee refers to the gelatinous yellow meat, and calipash to a dull green gelatinous substance next to the carapace, or upper shell — 'the famous green fat beloved of London Aldermen' (Napier, 1928).

Below:
Heron Island was the site of a turtle soup factory in the 1920s, and when turtles became scarce, it became a small fishing resort. Today it supports a population of over 300, including resort guests, staff and those engaged at the University of Queensland scientific research station on the island. In spite of this, the visitor is not particularly aware of the presence of others on the island.

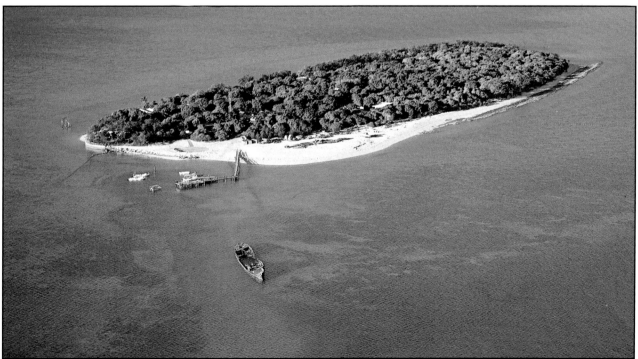

DEAN LEE

GARY BELL

Left :
Heron Island has always been known for its excellent fishing. Today, Marine Park zoning doesn't permit fishing immediately around the resort, but fishing trips, which go away from the island, yield excellent catches.

Left below:
The terrace and pool are well placed to enjoy sunset over the Tropic of Capricorn.

Opposite right:
Divers from around the world come to Heron where they can dive all day, never having to travel *to* The Reef —because they're right on it.

Below:
Snorkelling around reef pools at low tide.

COLFELT

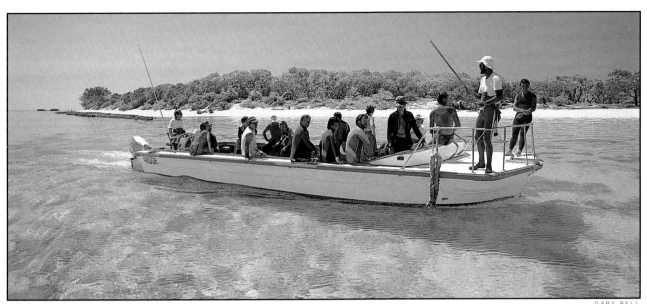

GARY BELL

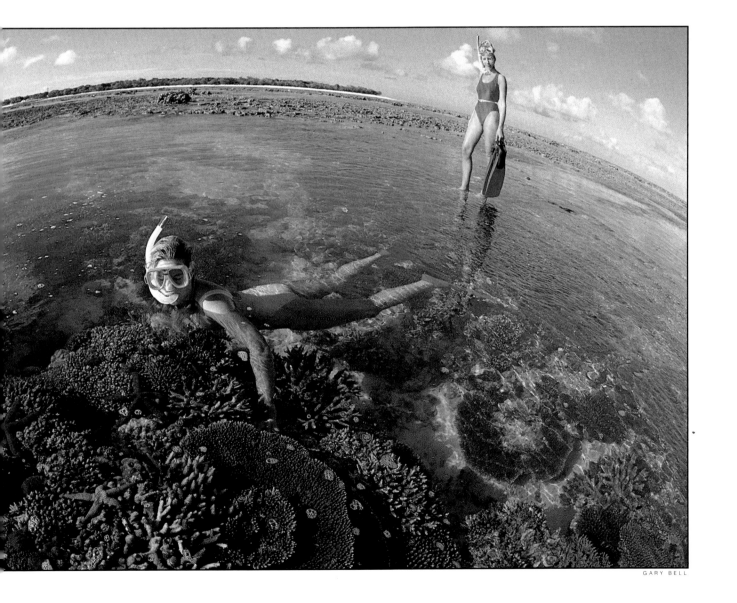

GARY BELL

CARLO GROSSMAN

COLFELT

Above:
Heron Island has three standards of accommodation ranging from simple bungalows to modern motel-style units set just off the beach. There is also one Beachfront unit (*above right*), a two-room suite in a choice position at the corner of the resort. Heron is a place for looking at nature, and none of the rooms has TV or telephone. Lodge units are four-bed bunkhouses popular with divers or families who will spend most of their waking hours outside.

The resort

The resort, with its meandering coral paths, is set amongst shady pisonia trees on the western end of the island, the buildings all partly obscured by the broad green leaves of the trees. Because of its easterly position, Heron runs on 'resort time' which is one hour ahead of the mainland. The Marine Parks rangers and those at the research station keep standard time to improve communications with the mainland.

The island is 44 nautical miles (81 km) offshore, and guests have two options for getting there: helicopter, or high-speed catamaran. The catamaran is much less expensive than the helicopter and can be a very pleasant trip; however, if it's windy the trip will be bumpy, and a good number of those who are not hardened sailors will experience seasickness. The seasick prone should bear this in mind, as some travellers spend their first hours on the island recovering from the journey. The helicopter offers a thrilling ride with spectacular views of some of the reefs and coral islands of the Capricorn Group.

As a Barrier Reef resort, Heron has one great advantage: its guests don't have to travel anywhere to get to the Barrier Reef, because it is right outside the bedroom door. Probably 20% of the island's guests are divers, but no matter what one's age or physical condition, the reef is accessible to all, from toddlers to 90-year-olds—reef walking, snorkelling, coral sub viewing or perhaps a vicarious experience at the information centre. Heron is one of a few resorts where a real effort has been made, by the resort and by Marine Parks personnel, to interpret The Reef and its wildlife for guests.

Accommodation

Heron has 100 units and a total capacity of about 300 guests. The rooms range from 'basic' to a high standard of motel accommodation. There are three styles—Lodges, Reef Suites and Heron Suites. Lodges are fundamentally small bunkhouses designed for occupancy by two to four people, with double bunks or double and single beds, radio and tea/coffee making facilities. They do not have private bath/toilet but use communal facilities. Reef Suites, the mid-range, and Heron Suites, the top of the range, are both motel-style rooms, pleasantly decorated and airy (the principal difference being that the Reef Suites are older). Both have private bath/toilet, refrigerator, radio, tea/coffee making

facilities and ceiling fans. The all-inclusive tariff at Heron varies with the standard of room occupied; the cost per person per day for occupying a Lodge is about 70% less than the cost of a Heron Suite. There is also one Beachfront unit, a three-room suite, which has a superb and isolated position at the north-west corner of the resort.

Reef and Heron Suites are within a few paces of the beach, separated from it by a line of graceful casuarinas. The Lodges are in the centre of the resort area, along the coral path. None of the rooms is air-conditioned, as the island hasn't sufficient power-generating capacity; the lounge bar, however, is.

There are no locks on the rooms, and theft has never been a problem at Heron. The resort recommends that valuables be left in the office for safe-keeping, which is sometimes a trifle inconvenient, particularly for cameramen, because the office is closed from 6.00 p.m. until 8.45 a.m., and sunsets, sunrises and turtles don't keep these hours.

Eating, drinking and entertainment

Heron has a communal dining room, shared by guests and the occasional visiting birds, with set meal times, where guests can eat very nice food in abundant quantity. Breakfast and lunch are buffet; dinner is *à la carte*, with table service (except on seafood buffet nights). At the time of your first meal you will be assigned a table at which you will have all of your meals for the duration of your stay; there will be perhaps two to four other people sitting at the same table. The registration form you fill out on arrival gleans your basic demographic details (e.g. age range, nationality) and it would seem that this plays some role in seating arrangements—undoubtedly well intentioned and based on some ancient resort wisdom, but flawed, as such paternalism often is. It is a Heron tradition, and it suits some people well. Don't be afraid to ask for a change of table or to sit by yourself if you want to.

Most Heron visitors are so exhausted after their day in the water, on the reef, or just being active outdoors that they are not inclined to carry on into the night. The lounge bar is open until midnight, and you can always find someone to chat to, including a few interesting characters who have been on the island since World War II. A small band plays several nights a week, and activities such as bingo and games of chance

Below left and right:
Reef walking at low tide is a fascinating way to while away an afternoon, discovering the many secrets of the reef flat. Stout walking shoes are a must.

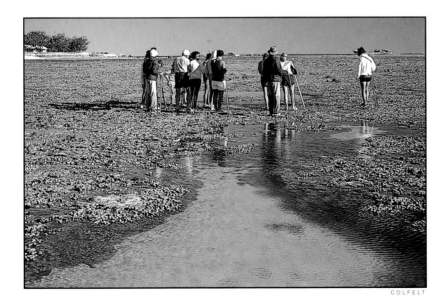

COLFELT

COLFELT

GARY BELL

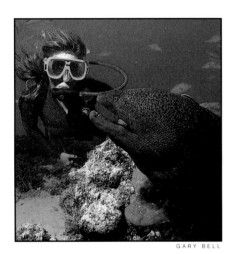

GARY BELL

Top:
Protector, originally a breakwater, today adds a bit of the flavour of the past to Heron's harbour.

Above:
Protected by legislation for a number of years now, Heron's sea creatures know little fear. At 'The Bombie' a moray eel provides entertainment for incredulous divers. These eels can be very tame .

are sometimes organised. There are occasional slide talks and video movies in the theatrette. The lounge bar has billiard tables. During turtle nesting season the bar is empty, because everyone is out watching the turtles digging holes and laying eggs.

Activities

One of the first things to do at Heron is to take the free guided walk around the island, a two-hour tour that will open the eyes to the wonders of a coral island. The second activity should be a trip in the coral viewing sub—out the channel and along the reef to 'The Bombie'. These give the visitor some appreciation of the wildlife both above and below the island and will whet the appetite for further exploration. The free guided reef walk will cap off the island familiarisation course, exposing the fascination of life on a reef flat at low tide.

The island is only about one mile (1.6 km) in circumference, and it takes about half an hour to walk around the beach. The beach on the northern side (the lee side in winter) has fine white sand and is lined with elegant casuarinas whose needles cast a gentle, dappled shade, and they sigh in the breezes. For those who desire minimal activity this is a lovely place for lying in the sun and doing nothing.

Diving

Heron's position right on the Barrier Reef eliminates the two-hour trip that divers normally have to make to The Reef. With a good range of dive sites, Heron has been said to have the richest and most diverse collection of tame tropical fish found anywhere in the world. The Heron 'Bombie', a short distance from the harbour entrance, supports an explosion of fish, including a tame moray eel which comes out to be fed by hand and to be tickled under the chin. Dive sites are all around the island, on both sides of the Wistari Channel all along the northern rim of Heron's reef. Heron has been protected under Marine Parks

legislation for so long that the fish have forgotten what fear of humans is; as one photographer said, you 'have to push the fish out of the way' when taking photographs.

The furthest dive site is a mere ten minutes away. Visibility averages 11–12 m (35–40 ft), not the sort of visibility one finds in the Indian Ocean or the Caribbean, and this is due to a combination of the shallow water, the presence of the adjacent large reef flats, and the big tides (which flood north and ebb south) in this part of The Reef. However, the richness of marine life more than makes up for any limitation in visibility. Visibility is best at neap tides and at low water. Diving is shallow (9–11 m), with a normal maximum of 18 m (60 ft).

Divers should bring their 'C' (certification) card, and those intending to do a dive course will need two passport photos and a medical certificate to say that they're fit to dive. Courses start every Sunday, and guests must arrive the day before. All diving equipment may be hired on the island. Serious divers will probably want to bring their own gear (except perhaps weight belt and tank) to save on gear hire.

Snorkelling

Heron has a wealth of snorkelling sites most of which can be reached by walking to the edge of the reef or to the pools on the reef flat. Snorkellers may also go out with the divers in the dive boat. It is essential, if one is to enjoy snorkelling, to have a mask that fits well; your chances of always having a well-fitting mask will be greatly increased if you bring your own.

Reef walking

Heron's extensive reef flat to the north of the resort can provide hours of diversion at low tide. The island has a bin full of old tennis shoes and also provides walking sticks, shoes being *essential* for reef walking and sticks being very helpful for the inexperienced and those with uncertain balance. For absolute comfort guests will do well to bring their own reef-walking shoes (any old pair of footwear that you don't mind getting wet, provided it has a stout sole and completely covers the foot). A pair of heavy athletic socks to be worn on the reef are a good idea as well. In the warmer months, reef walkers will want a broad-brimmed hat and a long-sleeved shirt, as the sun is very strong.

Turtle and bird watching

Heron is a major turtle nesting site for green and loggerhead turtles from late October until mid-March. Marine Parks personnel and volunteers are on hand throughout the nesting season making notes and tagging turtles as part of a continuing programme of research conducted by sea turtle expert Colin Limpus of the Queensland National Parks and Wildlife Service. They are on the beach every night and are happy, when they have time, to answer questions. There are a number of do's and don'ts about turtle watching which are explained in detail under 'Turtles' in the 'Notes for Reef Travellers' later in this book.

Heron is also an important nesting site for several species of sea birds, including black noddies, *Anous minutus* (also called white-capped noddies) and for wedge-tailed shearwaters, *Puffinus pacificus* (mutton birds). Noddies build their nests in the branches of the pisonia trees and when present in large numbers during the season can make walking beneath these trees extremely 'hazardous'. Mutton birds, inexhaustible, tible graceful birds at sea, are clod-footed comics on land. More is said about these birds in 'Notes for Reef Travellers', but it is advisable

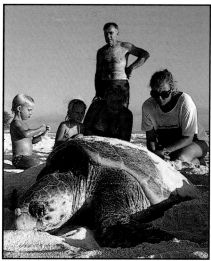

DEAN LEE

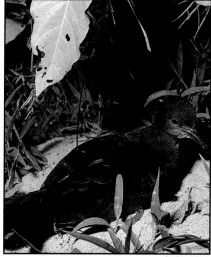

GARY BELL

Top:
Turtle watching during the laying season (October–March) is a favourite pastime at Heron. Female turtles are shy and may be frightened if approached before they have dug their holes and begun laying, but when settled they can be observed and photographed without being disturbed.

Above:
Heron Island, like many of the cays of the Capricorn Group, is an important nesting site for the wedge-tailed shearwater, *Puffinus pacificus*. These birds nest in burrows which they dig in the friable soil beneath the pisonia forest. Shearwaters in the nesting season create a lot of raucous noise during the night.

for visitors to know, when walking in the pisonia forest at Heron, that mutton birds make their nests in the friable soil beneath the pisonias, creating a maze of underground tunnels close to (but virtually invisible from) the surface; keep to the paths or you may cave-in a burrow and crush a mother or chick. Mutton birds and noddies set up a most incredible ruckus during the night—music for nature lovers, but light or fitful sleepers may be awakened from time to time.

Heron Island research station

Heron Island has one of only two research stations on the Great Barrier Reef to be located on a coral cay, and it provides easy access, by boat or foot, to an extensive range of reef habitats in all weather conditions. This, as well as its ready access by helicopter and ferry services from the mainland, makes it very suitable for reef studies, particularly experimental work and long-term projects. It is operated by the University of Queensland. The station accommodates 80 visiting researchers and other guests on a self-catering basis. Of interest to resort guests is the research station museum, with its specimens of various Barrier Reef beasts.

Below:
Heron Island has been said to have the largest, most diverse collection of tame fish in the world.

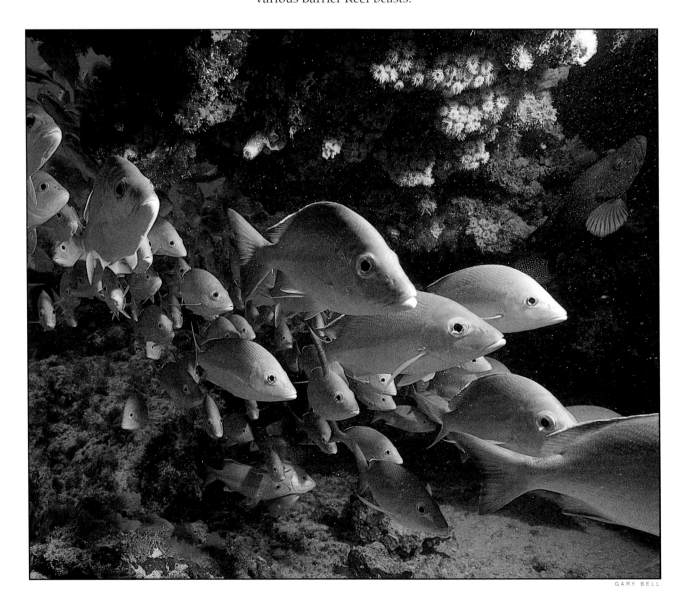

GARY BELL

The Capricorn cays

Camping on a Barrier Reef island can be a marvellous family holiday, affordable in a time when tourist development is, by the very nature of capital, increasingly for the well-to-do, and holidays for the whole family are becoming, for many, prohibitive. The major cost is getting to the island, which is by private charter vessel, but even so this cost pales next to the cost of a resort holiday.

Three coral cays of the Capricorn Group are available for camping—North West, Mast Head and Tryon Islands; a fourth cay, Lady Musgrave Island in the Bunker Group further south, may also be reached from Gladstone (see page 50). These coral islands have a very special character, and they also exist in delicate balance with their environment. Close attention is being given to their management by Queensland National Parks and Wildlife Service not just to preserve the 'naturalness' of the islands but because they are important breeding sites for turtles and sea birds. Some species of sea birds which depend upon these islands as their only breeding sites are sensitive to disturbance. A few of these are feeling the pinch of man's activities and are endangered.

Two islands of the Capricorn Group, Mast Head and Tryon, are set aside as 'wilderness camping' islands, which means extra restrictions are placed on them—numbers of campers permitted are fewer, and no engine-driven machinery, such as portable generators and compressors, may be used. The wilderness islands are those which are considered more sensitive to disturbance, and they have a unique place in tourism in that they offer what is today a rare opportunity for a true wilderness experience—a place where man can totally escape civilisation and be together with nature as it has existed almost undisturbed for thousands of years.

Camping holidays on an island mean living simply and observing the beauty and wonder that only nature provides. Children, especially, learn to love the creatures of the islands and their reefs and they will remember these experiences as they become adults. School holidays are busy, and advance booking is necessary. Camping permits are issued, on a first-come-first-served basis, upon payment of fee (see 'Camping on the islands' for information about permits).

MAST HEAD ISLAND

Location: 23° 32'S 151° 43'E (59 km north-east of Gladstone).
Island type: Wooded coral sand cay (65 ha) about 1200 m x 400 m on the north-western end of a platform reef (1380 ha) about 6 km x 2 km. National Park.
Access: From Gladstone, via private charter, such as with MV *Calypso Kristie* or MV *Odessa*. Numbers of campers permitted at any one time is restricted to 60 (but reduced to 30 during the bird nesting season, October–March). A camping permit must be obtained in advance from QNPWS, Gladstone.
Facilities: None.

Mast Head is the second largest cay in the region. Its massive reef seems to extend to the horizon when viewed from the island, and waves are just barely visible on the horizon crashing on the south-east edge of the reef. Access to the island is not easy, as the reef has no break or lagoon; at high tide, shallow-draught boats may approach the beach on the lee side, but at low tide the reef dries for a considerable distance out from the island. Mast Head affords an uncomfortable anchorage for vessels sheltering in bad weather; the waves refract around both sides of the reef and meet on the leeward side, causing boats at anchor to roll.

COLFELT

Above:
Camping holidays on Barrier Reef islands give the family, and particularly children, a personal introduction to The Reef, and they provide time for pursuit of simple pleasures.

By some luck, unlike that of many other cays in the region which have, in the past, been stripped of vegetation by hoards of goats, excoriated by guano miners, and blasted with bombs by practising soldiers, Mast Head has remained relatively unmolested. It is a magnificent example of a cay by any number of criteria, including its fine pisonia forest, which is in a mature, climax state—one of the last such stands of these trees left in the world, according to the Smithsonian Institution in Washington. Mast Head is a particularly important nesting site for loggerhead and green turtles. It has significant nesting colonies of black noddy terns (*Anous minutus*) and of wedge-tailed shearwaters (*Puffinus pacificus*). It is one of a few nesting sites for several species of terns, two of which are endangered. These species are particularly sensitive to noise and disturbance by beach walkers. When approached within 50 m they become frightened and may leave their eggs; if disturbed when first nesting they may not nest at all.

For these reasons the QNPWS has strongly recommended that: (1) access to Mast Head be restricted to strictly controlled numbers of well-briefed wilderness campers (that no engine driven machinery should to be taken onto the island); and (2) that visits by commercial day-trip vessels should not be permitted because day-trippers are totally inconsistent with the management objectives for the island and are potentially very disturbing to the birds which nest on the beach.

NORTH WEST ISLAND

Location: 23° 18'S 151° 42'E (76 km north-east from Gladstone).

Island type: Vegetated coral sand cay (150 ha) about 1700 m x 800 m on platform reef (7310 ha) about 11 km x 3 km. National Park.

Access: From Gladstone, via private charter (barge *Calypso Kristie* or high-speed catamaran *Odessa*). From Rosslyn Bay (E 31), via high-speed catamaran *Capricorn Reefseeker* (several times a week) or barge *Stampede* (variable schedule). Number of campers at any one time: 150. Private and commercial camping is permitted.

Facilities: Toilets, located near hut on the beach which has several small water tanks fed from roof run-off; water supply cannot be relied upon.

North West Island is the largest cay of the Great Barrier Reef. During the past century it has been mined for guano (about 1891–1900) and at one time had a jetty for guano loading. A child's grave (1898) near the shed is that of the daughter of a guano-ship captain. From 1910 to 1914 a turtle soup factory was active on the island, and Captain Cristian Poulson, who later founded Heron Island resort, operated this factory from 1924 to 1928. Remains are still in evidence. There are feral cats, domestic fowl, rats, mice and some plants and insects introduced during times of human occupation.

North West is the largest of the camping islands with provision for 150 campers; half of this number is allocated to commercial camping operators, except during school holidays when only private campers are allowed.

A large catamaran, *Capricorn Reefseeker*, brings day-trippers to the island four times a week from Rosslyn Bay and Great Keppel Island.

North West has a good reef with prolific coral growth along the edges. The island is the largest breeding site on The Reef for black noddy terns and for shearwaters, and it is an important turtle rookery. It also has one of the last major stands of *Pisonia grandis* left in the world.

Below:
Camping at the top of the beach on North West Island, with the tall pisonias of this island's magnificent forest as a back-drop. The sound and scent of the sea and the sea birds are campers' constant companions.

DEAN LEE

COLFELT

TRYON ISLAND

Location: 23° 15′S 151° 47′E (86 km north-east of Gladstone).
Island type: Vegetated coral sand cay (14 ha) on platform reef (500 ha). National Park.
Access: From Gladstone, via private charter vessel (barge *Calypso Kristie* or high-speed catamaran *Odessa*). Number of campers at any one time: 35. Permit required.
Facilities: None.

Tryon Island is a small cay located north-west of the centre of its reef. It is a National Park, thickly vegetated with pisonia forest surrounded by other species commonly seen on these islands. It, like the other cays in the group, is a turtle and sea bird rookery. This delightful small island has been set aside for wilderness camping.

Above:
Coral cays are built up by the action of the waves which, under the right circumstances, accumulate a pile of coral sand, usually towards the leeward end of a reef. The tail ends of these cays are frequently mobile and may shift position from year to year. In geologic terms the islands are extremely young, having been created during the past 3000 years.

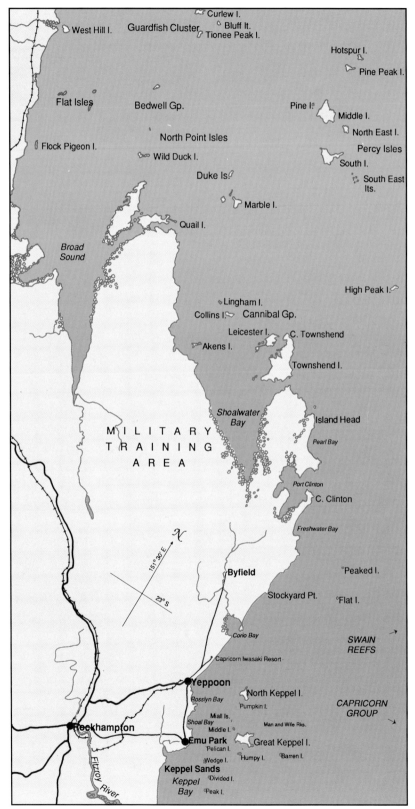

Principal destinations of this section

From Rosslyn Bay

- *Great Keppel Island*
- *North West Island*
- *Middle Island underwater observatory*
- *National Park islands of Keppel Bay*

SECTION II
THE CAPRICORN COAST

Rockhampton and the coastal gateways of Yeppoon and Rosslyn Bay; Great Keppel Island.

'Where The Outback meets The Reef' is what the slogans say about Rockhampton, the defacto capital of central Queensland and beef capital of Australia. This historic city of 55 000 on the Fitzroy River, referred to by Queenslanders simply as 'Rockie', is the main rail link of central Queensland and is the feeder city for the Capricorn Coast, a 50-odd kilometre stretch of sandy coastline between Keppel Sands (E 32) in the south and Byfield (EF 30–31) in the north. The mainland immediately north of this is a no-man's-land, the giant Shoalwater Bay Military Training Area. Rockhampton is the nearest city to the coastal town of Yeppoon (E 31) and to Rosslyn Bay (E 31), which is the harbour from which travellers depart for The Reef.

The continental shelf widens immediately north of this latitude and The Reef moves further offshore. Once north of the Capricorn Group of islands, the Swain Reefs are found at a distance of 200 km from the mainland. Along the coast northwards from the Tropic of Capricorn there are numerous clusters of continental islands, hugging the coast, many with fringing coral reefs.

How to get to Rockhampton
By road. Rockhampton is about seven and a half hours' drive from Brisbane and a little less than two hours from Gladstone. All of the major bus companies stop there; it's ten hours and a bit from Brisbane.

By air. It is one hour by direct flight from Brisbane (Ansett Airlines, Australian Airlines). Rockhampton is also serviced by Sunstate Airlines, on its coast-hopping route that connects all of the main coastal gateways from Bundaberg to Townsville.

By rail. It takes about 13 hours from Brisbane by train.

Tourist information
The Capricorn Tourism and Development Organisation is located on the Gladstone Road, 4 km south of where the highway crosses the river, PO Box 1313, Rockhampton, Qld 4700. Telephone (079) 27 2055.

Rockhampton weather
Rockhampton is one of the driest cities of the coastal area.

COLFELT

Above:
Rockhampton and some of its surrounding towns have a sense of history about them, with many buildings of a previous day gracing their streets. The Criterion Hotel in 'Rockie', on Quay Street, can be seen by motorists crossing the bridge over the Fitzroy River.

	Jan.	Apr.	July	Oct.
Avg. Daily High	32°C	29°C	23°C	29°C
Avg. Daily Low	22°C	18°C	9°C	17°C
Days Rain (over 0.2 mm)	12	6	6	7
Normal Rainfall	131 mm	34 mm	16 mm	39 mm
Mean Sea Temp.	27°C	25°C	21°C	23°C
Normal Annual Rainfall = 797 mm				

Accommodation
Rockhampton has a number of three- and two-star motels, a few modern hotel-motels and number of decorative old-style hotels, some of which have renovated accommodation but some of them, from the

73

tourist's point of view, are really more for drinking than overnighting.

Rockhampton environs

Rockhampton's Botanical Gardens are renowned as having one of the finest collections of tropical species in Australia. The city's relatively new Aboriginal Culture Centre, called Dreamtime, is unique, with its paintings and artifacts, displays and dance groups. Thirty-eight kilometres south of Rockie on the Burnett Highway is historic Mt Morgan, with its gold mine (the largest open gold mine in Australia) and museum and beautiful old buildings.

YEPPOON

Those heading out to The Reef by water may find it preferable to drive 40 km (about 30 minutes) to Yeppoon, a quiet resort town by the sea, and to spend the night there before going on to Rosslyn Bay next morning, the departure point 7 km south. Yeppoon is neither as hot nor as cold as Rockhampton, being right on the coast, and although its total rainfall is higher, it has marginally fewer days when it rains — plentiful sunshine is one of the boasts of this area.

	Jan.	Apr.	July	Oct.
Avg. Daily High	29°C	26°C	21°C	26°C
Avg. Daily Low	23°C	19°C	11°C	18°C
Days Rain (over 0.2 mm)	11	8	5	5
Normal Rainfall	172 mm	72 mm	29 mm	42 mm
Mean Sea Temp.	27°C	25°C	21°C	23°C
Normal Annual Rainfall = 1227 mm				

Below:
Rosslyn Bay is the departure point for island and Reef destinations of the Capricorn Coast. The water taxi *Aquajet* has several scheduled runs to Great Keppel Island each day, and the catamaran *Capricorn Reefseeker* calls at Keppel four days a week to pick up passengers for its trip to the Barrier Reef cay, North West Island, two and a quarter hours out from the mainland. The catamaran *Victory* departs for Great Keppel and an all-day island cruise every day, and ferries such as *Denison Star* and *Seafari* also take passengers across to the islands several times a day.

Accommodation

Yeppoon has one three-star-plus motel, the Bayview Tower, a high-rise right at the edge of Keppel Bay, and there are several motels in the two-star plus and two-star category. About 8 km north of Yeppoon is the Motel Melaleuca, part of the Capricorn Iwasaki Resort complex but which functions as a three-star-plus motel.

Capricorn Iwasaki Resort

In 1972 a Japanese hotelier and businessman, Yohachiro Iwasaki, purchased some 8500 hectares of virgin land along the coast just north of Yeppoon and began what was to be a four-stage development, including a wildlife sanctuary, major resort and an international airport. Appreciating the Japanese fervour for curiosities of the Australian bush, Iwasaki's nature sanctuary would contain a little bit of everything Australian. As one approaches the resort, which is 8 km from Yeppoon, it is possible to get some idea of the magnitude of the project, of which only the first stage is complete. The last 5 km of elegantly landscaped divided road passes through bush country where kangaroos stand 'hitch-hiking' by the roadside like Disneyland characters. The resort is a 406-room hotel with four bars, two restaurants (one is traditional Japanese and one is called 'The Billabong Bistro'), a mammoth freshwater pool, 18-hole golf course, tennis courts, lawn bowls, horse riding and para-sailing on the beach. There are ordinary hotel rooms as well as suites with their own cooking and laundry facilities. Most Australians probably had the idea that Iwasaki was to be an exclusive resort for well-to-do Japanese, one that just happens to be located in

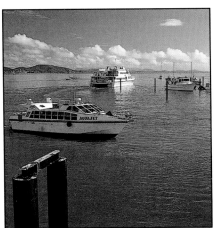

COLFELT

Queensland; this may have been the original idea, and there are Japanese to be seen there, but it is now being sold to Australian travel agents at very competitive prices.

Camping and caravan parks
From Yeppoon to Emu Park (17 km south) there are several caravan parks, and Yeppoon itself has Yeppoon Backpackers, with hostel accommodation (four to a room), which caters for many heading off for camping on Great Keppel Island or on the Barrier Reef cay, North West Island (see page 70 and 'Reef trips' below).

ROSSLYN BAY

Rosslyn Bay is an eight-minute drive (about 7 km south) from Yeppoon and is the exit point to The Reef. A new marina complex is under construction there. From the jetty the fast catamarans, monohulls and water taxis depart for The Reef (North West Island) and for Great Keppel Island. There is a parking lot at the harbour, but those leaving for more than just a day trip often park their car 1 km back up the road at the Kempsea Car Park, which provides lock-up undercover parking for cars, motorcycles, caravans and boats. Kempsea takes customers down to the boat harbour and meets the boats when they return.

Reef trips and island cruises

The nearest Barrier Reef destination to Rosslyn Bay is North West Island, the largest cay of The Reef located 100 km to the east. The catamaran *Capricorn Reefseeker* takes day-trippers to North West on Tuesday, Thursday, Saturday and Sunday, calling in at Great Keppel on the way. It takes about two and a quarter hours to get to North West. Diving, snorkelling, guided snorkel and island tours are offered, and the live underwater video provides amusement while lunch is served. *Reefseeker* also transports campers to North West, both private and those camping at the commercial campsite of Yeppoon Backpackers, the latter operating three out of every four weeks except during school holidays. Their camp has two-man tepee tents and a large communal tent; they can take 15 campers at one time; all meals and equipment included in the price, and dive tuition is available.

The catamaran *Victory* departs for Great Keppel daily and picks up passengers for its all-day fun cruise around the island. *Victory* stops at the Middle Island underwater observatory where fish and coral can be viewed and photographed through huge plate glass windows.

National Park islands

A number of islands in Keppel Bay which are National Parks have limited facilities for campers. Campers need to take all equipment, food and water, and a camping permit is required from QNPWS, Rockhampton—telephone (079) 27 6511. Access is by water taxi from Rosslyn Bay. North Keppel Island (16 km NE) has camping on the north-western side with toilets and fresh water (suitable for washing only). Take insect repellent. Humpy Island (20 km E), the most southern of the Keppel Group, feels the full impact of the trade winds, and its vegetation is stunted and does not provide much shade. There are toilets and a rainwater tank. Humpy offers some good snorkelling. Other islands on which camping may be done are Middle Island (14 km E), Miall Island (12 km E) and Halfway Island (19 km E); these have no facilities.

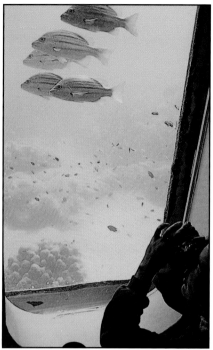

COLFELT

Above:
The Middle Island underwater observatory provides an opportunity for tourists to view fish and coral at close quarters without getting wet. Visibility may be limited when it rains or when the sea is stirred up by winds and strong tides.

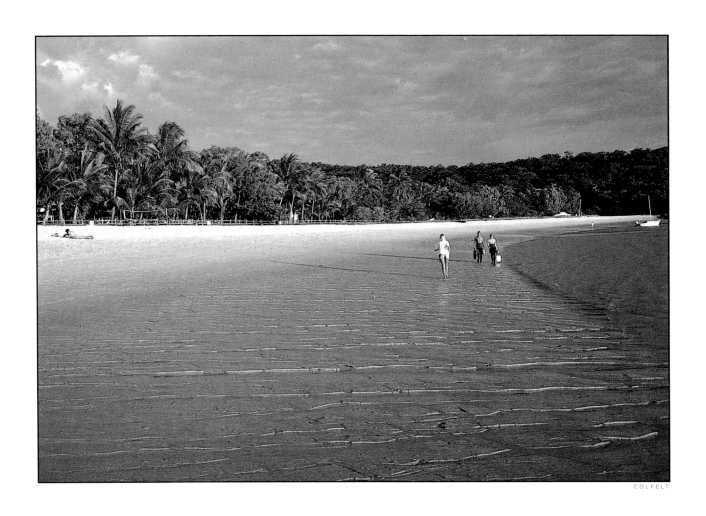

COLFELT

GREAT KEPPEL ISLAND

Great Keppel Island is a large, rocky continental island that lies quite close to the mainland in an area of the Queensland coast where rainfall is at its lowest. The island has 17 clean white sand beaches scattered around its circumference, and it is little wonder that 'sun, sand and sea' feature prominently in its list of attractions for tourists. The island is well known to Australians through its strong promotional appeal to the young, and its slogan 'Get wrecked on Great Keppel' is now in the annals of marketing history, a success story which has helped Keppel achieve the highest occupancy rate of any resort inside The Reef.

The high-profile campaign to attract 18- to 29 -year-olds has possibly obscured the fact that Great Keppel really has two personalities. The first is evident during the school holidays, especially in summer, when the resort is bursting with nubile brown bodies all in frenetic pursuit of exhaustion. The other side of Keppel may be seen when the young are back at school or have retreated to the relative safety of a job, and then people of all age groups are seen on the island.

Great Keppel offers activities galore, but there is latitude to proceed at your own pace—either to join in the fun or to drop out almost entirely. It is perhaps not the place for those seeking their own private island, but Keppel is big enough so that one can escape with a picnic to a secluded sandy beach away from the crowd.

Great Keppel Island also has a commercial tourist park for campers, Wapparaburra Haven, and a youth hostel.

'Wapparaburra' is what the Aborigines called Great Keppel Island long before James Cook sailed past, on May 27, 1770. It was Cook who bestowed upon the island yet another of those stolid-sounding names that most of our islands now have—instead of the prettier ones that the Aborigines gave them—names of well-placed British citizens of the 18th century such as that of Augustus Keppel (1725–1786), who was a Rear Admiral of the Royal Navy at the time and who was later to become First Lord of The Admiralty.

Great Keppel is one of a group of continental islands just east of Yeppoon. It is covered with eucalypt forest, with some pandanuses and casuarinas along the fringes of its beaches and a few coconut palms planted in front of the resort.

The resort
The first impression one gets on arriving at this island by sea is one of youth. As the catamaran *Victory* pulls up at the northern end of the beach to unload passengers picked up at Rosslyn Bay, it is met by a mass of young travellers, many with rucksacks—campers who are staying at Wapparaburra Haven. They are waiting, along with guests from the Great Keppel resort, to join *Victory* on its daily fun cruise around the island.

The impression of youth is sustained at the resort itself, which is situated at the opposite end of Fisherman's Beach. The names of var-

Opposite:
Fisherman's Beach, one of 17 clean white sand beaches on Great Keppel Island, expands in a long crescent in front of the resort, which is just behind the trees at the top of the beach .

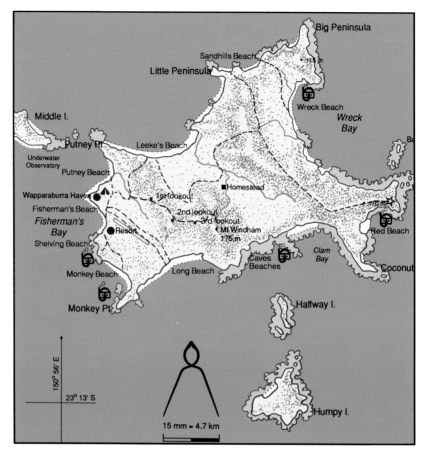

ISLAND SUMMARY
Great Keppel Island

Location: 23° 11′S 150° 57′E
Gateway: Rosslyn Bay (17 km)
1732 km NNE of Melbourne
1189 km N of Sydney
519 km NNE of Brisbane
885 km SE of Cairns

Island and resort details

High rocky continental island (1478 ha), covered with open eucalypt forest, with numerous clean white sand beaches and some fringing coral reefs, particularly on the southern and eastern sides.

Access

From Rosslyn Bay: (20 mins) by catamarans *Victory* (9.00 a.m. daily) or *Capricorn Reefseeker* (9.00 a.m., 4 days a week); (30 mins) by ferries *Seafari* and *Denison Star* (9.00 a.m.); or (20 mins) by water taxi *Aquajet* (9.30, 11.30 a.m. and 3.30 p.m.). From Rockhampton, (20 mins) by Sunstate Airlines. Day trips to Great Keppel are also available departing from the Gold Coast.

Resort capacity, accommodation, resort facilities

Maximun 400 guests. Numerous day-trippers. **Accommodation:** 160 units of two types, Beachfront and Garden, all with private facilities. **Resort facilities:** 6-hole golf course; 3 tennis courts (2 floodlit); squash courts; badminton court; commando course; 2 pools; archery range; all water sports equipment; shop; hairdresser; snack bar; games room; disco; convention facilities for 100. Keppel Kids Klub (all-day child supervision) during school holiday times. This large island has natural ground water.

Tariff

All inclusive (except for alcohol and water sports requiring petrol). Children 3 to 14 years half price.

Eating and drinking

Admiral Keppel dining room (7.30 a.m. to 9.30 a.m., 12.00 noon to 2.00 p.m., 6.30 p.m. to 7.45 p.m.). Kids' dinner (5.30 p.m. to 6.00 p.m.); Café snack bar (9.00 a.m. to 5.00 p.m.). Bars: Pool Bar

(9.30 a.m. to 5.00 p.m.); Sunset Lounge (5.30 p.m. to 1.00 a.m.); Sand Bar (daily till midnight); Wreck Bar (daily till 3.00 a.m.).

Activities

Land: Aerobics; archery; badminton; basketball; bushwalks; cricket; darts; golf; horse riding; netball; racquetball; soccer; softball; squash; table tennis; tennis; touch football; underwater hockey; volleyball.

Water: Aqua bikes; boom-netting; catamaran sailing; coral viewing; cruise around the island; visit to Middle Island underwater observatory; dinghies with outboard motor; helicopter joy-rides; paddle skis; para-sailing; sailboarding; scuba diving; snorkelling; tobogganing; waterskiing. Reef trips via *Capricorn Reefseeker* or helicopter to North West Island.

Anchorage for yachts

The most protected anchorage is at Leeke's Beach in the northwestern bay, although it can be swelly in heavy weather and during spring tides. The anchorage off the resort shoals a long way out; check tide tables.

Great Keppel Island Resort, via Rockhampton, Qld 4700. Telephone: (079) 688 199. FAX: (079) 688 215. Telex: 49467

ious resort facilities and items in the resort's informative 'A–Z' booklet employ comic-book spelling; for example, 'Klicker' is the resort photographer and 'Klickery' is his office; and 'kocktails' are served in the bar, and if you've brought youngsters with you, the 'Keppel Kids Klub' may be fun for them. The resort's news bulletin, 'The Daily Wrecker', announces a flurry of activities for the day—'archery, sailboarding demo, golf tournament, para-sailing, aquarobix, inkourt kricket, bushwalk', plus a feast of 'nocturnal wrecking'. The 'Wrecker' signs off 'with love and sloppy kisses' from 'Dr Keppelopolous and his lethal krew of wreckers'.

The resort is attractively landscaped, with coconut palms along the beachfront. At the far end one finds the day-visitors' area, and moving back towards the resort, the Wreck Bar and disco, the electronic games room, snack bar, resort store, hairdresser, departure lounge, the Beachfront units flanking the main restaurant and bar area. Heading east back from the beach, the resort opens out over a wide expanse of green lawn, punctuated by large gum trees, with tennis courts surrounded on two sides by the Garden units.

Accommodation and tariff

Great Keppel's 160 units are of two standards, Beachfront and Garden, long, double-storey blocks of uninspired architecture, rather plain but softened by the use of lattice and bougainvillea vines. Both types of units are of similar comfortable standard with balcony, private bathroom, refrigerator, ceiling fan and tea and coffee-making facilities. Beachfront units are situated behind the palms at the top of Fisherman's Beach and look out over Keppel Bay. Garden units are set further back and look out on the green expanse of lawn. There are also Garden family units, which are single-storey duplexes situated across the lawn at the eastern end of the resort area. The Garden units are on balance quieter than those at the beachfront, being further away from the night-time activities. There are laundry facilities for use (free) by all.

Keppel's tariff is all-inclusive (excluding alcohol and water sports requiring the use of petrol), so once you've paid for the room you don't

Below:
Great Keppel is a continental island with a natural cover of eucalypt forest and some casuarinas and pandanuses along its beaches, which virtually surround it.

JOHN GOLLINGS

have to continually keep dipping into your pocket. The rate for Beach-front units is slightly higher than that for the Garden units.

During Queensland and New South Wales school holiday times, extra staff is employed by the resort to operate the Keppel Kids Klub, an all-day child-minding service of sorts for 3–15-year-olds. The children have their own activities schedule and their own 'Daily Wrecker'. All year round there is baby-sitting for children during and after Kids Dinner, from 5.30 p.m.–8.30 p.m. every evening.

Eating, drinking and entertainment

The Admiral Keppel dining room presents meals of a good standard, buffet breakfast and lunch and *à la carte* table service at dinner. You may eat however much is necessary to keep from being terminally wrecked in this look-alike ship's dining room—provided you are not rendered too seasick to eat by the electrified brass lanterns which are made by mechanical means to sway slowly back and forth (kute!).

For drinks there are: the quiet Sunset Bar, with piano music; the Sand Bar (next to the dining room) where a live show is presented nightly by staff; the Wreck Bar, with its $100 000 lighting and sound equipment, situated as far as possible from the main resort area because this is where the disco thumps every night from 10.30 p.m. until 3.00 a.m.

Activities

Apart from a bedazzling array of organised activities (see summary on page 78), Great Keppel has a very good range of sports facilities, including a 'commando course' fun fitness centre with scrambling nets and other obstacles. A complete range of water sports equipment is supplied for free use by guests—catamarans, paddle skis, sailboards. Jet skis, dinghies with outboard motor, and water bikes are available, as are water skiing and para-sailing, but these are 'extras' because they use petrol. Horse riding is also offered as an organised activity.

Walks and beaches

Keppel has several attractive walks including one to the lighthouse at the other end of the island (two and a half hours each way) over most-

Above left:
Beachfront units at Great Keppel Island resort look out over Keppel Bay.
Above:
Volleyball on the beach is one of a host of ways to 'get wrecked' at Great Keppel.
Right:
The resort has a complete range of water sports equipment which is available to house guests at no extra charge.

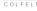

COLFELT

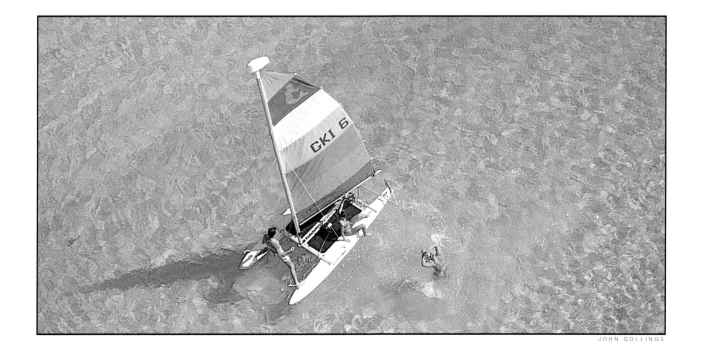

JOHN GOLLINGS

COLFELT

Above:
Great Keppel's expanse of lawn behind
the main resort buildings is punctuated
with elegant gum trees. The Garden
units look out over the lawn
and tennis courts.

ly dirt road with several lookouts along the way. In the warm months this walk can be a thirsty one, and walkers should carry a Thermos of water (which the resort will supply) and a piece of fruit. Leeke's Homestead (one hour) was operated by Ralph and Lizzie Leeke from the 1920s to the 1940s, where they grazed cattle and sheep. The building has been restored, and twice weekly there is an organised walk to the homestead, culminating in billy tea and damper served in the paddock.

A number of Keppel's beaches can be reached by walking, including some of those which offer snorkelling south of the resort; these are 20–40 minute walks each way. It is possible to walk right around the northern side of the island by the beaches (with a few detours inland over peninsulas, such as at Putney Point).

Keppel's beaches are for the most part pleasant in all tide conditions, and it's always possible to find one protected from the wind.

Diving

Scuba diving on Great Keppel is conducted by Haven Diving, located at Wapparaburra Haven, operated by Robert and Melinda MacKinlay, who have been running the business on the island for many years. At a desk by the Sand Bar pool, diving arrangements may be made, and pool demonstrations are regularly given there.

Haven offers NAUI courses from introductory up to and including instructor level. Because of the large numbers on the island they are able to conduct courses starting almost every day of the week. Haven has a 16 m steel-plated dive boat.

Diving around Keppel is generally in shallow water (maximum depth 28 m at the offshore islands). The area is subject to large tides. Visibility is better in winter (average 15–20 m) than in summer (average 6–9 m). There are a few sites around the island (the better sites are on the eastern side), but the very best diving in the area is out at Barron, Child and Egg Islands and at Outer Rock—exciting diving with huge boulders and ledges in 15–18 m depth. In the Keppel area olive sea snakes (*Aipysurus laevis*) are frequently encountered, and while sea snakes are poisonous, and somewhat curious, they almost never bite unless provoked and are not a particular worry for divers.

Snorkelling

The nearest coral for snorkellers is off the point between Fisherman's Beach and Shelving Beach, not remarkably good, but it gets better heading southwards to Monkey Point. The best snorkelling is on the eastern side of the island or at the outlying islands.

Cruises and Barrier Reef trips

The catamaran *Victory*, which brings passengers over to the island every morning, does a daily island cruise. It stops off at the Middle Island underwater observatory and then heads off for a day of boom-netting (frolicking in the water in a net attached to the side of the boat while it motors along), snorkelling, swimming and sunbaking; lunch is provided.

The catamaran *Capricorn Reefseeker* calls at Keppel four days a week to pick up passengers who wish to see the Great Barrier Reef. *Reefseeker* does a day trip to North West Island (see page 70). Helicopter flights are also available and operate a schedule which is dependent upon tides. The helicopter trip is about double the price of the catamaran trip.

Wapparaburra Haven

Bob and Di Blatch have operated Wapparaburra Haven on the spit between Fisherman's and Putney Beaches for the past 18 years. This camping resort consists of three tent villages, 12 cabins and 55 individual tent sites. The rates depend upon the type of accommodation, length of stay, and there are concessions for families.

The tent villages each have 12 tents (3 m x 4 m) which are divided down the centre by a plastic partition and which are designed for occupancy by a maximum of four people (single campers occupy one side). Each side has two vinyl-covered mattresses and an electric light. One of the tent villages is operated by Keppel Camp Out, for its own customers; this organisation is part of the national Camping Connection group. Campers at Keppel Camp Out pay an all-inclusive rate for accommodation, meals with wine, linen, aquatic hire, etc.—a camping version of a 'Club Med' holiday. The other villages are for casual campers. Each has a communal area for cooking, eating and washing up. Wapparaburra also has 12 self-contained cabins, i.e. with gas stove, pots, eating utensils and linen supplied. The 55 individual campsites are located behind the dunes of Putney Beach. All campers at Wapparaburra Haven use communal toilet/shower facilities.

A small store with a full range of groceries, vegetables and a basic selection of meats is located next to the restaurant, which serves breakfast and dinner; on four nights it's *à la carte*, and three nights are 'specials' (e.g. barbecue, roast, spaghetti) where you can eat all you like.

Right next to Wapparaburra is a Youth Hostels Association hostel with 12 cabins to accommodate approximately 50.

Camping at Great Keppel is very popular, and school holidays are solidly booked one year in advance. Campers may use the day visitors' facilities of the Great Keppel resort, including the Wreck Bar and disco, and they may book for meals in the dining room if space is available.

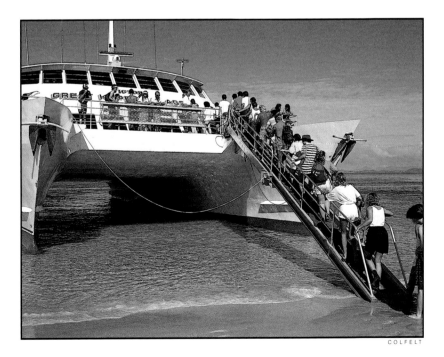

COLFELT

Left:
The catamaran *Victory* is one of several vessels operating between Great Keppel Island and Rosslyn Bay on the mainland. Passengers are unloaded directly onto Fisherman's Beach, where others join the vessel for its daily lunch cruise around the island.

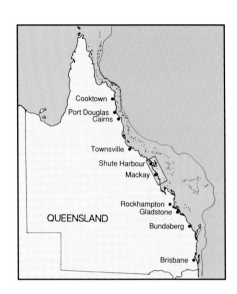

Principal destinations of this section

From Mackay

- *Brampton Island*
- *Lindeman Island*
- *Bushy Islet*
- *Credlin Reef*

From Shute Harbour or Airlie Beach

- *The Whitsunday Islands*
- *Brampton Island*
- *Daydream Island*
- *Hamilton Island*
- *Hayman Island*
- *Hook Island*
- *Lindeman Island*
- *Long Island*
Contiki Whitsunday Resort
Palm Bay Resort
- *South Molle Island*
- *Whitsunday Island*
- *Bait Reef*
- *The Hardy/Hook Reef complex*

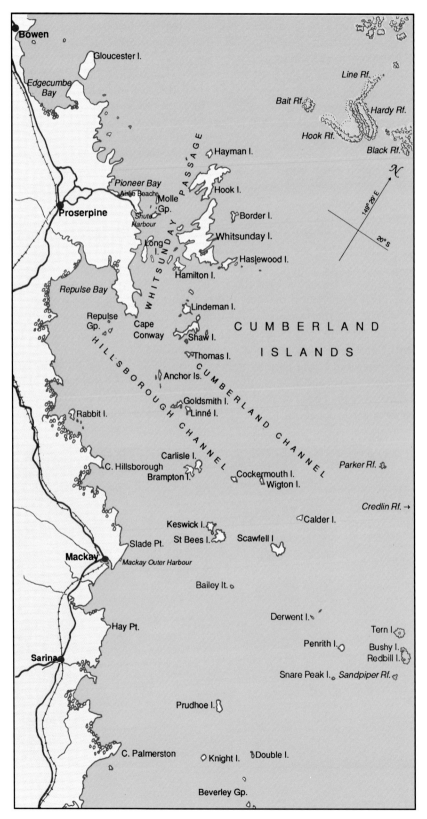

SECTION III
THE WHITSUNDAYS

Mackay, Proserpine, Airlie Beach, and Shute Harbour;
the Cumberland (Whitsunday) Islands and outlying reefs

Along the coast between the sugar town of Mackay (DE 26) and the tomato town of Bowen (D 23–24) lies the greatest density of islands to be found anywhere on the eastern Australian margin. From a distance they appear like blue cones floating on a shimmering horizon. The surrounding waters are a vibrant turquoise, the colour due in part to the presence of fine sediments stirred up by the huge tides that sweep this part of the coast. Located between 20^o and 21^o south latitude, the climate is balmy in winter and warm to hot and humid in summer. The nearest reefs of the Great Barrier are located 32 km to the north-east.

These islands are, in fact, the tops of a coastal mountain range that was overtaken by geologic events—by tectonic movements of the earth's crust and by a rise in sea level after the most recent ice age. The old valley between the mountains and the mainland was deep enough so that when it flooded large ships were able to pass through, a fact which the master navigator James Cook was to establish in the latter part of the 18th century.

The majestic beauty of these islands was appreciated long before James Cook put them on the map. The Aborigines were the first to come, probably before they even *were* islands. By 1770, the year Cook discovered them, Aborigines in significant numbers were travelling from the mainland to most of the islands in search of food, reaching them in swift outrigger canoes made of thin sheets of bark sewn together, the ends shaped, caulked with pine gum, and with sticks for thwarts that held them in shape. These black men were Nagro people. As white men moved into and through the area, the Nagro earned a reputation for being fiercely independent, and there were bloody confrontations on the beaches and on the mainland. It has been said that resistance to European invasion by these people was the most tenacious ever put up by an Aboriginal community. They were also skilful hunters and fishermen, as much at home in the water, it is said, as if they had webbed feet and gills, and so good with a spear that they could 'hit a sixpence floating on the tail of a kite'.

On Sunday, June 3rd, 1770, Lieutenant James Cook made his way through the passage that commences just north of the Conway Peninsula (E 25). He noted:

> The land both on the Main and Islands especialy on the former is tolerable high and distinguished by hills and Vallies which are diversified with woods and Lawns that look'd green and pleasant. On a Sandy beach upon one of the islands we saw two people and a Canoe with an outrigger that appeared to be both larger and differently built to any we have seen on the Coast.

As a seaman Cook also observed:

> … every where good anchorage. Indeed the whole passage is one continued safe harbour.

He called the passage *Whitsunday's Passage* because that particular Sunday was Whit Sunday*, the seventh Sunday after Easter and the day on which the Christian church celebrates the feast of Pentecost. And he

*Literally, 'White Sunday', after the custom in the Christian church of the wearing of white baptismal robes by those newly baptised at the feast of Pentecost.

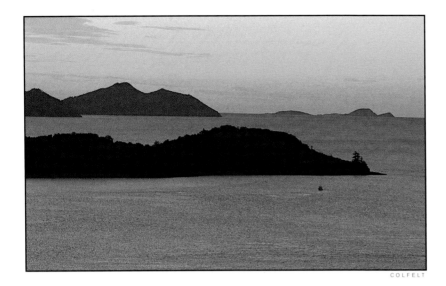

COLFELT

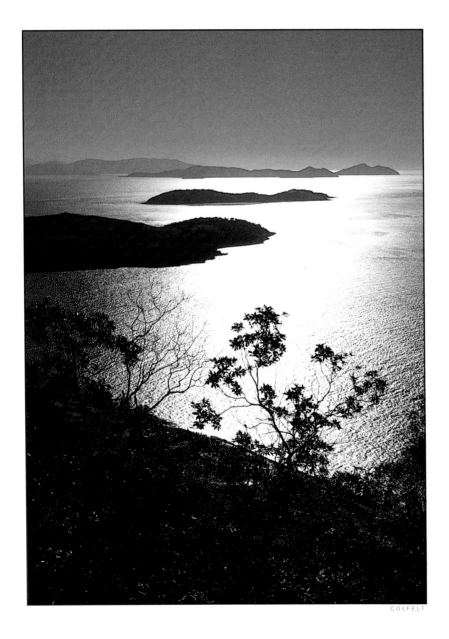

COLFELT

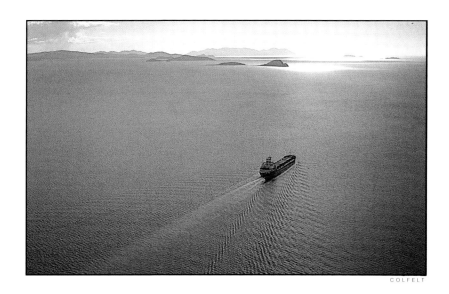

The islands surrounding the Whitsunday Passage have been appreciated by seamen ever since James Cook put them on the English charts in 1770. The Aborigines knew them long before then. Today they are Australia's favourite cruising grounds for yachtsmen and a popular resort destination as well. Ships pass through the islands on their way up the 'inner track', the route north inside the Great Barrier Reef.

COLFELT

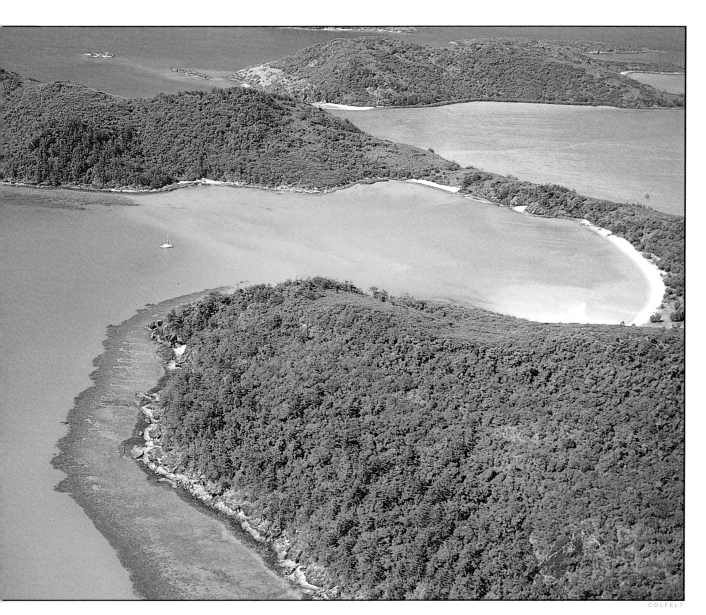

COLFELT

**The Cumberland Islands of our charts today are made up of the Whitsunday Group (57 islands), the Lindeman Group (18), the Sir James Smith Group (18) and 17 other islands to the south. Depending upon one's definition of island, but in this instance excluding those referred to on the charts as 'Rock', there are altogether 110 Cumberland Islands (140 counting the rocks). Terminology, however, has become blurred; in fact, 'Cumberlands' would not be recognised by many tourists today, 'Whitsundays' more often than not being used to refer to all of the islands, including some to the north-west of the Whitsunday Group. Cook said that the islands he named Cumberland were those which, with the mainland, form the Whitsunday Passage, and by this definition there are 71 'Whitsunday' Islands. Someone somewhere some time ago suggested that there are 74 Whitsundays, and this number has been pounced upon, stuffed into the bag of unarguable truths, and it is often touted in tourist promotion. Whichever number you like, there are lots of islands in this particular part of the Barrier Reef Region.

named the islands which formed the passage the Cumberland Islands** in honour of the Duke of Cumberland, the younger brother of the then monarch of England, George III.

During the 100 years following Cook, many ships of exploration and trade were to frequent the Whitsunday Passage, and it was to become part of the preferred route northwards for trading vessels. The captains of early pearling luggers and bêche-de-mer fishing boats liked to use the islands as rest stops en route north, knowing that when setting sail again they would not have lost any of their crew.

Within ten years of the European invasion of the Mackay area, the Aboriginal population was halved, either going down before the white man's diseases or before the guns of the Native Police, and in the subsequent ten years the Aborigines were all but gone. The only permanent Aboriginal settlement on the islands was on Whitsunday Island, where the last remnants of a community still resided when James Whitnall set up a timber mill at Cid Harbour in 1884. The mill closed in 1904. There is evidence of the Aboriginal presence on many of the islands, and today at Nara Inlet, on Hook Island, cave paintings may be viewed by tourists. The remains of a quarry, where natives used to gather stones for axes, is still in evidence on South Molle Island.

Tidal currents run swiftly between the islands, maintaining a constant strong circulation of water, one of the reasons for the excellent development of fringing coral reefs around the Whitsunday Islands. No doubt this added immensely to their appeal for the first white settlers, in the early 1900s, and for the early tourists 25 years later.

By the mid 1920s grazing leases had been taken out on a number of the islands, and several were inhabited by adventurers. Towards the late 1920s some of these began taking in a paying guest or two. But it wasn't until after World War II that tourism in the Whitsunday area really got moving; today it is one of the busiest destinations of the Barrier Reef area, offering a wide range of island resorts and Reef activities. The Whitsunday Section is served by several cities and towns, the first to be reached from the south being Mackay.

MACKAY

It has been said, 'Mackay is a mango mentality', a complete nonsense that nevertheless communicates something about the place. It's tropical, with palm-lined streets, relaxed, no high-rise buildings, no hustle and bustle and no peak-hour traffic. The city, which is located on the Pioneer River about 5 km from the coast, itself has a population of 22 000, but in the greater metropolitan area of Mackay some 50 000 reside. A third of Australia's sugar is grown in this district, that is from Sarina (D 27) to Proserpine (D 24–25), and Mackay is the 'sugar capital' of the country, with a huge export facility located at the man-made Mackay Outer Harbour. When sugar prices are down, the city falls back on the economic activity surrounding regional coal mining and exporting, the exporting taking place 40 km south at Hay Point, where the largest coal loader in the world is located. There is a beef industry, too, and also small-crop farming. So, in bad economic times when tourists are scarce, Mackay gets a tummy-ache rather than an ulcer. As is true of most of Queensland's coastal gateways, however, tourism is becoming increasingly significant, and they are aware now, in Mackay, that one tourist is worth five tonnes of sugar.

To the north are emergent beach and holiday suburbs—Slade Point, Black's Beach, Dolphin Heads, Eimeo, Bucasia, Shoal Point. Mackay has beaches both north and south of the city, from Sarina to Shoal Point, some of them as long as 10 km.

Mackay is the southern gateway to the Whitsundays and the principal point of approach to the southernmost island resort, Brampton Island (which is discussed later in this chapter).

How to get to Mackay

By road. Mackay is almost exactly midway up the Queensland coast between Brisbane and Cooktown; it's a day's drive from Brisbane, about four hours' drive from Rockhampton, the next major centre to the south, a little over four hours' drive from Townsville to the north. By Bus, Mackay is about 15 hours from Brisbane, 10 hrs 30 mins from Cairns.

By plane. Mackay is serviced daily by Ansett Airlines and Australian Airlines with flights originating in Brisbane. Sunstate Airlines flies to Mackay on its daily coastal run. Seair Whitsunday has daily flights from the Whitsundays.

By rail. The trip from Brisbane is about 18 hours; from Cairns it's about 14 hrs 30 mins.

Mackay tourist information

Up-to-date information on all activities, including Reef trips and cruises, is available at the tourist information centre, on the main highway (Nebo Road) south of the city centre. Telephone (079) 52 2677.

Mackay weather

Mackay has a tropical climate moderated by the proximity of the city to the ocean.

	Jan.	Apr.	July	Oct.
Avg. Daily High	30°C	27°C	24°C	27°C
Avg. Daily Low	23°C	20°C	12°C	19°C
Days Rain (over 0.2 mm)	16	15	7	7
Normal Rainfall	240 mm	122 mm	28 mm	28 mm
Mean Sea Temp.	27°C	25°C	21°C	23°C
Normal Annual Rainfall = 1605 mm				

Accommodation

The highway approaching Mackay from the south is lined with motels, a few in the 'tourism award' category and the rest ranging from three-star-plus to two-star. There are the traditional 'hotels' in the city, some beautiful to look at and with rooms offered, and several motels. North of the city, in the northern beach towns, are holiday units, small resorts (including a tent-accommodation resort), and a number of camping and caravan parks. Mackay has a backpackers' hostel.

Mackay environs

About 80 km west of Mackay is Eungella National Park (pronounced young-gah-lah and meaning 'land of cloud'), one of the largest in Queensland, its name betraying its altitude. Straddling the Clark Range and overlooking the Pioneer Valley and the coast, Eungella National Park has rainforest walks and abundant wildlife, including platypuses. It's a place to escape the tropical heat and civilisation. Wallaumarra

Rainforest Sanctuary offers a 'retreat experience' in a two-bedroom cottage with kerosene fridge, wood-burning stove and oil lamps.

The Peak Downs Highway runs south-west from Mackay through cattle country and into coal country; 178 km from the city, if you turn right and travel another 13 km you arrive at Moranbah (A–B 27), the town that Utah built. Free tours of the Utah coal mines, at Peak Downs (37 km south) and at Goonyella (25 km north), are offered several days a week.

Mackay Outer Harbour; Reef trips and cruises

Heading north out of the city, Barnes Road crosses the Pioneer River, and about 5 km further is Mackay Outer Harbour, the principal purpose of which is to store and load sugar for export. The harbour also serves as the departure point for cruises to the islands and The Reef.

One of the best known names in Reef cruises along the Queensland coast is that of Roylen Cruises, a company founded by Captain Tom McLean after World War II (the name is a hybrid, being the last parts of the Christian names of Captain Tom's children, Fitzroy and Helen). Roylen's first cruise boat in 1946 was a converted Fairmile gunboat, *Shangri-La*, and two of its early charterers were Reg Ansett and Colin McDonald, who were at the time reconnoitring the islands for a site to build a resort (Ansett later purchased Hayman Island). Over the years, McLean built up a whole fleet of converted Fairmiles, good seaworthy boats that made excellent cruise vessels for these waters which, at times, can be whipped up by blustery trade winds and the six metre tides of the area. A five-day cruise to the islands, including a day at the Barrier Reef, is the basic formula of the Roylen cruise, and these have enjoyed great success over the years. Today the cruises are on large catamarans, the *Roylen Endeavour* and *Roylen Endeavour II*. Roylen also does daily trips to Brampton Island, and three days a week this trip

Below:
Bushy Islet, sometimes incorrectly called Bushy Atoll (there are no atolls on the Great Barrier Reef), is a true coral island, distinctive because it is surrounded by continental islands and because it is the only island in this section of The Reef with a pisonia forest. Bushy lies about 91 km east of Mackay and is a day-trip and cruise destination.

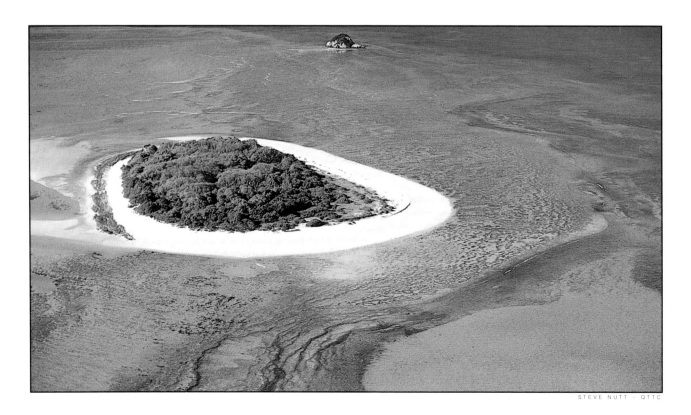

STEVE NUTT – QTTC

continues on to Credlin Reef, 102 km north-east of Mackay, where snorkelling, diving, coral viewing and lunch is offered. Roylen day trips to Lindeman and Hamilton Islands depart several days a week, and guests may stop at either island for lunch and a swim.

Other cruises available from Mackay include those of Elizabeth E Coral Cruises, which operates four-day (three-night) excursions to the islands and The Reef in their very comfortable 33 m *Elizabeth E II*.

A day trip to The Reef via amphibious aircraft departs from Pioneer Air at Mackay airport, its destination Bushy Islet, a coral cay and reef 91 km east of Mackay. The schedule varies with the state of the tide, departure being about two hours after high tide. There must be a minimum of two passengers. The amphibian lands in the lagoon, where there is a glass-bottom boat for coral viewing, and passengers may go ashore on the island or go reef walking (in water about 0.2 m deep). It takes about 30 minutes to get there, and you spend two and a half to three hours at the island.

PROSERPINE

Proserpine (D 24–25) is situated about 22 km from the coast on the river of the same name. It is the seat of the Proserpine Shire, a 1640 km^2 swath of green sugar cane and cattle country that also incorporates the islands of the Whitsunday Group. Proserpine has historically been a gateway to the islands because it is the nearest and largest mainland settlement with a jet airport rather than because of its particular interest in tourism. Proserpine is really a farming town. Situated on the main coastal railway line and on the main highway north, it provides some services that the growing coastal communities cannot provide for themselves. There is now another jet airport for the Whitsundays, on Hamilton Island, owned jointly by Ansett Airlines and the Hamilton Island Enterprises, and this has become an equally busy gateway. During the sugar season (June–December) tourists can take conducted tours of the Proserpine sugar mill.

How to get to Proserpine
By road. Proserpine is a little over one hour's drive from Mackay and about three hours by car from Townsville. On the bus it's about 15 hours from Brisbane, two hours from Mackay and four and a half hours from Townsville.
By air. Ansett Airlines and Australian Airlines fly from Brisbane five days a week. Non-stop, the trip takes one and a half hours; flights via Rockhampton and/or Mackay take 30–50 minutes longer.
By rail. Proserpine is about 21 hours from Brisbane by train, 12 hours from Cairns, eight hours from Townsville.

AIRLIE BEACH

Airlie Beach (DE 24–25) is a small resort town, 22 km from Proserpine, on the southern shores of Pioneer Bay. Along with its rapidly growing dormitory suburb of Cannonvale (2 km to the west), it is the principal support centre immediately adjacent to the Whitsundays. Airlie has all the shops one might expect in a small resort town, and Cannonvale has the large supermarket and shopping centre that its larger population of permanent residents demands. Airlie provides the infrastructure and caters for tourist activities, with its holiday accommodation, kiosks,

Below:
Abel Point, just west of Airlie Beach, is the site of a new marina development on the mainland and will provide a well-protected anchorage in the northern Whitsunday area.

COLFELT

resort-wear shops, hardware store, Avis rent-a-car agency, chemist, newsagency, dive shops, ships chandlery and travel/booking agencies. There are about 15 restaurants in the area, some quite good, and a number of take-away food outlets.

How to get to Airlie Beach

By road. Airlie Beach is about 40 minutes by road from Proserpine, a beautiful drive through tall sugar cane, with the Conway Range a dramatic back-drop. It is about three and a half hours' drive from Townsville. There are seven bus services a day from Proserpine.

Whitsunday tourist information

The Whitsunday Tourism Association is in the centre of Airlie Beach, a few doors from the newsagency, at 348 Shute Harbour Road, Airlie Beach, Qld 4802. Telephone (079) 466 673. FAX (079) 467 387. There are several travel and ticket/booking agencies in town.

Accommodation

A broad range of accommodation ranging from backpackers' hostels to motels may be found—in all, counting a few new facilities in neighbouring Cannonvale and along the road to Shute Harbour, eight motels, five caravan parks, 11 concerns offering holiday flats, and six resorts. Mainland accommodation and resorts offer the family and those travelling on a budget the opportunity to tailor a holiday to suit the purse while still having available the full range of Reef activities and cruises that the area has to offer. The whole of Airlie Beach has something of a resort atmosphere, and there are plans to build a number of new resort-hotel complexes in the vicinity.

Below:
Airlie Beach surveys a brilliant blue expanse of water, and the islands to the north sit up majestically, breaking the line of the horizon. At mid-morning, when the angle of the sun is just right, diamonds dance on the rippled surface of the bay, which is protected by lofty hills to the east and south-east. Airlie is a good place for yachts to anchor to replenish supplies while cruising in these Barrier Reef waters, and the Airlie Hotel, just across The Esplanade from the beach, is a gathering place for all and sundry—old sea dogs, beachcombers, tourists and locals, and there is always something going on, whether it be just conversation, or cane toad races.

RICHARD TIMPERLEY

SHUTE HARBOUR

Shute Harbour is the best mainland natural harbour for miles in either direction, protected in all weathers by the surrounding hills of the Conway Range and by its near offshore islands. It is the major point of embarkation for the Whitsunday Islands and the Barrier Reef destinations beyond. Shute Harbour is basically a couple of public jetties, a boat-launching ramp, a bus stop and a large (but not large enough) parking lot, with a few offices for local tourist operators, Porter's kiosk and a small café. There are no other shopping facilities, and Reef travellers should not arrive here expecting to be able to do much last-minute shopping. Hamilton Island's freight depot is 100 m west of the jetties, and another 100 m down the road from the depot is a lock-up parking garage and service station. Shute Harbour has a couple of small, informal motel/lodges.

How to get to Shute Harbour

By road. Shute Harbour is about 12 minutes (15 km) from Airlie Beach by car over a road that meanders through the tropical fringes of Conway National Park. It is easy to hitchhike on this stretch of road, and seven bus services go daily between Shute Harbour, Airlie Beach and Proserpine.

By air. Seair Whitsunday has daily flights from Mackay and Cairns–Townsville, in De Havilland Beaver and Britten-Norman Islander aircraft, landing at Whitsunday airstrip, about 3 km from the harbour on Shute Harbour Road. The airline also operates regular services between Shute Harbour (or the airstrip) and Lindeman, Hayman, South Molle and Daydream Islands, as well as air taxi, charter, and scenic flights around the islands and to The Reef.

Below:
Shute Harbour is the principal point of embarkation from the mainland for the Whitsunday Islands. At 8.00 a.m. each day of the week the island cruise boats assemble at the jetties, their hulls gleaming in the morning sun, their skippers and crews spruced up smartly in white. Sun-tanned girls clutching clipboards stand on the jetties enticing passers-by to join a cruise to the Barrier Reef, to take a trip to the resort islands, a day of sailing in the Passage with lunch aboard one of Australia's grand old ladies of yacht racing, such as *Gretel* or *Apollo*, which have come to live out their golden years in comfortable retirement cruising around these islands. Seaplanes belonging to Seair Whitsunday, the local air taxi and Reef aerial tourist airline, take off from the harbour bound for points throughout the islands and the Barrier Reef.

COLFELT

By sea. The water taxi does regular runs to and from Hamilton Island, connecting with Ansett flights landing at Hamilton airport. Hamilton Island Cruises operates a daily catamaran service to Hamilton Island.

Whitsunday weather

The Whitsundays have mild winters and warm to very warm summers. In winter when the trade winds are piping, a spray jacket or wind cheater is required; out of the wind swimming gear is all that's needed. When the sun goes down, a jumper and slacks are comfortable. The following table gives weather statistics for Hayman Island, the nearest coastal weather station on the islands.

	Jan.	Apr.	July	Oct.
Avg. Daily High	31°C	28°C	23°C	28°C
Avg. Daily Low	25°C	23°C	17°C	21°C
Days Rain (over 0.2 mm)	13	14	5	5
Normal Rainfall	203 mm	115 mm	36 mm	16 mm
Mean Sea Temp.	27°C	26°C	22°C	24°C
Normal Annual Rainfall = 1445 mm				

Below:
Bait Reef is the first of the outlying reefs of the Great Barrier to be reached from the Whitsundays, about 62 km from Shute Harbour. It is a pristine reef and offers the best Reef diving in this area. Tourists who are not divers can also visit Bait Reef via Seair Whitsunday, which offers an exciting trip out in a seaplane, snorkelling and coral viewing from a small coral 'sub'.

How to get to The Reef

About 74 km north-east of Shute Harbour lies a complex of reefs which the chart-makers have poetically labelled Hook, Line, Sinker and Bait (for reasons which become apparent when looking at a map). At the back of the long 'hook' of Hook Reef is a deep channel about 0.6 km wide which separates it from Hardy Reef, a large platform reef with a lagoon which has become the centre for Barrier Reef trips in this area. Anchored in the channel between Hook and Hardy are several pontoons which are the bases for the catamarans that transport Reef visi-

COLFELT

tors from the mainland and the islands.

Reef trips depart Shute Harbour almost every day of the week on one of several motorised catamarans, either Hamilton Island Cruises' wavepiercer *2000*, or the South Molle *Capricorn*, which goes via South Molle Island, or with Fantasea Cruises' *Quick Cat II*, an economy Reef trip (bring your own lunch). Coral-viewing 'subs', glass-bottom boats, and snorkelling are offered; diving is available.

Seair Whitsunday operates regular trips to The Reef in amphibians or seaplanes from its headquarters at Whitsunday airstrip, landing in Hardy Reef lagoon for reef walking at low tide, or landing at Bait Reef where the airline has a small coral-viewing 'sub'. Seair Whitsunday also picks up passengers throughout the islands and will even fly into some anchorages to pick up those aboard yachts. The trip out gives a panoramic perspective of the islands, and landing on a reef lagoon in a seaplane is an adventure in itself. Helijet, a helicopter aerial service based at Hamilton Island, picks up passengers from a number of locations for regular trips to Hardy Reef, landing on special pontoons near the main pontoon of Hamilton Island Cruises. Helicopters are expensive to operate, and throughout The Reef area they are the most costly travel alternative; they can also be the most comfortable.

Cruises in and around the islands

Three island cruises, a picnic on Whitehaven Beach, diving and snorkelling at island anchorages, a trip to the Hook Island underwater observatory, are just some of the many options for Whitsunday visitors departing from Shute Harbour every day. Those in search of a more prolonged journey through the islands may join, for example, a safari aboard *Golden Plover*, a 'sampler' of sailboarding, camping and diving around the islands. Departing from Hamilton Island, *Coral Cat*, a

Below:
The fringing reefs of the Whitsunday Islands are moulded by strong tidal currents, and they are among the best to be found on the continental islands of the Queensland coast, providing good diving and snorkelling sites. They are visited by the many day-cruise boats that depart Shute Harbour daily. Langford Island's large reef (middle) in the northern Whitsundays, provides excellent diving, as does all of the northern shoreline of Hook Island (the large island in the background).

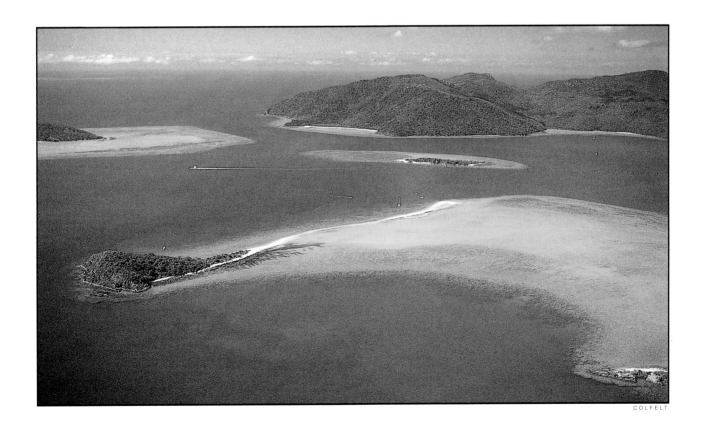

COLFELT

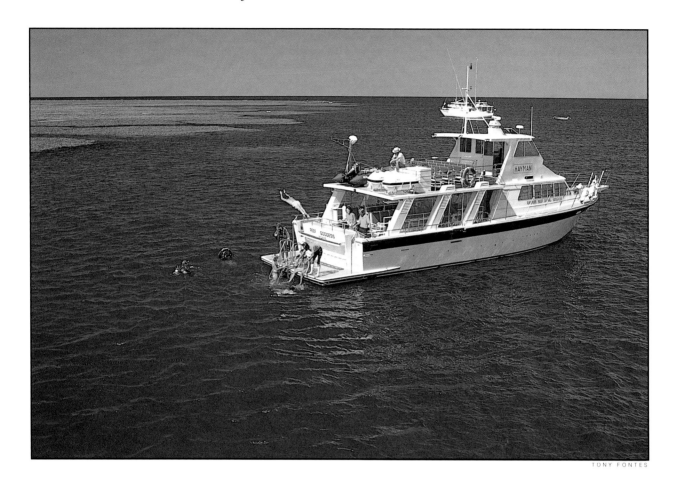

TONY FONTES

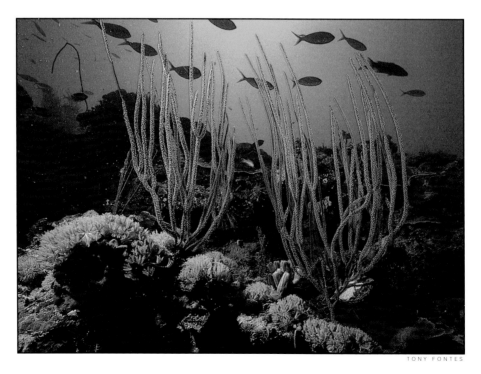

TONY FONTES

motorised catamaran converted for five-day cruises, does a weekly journey through the islands and The Reef leaving every Monday and returning on Friday. Also departing from Hamilton is a very luxurious auxiliary sailing catamaran, *Southern Spirit*. Complete with gold-plated hand rails, thick salmon-coloured carpet and salmon-coloured suede walls to match, air-conditioned staterooms with en suite bathroom, *Spirit* does seven-day cruises through the islands with one day at The Reef. Its tariff includes all alcohol, meals prepared by a first-class chef, scuba gear, sailboards and jet-skis. With satellite telephone facilities and every other electronic gadget imaginable, this cruise is placed at the upper end of the market.

Diving in the Whitsundays

The Whitsunday Islands have some of the best fringing coral reefs of any islands on the Queensland coast. Bathed in nutrient-rich waters circulated by the very large tides that race through the islands, the reefs are kept relatively free of terrestrial sediments that are characteristic of waters along the coast near the mainland, and the Whitsundays are renowned for their great diversity of corals. They are one of the best diver training areas in Queensland because no matter what the weather there is always somewhere to dive.

The big tides, with a maximum rise and fall of 4–5 m, and the brisk south-east trade winds often keep the seas churned up, so, particularly at times of spring tides, water clarity in the Whitsundays is reduced. On average, visibility around the islands is about 4.5–9 m (15–30 ft); at times of neap tides (low tidal range) and light winds visibility may be as much as 15 m (50 ft), but more often it is 6 m (20 ft). For divers and snorkellers there is, however, a reverse side of the coin. Corals depend upon light to stimulate the algae that live within their tissues. Some species have fairly narrow limits of light within which they thrive. As particles suspended in water reduce light penetration, it is possible in the Whitsundays to see a greater diversity of corals within a relatively small vertical distance than one sees on the Barrier Reef itself. Along the northern margins of Hook Island, divers and snorkellers can enjoy some really excellent fringing reefs, and the relatively shallow water makes for especially good snorkelling.

A number of diving establishments on the mainland in Airlie Beach offer everything from introductory to certificate courses and can arrange diving around the islands or at the outlying reefs. It is a highly competitive business, and pricing can be cut-throat. The longest established operator in the area is Barrier Reef Diving Services (BRDS), which has a dive shop in The Esplanade and a school facility at the end of Mandalay Peninsula. BRDS is operated by the very qualified PADI Course Director and underwater photographer, Tony Fontes, and by an ex operating-theatre sister, now diving instructor, Maureen Prior. Their school has trained many of the instructors who teach or operate their own dive businesses in the Whitsundays and is one of the few in Queensland which holds instructor courses. Diving is available at all of the island resorts (more discussion is included with each resort).

At The Reef itself, which is two hours away by boat, Bait Reef possibly offers the best diving, but there is a good variety of sites around Hook, Hardy and Sinker Reefs.

The Whitsundays are not traditionally an 'all-out diving' area; diving has always been one of many activities, along with the sailing, the

Opposite above:
Reef Goddess is Hayman Island's ultra-modern dive boat which visits Bait Reef from Hayman most days of the week. A 20 m Westcoaster, designed in Perth to cope with the choppy conditions produced by the infamous 'Fremantle Doctor', she travels at 22 knots, her beamy hull providing a stable platform at anchor. She has many conveniences for divers. For example, each diver has an assigned seat with folding back, behind which are stored two air tanks which never need be wrestled with; after gearing up, divers simply slide the tank onto their back, stand up and walk over the side.

Opposite below:
A Gorgonian (whip coral) at Bait Reef.

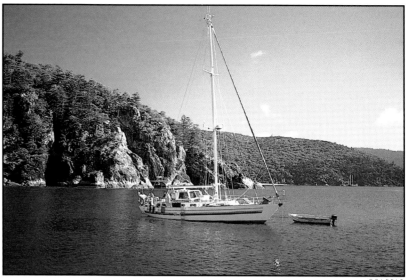

COLFELT

Above:
The Whitsundays have become the yacht charter capital of Australia, with the largest fleet of charter vessels, both sail-it-yourself and with crew, in the South Pacific. Pictured is a crewed charter yacht, *Fame*, out for a day of island diving at The Pinnacles, northern Hook Island.

resorts, the restaurants. So it is always easy to work diving into a Whitsunday holiday, but those looking for nothing but diving have to juggle arrangements to dive every day. No single boat goes to The Reef or to island dive sites every day of the week.

Yacht charter

The Whitsundays have long been appreciated for their many anchorages each within easy sailing distance of the next; Cook even remarked upon this aspect of the islands when he passed through in 1770. Most of the islands are unspoilt National Parks, a mere handful having resort developments. They have always been the favoured cruising haunt for yachtsmen in the know and with time on their hands in winter. But it wasn't until the late 1970s that the first 'bareboat' charter companies began operating there, offering sail-it-yourself yachts and opening up this magnificent cruising area to those who could never hope to sail there themselves. The Whitsundays have become Australia's most popular cruising grounds, with the largest fleet of sail and power charter yachts in the South Pacific; some seven companies have yachts for hire. Crewed charters are also available.

Bareboat charter means 'You are the skipper, your friends the crew'; all you need to do is to attend a briefing and then satisfy the charter operator that you can handle the boat. If you fail that test you can arrange to have a guide/skipper come aboard until you're confident and competent. Yachts available range from 7 to 15 m, from small sailing or power craft up to the most up-to-date, well-appointed purpose-built yachts with berths for 12 (although eight is the maximum number permitted on yachts without a professional skipper).

Bareboating is the best way to really see the Whitsundays, allowing you to get around at your own pace among the islands' many anchorages. Conditions of hire vary from company to company, but normally a $500 deposit is required at the time of booking, which serves as a security bond which is returned after the charter. The full cost is payable about one month prior to departure. The least expensive yachts are about $100 to 150 per day, the most expensive over $650 per day, but shared among the occupants it is not an expensive holiday.

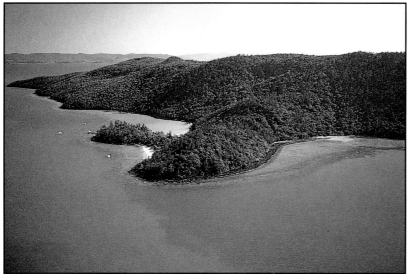

COLFELT

Camping in the Whitsundays

The Whitsunday Islands provide a chance to indulge in what many believe to be the ultimate camping experience, sleeping out under the stars on a 'south sea isle'. There are facilities for both commercial and private camping on the mainland and islands, and one or two commercial operators specialise in island camping/cruise safaris. A staging ground used by some campers before they set off for the islands is the National Park campsite opposite Conway Ranger Station, on Shute Harbour Road about 2 km from the harbour. Some campers use one of the several backpackers' hostels, or caravan parks located along the highway from Cannonvale to Airlie Beach to Shute Harbour.

On the islands a number of sites are available depending upon the size of your party and whether you prefer to go to one of the 'developed sites', which offer amenities such as pit toilets, fireplaces, picnic tables and (sometimes) tank water, or whether you prefer roughing it and getting away a bit. The Park rangers provide a complete list of recommended sites which have been selected for their natural attributes, and one of these will probably suit you.

Private campers must arrange their own transport to the islands and must take all of their food and water. The usual method of getting there is either via the water taxi or by day-cruise boats which will drop off campers en route. Access to some sites is possible only at high tide, and this should be considered when selecting the site and mode of transport. Commercial camping facilities are available on Hook Island and Long Island (Palm Bay).

In all National Parks in Queensland a permit is required for private camping. Bookings are necessary to ensure getting a site. The Conway National Park site has limited space and is almost always full, so advance booking is essential; campers may stay up to four days there. On payment of a fee ranging from $2 per night to $7 per night (depending upon the facilities at the site), bookings are accepted and permits issued by the National Parks Proserpine District Office at Conway Ranger Station, 2 km from Shute Harbour, PO Box 332, Airlie Beach, Qld 4802. Telephone (079) 469 430. For more about camping, see 'Camping on the islands'.

Above:
In the narrow passage between Hook Island and Whitsunday Island is the Hook Island underwater observatory, which provides an opportunity for day visitors to view fish and corals at close hand from an underwater caisson. Underwater observatories date back to before the days of relatively easy access to The Reef and before the advent of coral viewing 'subs'. Their location on islands means that, at times of spring tides or strong winds, visibility may be limited by sediments stirred up in the water. This observatory is readily accessible from the mainland and from nearby island resorts, and it is an easy trip, usually over smooth water, so it offers an inexpensive alternative to a Reef trip. There is a small camping facility with shop near the observatory.

BRAMPTON ISLAND

Brampton is a continental island located towards the southern end of the Cumberland chain, about 18 nautical miles north of Mackay. Its resort, recently completely renovated, is relatively small and informal (at capacity, about 200 guests) and is aimed primarily at couples aged 25 to 40 years. A National Park, Brampton has a good walking track that practically encircles the island, offering many spendid vistas and a route of escape to secluded beaches. Almost all of Brampton is native bushland with an abundance of flora and fauna. Across a narrow coral channel, which can be traversed on foot at low tide, the rugged, undisturbed Carlisle Island beckons to explorers.

It is said that the scenery in the southern Cumberland Islands resembles the Lake District of north-western England, and certainly the islands today carry many names of Cumbria: St Bees, Keswick, Cockermouth, Wigton, Calder, Skiddaw, Maryport, Helvellyn, Scawfell, Carlisle, Brampton. Bêche-de-mer fishermen of the 19th century found the islands, particularly Brampton, an attractive place to boil and smoke their catch, in the days when the Whitsundays were fished for this 'delicacy' so prized on the tables of Chinese epicures. Because these islands were the closest to the large, cosmopolitan settlement of Mackay, escaped convicts from New Caledonia occasionally used Brampton as a staging ground before going ashore; in Mackay, foreigners were much less noticeable than in the small northern ports.

It was Queensland Government policy in the late 19th century to plant coconut palms on the continental islands along the shipping route north. Wrecks were not uncommon in these hazard-strewn waters, and the coconut could provide for the shipwrecked a complete source of energy-rich food, and water too. Brampton Island became a coconut nursery, where stock was produced for many of the surrounding islands, and in the resort area today a number of these remain.

One of the earliest settlers in the Cumberland Islands was Joseph Busuttin, who went to live on St Bees, 22 km to the south-east of Brampton, in 1907; he was seeking a healthier climate in which to live with his malaria. Ten years later, in 1917, he acquired the pastoral lease for Brampton Island in addition to those already held for St Bees and Keswick. His early attempts at breeding chinchilla rabbits on Brampton failed. So he turned to the breeding of the sturdy 'Walers' that were such successful cavalry horses in the wars of the late 19th and early 20th centuries (a few of these horses still run wild on Carlisle Island).

The Busuttins were among the earliest island settlers to take in paying guests, on St Bees; the visitors were enchanted with island life and the feeling of escape, and their clientele grew. In the early 1930s they decided to set up a resort on Brampton as this island had more advantages—good anchorage, beautiful beaches, water, abundant wildlife. Joseph's son, Arthur, and his wife, Jess, ran the new resort, the first tourists arriving in 1933. The Busuttins sold Brampton in 1959, and in 1962 Tom McLean's Roylen Enterprises Pty Ltd bought the lease and ran the resort in conjunction with his cruise business until 1985.

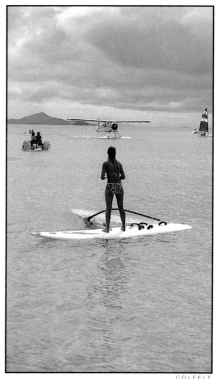

COLFELT

Above:
Brampton's main beach is on the lee side of the island and is the focal point of the resort. It looks out to the neighbouring Carlisle Island and north to the Sir James Smith Group.

Opposite:
The resort has recently been completely rebuilt; with a maximum of about 216 guests, Brampton is a smallish resort on a big island, with opportunities to escape to deserted beaches.

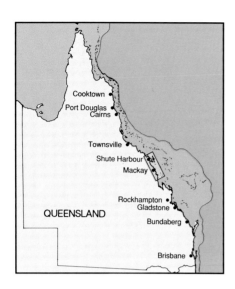

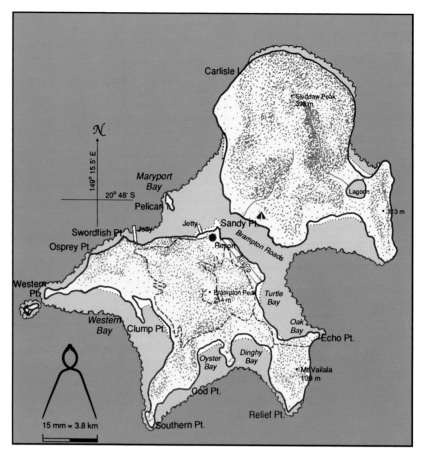

ISLAND SUMMARY
Brampton Island

Location: 20° 49'S 149° 16'E
Gateway: Mackay (34 km)
1941 km N of Melbourne
1465 km N of Sydney
831 km NNW of Brisbane
571 km SE of Cairns

Island and resort details

High continental island (907 ha) with predominantly open eucalypt forest, patches of closed forest and grassland; numerous coconut palms in the resort area. Brampton has a number of fringing coral reefs and 7 sand beaches. It is a National Park, with walking tracks. A narrow shallow channel separates it from neighbouring Carlisle Island, an uninhabited National Park.

Access

From Mackay: by Australian Airlines De Havilland Twin Otter daily (20 mins); by Roylen Cruises catamaran (1 hr) departing Mackay Outer Harbour daily at 9.00 a.m. (Tuesdays 10.00 a.m.).

Resort capacity, accommodation, facilities

216 guests, plus day visitors. **Accommodation:** 108 Blue Lagoon units, all air-conditioned and with private bathroom. **Resort facilities:** 6-hole golf course; 3 tennis courts (2 lighted); freshwater swimming pool; salt-water swimming pool; archery range; all water sports equipment; entertainment lounge; games room; coffee shop; boutique and gift shop; laundry; conference room; disco. Baby sitting available; children's activities are organised during school holidays. Water from catchment and bores.

Tariff

All inclusive (except water sports requiring petrol, and for alcohol). Children 3 to 14 years half price.

Eating and drinking

Resort dining room, the Carlisle Restaurant (8.00 a.m. to 9.30 a.m., 12.30 p.m. to 2.00 p.m., 7.00 p.m. to 8.15 p.m.); Coffee shop (10.00 a.m. to 5.00 p.m.); Daytime Bar (9.30 a.m. to 6.00 p.m.); Cumberland Lounge Bar (6.00 p.m. to 12.00 p.m.); Nautilus Bar (9.00 p.m. till late, but not every night); Captain Tom's Disco Bar (some nights only, 10.30 p.m. to late).

Activities

Aqua-bikes; beach volleyball; catamaran sailing; coral viewing; fishing; reef walks; sailboarding; snorkelling; surf skis; aerobics; archery; badminton; barbecues; carpet bowls; cricket; golf; island walks and picnics; palm frond weaving; pool; softball; touch football; tennis; table tennis; video movies.

Reef trips (to Credlin Reef) are available 3 days a week on the Roylen catamaran from Mackay.

Anchorage

Good anchorage is available off the deep-water jetty (west of the resort). Visiting yachts are welcome and are asked to observe good casual dress standards and to register with reception on arrival.

Brampton Island Resort, Brampton Island, via Mackay, Qld 4740. Telephone: (079) 51 4499. FAX: (079) 51 4097. Telex: 146024.

The resort

Brampton is one of four resorts in the Barrier Reef Region owned and operated by Australian Resort Companies, a subsidiary of Australian Airlines. It is aimed primarily at couples, a romantic retreat for those on their first or subsequent honeymoon, an island for quiet relaxation where guests can either enjoy each other or the natural surroundings. Families will also enjoy it. The atmosphere is relaxed and informal; the staff is encouraged to mix in with the guests, and everyone is on a first-names basis. The resort has been virtually rebuilt since it was acquired from Roylen in 1985.

Accommodation

All rooms are of uniform standard, air-conditioned with private bathroom, and all have been decorated with elegant simplicity employing shades of coral and green, cane furniture, and pastel prints to evoke a soft, tropical atmosphere. There are no TVs or phones in the rooms to interfere with the feeling of escape. As is usual with Australian Airlines' resorts, the tariff is all-inclusive (except for alcohol, and sports requiring the use of petrol) so that having booked and paid for a holiday, money need not intrude again.

Eating, drinking and entertainment

All meals are served in the dining room, where couples may sit by themselves or join others. The food is of good, consistent resort standard, served buffet at breakfast and lunch, with table service for dinner. The lounge bar is open from 6.00 p.m. every night. 'Theme nights' are the main entertainment, and there is a disco which operates according to demand for those who wish to play up late.

Activities

The sand beach directly in front of the resort looks north to the islands of the Sir James Smith Group, which sit majestically on the horizon. This beach, unlike many in the Whitsundays, remains usable for water sports at all tides (the fringing reef does not dry), and the beach is the epicentre of the resort. Brampton offers a complete range of water sports. It has a short, 'fun' golf course, tennis courts and an archery range. A full schedule of organised activities is offered.

Island walks

Brampton, a National Park, has an excellent circuit track that leads to several deserted sandy beaches where guests can escape with a picnic. Walkers have the opportunity to see an abundant variety of flora and fauna—golden orchids growing on trees (in season); flocks of rainbow lorikeets; the fascinating scrub fowl (*Megapodius freycinet*) or, perhaps more likely, its ingeniously constructed nest which does all of the work of hatching the young; with luck, the more observant may catch a glimpse of the harmless tree snake gliding effortlessly over the leaves and branches of a bush, defying gravity. The track takes three hours, allowing time to stop and admire the scenery. In the morning, set off in an easterly, clockwise, direction to take advantage of the best aspect of the sun on the water; an anti-clockwise circuit is best in the afternoon. The resort provides back-packs and picnic lunches for walkers.

Reef trips and island cruises

Roylen Cruises operates a daily catamaran service to the island, and several days a week the catamaran goes out to Credlin Reef for a day of snorkelling and coral viewing at the Barrier Reef. Roylen catamarans also go to Lindeman and to Hamilton Islands a few days a week.

Below:
Brampton's fresh-water swimming pool is set amongst palms and under the branches of a massive fig tree, which was planted in 1934 by the Busuttins who lived and operated the resort there.

MARY COOKE

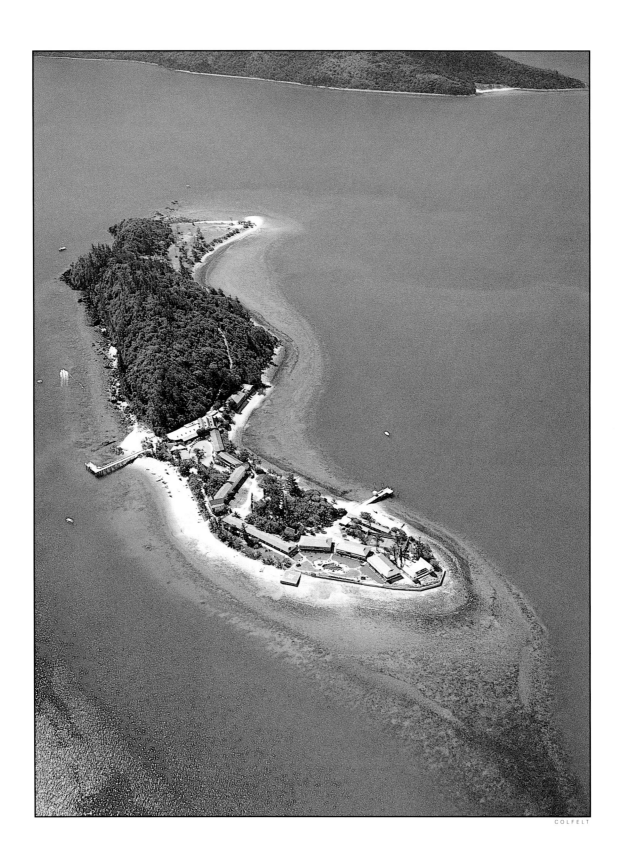

COLFELT

DAYDREAM ISLAND

Daydream is a tiny island much of which is covered by its resort. It is an island 'for the young and the young at heart' and caters for a very broad spectrum of guests, from international youth tours to busloads of oldies touring around Australia. You're never very far from where it's all happening on this island, and the atmosphere is that of a 'fun club', relaxed and informal.

In 1933 Paddy Lee Murray set sail from Sydney in his yacht *Daydream* on a round-the-world cruise with his wife Connie, a deck hand, Chilla, and the Murrays' Airedale, Toby. Like so many other sailors both before and since, the Murrays fell in love with the Whitsundays; they did not go any further. They were particularly attracted to a small island just across the Molle Channel from the mainland—West Molle Island on the charts. The island belonged to Henry Lamond, a pastoralist and writer from western Queensland who, in 1927, had fled the mainland and its cruel droughts to an island paradise on South Molle. Lamond, like most of the island dwellers in those days, was always wondering where the next two pounds were coming from to pay 'Otto' Altman for his regular deliveries of mail and stores to South Molle from Proserpine. And he was very anxious to make the islands better known and to establish their value. So when Murray arrived, confessing his love for and a burning desire to purchase West Molle, it was a happy day, indeed, for Henry Lamond.

Murray bought the island for 200 pounds and renamed it after his yacht. The first buildings were very basic, with corrugated iron walls and roofs, and the floors were coral. In days to come tourist vessels, such as *Canberra, Ormiston, Kanimbla,* and others, bearing travellers from down south, were to anchor off Daydream for one day on their scheduled cruises. The island was one of the forerunners of tourism in the Whitsundays.

The resort
Most of the southern half of Daydream Island is occupied by its resort, which is centred around what for years was the 'largest salt-water swimming pool in the southern hemisphere', a claim as much emulated as was Daydream's famous Island (pool) Bar. More recent additions to the resort have spread towards the southern end, making a greater degree of peace and quiet possible than there used to be when the majority of units were at or very near the poolside. The resort is on a narrow neck of the island, and many of the rooms have shimmering views of the Whitsunday Passage on both sides. Daydream's long, coral shingle beach is just beside the central complex, where guests while away hours in the sun enjoying the many water sports activities. North of the resort area a steep hill rises; it is covered in lush vine forest, and through the forest a trail leads to a secluded and protected beach, called 'Sunlovers Beach', where guests can attempt escape from civilisation and its dress customs, and where there is some good fringing coral reef for snorkellers. Day cruise yachts often anchor here for lunch, adding a bit of romance to the scene. At the far north of the island is more coral

Opposite:
Daydream Island sits right at the edge of the Whitsunday Passage, just across the Molle Channel from the mainland. The southern half of the island is virtually all resort; the northern parts are covered with lush vine forest, and in its northern bays the island has some good fringing reef development. Daydream was one of the early resorts of the Whitsundays, and before World War II steamers carrying tourists used to call in on their way up the coast. After the war flying boats put down in the Molle Channel to drop off guests bound for Daydream and the neighbouring South Molle resort.

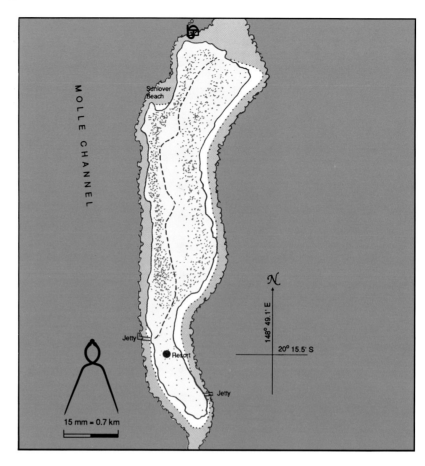

ISLAND SUMMARY
Daydream Island (West Molle)

Location: 20° 15′S 148° 40′E
Gateway: Shute Harbour (7 km)
1994 km N of Melbourne
1535 km N of Sydney
909 km NNW of Brisbane
492 km SE of Cairns

Island and resort details

A small (10.5 ha) continental island, the southern half of which is largely covered with resort development and the northern half with dense tropical forest and grassland areas. A walking track from the resort leads to some very good fringing reef at the extreme northern end of the island. Coral shingle beaches.

Access

From Proserpine via Shute Harbour: bus from airport to Shute Harbour (50 mins), then via island launch MV *Daydream* (20 mins). From Hamilton Island: via water taxi (40 mins) or helicopter (10 mins). The island has a helipad, and Seair Whitsunday amphibians can land there.

Resort capacity, accommodation, facilities

Normal capacity about 200 guests (at times up to 25% more) plus numerous day visitors. **Accommodation:** 96 units, Daydreamer and Sunlover, of slightly different standard based primarily on location, all with private bathroom, TV, radio, direct dial phone, refrigerator, tea/coffee making facilities. **Resort facilities:** Tennis court; large salt-water swimming pool; fresh-water swimming pool; spa/sauna; all water sports equipment; coffee shop; disco; dive shop; souvenir-gift shop; coin-operated laundry; entertainment lounge. Baby sitting by off-duty staff usually available.

Tariff

All inclusive (except for alcohol, and water sports requiring the use of petrol). Children under 3 free; children 3 to 14 years half price.

Eating and drinking

Resort dining room (7.00 a.m. to 9.00 a.m., till 9.30 a.m. for Continental breakfast; 12.30 p.m. to 2.00 p.m.; 6.00 p.m. to 8.00 p.m.) Coffee shop/snack bar (9.00 a.m. to 6.00 p.m.). Island (pool) Bar (9.00 a.m. to 6.00 p.m.); Polynesian Lounge Bar (8.00 p.m. to 12.00 p.m.); Downunder (disco) Bar (6.00 p.m. to 7.00 p.m., 10.00 p.m. to 2.00 a.m.).

Activities

Aqua-tube rides; boom-netting; catamaran sailing; coral viewing in glass-bottom boat; dinghy hire; mini speed boats; outrigger canoe; paddle boats; sailboarding; scuba diving; snorkelling; surf-skis; aerobics; beach activities (organised); billiards; table tennis; volleyball.

Barrier Reef trips (by seaplane) are available every day directly from Daydream with Seair Whitsunday. A launch departs daily about 8.15 a.m. for Shute Harbour where connections can be made for all island cruises and outer Reef trips, with the catamarans *2000*, *Quick Cat II*, or *South Molle Capricorn*. The island itself operates several island cruises.

Anchorage for yachts

Daydream is a poor anchorage, but moorings are available on the eastern side for visiting yachts (for the normal island mooring fee). Visitors should observe normal island dress standards and should register with reception upon arrival.

Daydream Island Resort, PMB 22, Mackay, Qld 4740. Telephone: (079) 469 200. FAX: (079) 469 216. Telex: 48519.

shingle beach, and the snorkelling, in small bays and pools protected from the prevailing south-easterlies, is better still.

Accommodation and tariff
There are two standards of accommodation, in Daydreamer and Sunlover units. Daydreamer units incorporate what used to be called 'Poolside' (double-decker units right along the edge of the pool) as well as the units a little further away. Sunlover units are more towards the south of the island, those furthest away being the most recently constructed. A fresh-water swimming pool nearby seems to sit right in the middle of the Whitsunday Passage. All rooms are comfortably furnished with air-conditioning, private bath, direct dial phone, refrigerator, TV. Video recorders may be hired from the resort shop. The tariff is all-inclusive (except for alcohol, and water sports requiring the use of petrol). Sunlover units cost slightly more than Daydreamer. Stand-by rates are available.

Eating, drinking and entertainment
Breakfast is a buffet in the dining room with the morning sun streaming in from across the Whitsunday Passage; lunch is a buffet barbecue at poolside or in the Polynesian Lounge; dinner is *à la carte* with table service in the dining room. Sybil Harrison, Daydream's personable public relations person who has been in the Whitsundays for years, is unmistakable for her 'Dame Edna' cats-eye glasses (she claims she gave the idea to Barry Humphries). A mother figure, Sybil makes sure that everyone is happy, that singles are not left alone and that honeymooners can be by themselves if they wish. The food at Daydream is simple and plentiful, with a flourish here and there. There are three bars which span the daylight hours and which serve on into the night (at the disco Downunder Bar).

Activities
The heart of island activities is the beach, where just about all known beach sports take place, from para-flying to paddle boats. The island has a dive shop operated by Barrier Reef Diving Services, offering introductory and certificate courses (PADI); the *Whitsunday Diver* calls by several days a week to pick up those who wish to dive on the Barrier Reef, and divers are also catered for on the Reef trips with the catamarans (see below). The island has a resident band, and informal entertainment is offered every night in the Polynesian Lounge, often with guest participation, ranging from talent quests to 'horse racing' to 'vice versa' nights.

Reef trips and island cruises
Seair Whitsunday offers daily seaplane trips to the outer Reef direct from Daydream. Reef trips on the three catamarans that go to Hardy Reef are available by taking the 8.15 a.m. launch to Shute Harbour (or to South Molle Island, depending upon the day). A host of island cruises depart from Shute Harbour every day. The island's cruiser MV *Daydream* does a day trip to Hamilton Island, and a day trip to Langford Island with its excellent fringing coral reef. A three-island cruise is available with *South Molle Reef*, which calls in several days a week; this trip includes a stop-off at the Hook Island underwater observatory where visitors can see fish life and coral without even getting wet.

COLFELT

COLFELT

Above:
Daydream's fresh-water swimming pool (top), with intimate water views, seems to float in the Passage along with other pleasure vessels and ships. The resort's large salt-water pool (bottom) is surrounded by Daydreamer units, many of which enjoy sparkling views out over both sides of the island.

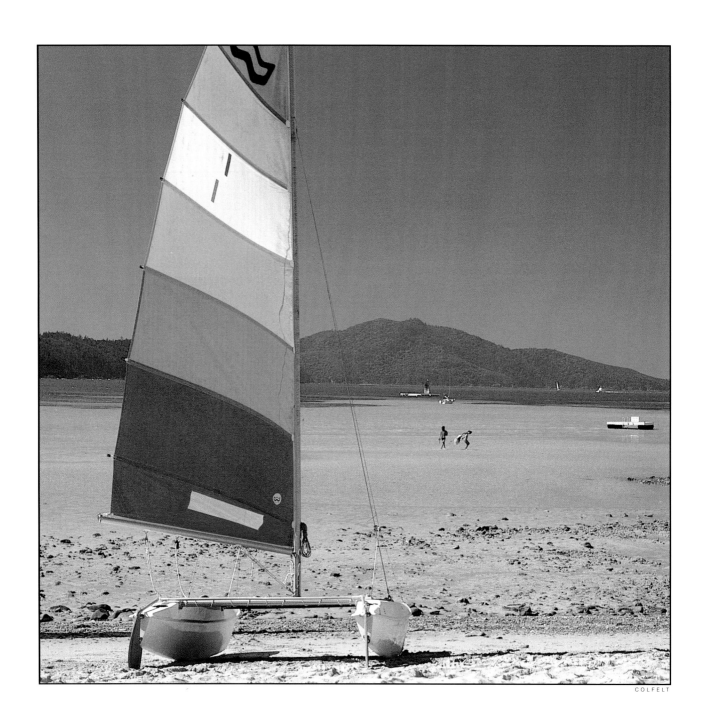

COLFELT

HAMILTON ISLAND

Hamilton Island is a rocky, high continental island in the heart of the Whitsundays. It has the largest offshore resort development in Australia. Built by a free-wheeling, self-made entrepreneur, Keith Williams, Hamilton Island, with its man-made harbour and jet airstrip, is really a port and a small town as much as it is a resort. All resort functions other than accommodation are operated by concessionaires, and being a guest at Hamilton really means being a visitor in a hustling, bustling, private-enterprise community, 'Williamstown', with high-rise buildings set in magnificent surroundings. Hamilton has a great variety of facilities and things to do. It is itself a gateway to the Whitsundays and a departure point for Reef activities available from the Whitsundays.

Before the advent of Keith Williams and his development that shook the existing Whitsunday resorts out of a comfortable and somewhat folksy lethargy, Hamilton Island, during the first 75 years of the century, was used in a number of ways: for grazing; as a base for a doctor's study of tropical medicine; as a place to prepare coral for sale (when coral collecting was still a viable occupation); and as a watering hole for pearling luggers on their way north. It is the tenth largest island of the Cumberlands, deeply embayed and with several of what James Cook would have termed 'tolerable high' hills (one of them 230 m) that offer magnificent views of the Passage and surrounding islands. On the north-eastern side of the island is Catseye Bay, which has the island's main beach and a large expanse of coral reef that dries at low tide. It is protected from the prevailing south-east winds by the lofty Passage Peak and is a marvellous stretch of water for sailboards, catamarans, surf skis and all forms of aquatic sport.

In 1975 the Hamilton grazing lease became the property of a man who once earned his living buying khaki-coloured motorcycles from the army and 'punking them up in fancy colours', then selling them at a profit. This was the same man who became the country's largest manufacturer of motorcycle accessories, a builder of great motor racing circuits, Australian water-ski champion, and creator of one of the Gold Coast's most popular tourist attractions, Sea World.

The resort
Hamilton Island resort cannot be understood in isolation from Keith Williams. He is a man of dynamic energy whose religion is free enterprise, who preaches de-regulation, who takes a 'hands on' approach to everything in life and who is known neither for his love of bureaucracy, nor for back-pedalling, nor for his subtlety. Hamilton Island is as bold and brash as is Williams, and it is his island kingdom. He dominates Hamilton almost as a monarch, and those who violate the island rules usually find themselves on the 'next boat out'. Williams has moulded Hamilton Island (which is in the middle of a group of National Park islands of great unspoilt natural beauty) like a piece of plasticine, taking down a hill here and putting it into a bay there. The high-rise buildings of Hamilton glitter in the sunrise and twinkle at night. The parade of small utility vans, electric carts, island taxis, with their drivers wearing short-sleeved white shirts, white shorts and long white

COLFELT

Above:
Turbo petholatus, the catseye turban, which has a glassy, rounded, eye-like operculum that is used in making jewellery.

Opposite:
Catseye Bay is the focal point of the Hamilton resort area, a sand beach that looks out to the rising sun over Whitsunday Island. A large fringing reef almost fills the bay, drying at low tide, a characteristic of many beaches in the Whitsunday area where the tide rises and falls almost four metres. Catseye Bay gets its name from the common name for the turban shell that can sometimes be found there just below low tide level.

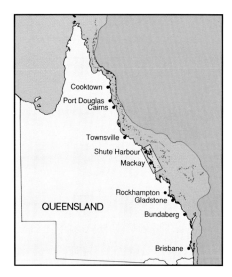

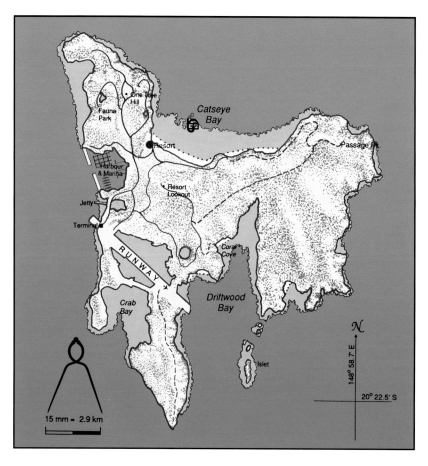

ISLAND SUMMARY
Hamilton Island

Location: 20° 21'S 148° 57'E
Gateway: Hamilton Island Airport,
or Shute Harbour (16 km)
1985 km N of Melbourne
1521 km NNW of Sydney
893 km NNW of Brisbane
509 km SE of Cairns

Island and resort details

High rocky continental island (709 ha) with open eucalypt forest and grasslands. Private leasehold. Generally rocky shoreline with several sand beaches; fringing reefs expose at low tide.

Access

Direct to the island daily from most major cities with Ansett Airlines (several times daily from some centres); non-stop flight takes 2 hrs 40 mins from Melbourne and 1 hr 30 mins from Brisbane and Cairns. From Proserpine or Mackay: Hamilton Island light aircraft can make connections with Ansett flights. From Shute Harbour: by catamaran (30 mins), daily service (9.00 a.m.) with Hamilton Island Cruises *2000* or *Quick Cat II*; by water taxi (30 mins), several daily services (to meet Ansett flights).

Resort capacity, accommodation and facilities

1300 guests and numerous day visitors. **Accommodation:** Individual buré units; 1- and 2-bedroom hotel-style units in 2- and 3-storey lodges; 2-bedroom self-contained apartments in 3-storey condominium blocks; 1-bedroom self-contained apartments in high-rise (14-storey) blocks; 4-bedroom self-contained penthouse suites in high-rise (15-storey) Yacht Harbour Towers; self-contained private villa. **Resort side facilities:** 3 restaurants; coffee shop; 3 bars; several fresh-water pools; dolphin pool; resort shops; 6 tennis courts (lighted); 2 squash courts; gym; sauna and spa; masseuse; electric buggy hire; all water sports equipment; photo shop; travel office; medical centre; hairdresser; kids club; recreation room; entertainment and convention facilities. **Harbour side facilities:** 4 restaurants; pub; Trader Pete's island store; dive shop; general store; delicatessen; bottle shop; pharmacy; boutique; bakery; fish market and ice factory; ice cream parlour; disco and bar; yacht charter base; dinghy hire;

200-berth marina; showers and toilets; misc. marine support services; post office and Commonwealth Bank agency; TAB agency; National Bank. North of harbour and resort area are a fauna park and motorbike museum.

Tariff

Room only. Hamilton is a 'free enterprise' island; virtually all services are provided by private franchises and cost extra.

Eating and drinking

Resort side: Dolphin Room restaurant (breakfast and dinner); coffee shop; Outrigger Room (seafood, dinner only); Beach Bar and Grille (all meals); James Cook Bar and Lounge (10.00 a.m. to 1.00 a.m.); pool bar (9.30 a.m. to 5.00 p.m.). **Harbour side:** Mariners Inn (lunch and dinner, snacks all day) and Barefoot Bar (10.00 a.m. to 10.00 p.m.); Corsaro Italian restaurant and bar (dinner only); Pink Pizza Parlour (12.00 noon to 11.00 p.m.); Chung Shan Yuen Chinese restaurant and bar (lunch and dinner); Dirty Nellie's Disco (8.00 p.m. to 3.00 a.m.); fish market (8.00 a.m. to 8.00 p.m.); bakery (7.00 a.m. to 5.00 p.m.).

Activities

Aerobics, fitness classes, island walks, squash, tennis, volleyball, catamarans, dinghies for hire, fish feeding, game fishing charter, indoor bowls, jet skis, para-sailing, sailboards, scuba diving instruction, snorkelling, speedboats for hire, surf skis, waterskiing, yacht charters (bareboat). Various island cruises are available with *Banjo Paterson* and *2000*; Barrier Reef trips with *2000* depart several days a week; helicopter Reef trips on demand.

Anchorage for yachts

Marina berths available on casual or longer term basis; occupants entitled to use all island facilities.

Hamilton Island Enterprises Pty Ltd, Hamilton Island, Qld 4803. Telephone: (079) 469 144. FAX: (079) 469 425. Telex: 48516.

socks, clutching hand-held radios—Keith's cavalry 'movin', shootin' and communicatin' '—keeps pedestrians waiting to cross the harbour intersection, sometimes for minutes at a time. With a $25 000 000 jet airport capable of handling Boeing 767s, Hamilton has itself become a gateway to the Whitsundays. The harbour side is a private enterprise community all on its own, a port, and the major yachting centre north of Mooloolaba.

Somehow the island has absorbed all of this. Walking through the resort at night, with a gentle breeze rattling hundreds of palm fronds, the hiss of sprinklers adding moist softness to the tropical air, with lights casting deep shadows across the faces of the accommodation blocks, it is still possible to become lost in the larger magic of the Whitsundays.

Williams' free-enterprise approach has led him to divest virtually all resort functions, apart from accommodation, to private franchisees. The licensees have the normal high expenses of operating on an island as well as a franchise fee of about 20% of their takings. On Hamilton Island guests deal with 50 individual providers of services, each with one business to worry about. As a result the resort hasn't the cohesive atmosphere of establishments where the operator cares personally for the guests' every need. Excursions operate if there are enough people to make them viable for the operator, not because one or two guests have a whim to go. All activities and extras may be charged to the room, and there are extra expenses for everything you do. The other side of the coin is that Hamilton offers a greater variety of activities and services than is often found in a mainland community.

Accommodation
Guests at Hamilton have a choice of very high standard motel- or hotel-style accommodation or they may opt for completely self-contained apartments. Hotel accommodation is in individual burés or in two- and three-storey blocks (Bougainvillea and Allamanda). All rooms have air-conditioning, private bath and are tastefully furnished to meet almost every possible contemporary expectation. Hamilton charges a base rate for a room and two occupants; there is a nominal additional charge for additional occupants, the number that can be accommodated varying from one type of unit to another.

Hamilton also offers completely self-contained one-bedroom suites, with kitchen, in the high-rise Whitsunday Towers. It offers two-bedroom self-contained apartments, with kitchen and lounge, in three-storey blocks (Frangipani, Lagoon, Poinciana, and Hibiscus). Each block has its own swimming pool. The two-bedroom apartments accommodate up to six people (base rate is for five).

Those looking for complete luxury can have an entire floor in the Yacht Harbour Towers overlooking the harbour, or even their own private villa, Illalangi, set apart from the resort on the residential part of the island. With magnificent Whitsunday views, Illalangi provides accommodation for a maximum of eight people, six adults and two children, in a private house with three double bedrooms and one children's bedroom, four bathrooms, lounge, breakfast room, dining room and downstairs bar which opens onto a sundeck over the pool and garden. Access is by private road, and residents of this retreat may elect to have several levels of service with butler, chef and maid.

On the Hamilton drawing board (due for completion in 1990) is a new 22-storey, 320-room Hamilton Towers Hotel. And a new Mediter-

COLFELT

Above:
Dolphins in the pool next to the Dolphin Room restaurant are fed twice daily. Their antics are engaging.

Right:
Hamilton's hotel-style Bougainvillea units are in a two-storey block just above the beach overlooking Catseye Bay, where they survey a wide sweep of water and the sun rising over Whitsunday Island.

Bottom right:
Yacht Harbour Towers offers luxurious penthouse accommodation on the saddle overlooking Hamilton Harbour. This 15-storey block has full-floor units with four bedrooms, each with bathroom (maximum of eight people). Included in the price is the use of an electric buggy while on the island. The Towers building also has its own private pool.

Below:
Seen beyond the huge fresh-water swimming pool with its meandering curves are the Whitsunday Towers, 14-storey blocks of one-bedroom suites, completely self contained with kitchen and which can accommodate a maximum of five persons (base rate is for four). Each unit has its own balcony, with spectacular views over Catseye Bay. The twin towers share their own swimming pool.

COLFELT

COLFELT

COLFELT

Left:
Catseye Bay, with the island's main beach is protected from the prevailing south-east winds by the lofty Passage Peak. It is a marvellous stretch of water for sailboards, catamarans, surf skis and all forms of aquatic sport. Snorkellers hand-feed myriad tropical fishes at Harry's Hole, located near the edge of the fringing reef.

Below:
Hamilton's individual buré units are set on a lawn among beautiful old gum trees indigenous to the island.

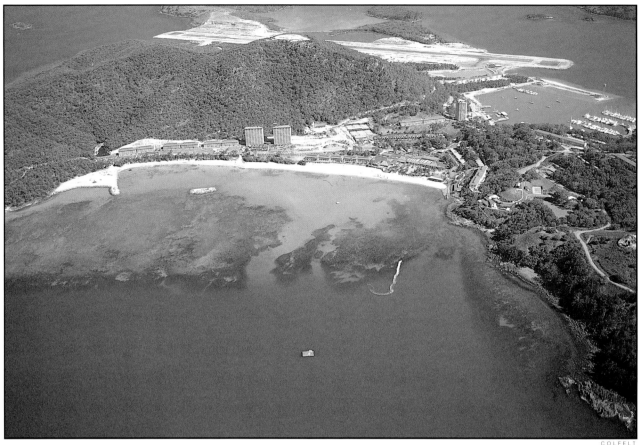

COLFELT

Above:
There are two sides to Hamilton, the resort on Catseye Bay (foreground) and the harbour across the saddle to the west. Catseye Bay is the focus of the resort, with its many beach activities and its reef, which offers diversions for snorkellers and student scuba divers. The harbour is a port and the centre of a busy private-enterprise community, with many more facilities than are usually found on a resort island, including a bakery. Hamilton Island Charters has bareboats for hire, making it possible for those capable of handling a boat to mix a bit of island cruising with a resort holiday—one way to escape the bustle of activity on this island. Dinghies are available for hire, too, to take a picnic to a nearby beach or perhaps visit the Coral Arts jewellery shop on Dent Island.

Right:
Sunset from One Tree Hill.

COLFELT

ranean Village, with cobblestone streets, situated at the north-western cove of the island, with 190 suites, 168 condominiums, and a 120-boat marina, is to be finished by 1995.

Eating and drinking

There are seven different restaurants on the island, offering a wide choice of menus, including seafood, Italian, Chinese, international. There are take-away food outlets and some ten places to get a drink.

Activities

The central resort complex surrounds the beautifully finished lobby and convention centre, the latter called the Phoenix Room (see explanation at the right) with its high-pitched shingle roof. Keith Williams' experience with mainland amusement parks is apparent on Hamilton, and the resort offers more diversions, restaurants and activities than any other in the Whitsundays. At Catseye Bay there is equipment to hire for every possible aquatic activity. Across the island is an Australian fauna park, where visitors may catch a glimpse of kangaroos or quokkas, koalas and saltwater crocodiles, and other native curiosities. An oceanarium is under construction at the harbour. There are electric buggies for hire—a great way to dash up to One Tree Hill to photograph the sunset. Hamilton has excellent sporting facilities.

Sailing, diving, fishing

Hamilton Island Charters has a fleet of luxurious sailing yachts for hire to those who can handle a boat. This is the best way of all to really get to see the Whitsundays and a great way to escape to a quiet anchorage for a couple of days.

Hamilton's dive operator, H2O Sportz, one of the most experienced in the Whitsunday area, offers regular certificate courses or introductory courses for those who are not sure that they want to go the whole distance. Learning to dive at Hamilton offers the best of both worlds, the opportunity to get an Open Water Diver ticket without forsaking hedonistic pursuits, and the rest of the family can enjoy the resort, too. Diving can be arranged with the catamaran *2000* on days it goes to The Reef, and on several other days the modern dive boat *Whitsunday Diver* goes either to Bait Reef or to dive sites within the islands.

Several fishing charter vessels operate from Hamilton Harbour, offering the chance to do light-tackle game fishing, which can be quite good in the Whitsundays, or perhaps to catch some reef fish.

Reef trips and island cruises

Hamilton Island Cruises offers Reef trips several days a week on its state-of-the-art wavepiercer catamaran *2000*. Departing at 10.00 a.m. it provides lunch and two hours at The Reef with snorkelling and coral viewing from its coral 'sub' anchored at Hardy Reef. Helicopters depart for The Reef from Hamilton airport and take sightseeing trips around the islands on demand. Day trips on the catamaran *Quick Cat II* depart for other resort islands and to Whitehaven Beach, a magnificent 9 km stretch of pure silica sand on the eastern side of Whitsunday Island. Two vessels offering five-day and seven-day island and Reef cruises operate from Hamilton, the converted catamaran *Coral Cat* and the luxurious sailing auxiliary *Southern Spirit*.

ROBIN COPELAND

Above:
Just one year after Hamilton Island resort opened, the central resort complex and entertainment centre was, in April 1985, completely destroyed by fire. In typical Keith Williams style, rebuilding was commenced while the ashes were still hot, the first convention being held in the new facility in August that year. Williams named the new convention centre the Phoenix Room.

COLFELT

Above and right:

The view from Hamilton's One Tree Hill looks over the Dent Passage to Plum Pudding Island (above right) and to Dent Island (above left). On Dent's northern end is Coral Arts, a small business that manufacturers and sells shell jewellery and coral souvenirs, all made by Bill and Lean Wallace, who have lived in the Whitsundays since 1951. The shop, which is just at the top of the beach, occupies a unique structure built by the Wallaces and based on a Samoan *falé*, with its typical steep-pitched, aerodynamic roof that sheds the wind and weather—'based on 1000s of years of know-how, and perfect for the tropics', according to Bill Wallace (right).

Coral Arts is festooned with Pacific artefacts and other fascinations, its showcases brimming with shell bracelets, necklaces, combs, amulets, ear-rings and other jewellery of the sea. A small nautical library is 'there to keep the husbands occupied', according to Bill, an ex flight engineer who was brought to the Pacific by the war. Since arriving in the Whitsundays Bill has dived for trochus shells, collected coral (which used to keep the Wallaces occupied in a full-time export business), was once a skipper and is now a jewellery manufacturer. Lean is originally from Sydney; they met while on holiday in Cairns.

Hamilton Island takes guests over to Coral Arts for an hour or so several days a week, and a number of Whitsunday cruise vessels call by so that travellers can browse in the shop and talk to the Wallaces, who are founts of local lore.

COLFELT

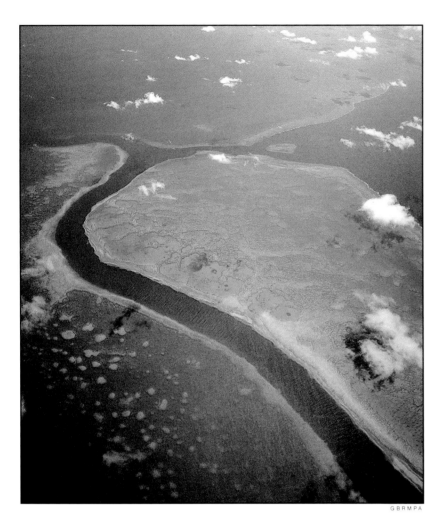

Left:
Barrier Reef trips from Hamilton Island visit the Hook/Hardy Reef complex, about 70 km north-east of the island. Hardy Reef is a large (4190 ha) lagoonal platform reef separated from Hook Reef by a deep, narrow channel through which swift currents run. A pontoon anchored in the channel is the base for coral-viewing and other Reef activities.

Below:
In April each year, Hamilton Island Yacht Club conducts a Race Week which attracts many of Australia's top ocean racing yachts. It is usually an exciting week, with stiff competition, and sometimes stiff winds and lumpy seas in the Whitsunday Passage.

GBRMPA

SANDY PEACOCK

COLFELT

HAYMAN ISLAND

Hayman has a glamorous new resort hotel where no expense has been spared to create a grand, luxurious, worldly environment. It offers a high style of living in elegant surroundings, and like dining at a fine restaurant, is not inexpensive but is an experience in itself. For divers, this resort may very well offer the best opportunities in the Whitsundays, with a world-class dive boat, although it is not necessarily tailored to suit the average diver's budget. Hayman offers light-tackle game fishing, too, under the guidance of some of the Whitsunday's most experienced skippers.

Unique in Australia, Hayman has set uncompromising standards for the market it seeks to attract.

Hayman Island sits at the northern end of the Whitsunday Passage and, along with Hook Island immediately to its south-east, is the first of the Whitsundays to intercept the rising tide as it sweeps towards Broad Sound (D 29). Twice in each 24 hours, as the tide changes, massive volumes of water race southwards through the narrow channel between these islands and around their relatively protected shores, bathing them in the clear Coral Sea and resulting in some of the best growth of fringing coral reef to be found in the Barrier Reef Region.

Hayman got its name in 1866 from Cmdr. Nares of HMS *Salamander*, who bestowed upon the island the name of his ship's master and navigator, Thomas Hayman. At the turn of the century the island was used by another Thomas, Thomas Abell, for timber-gathering. Abell also had a herd of goats, which somehow survived in spite of the fact that there was no permanent water, the rain disappearing through the pink granite of the island almost as soon as it fell. Abell sold his lease and goats to Boyd Lee, in 1907. Lee was a keen fisherman (later to be called 'Alligator Lee', a title he earned when he captured a live crocodile for Zane Grey to use in his film 'White Death' which was made at Hayman Island). Lee sensed the potential of the Whitsunday islands for tourism, and he wanted to start up a fishing resort, on Grassy Island, nearer to what was at the time the principal mainland gateway to the islands, Cannonvale. In 1933 Boyd Lee put Hayman on the market for £750, £1 for every goat on the island, a method of reckoning the price which was to be used again. The depression was still being felt, and finally he was able to sell the lease, for something less than the asking price, to Monty Embury, a school teacher, who ran expeditions to the island for several years. Embury, in turn, sold Hayman to the Hallam brothers in about 1935, and they for many years ran a small fishing resort there.

After World War II, when people began to think about taking holidays again, Reginald Ansett was looking for a Queensland island on which to establish a resort. One motive was to provide extra business for his Ansett Airlines during the relatively quiet winter months. He purchased Hayman in 1947, paying £10 000, £10 for each of 1000 goats which, water or not, were still thriving on the island. When the Royal Hayman resort opened in July 1950, it was a showpiece, and Hayman has, ever since, been a familiar name to Australians.

COLFELT

Above:
The view south from Hayman's horseshoe sand beach takes in the majestic blue-green peaks of Hook Island, only a mile or so distant, the highest mountains in the Whitsundays. These provide some shelter from the trade-winds, and the waters between Hook and Hayman can be almost like one large lagoon, Hayman's own 'playground'.

Opposite:
Hayman's huge swimming lagoon is filled with filtered sea water 1.3 m deep throughout; it has a fresh water swimming pool in the middle. The pools are the centre of focus of the West Wing; Hayman provides waiter service at poolside to cater for the guests' every whim.

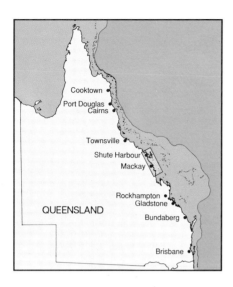

ISLAND SUMMARY
Hayman Island

Location: 20° 03'S 148° 53'E
Gateway: Hamilton Island (34 km)
2017 km N of Melbourne
1555 km N of Sydney
926 km NNW of Brisbane
480 km SE of Cairns

Island and resort details
High continental island (322 ha), located at the northern end of the Whitsunday Group, composed largely of pink granite, with massive fringing reef (on its south side) that dries at low tide. One of a handful of islands of the Cumberlands which are not National Parks. Native vegetation is open eucalypt forest; there is extensive landscaping with exotic species around the resort. Hayman has a profusion of bird life and some good fringing coral. Several sand beaches.

Access
From Hamilton Island: via Hayman launch *Sun Goddess* (30 mins). The island has a helipad, and it is also accessible via Whitsunday Airstrip with Seair Whitsunday amphibians. Hayman has a helipad, too.

Resort capacity, accommodation and facilities
480 guests, no day visitors. **Accommodation:** East Wing: 11 Penthouse suites (3-, 2- and 1-bedroom), 7 suites and 42 rooms; West Wing: 6 suites and 84 rooms; 12 Beachfront rooms; 12 Palm Garden rooms; 20 Palm Court rooms; 16 Coral Court rooms. All rooms/suites have marble bathrooms with bath and shower (spa baths in suites) with hairdryer and bathrobe ; air-conditioning; colour TV and video player; electronic safe; ISD direct-dial phones; radio and background music. 24-hour room service. Daily laundry/dry cleaning. **Resort facilities:** Library; billiards room; card room; entertainment theatre/lounge; 2 tennis courts and 1 half-court; massive salt-water swimming lagoon with fresh-water pool (West Wing); fresh-water swimming pool (East Wing); complete range of water sports equipment for hire; walking tracks; complete scuba diving facility with training pool;

dive vessel *Reef Goddess*; harbour and marina; dinghies for hire; fishing charter boat.

Tariff
Room only.

Eating and drinking
La Fontaine Restaurant, formal Louis XVI salon (jacket and tie required), classic French cuisine (7.00 p.m. to 11.00 p.m., closed Tues. and Wed.); Shima-Teien Restaurant, oriental (jacket and tie preferred), Japanese and Asian dishes (6.30 p.m. to 11.00 p.m., closed Sun.); Polynesian/Australian restaurant; La Trattoria Restaurant, Italian (7.00 p.m. to 11.00 p.m. daily); Viennese Coffee House, breakfast (7.00 a.m. to 11.00 a.m.); light meals, snacks, continental bakery (11.00 a.m. to 10.00 p.m.); carvery lunch (12.00 noon to 2.30 p.m.); dinner (6.00 a.m. to 10.00 p.m.); the Beach Pavilion; the West and East lanais have 24 hr food and drink service.. Club Lounge (11.00 a.m. to 2.00 a.m.); entertainment centre (7.00 p.m. to 1.00 a.m.).

Activities
Aqua aerobics, badminton, billiards and snooker, bush walks, indoor carpet bowls, table tennis, tennis, catamarans, dinghies, diving, fishing, game fishing, Lasers, paddle skis, parasailing, sailboards, snorkelling, spyboards, waterskiing.
Island barbecues, day and half-day island cruises, sunset cocktail cruises, diving at the Great Barrier Reef.

Anchorage
Use of Hayman's harbour and marina is restricted to resort guests and their guests.

Hayman Island, Queensland 4801. Telephone: (079) 469 100. FAX: (079) 469 410. Telex: 48163.

Towards the middle of 1985, the Whitsundays were changing. The entrepreneur Keith Williams had opened the new Hamilton Island resort, and by comparison the rest of the Whitsunday resorts were looking a little tired. Ansett Transport Industries, which owns Hayman, planned to give Hayman a $25-million face-lift, but at some point that plan was scrapped in favour of starting all over again. Hayman was closed, razed, and today, an unbelievable $260 million later, the new Hayman is in a world of its own at the top of the Whitsundays.

The resort

No amount of expense nor trouble has been spared in creating a five-star international resort, a 'grand hotel in classic style', as Hayman calls itself. The development has been guided by Swiss-born General Manager, Denis Richard, long experienced in the grand manner of European hotels, who has had a seemingly unlimited budget to support his unceasing quest for perfection, the definition of which he changed from time to time during the construction (and, as seems to be true of all such projects, it took about two years longer to finish than expected). Ansett Transport Industries stopped talking about how much it had spent on the new Hayman when the investment reached the $260 million mark, a figure that sends financial analysts scuttling for an abacus. 'Nothing but the best' is Hayman's motto, and this is followed throughout the resort.

Hayman is a blend, a collection of themes from around the world, and it shuns single-adjective descriptions. It is a London club, with all of its plushy darkness, incongruously in the tropics; it is Louis XVI at the edge of the Great Barrier Reef; it is the Mediterranean, Vienna, Mexico, the Orient; it is stylish, extravagant, eclectic—it has even been called 'a magnificent wank'. It has also been elected to membership of The Leading Hotels of the World, an organisation founded in 1928 which nominates only what it considers the world's most eminent establishments.

The Hayman resort spreads horizontally through a large natural horseshoe between the hills of the southern end of the island. The shoreline here is a carefully manicured crescent of sand beyond which Hayman's huge fringing reef yawns expansively at low tide. The three-storey architecture is contemporary, at the same time vaguely suggestive of pueblos nestled into their surrounding hills, dusty pink, slightly stark. The resort is luxuriously landscaped, with formal gardens, tropical gardens, Japanese gardens; over one million plants have been imported for landscaping.

Accommodation and tariff

Resort accommodation is spit into two main areas, the West Wing, which sits overlooking one of the largest salt-water swimming pools in the southern hemisphere (it is really almost a lake), with a fresh-water pool in the middle, and the East Wing, with its surrounding swan ponds, pools and a large oval fresh-water swimming pool. The two wings are separated by the central resort complex which contains shops, a central lobby, Club Lounge, library, billiards room, formal dining room and entertainment centre.

The rooms at Hayman all have a residential feeling, with eggshell tones, marble bathrooms, luxurious appointments. All have air-conditioning and ceiling fan, ISD direct-dial phones, including one in the bathroom. In an attempt to maintain a more intimate resort atmosphere

COLFELT

Above and Below:
'Nothing but the best' is the philosophy at Hayman, as evidenced by decorative touches such as 500-year-old temple doors from the Punjab (above), a hand-woven wall-to-wall Taiping carpet in the formal restaurant, linen bed sheets, a $70 000 acrylic sculpture in the centre of the main lobby, antique Greek olive oil jars along the walkways, oils by some of Australia's best known artists, such as 'Darling Downs in Suspension' (below), Graeme Townsend's Sulman prize-winning painting, which hangs in the corridor between the main lobby and the Club Lounge.

COLFELT

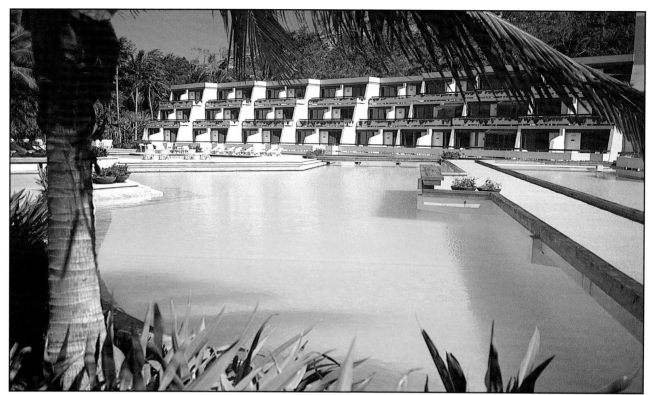

COLFELT

Above:
Hayman's West Wing surrounds the lagoon. Each of its 84 rooms has a bathroom in Wombean marble, colour TV and video, electronic programmable safe, telephones never more than an arm's length away, balcony, and a view of Whitsunday waters looking towards Hook Island.

in this large hotel, rather than using one central check-in area, guests complete the formalities aboard the luxurious *Sun Goddess* while sipping a glass of champagne on the way up the Whitsunday Passage from Hamilton Island airport. They are then taken from the marina by bus to their accommodation wings, each of which has a 'Lanai', a Hawaiian word which describes an indoor-outdoor space, partially enclosed, lushly planted with water running through and which acts as an informal and more intimate reception area. There are sofas and reading lamps, tables set for dining. The resort has an elegant central lobby, but guests never really need go there except perhaps when seeking information from the concièrge; all other wishes are catered for in the Lanais, including 24-hour food and drink.

West Wing rooms and suites are smaller than those of the East Wing. Other accommodation (the least expensive) is located between the West and East Wings—in Palm Court, Beachfront, Palm Garden, and Garden Court units. On a separate, private level, the East Wing has 11 penthouse suites, which are the final word in Hayman luxury, each with a theme—north Queensland, Greek, Contemporary, Japanese, Italian, Moroccan, South Seas, English, Californian, Art Deco, French Provincial.

Hayman's tariff is room-only, and everything else is extra. The resort has projected an image of exclusivity and luxury, and it is, indeed, not inexpensive. However, quality is provided and the rates need to be viewed in that perspective. Hayman is possibly like going to the best restaurant in town rather than one of the second echelon; if you can afford the extra 30%, you get about 100% in return, because it is not just a good meal but an experience.

COLFELT

Eating and drinking

Hayman has a range of choices for eating, at one of six restaurants, or at poolside, or in your room (24-hour room service). The restaurants include: the grandest, La Fontaine, a formal dining salon (jacket and tie required) with elegant Louis XVI furnishings, serving classic French cuisine, with a distinguished wine list presented by a sommelier; Shima Teien, oriental (jacket and tie preferred), overlooks a Japanese garden complete with pond and tea house, serving sushi, sashimi and a variety of other dishes from the orient, some prepared at table-side; La Trattoria, with white-washed walls and checked gingham table cloths, serves Italian food; a Polynesian–Australian restaurant, casual, colourful, with piano bar; a Viennese Coffee House, serving breakfasts, light meals, carvery lunch, sandwiches, salads and all manner of continental baking and confectionery; the Beach Pavilion, informal, by-the-beach with thatched roof and Mexican decor, for snacks (and drinks). For drinking Hayman has: the Club Lounge, which is a London club transported to the tropics, rich and warm, with Louis XVI and early American reproductions; the entertainment centre, with its showpiece bar of highly polished green granite.

Activities

Hayman's beach, which during the rebuilding of Hayman had some 66 000 tonnes of sand added to it, is kept swept and manicured like a lawn, and catamarans, sailboards, paddle-skis and all manner of water sports equipment sit lined up on it ready to go. At low tide, as is true of most Whitsunday islands, the reef dries a long way out, although some shallow water remains next to Hayman's newly remodelled beach. There is waterskiing and parasailing, or for those who prefer to

Above:
The Club Lounge, a little bit of London in the Pacific, features American oak panelling, silk-lined walls, reproduction furniture and incorporates a library and billiards room.

COLFELT

Above:
Each of Hayman's accommodation wings has its own Lanai, an indoor-outdoor, informal reception area where guests can relax and where food and drink is available at any time.

get away and enjoy the magnificent Whitsunday surroundings, one can hire a dinghy with outboard motor and go for a picnic lunch and a snorkel on one of the adjacent island beaches (at Langford, Black or Hook Islands, or perhaps at Hayman's own Blue Pearl Bay). Organised snorkelling trips to Black Island ('Bali Hai'), with its good fringing coral, are available, sometimes with a barbecue on the beach.

Hayman has tennis and badminton courts, and a state-of-the-art gymnasium, with Nautilus equipment, sauna, spa, plunge pool and flotation tanks. Those who want to stretch their legs can follow the trail beyond the marina up the hill and across to Blue Pearl Bay, or right to the other end of the island; beautiful sweeping views of the Passage may be seen from the top of Hayman.

Diving and snorkelling

Diving at Hayman is conducted by Barrier Reef Diving Services, the Whitsunday area's senior dive team, and the facilities for diving, including the dive vessel *Reef Goddess*, are, like everything at Hayman, the best available in the world. The dive facility has its own fresh-water pool, and full PADI certificate courses (including Advanced Open Water courses) are available, as are review courses, environmental orientation, reef ecology, underwater photography, night diving, and a range of introductory courses offering island or Reef dive sites with personal instructor. *Reef Goddess* goes to the outer Barrier on most days, to Bait Reef, which offers a multitude of sites and the best diving in this section of The Reef. *Reef Goddess* also goes to dive sites on the northern side of Hook Island if the weather isn't suitable for Reef excursions. *Goddess* is an all-purpose dive boat, with every comfort and convenience. Each diver has his or her own position on the boat, where equipment is stored (including dry storage for cameras and towels). Two full air tanks are in a bin behind each seat, the back of which folds

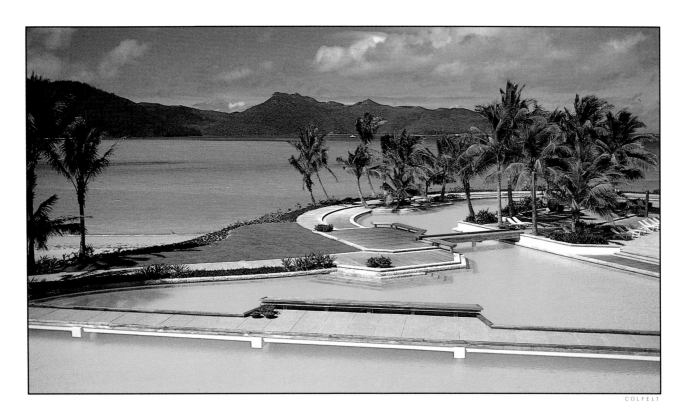

COLFELT

down, and tanks never need be wrestled with; when divers are ready to go, they just slide the tank onto their back, stand up and walk over the side. All equipment may be hired, including underwater video (8 mm), snorkeller's video (8 mm), still cameras (Nikonos V), strobe, and diver propulsion vehicles. Hayman will pack gourmet picnic lunches for divers and snorkellers going to the Reef.

Island cruises and Reef trips

Hayman offers sailing yacht cruises through the Whitsundays as well as cocktail sunset cruises, and various trips to the Barrier Reef are available. The South Molle Island catamaran *Capricorn* calls in at Hayman three days a week to pick up passengers for its trip to Hardy Reef, where glass-bottom boats, coral 'sub' viewing, snorkelling and scuba diving are offered. For a bit of excitement Seair Whitsunday offers two trips to The Reef in its amphibians which taxi into Hayman's harbour and drive up on to the ramp to pick up passengers.

Fishing

Hayman has its own game-fishing charter boat and several very experienced local skippers. Bottom-fishing expeditions are also offered. Full-day charters go out to the Barrier Reef; half-day charters fish around the islands. Mackerel season is from May until the end of September; sailfish and marlin come from the end of August through November; tuna are available from October to February. The Whitsundays are considered a 'light tackle' area; marlin as large as 136 kg (300 lb) have been caught, but the average *good* catch would be closer to 40 kg (88 lb). Less serious fishermen can take themselves out in a hire dinghy and drop a hook along any of the reefs in the immediate vicinity (no fishing is allowed along the northern shores of Hook Island, which is a Marine Park 'B' zone).

Above:
The West Wing pool complex, with its criss-crossing boardwalks and coconut palms, almost a symbol of the resort, merges with the Whitsunday Passage.

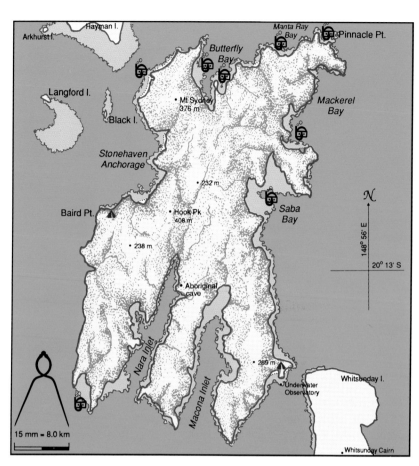

Below:
Nara Inlet, a fjord-like, deep inlet on the southern side of Hook Island, is a good anchorage for yachts because it provides protection in all weathers. It once was a favoured spot with Aborigines, too, and in the hills surrounding the inlet are caves with their paintings. Carbon dating of shell remains in one cave indicate that they date back some 8000 years.

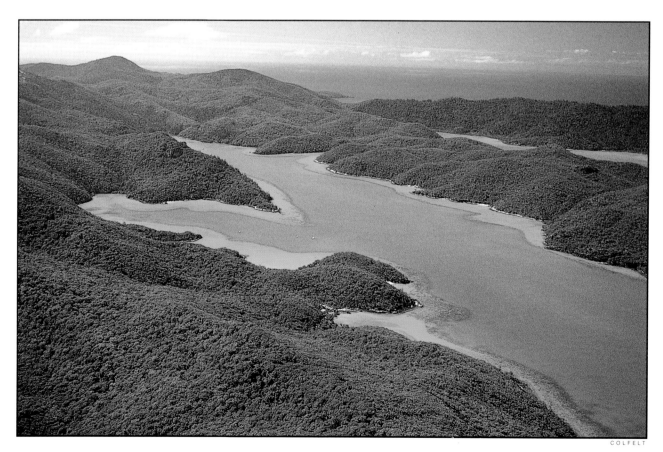

COLFELT

HOOK ISLAND

Location: 20° 07'S 148° 55'E (29 km north-east of Shute Harbour).

Island type: Hook is a high continental island (5180 ha) of volcanic origin; it is a National Park, with the highest mountains in the Whitsundays, rugged terrain and several deep bays. It has excellent fringing reef development.

Access: Hook is reached by day-cruise boats, departing mostly from Shute Harbour. *Islander* departs Shute Harbour daily at 8.15 a.m. for the underwater observatory (90 mins). Other cruises from resorts visit the observatory. Seair Whitsunday can land its amphibians at several anchorages around the island.

Facilities: Underwater observatory and small camping resort with 12 cabins (six bunks each) and 50 tent sites, restaurant and bar, small store, bush-walking tracks. (Bookings through South Molle Island Travel, Airlie Beach: telephone (079) 466 900.) QNPWS permits camping at several sites around the island.

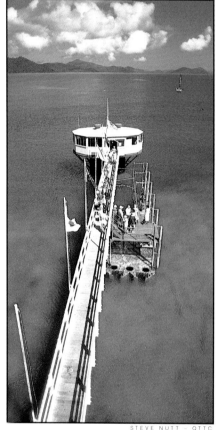

STEVE NUTT – QTTC

Hook is a majestic volcanic island at the north-eastern end of the Whitsunday Passage. Around the turn of the century timber cutting took place there, and at one time a sizeable herd of wild goats roamed its craggy hills; some are still on the island. The shores of Hook are ringed by fringing reefs as good as any to be found along the Queensland coast, with a diversity of coral sometimes not matched at the outer reefs. Hook has two fjord-like inlets on its southern side, Macona and Nara, which penetrate the island to a depth of more than 5 km. These are favoured anchorages with yachtsmen because they afford good protection and because waterfalls run after rain and during the wet season, providing a source to refill yachts' water tanks. The surrounding hills hide a number of caves used in the past by Aborigines, and recent archaeological work has dated material in one of these at about 8000 years before present. Another cave has paintings on its walls which are particularly interesting because they employ motifs usually associated with tribes living well inland. Queensland National Parks and Wildlife Service has marked a trail, which commences just beyond the last bay on the right-hand side of the inlet, to help visitors find this cave, and an enclosure has been erected to help protect the area. Visitors are asked to keep behind the ropes and to be sure to close the gates to prevent art-loving goats from doing damage.

The northern side of Hook Island has some of the best dive and snorkelling sites in the Whitsundays, among which are Manta Ray Bay, The Pinnacles, and Butterfly Bay, so named because it resembles the shape of a butterfly wing (coincidentally, butterflies are sometimes seen swarming in the shady groves around its creeks). A coral-viewing 'sub' anchored in Stonehaven Anchorage takes sightseers around Black Island's fringing reef.

The Hook underwater observatory, in the narrow passage between Hook and Whitsunday Islands, is another of the observatories built in the days before the advent of coral-viewing 'subs' and before it was possible to take day-trips to The Reef. They still provide an opportunity to see and photograph fish at very close quarters, but because they are usually close to islands, visibility from inside is sometimes reduced, particularly at times of spring tides or strong winds. In recent years marine biologists have transplanted coral around Hook observatory, and for those who haven't the time, money or inclination to go to the Barrier Reef, this is one way to get a close look at marine life without travelling too far or getting wet.

Above:

Hook Island underwater observatory is located in the narrow passage between Hook and Whitsunday Islands, about a 90-minute trip by ferry from Shute Harbour. There are coral-viewing 'subs' and glass-bottom boats, too. The observatory has an associated small camping resort, with restaurant and store. Campers stay either in one of the 12 six-berth cabins, or they bring their own tent; bed linen is available for hire.

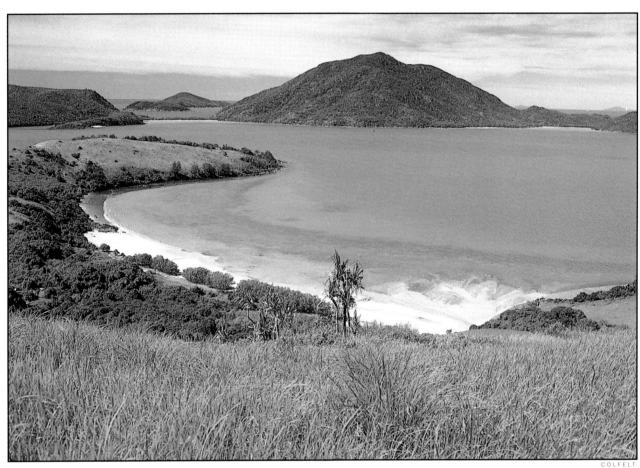

COLFELT

LINDEMAN ISLAND

Lindeman Island is located in the middle of the Cumberland Group, slightly off the beaten track, which suited the family-style resort that operated there for many years. It was sold in 1987, and the new owners closed it down to build the smart new resort on the old site. Lindeman has gone up-market a little; it is now really more a place for couples than for families, although some special facilities for the young are still provided. The island has a nine-hole golf course, a number of beaches, and some good walks. A medium-size resort with a medium blend of entertainment and activities, Lindeman is pitched at those seeking a resort a bit above the Australian average who are willing to pay just a little extra for it.

Lieutenant James Cook remarked on a feature of the lands surrounding the Whitsunday Passage in his log entry for Sunday afternoon, the third of June, 1770—that some parts had 'Lawns that looked green and pleasant'. The lawns that he referred to were grasslands, which are particularly prominent on Lindeman, South Molle and North Molle islands in the Cumberland Group. It is not known when these grasslands were created, perhaps before the last ice age, but they were almost certainly maintained during the last 8000 years by Aboriginal burning, the regime of fire known so well to those people and a practice that was continued by the Europeans who followed them. Perhaps fire was originally used to clear forest land and allow light to penetrate to the soil, encouraging the growth of edible foods. Periodic burning made the country easier to walk over and to see tracks and holes of various prey. Burning may have incorporated some ancient wisdom about maintaining habitats in different stages of development, promoting a diversity that protects all living communities, insuring that there would always be a ready supply of game. And maybe, too, like cane cockies, they took some joy in a 'bloody good fire' (cane cockies, or sugar cane farmers, set fire to cane fields prior to harvest, a practice that was started largely because it made harvesting less dangerous and easier for cane cutters; machines are used for harvesting today, and the fires are still lit).

The Aborigines used to move freely about the Whitsundays in swift outrigger canoes, exploiting the islands for sea birds, dugong, turtles, yams, wild cherries and plums, trochus shells, the flesh of the bailer shell, green ants, cockatoo apples, flying foxes and fish, and they knew where to find these in different seasons. They called Lindeman Island Yarrakimba, which meant snapper bream. Lindeman's English name is that of a naval sub-lieutenant, George Lindeman.

The first lease on the island was granted to another mariner, Captain James Adderton, who in 1905 set up a sheep farm, evidently enlisting labour from members of a group of Aborigines there at the time. At one point there were 3000 sheep on Lindeman, and coastal steamers called by for wool which they collected from the beach in their lifeboats.

In the early 1920s the Nicholson family settled on the island, and they are alleged to be the first to have done so with the object of tourism uppermost in their minds. The Nicholsons' first guests arrived in 1927.

COLFELT

Above:
The final ascent to Mt Oldfield and its magnificent views, the path lined with *Xanthorrea* ('black boys'), a favoured vegetable food of Aborigines, which regenerated with tender green shoots after fire..

Opposite:
Lindeman's grasslands were created in the distant past, by Aborigines using fire, and in the early 20th century these paddocks attracted the eye of graziers; before it had tourists the island had a sizeable sheep population. Lindeman has several sandy beaches, such as that at Plantation Bay, where the resort's 'Adventure Valley' camp is located. In the background is the thin sandy strip of Neck Bay, on Shaw Island.

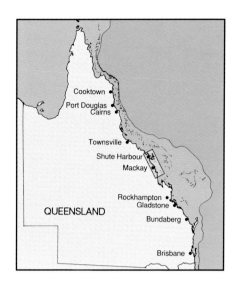

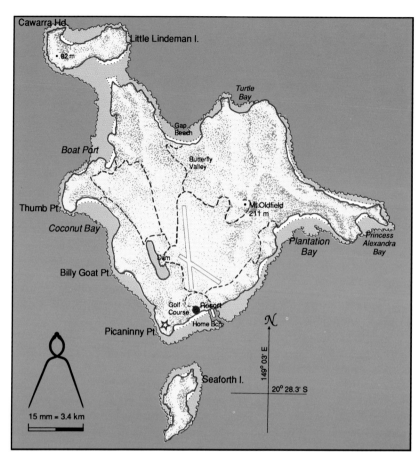

ISLAND SUMMARY
Lindeman Island

Location: 20° 27'S 149° 03'E
Gateways: Proserpine (49 km),
Hamilton Island (15 km), Shute
Harbour (31 km), Mackay (76 km).
1977 km N of Melbourne
1509 km N of Sydney
878 km NNW of Brisbane
524 km SE of Cairns

Island and resort details

A high continental island (790 ha) of volcanic origin covered with large areas of grassland, open eucalypt forest and rain forest. It is a National Park. There are several good walking tracks, such as the one to the top of Mt Oldfield, where it is possible to look out for 360° around the horizon. Lindeman has numerous coral sand beaches scattered around its shores. The resort is located on the south-eastern side at Home Bay.

Access

From Proserpine airport: by Seair Whitsunday (20 mins). From Shute Harbour or Whitsunday airstrip: by Seair Whitsunday (12 mins). From Hamilton Island: by Seair Whitsunday (5 mins) or (if numbers warrant) by launch (25 mins). From Mackay airport: by Seair Whitsunday (25 mins). From Mackay Outer Harbour: by Roylen Cruises catamaran (3 days a week) (2 hrs and 10 mins).

Resort capacity, accommodation, facilities

350 guests, plus occasional 'day guests'. **Accommodation.** Two standards: 104 Seaforth units, all air-conditioned with private bathroom, ceiling fan, colour TV, direct-dial phone, fridge and mini bar; Whitsunday units, with private bathroom, ceiling fan and fridge. **Resort facilities:** 9-hole golf course; 2 all-weather tennis courts (lighted); fresh-water swimming pool; all water sports equipment; coffee shop; resort boutique; recreation room; night club; coin-operated laundries in each accommodation block; conference facilities. Free child-minding is available daily 9.00 a.m. to 12.00 noon (3 to 8-year-olds), during children's dinner (5.30 p.m.) and until 9.00 p.m. (3 to 15-year-olds). Baby sitting service is available at additional charge.

Tariff

All inclusive (except for alcohol, and water sports requiring the use of petrol). Children 3 to 14 -years half price.

Eating and drinking

Resort dining room, Islander Restaurant (7.00 a.m. to 9.00 a.m., 12.30 p.m. to 2.00 p.m., 7.00 p.m. to 8.30 p.m.) A la carte restaurant, Nicholson's (not every night, 7.30 p.m. to 9.30 p.m.); Coffee shop (8.00 a.m. to 5.00 p.m.); Lounge bar (5.00 p.m. to late); Pool bar (10.00 a.m. to 5.30 p.m); Juliet's night club (not every night, 11.00 p.m. to 2.00 a.m. or so).

Activities

Aerobics, archery, beach cricket, bird feeding, boomerang throwing, bush walks, cricket, golf, tennis, walks to island's beaches, aqua aerobics, catamaran sailing, dinghies for hire, fish feeding, jet skis, paddle skis, para-sailing, sailboarding, scuba diving instruction, softball, water volleyball, waterskiing and waterskiing classes.

Barrier Reef trips are available via Hamilton Island on the wave-piercer catamaran, *2000*, 3 days a week, and from Lindeman with Seair Whitsunday.

Anchorage for yachts

Lindeman has a number of moorings for visiting yachts (the customary overnight fee is charged). Toilet and shower facilities are available for use by visiting yachtsmen.

Lindeman Island Resort, Lindeman Island, Qld 4741. Telephone: (079) 469 333. FAX: (079) 469 598. Telex: 43138.

The resort

Located in the centre of the Cumberlands, Lindeman is off the beaten track from the gateways to the north and south, and its relative isolation and many natural attributes traditionally fitted it for a role as a quiet, family sort of island, one where day-trippers did not make a daily assault on the resident guests. Like several other Whitsunday resorts, Lindeman has recently undergone a metamorphosis. It was sold and closed in 1987, and during that year the new owners, Adelstein Investments and Australian Investors Corporation Ltd., virtually demolished and rebuilt it. The new resort is in the same location, tucked against a hill in a bay on the south-western end of the island. The huge Shaw Island, not more than a few kilometres away, provides a barrier against the worst of the weather, extending as it does from the north-east side of Lindeman right around to its south.

Most Lindeman guests arrive by small aeroplane, touching down on a pretty grass airstrip on the flat-topped hill above the resort. They are then ushered into a mini-bus and driven down the steep slope, descending through a lush canopy of trees to the reception area. The architecture of the new resort is attractive and thoughtful. The central complex is a series of open pavilions by the sea which take full advantage of the setting. The buildings, in natural timbers with pyramid-shaped shingled roofs, impart a village atmosphere; as guests walk up the steps and into the reception lobby, they immediately become part of the action taking place on several levels around them. Just a step outside the large doors, which are usually open, is the pool, surrounded by a wide timber boardwalk and shielded from south-east winds by glass screens; the beach is just beyond, and in the distance the profile of Shaw Island provides a fitting backdrop. Catamarans and sailboards can be seen slicing backwards and forwards in front of the all-tide beach a mere 50 m away from the front desk—all very inviting to the new arrival. Down a few steps on the right is the lobby bar, with its chrome and glass, and beyond that in the adjoining pavilion is the resort dining room. Each of the central pavilions opens into the next, providing a feeling of connection and intimacy, but the spaces are broken up into individual units to avoid any sense of crowding.

Accommodation and tariff

There are two standards of accommodation. The new Seaforth units are in three-storey blocks, situated either right on the seawall looking out towards Seaforth Island about 700 m across the water, or under the hill and looking out over the pool to the beach. Seaforth units all have a balcony or patio; the bedrooms are large and attractively furnished with queen size bed, a cane couch (which converts to a bed) in a bay window, wicker furniture, terracotta floors; bright, colourful prints are used on the bedspreads and curtains. All rooms have fridge and mini-bar, colour TV, direct-dial phone, ceiling fan, radio-alarm. The bathrooms are crisp and white, perhaps a bit on the small side, a sacrifice necessary to provide space for the balcony or patio.

The second standard units are those of the old Lindeman resort, which used to be the Whitsunday units, now called Hillside and Waterfront, which have been spruced-up a bit but which are still without the modern hotel extras, such as air-conditioning, colour TV and direct-dial telephone—things that family resorts of the past didn't give a second thought to. These rooms are, as their names suggest, either right on the side of the hill or more or less at the top of the beach further along

COLFELT

Above:
Lindeman's architect, rather than pulling the resort back from the water, put it as much into the foreground as possible, providing a fresh, seaside atmosphere. The pool is just above the beach, protected from the sometimes gusty south-east winds by glass screens.

COLFELT

Right and below:
The design of the central pavilions is open, and the lobby, lounge and dining room can be made an extension of the outside by folding back the large wood-frame glass doors. In turn, the pool area is an extension of the beach.

COLFELT

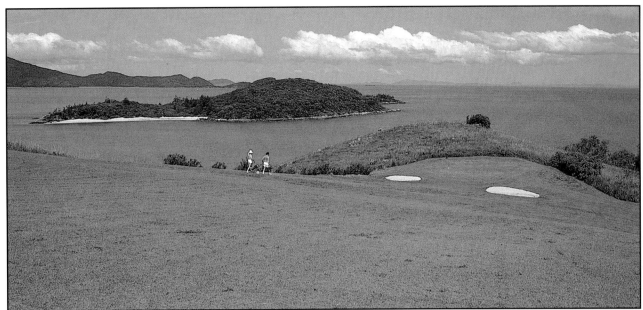

COLFELT

COLFELT

Above:
Lindeman's grassy hills overlooking the sea provided the perfect context for a golf links, with sweeping views of the Whitsunday Passage. The resort has a nine-hole course with the customary penalties for hookers and slicers.

Left:
Evening reflections on the pool.

towards the jetty. They have ceiling fan and fridge, and they cost about 25% less than Seaforth units.

Lindeman was always a family island, and the new management has obviously struggled with this legacy as it set about constructing a smart new resort where, according to the advertising, 'You can't see the luxury for the trees'. The chic architecture, and the restaurants which serve a high standard of food, are part of a clear design to place the resort a notch above its previous market. In an effort not to turn its back on families it still offers free child-minding in the morning and evenings as well as children's Adventure Valley camps (during school holidays (if numbers warrant). There is one, all-inclusive, tariff.

Eating and entertainment

Lindeman has two restaurants, the Islander, which is the main dining room, and the Nicholson Room, a smart, *à la carte,* upstairs affair which, on several nights a week, serves a high standard of international cuisine prepared by a European chef. Guests dining at the Nicholson, where meals are not included in the tariff, get a credit towards their dinner.

The Islander Restaurant is on two levels; some of its tables are at ground level right next to full-length folding windows which, weather permitting, are folded back to create an almost open-air atmosphere; others are on a raised platform in the centre of the room and have an unobstructed view out over the beach. The decor is a blend of wood and natural colours, restful by day, atmospheric at night. Breakfast and lunch are sumptuous buffets; dinner is a very good three-course meal served at the table.

Below:
Tiny lights outline steps and ceiling spaces under the pavilion roof at night, and with the doors folded back, the lounge and dining room are open to the balmy evening air.

Entertainment is informal, with theme nights and barbecues at poolside. Several nights a week the nightclub, Juliet's, on the hill by the air terminal, is open for those who wish to drink and dance till the wee hours.

COLFELT

Activities

Lindeman provides a range of organised activities and an abundance of opportunities for those who prefer to organise themselves. The island's grasslands made it an obvious place for a golf course, and Lindeman has a true links, with some spectacular vistas out to the Passage and some severe penalties for golfers who slice. The course has been improved and is now nine holes. There are two lighted all-weather tennis courts. The island also has many natural attributes. The all-tide beach in front of the resort is a marvellous water sports playground provided the trade winds are not piping in, and a complete range of water sports equipment is available (no charge is made for muscle- or wind-powered aquatic contraptions used by house guests). Dinghies may be hired, and there are a number of other attractive beaches on Lindeman, as well as on the adjacent Seaforth and Shaw Islands, where it is possible to escape with a picnic lunch. Boat Port, on the north-western side of Lindeman, is quite protected when it is windy at Home Beach.

Being a National Park, Lindeman has several graded bush tracks, one which meanders through forest and a valley of brightly coloured butterflies until it makes the ascent up a grassy slope to the summit of Mt Oldfield—a spectacular place from which to watch the sunset.

Diving, snorkelling and Reef trips

PADI scuba-diving instruction is available at Lindeman, and guests can make connections with Reef trips departing from Hamilton Island three days a week for diving, snorkelling and coral viewing at the Barrier Reef. Trips to the Barrier Reef by seaplane are also available with Seair Whitsunday. The high tides in Lindeman's part of the Whitsundays, and the resulting strong currents that race between Shaw and Lindeman Islands, often produce poor visibility in the water here; Seaforth Island offers better snorkelling.

Below:
Lindeman's all-tide Home Beach looks southwards towards Shaw Island, which provides some protection from the prevailing trade winds.

COLFELT

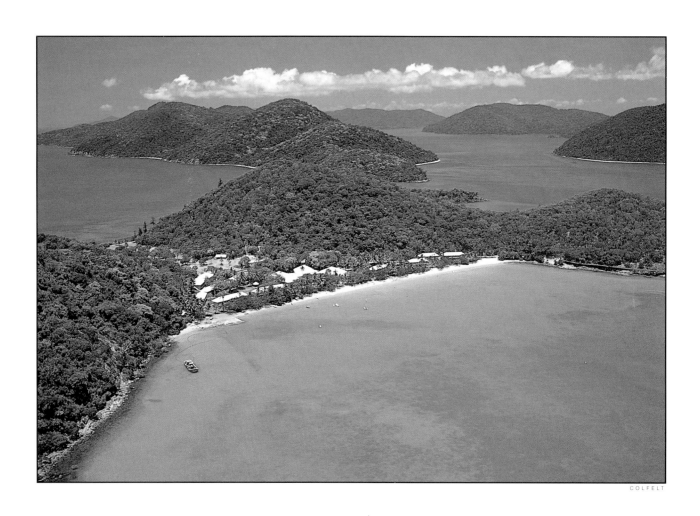

COLFELT

LONG ISLAND
CONTIKI WHITSUNDAY RESORT

Contiki Whitsunday is a brand new resort and the first in the world exclusively for 18–35 year olds. Conceived by a company which has specialised in adventure tours for the young during the past quarter century, Contiki offers accommodation ranging from backpackers' quarters to comfortable twin-share units. It is priced for its market and is a place where youth in full flower (or at least not yet going to seed) can be in its own element and play hard by day or by night.

Port Molle was the name given by Lt Charles Jeffreys, in 1815, to the relatively deep, protected waters just south of Shute Harbour. It is bounded by the mainland on the west and by a wide bay (today known as Happy Bay) at the northern end of Long Island. Jeffreys was on his way to Ceylon (now Sri Lanka) with a detachment of soldiers, and the name he selected was that of an army colonel, the same name as was given to the nearby group of islands which provide protection for this good natural harbour on its northern side. Port Molle was explored in more detail by Captain Philip King, on *Bathurst*, in 1821, the first navigator to follow Cook in charting Australia's hazard-strewn Barrier Reef waters, and by Capt. Blackwood (*Fly*) in 1843, who was laying early groundwork for future ports on the Queensland coast. For many years Port Molle was the most popular anchorage in the Whitsundays, and history tells a number of tales of hostile encounters between ships at anchor there and local natives. The Aborigines frequented the islands surrounding Port Molle; they hunted for Torres Strait pigeons on West Molle (Daydream), they had a quarry on South Molle where they obtained stones that were ideal for making axe heads, and they used to go to Long Island for turtles. Aboriginal legend speaks of visitors coming by sea before Cook, and the rediscovery of an old wreck and large cannon balls at Happy Bay in the 1970s convinced some that Spanish galleons preceded James Cook to these Whitsunday shores*.

In the late 1800s red cedar was cut from Long Island and taken over to be sawn at John Whitnall's mill at Cid Harbour, Whitsunday island, after which it was bound for export. In the 1920s 'Otto' Altmann had a banana plantation on Long Island, and in his 9 m boat, *Senix*, he used to do a mail run and grocery delivery service for some other Whitsunday Island settlers.

Happy Bay resort was established in 1934, and this homely resort with its small cabins ran successfully until the early 1980s. Its name has stuck to the bay. A small resort at Palm Bay, the second bay to the south was opened in 1933, but it was all but destroyed by cyclone Ada in 1970; today it is a small camping resort. At one time there was a resort at Paradise Bay, too, which is towards the bottom of the island facing the mainland. Happy Bay is the nearest good anchorage to Shute Harbour for yachts, and since the advent of bareboat chartering in the Whitsundays, it has been a popular 'first night' anchorage, being close enough to reach before the sun gets too low on the short first day of the charter.

The Happy Bay resort, operated for years by the innovative Mount-

* A great many wrecks in Australian waters have been said to be 'Spanish galleons', many more than is probably the case. This wreck was studied in 1983 by David Hopley, a geomorphologist at James Cook University, and Ronald Coleman, marine historian and archeologist of the Queensland Museum. After some detective work it was identified almost certainly as *Valetta*, a merchant trader wrecked in 1825. The 15 kg cannon balls are too large for a merchantman like *Valetta* and were probably from one of the larger vessels of the time, such as HMS *Rattlesnake*, which visited Port Molle and Long Island in 1847 and which probably engaged in some gunnery practice at anchor, as was often done on Her Majesty's ships in those days.

15 mm = 5.7 km

ISLAND SUMMARY
Long Island

Location: 20° 20'S 148° 51'E
Gateway: Hamilton Island (11 km) or
Shute Harbour (7 km)
1985 km N of Melbourne
1525 km N of Sydney
900 km NNW of Brisbane
501 km SE of Cairns

Island and Contiki Whitsunday resort details

Long island is an elongated, narrow continental island (1215 ha), of volcanic rock, separated from the mainland by a deep, narrow (0.5 km) channel. The island is a National Park and is densely vegetated with eucalypt and rainforest; there are resort leases at Happy Bay and Palm Bay. Long Island has several good walking tracks. Contiki Whitsunday resort is situated at Happy Bay, a large bay on the north-western side with a coral sand beach and wide fringing reef that dries out at a spring low tide. A small camping resort is located at Palm Bay a little over one kilometre to the south.

Access

From Hamilton Island: by water taxi (30 mins); from Proserpine via Shute Harbour; by bus from the airport (50 mins), then via water taxi (20 mins) (several regular services daily).

Resort capacity, accommodation and facilities

Total capacity about 400 guests (18 to 35-year-olds only), plus a few 18 to 35-year-old visitors in bareboat charter yachts. **Accommodation:** 145 twin units (in 11 two-storey buildings) each with private bath, ceiling fan, ISD direct-dial phone, 5-channel stereo music/radio system, tea/coffee-making facilities, balcony; 2 backpackers lodges of 16 rooms, each room designed for occupancy by 4 guests, in double-decker bunks, with desk and ceiling fan; occupants of lodges use communal toilet/shower facility. **Resort facilities:** Coffee shop; disco; dive shop; entertainment lounge; electronic games room; gymnasium; island shop; laundry; sauna, spa, steam room; 25 m swimming pool; 2 tennis courts; satellite dish for TV reception; all water sports equipment.

Tariff

All inclusive, with complimentary wine at lunch and dinner (other alcohol, and water sports requiring the use of petrol, are extra).

Eating and drinking

Resort restaurant, the Poinciana Room (7.00 a.m. to 9.30 a.m., 12.30 p.m. to 2.00 p.m., 7.00 p.m. to 9.00 p.m.); Pelican Bill's Café (9.30 a.m. to 7.30 p.m.). Sandbar (entertainment lounge bar) (2.00 p.m. to 4.00 a.m.); pool bar (9.00 a.m. to 5.00 p.m.).

Activities

Aerobics; archery; badminton; basketball; bush walks; cricket; darts; fitness course; ironperson contest; rugby; soccer; softball; table tennis; tennis; volleyball; fishing; hire dinghies; paddle skis; para-flying; sailing in Lasers, miniature Twelve Metre class yachts and 7 m catamaran; scuba diving; tobogganing; water-skiing.

Barrier Reef trips are available, via seaplane direct from the island with Seair Whitsunday, or by connecting with catamarans departing from Shute Harbour. Island cruises are also available from Shute Harbour; *Apollo* is at Contiki Whitsunday once a week for an island day cruise.

Anchorage for yachts

The resort has 14 moorings available (for the usual overnight fee); radio ahead for bookings. To land at the Contiki Resort part of the island, yachtsmen must be in the 18 to 35-year-old bracket (as must all guests).

Contiki Whitsunday Resort, PMB 226, Mackay, Qld 4740. Telephone: (079) 469 400. FAX: (079) 469 555. Telex: 48117.

ney family, had run out of puff in 1983, and it was sold; it then had a final, frenetic burst of activity as Whitsunday 100, where it was promoted as a place for the young (as opposed to the young at heart): 'If a falling coconut doesn't flatten you, the pace will', the ads went. After a couple of years of that everything had been pretty well flattened, and in 1986 the resort was sold and closed. It re-opened in mid-1988 as Contiki Whitsunday resort, and the 'Contiki' may be familiar to some as the name of the world's largest operator of tours specifically for 18 to 35-year-olds.

The resort

The all-new Contiki Whitsunday resort is nestled amongst the palms at Happy Bay, respecting the environment as much as is possible for a major construction project; some of the buildings were even shifted to fit in with the trees. Visitors arriving at the island land at a jetty on the western point and walk to the resort on a wooden ramp which winds pleasantly around the shoreline. Happy Bay itself has a lovely wide sweep of coral sand and an extensive fringing reef which is covered only by very shallow water at normal low tide.

The resort has two types of accommodation, some designed for the customary twin occupancy and some for groups of campers or backpackers on tour. In 11 two-storey blocks there are 145 fully-serviced units with private facilities, more than adequate without being luxurious, most with king-size bed but a few with three beds, ceiling fan, direct-dial phones, stereo music system, tea and coffee making facilities. There are two lodges for backpackers, each with 16 rooms and each room designed for occupancy by four. There is a communal toilet and

Below:
Contiki Whitsunday's accommodation is in two-storey blocks set with some sympathy among the coconut palms of the resort area, with the contrasting lush native bush of Long Island behind.

STEVE NUTT – QTTC

shower block for these lodges.

The accommodation surrounds the central resort complex where the dining room, entertainment area (disco) and bar, dive shop, resort shop, gymnasium (called the 'Sweat Shop'), pool and spa are located. Contiki's tariff includes all meals, which are served buffet-style in the dining room with free house wine offered at lunch and dinner. Needless to say there is entertainment every night until almost the next daylight. Guests have free use of a wide range of water sports equipment (including miniature Twelve Metre class yachts), a charge being made only for activities which require the use of petrol.

There is a resident diving instructor at Contiki, and PADI certificate courses (including introductory courses) are available. Dive trips to the Barrier Reef are via Shute Harbour with Fantasea Cruises *Quick Cat II*. Reef trips on *Capricorn*, and also the many island cruises, are available via Shute Harbour, and *Apollo* does a special cruise for Contiki one day a week, departing from the island itself. Seair Whitsunday will pick up passengers for the Barrier Reef in its amphibians right at Happy Bay.

Below:
The pool and spa at Contiki Whitsunday, fountains for youth.

Long Island is a National Park and has some lush tropical rainforest with several good bush tracks which offer tantalising glimpses of The Narrows, on the mainland side, and of the Passage, to seaward.

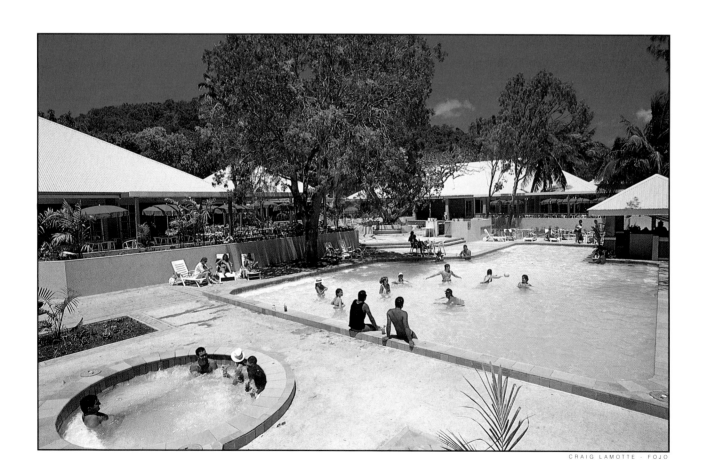

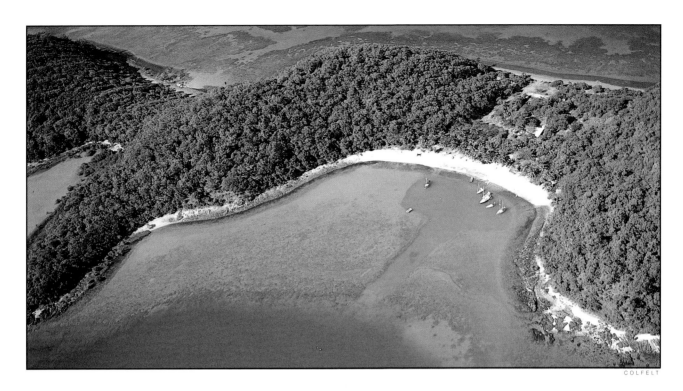

COLFELT

PALM BAY RESORT

Palm Bay Resort, PMB 28, Mackay, Qld 4741. Telephone: (079) 469 233.

Palm Bay is a tiny resort located just over a kilometre south of Happy Bay. An informal, budget-priced place for families and backpackers, it also offers peaceful anchorage within its lagoon and is a popular 'first night' stop-off for bareboat yacht charterers.

Palm Bay first opened as a resort in 1933 when it was operated by Tim Croft. It was one of the permanent casualties of cyclone Ada in 1970, when most of its buildings were blown off their cement slabs. The resort has operated since as a small, informal, friendly family camping affair, a combination of 'Sleepy Hollow' and 'Gilligan's Island'.

Accommodation on the lagoon side consists of nine cabins with kitchens (two of which have private facilities); there is a double bed and two double-decker bunks in each; bed linen is supplied. On the Passage side, accommodation is in 25 'camp-o-tels', fibreglass 'tent capsules' with fluorescent lights and radio-alarm clocks; ten of these have four berths (two double-decker bunks) and 15 have two berths (twin beds which can be pushed together to make a double). Communal toilet-shower blocks are located between the accommodation areas. Bed linen may be hired.

The central resort area consists of: reception; a small store which sells groceries, meat, dairy products and sundries; bar; small dining room where evening meals are available at a fixed price (the resort also sells barbecue packs); swimming pool; and barbecues.

A wide range of water sports equipment is available for hire, including jet skis, paddle boards, dinghies, catamarans, windsurfers; para-sailing, waterskiing, and 'big snake rides' are offered. Visitors are welcome to use the resort beach and facilities, and Palm Bay offers access to Long Island National Park's 13 km of walking tracks.

Above:
The Palm Bay resort is located on a narrow neck of Long Island and it has two sides, one facing The Narrows that separate the island and the mainland and the other looking east towards the Whitsunday Passage. A few years ago a channel was cut through the fringing reef and a small, all-tide lagoon created. Palm Bay now offers a good overnight anchorage for eight yachts (draught up to 2.5 m). Yachts pick up a mooring close to the beach and tie, stern-to, to a palm tree on the shore. There are also moorings outside the reef for deeper draught vessels. The usual charge is made for overnight anchorage.

SOUTH MOLLE ISLAND

South Molle lies a short distance across the Molle Channel from Shute Harbour, and its resort has traditionally been readily accessible to a wide cross-section of tourists and day-trippers. It first opened in 1937, with very humble accommodation, and it has grown with the times, now being one of the largest of the Whitsunday resorts and one which manages its many guests and casual visitors with deceptive ease. The resort has undergone almost continuous renovation over the past five years, and all rooms now offer air-conditioning with the rest of the accustomed three-star hotel comforts. The resident band provides entertainment every night, and there is a busy programme of activities.

One of the earliest islands to be inhabited, South Molle has a certain sense of history about it. It is large enough, with good walks and secluded beaches, to make it possible to get away, if one wishes to. The resort's all-inclusive tariff remains very competitive, offering value for money for families and travellers of all descriptions.

South Molle Island is close to the mainland, and with the advantages of its protected anchorage and beach on the lee side of the island, and its bountiful areas of grasslands, it became the first of the Whitsunday islands to attract a grazier, D.C. Gordon, who in 1883 took up a lease on the island. Long before that Aborigines had discovered a natural wealth of basaltic stones there which made excellent axes and cutting tools, and they called the island Whyrriba—'stone axe'—for that reason. The remains of the quarry where these were gathered may be seen today, on the way up to Spion Kop, the lofty prominence on the south-east side of Bauer Bay.

The grasslands of South Molle and North Molle were created by black hunter-gatherers with their regimes of fire, and the last of the Aborigines to live in the area told how they used to hunt on the neighbouring islands for game—for the weeneenee bird (Torres Strait pigeon) on West Molle Island, for wallabies, dugong and fish at Whitsunday, for turtles at Long Island.

South Molle, and indeed the Whitsunday islands themselves, were first popularised by the author Henry G. Lamond, who moved onto the island on Easter Monday in 1927. Lamond's earlier days were spent working and managing cattle stations in western Queensland. Through years of dust and droughts he was never able to shake off a childhood memory, one of shimmering tropical islands, an image that lingered long after his first trip through the Whitsunday Passage, in 1893, with his father, then the chief inspector of the Native Police in the Gulf of Carpentaria. Lamond's father pointed out the palm trees that had been planted on the sandy shores of many islands to supply food for shipwrecked sailors who knew nothing of the Aborigines' bush-tucker. Now many years later, Lamond confided to his wife, Eileen, that he was hankering for a change of scene from the Queensland outback and that an island might be just the thing.

Born and bred a country girl, Eileen was cautious about the proposal, and she is said to have agreed to *consider* moving on the condition that

COLFELT

Above:
Bauer Bay is quite tranquil even in the most blustery of weather, protected from the south-east trade winds by two lofty hills, The Horn and Spion Kop.

Opposite:
Aqua-bikes, dinghies, catamarans and other contraptions for fun on the water line the beach at Bauer Bay. The Whitsunday units are at the top of the beach, just behind the grass strip and palm trees.

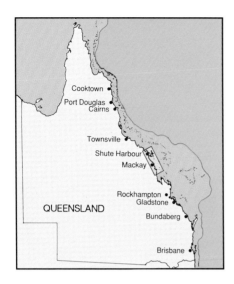

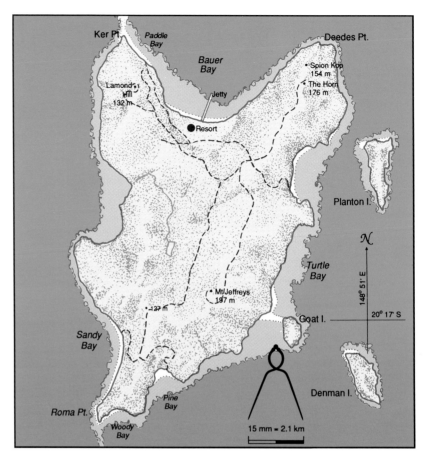

ISLAND SUMMARY
South Molle Island

20° 16'S 148° 50'E
Gateway: Shute Harbour (7 km) or
Hamilton Island (15 km)
1993 km N of Melbourne
1533 km N of Sydney
907 km NNW of Brisbane
494 km SE of Cairns

Island and resort details

South Molle is the largest of 7 islands making up the Molle Group. It is a rocky, high continental island (420 ha) covered with extensive grasslands, with areas of open eucalypt forest on rocky slopes and small patches of dense vine forest. The island has several coral sand beaches and some areas of well-developed fringing reef. It is a National Park and there are a number of good, graded walking tracks which offer spectacular views of the Whitsunday Passage and surrounding islands..

Access

From Shute Harbour: via South Molle's catamarans *Reef* and *Capricorn* daily at 9.00 a.m. (20 mins). From Hamilton Island: via water taxi (40 mins) which meets Ansett flights, or via helicopter (private charter) (5 mins). Seair Whitsunday amphibians can also land there.

Resort capacity, accommodation and facilities

Maximum about 500 guests plus day-trippers and some visiting yachtsmen. **Accommodation:** 202 rooms all with private bath, air conditioning, colour TV, direct-dial phone, fridge and mini-bar. 44 Whitsunday units right on the beach (max. 3 persons); 25 individual Beachcomber units just off the beach (max. 3 persons); 62 Reef units about 40 m from the beach (max. 4 persons); 30 Polynesian units on hillside overlooking Bauer Bay (max. 4 persons); 15 Family units behind the Reef units (max. 6 persons); 26 Golfside units looking out onto the golf course (max. 5 persons). **Resort facilities:** 9-hole golf course, 2 lighted tennis courts, 1 squash court, 25 m fresh-water swimming pool; children's wading pool; all water sports equipment; dive shop; gymnasium; sauna and spa; resort shop; hairdresser; coffee shop; fun parlour; entertainment lounge/disco; child-minding nursery; coin-operated laundromat. Free minding service for pre-schoolers (9.00 a.m. to 12.00 noon, 6.00 p.m. to 9.00 p.m.). Babysitting (by off-duty staff) is obtainable at normal rates.

Eating and drinking

Main resort dining room (7.00 a.m. to 9.30 a.m., 12.30 p.m. to 2.00 p.m., 6.00 p.m. to 8.00 p.m.); The Coral Room *à la carte* restaurant (6.30 p.m. to 8.30 p.m.); Coffee shop (9.30 p.m. to midnight); Discovery Bar (adjacent to pool) (10.30 a.m. to 1.00 a.m.); 1770 Bar (entertainment lounge bar) (10.30 a.m. to 1.00 p.m.); Golf Club bar (7.00 a.m. to 7.00 p.m.). Coffee shop has bottled liquor on sale.

Tariff

All inclusive (except for alcohol, and water sports requiring use of petrol).

Activities

Archery, beach sports, bird feeding, bush walking, carpet bowls, children's activities, golf, picnics, tennis, touch football, volleyball, aqua aerobics, aqua bikes, catamarans, dinghies with motor, fish feeding, fishing, paddle skis, para-flying, sailboards, sailing and windsurfing instruction, sausage rides, scuba training and demonstration, snorkelling, spy boards with motor, water skiing. Trips to the Barrier Reef are available (several days a week) on *Capricorn*; Reef trips are also possible with the helicopter from Hamilton Island and amphibious aircraft of Seair Whitsunday. Other island cruises are available.

Anchorage for yachts

South Molle has a number of moorings for yachtsmen (the customary fee is charged).

South Molle Island Resort, PMB 21 Mackay Mail Centre, Qld 4741. Telephone: (079) 469 433. FAX: (079) 469 580. Telex: 48132.

Henry found an island directly on a shipping route, surrounded by other islands, not too far from the mainland, and that it had to have a cottage surrounded by fruit trees. She no doubt thought she had set a sufficiently difficult task that this would be the last of it. As it turned out, the description fitted South Molle rather nicely.

The Lamond family lived on the island for ten years during which time Henry earned a living as an author of some note and by selling the wool of his cross-bred sheep. Lamond played an important role in publicising the Whitsundays with his articles published both in Australian newspapers and magazines and in journals overseas.

In 1937 Lamond exchanged his South Molle lease with Ernest Bauer for a dairy farm near Brisbane. Bauer, who had been a sugar farmer, dairy farmer, tailor and second-hand machinery dealer, among other things, also had a yearning for the idyll of island life, a flame that was kindled in more than one would-be adventurer by E.J. Banfield's *Confessions of a Beachcomber*—tales of paradise on Dunk Island.

The Bauers arrived at South Molle in May of 1937, with two other families, who left not very long afterwards. Island life, in reality, was not completely idyllic. The Bauer family, ten in all, went on to establish a resort on the island, and it wasn't easy, especially with the war intervening. The South Molle resort slowly took shape, and after a number of years it had earned a reputation for its relaxed informality. Old 'Pop' Bauer was a born entertainer who held his guests spellbound with stories and tricks after dinner. The resort accommodation was not fancy, but guests seemed to have a lot of fun, and they came back year after year.

The South Molle resort has changed hands a number of times since those days and has grown to be one of the larger of the Whitsunday resorts. Today operated by Ansett Airlines, it has retained an air of relaxed informality and continues to be comfortable in its niche as an easy-going family resort.

The resort

The resort is in the horseshoe bay, today called Bauer Bay, on the south side of the island between two tall hills, Lamond Hill and The Horn. It is well sheltered from the south-east trade winds. The beach is a mixture of quartz and coral sand, having been occasionally top-dressed in the past with sand imported to supplement the natural coral sand of its fringing reef. Like most such reefs immediately adjacent to Whitsunday resorts, it is largely cemented over; snorkellers find living corals to look at to the west towards Paddle Bay. The view north is beautiful, North Molle Island sitting up like a pyramid on the sparkling blue water, and the protected bay provides an excellent aquatic playground as well as a good anchorage for yachts.

Accommodation and tariff

South Molle has three standards of units, all of which have private bath, colour TV, air-conditioning, fridge and mini-bar and which accommodate from three to six people (and extra cots can be squeezed into some). At the top of the range are the Whitsunday units in a long, two-storey block in the centre and right at the top of the beach. The next bracket includes the Beachcomber units, individual cabins spread out along the beachfront on either side of the central resort complex, and behind these, the Reef Beachside units, about 40 m from the beach, in long, single-storey blocks. The third bracket includes: Polynesian units,

COLFELT

Above:
Aqua-aerobics in the Olympic pool.

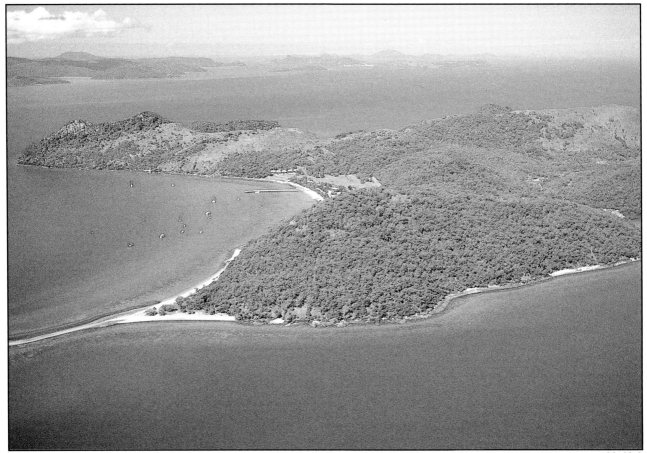

COLFELT

COLFELT

which are set about 200 m away from the central resort area on the hillside overlooking Bauer Bay; Golfside units, which will accommodate up to five persons, located at the back of the resort by the golf course; Family units, which accommodate families of six, with one room that can be shut off from the rest.

South Molle has an all-inclusive tariff; once you've paid for the holiday, you can forget about money.

Eating, drinking and entertainment

All meals are in the resort dining room, which is capable of serving a lot of people with a minimum of fuss. Fresh-air fiends can take their plates out and sit at a table by the pool. Guests are invited to sit with other guests in the dining room, which provides an opportunity to meet and make friends. Breakfast and lunch are buffet, and dinner is either table service or a barbecue by the pool. The food is plentiful and of a good resort standard. Island Feast Night is Friday, a special buffet barbecue with spit roast, a popular evening, and many bareboat yacht charterers and visitors from the mainland join in the activities.

South Molle also has an *à la carte* restaurant, the Coral Room, an intimate hideaway for dinner with a special menu and a bit more atmosphere than the dining room. A partial credit is given towards the price of dinner there.

Every night after dinner live entertainment is provided by the island's resident band, with guest participation on some nights. For those who prefer to be entertained in their room, videos are shown on the resort TV channel, and the island shop has video recorders for hire and a small video rental library.

Activities

South Molle offers a complete range of muscle-, wind- and motor-driven water sports equipment, at no extra charge for guests. Scuba diving instruction is available. There is a par 28, nine-hole golf course, day-and-night tennis courts, squash court and gym.

A National Park, South Molle has excellent graded walking tracks which lead to beaches on the other side of the island (the dining room is happy to pack a lunch for picnickers). The tracks also visit the island's high spots, such as Mt Jeffreys, Spion Kop and Lamond Hill, from which there are marvellous views over the island and the surrounding Passage.

Reef trips, diving and island cruises

South Molle has a dive shop and resident PADI instructor; scuba demonstrations are given in the pool and 'resort' and certificate courses are available. The resort operates two catamarans, *Capricorn* and *Reef*. *Capricorn* goes to the Barrier Reef several days a week, where guests can go coral viewing in the South Molle's coral sub and in glass-bottom boats, and snorkelling and scuba diving are also available. The resort offers a number of different island cruises, including a visit to the Hook Island underwater observatory (see Hook Island), a Three Island Cruise, a trip to the magnificent Whitehaven Beach on Whitsunday Island (see Whitsunday Island), and day excursions to the mainland.

Opposite top:
Bauer Bay, on the north side of South Molle Island, is enclosed on the west (lower left of the photograph) by The Causeway, a narrow isthmus that connects South and Mid Molle Islands. The entrance to Cid Harbour, Whitsunday Island, can be seen in the background.

Opposite bottom:
South Molle's nine-hole, par 28 golf course, with a temporary water hazard after a Whitsunday shower.

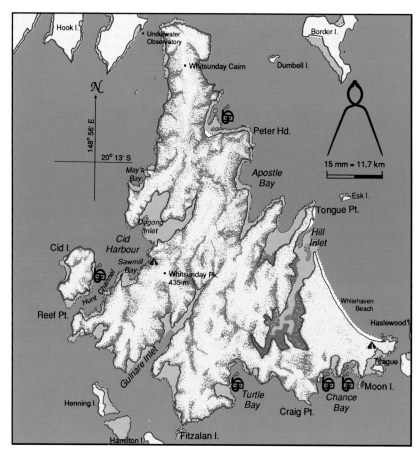

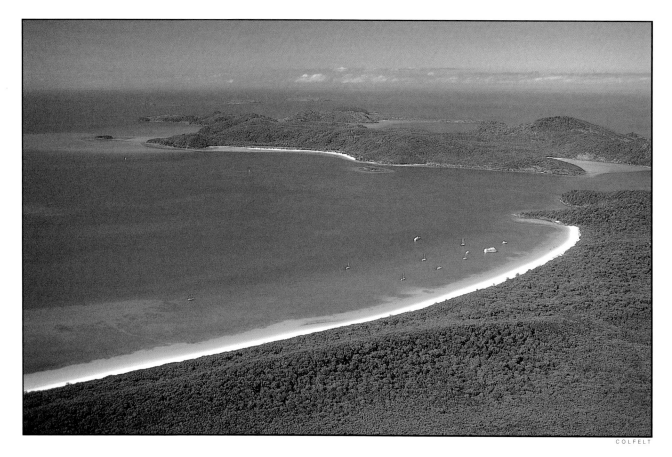

COLFELT

WHITSUNDAY ISLAND

Location: 20° 15′S 148° 50′E (20 km east-north-east of Shute Harbour).
Island details: Whitsunday is the largest of the Cumberland Islands, a high continental island (10 926 ha) with tall hills and numerous bays, some with good fringing coral reefs, deep inlets with rainforest and mangroves.
Access: Whitsunday is visited by day-cruise boats departing from Shute Harbour. Hamilton Island Cruises' and South Molle's catamarans take day-trips to Whitehaven Beach and may be joined at Shute Harbour or at the respective islands. Campers travel to Cid Harbour (Sawmill and Dugong Beaches) by day-cruise boat or water taxi from Shute Harbour.
Facilities: Whitsunday is a National Park, and there are developed campsites at Sawmill Beach and Dugong Beach, with toilets, picnic tables and tank water (except possibly during the dry months), and there is a campsite at Whitehaven Beach (with picnic tables and toilet).

Whitsunday Island dominates the eastern side of the Whitsunday Passage, a massive island which is said to be the only one which had a permanent Aboriginal settlement. A common sight in the Whitsundays is the hoop pines (*Araucaria cunninghamii*), which love the moist slopes of the islands, and those growing on Whitsunday Island caught the eye of early sailing ships' masters, who occasionally called into Cid Harbour, a large, natural harbour on the western side of the island, to cut a spar from the trees growing above the beach. These pines were too knotty to be ideal for the purpose, but they were very good in an emergency. Sawmill Beach at Cid Harbour was the site of the Aboriginal settlement and also the place where a sawmill was operated by John Whitnall between 1888 and 1904. Timber from Whitnall's mill was used to build many of the new houses at Bowen, the major port of the area in those days. Ruins of the mill are still there, and old tramway remains have been found at Gulnare Inlet, where timber was also cut and carted down to the water before being floated around to Cid Harbour. Myths about Cid Harbour having been a marshalling point for the US Seventh Fleet prior to the Battle of the Coral Sea do not withstand inspection, although it is said that Cid Harbour was used by some wounded destroyers afterwards.

Whitsunday Island is possibly best known today for the spectacular, 6 km stretch of pure silica sand on its eastern side, Whitehaven Beach. This is said to have been known to the Aborigines as 'whispering beach', the abode of the spirits, because of the sigh the wind makes when sweeping its long curve. The sand, 99% pure silica, is a legacy from a previous age, when a vegetated coastal plain lay to the south-east during a period of lower sea level. Whitehaven is a favoured destination for day-tripping catamarans, a popular anchorage for bareboat yacht charterers, and there is a National Parks campsite at the southern end of the beach. It is an unfortunate irony that this beautiful fine white sand is also appreciated by many fine white sand flies, and the use of insect repellent is highly recommended to visitors to the beach.

Between Whitsunday Island and Haslewood Island to the east is the narrow Solway Passage, which pinches the flow of the tide and which, when fresh winds and the tide oppose each other, can become a maelstrom, with whirlpools and breaking waves. Yachtsmen use care in negotiating this passage on windy days. The southern bays of Whitsunday Island have some excellent fringing coral reefs.

Opposite and below:
Whitehaven Beach on the eastern side of Whitsunday Island is by far the most spectacular beach of any island on the Queensland coast, a 6 km stretch of fine, white, pure silica sand. To the east lies Haslewood Island (which can be seen in the photograph opposite); together, Haslewood and Whitsunday create a broad, quiet stretch of water sometimes referred to as Whitehaven Bay.

COLFELT

Principal destinations of this section

From Townsville

- *Magnetic Island*
- *John Brewer Reef and the Barrier Reef Resort*
- *Orpheus Island and the Palm Islands*

Also

*Hinchinbrook Island**
*Bedarra Island**
*Dunk Island**

* Bedarra, Dunk and Hinchinbrook Islands are reached via Townsville in the case of travellers arriving from Australian cities to the south, but these islands may also be reached via Cairns (Dunk and Bedarra are actually nearer to Cairns than they are to Townsville). *Barrier Reef Traveller* has arbitrarily divided the coastline into six sections of equal geographic size, and these islands fall (and are therefore discussed) in the next section (SectionV: Hinchinbrook to Cairns).

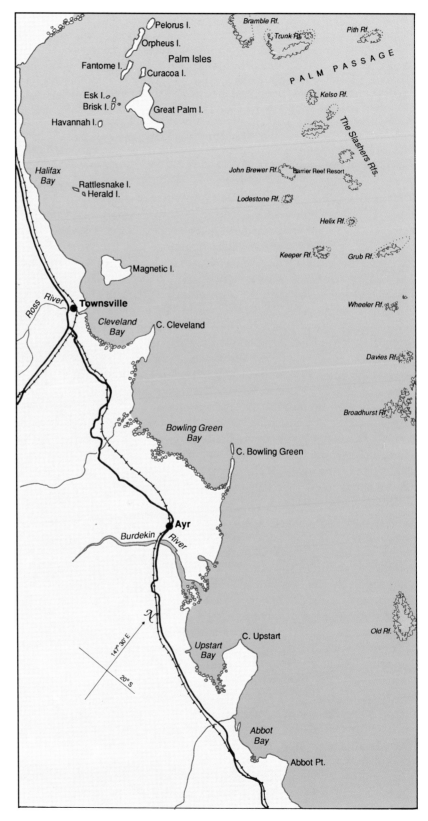

SECTION IV
TOWNSVILLE

Magnetic Island, John Brewer Reef and the Barrier Reef Resort;
Orpheus and the Palm Islands

Robert Towns, after whom the city of Townsville is named, was a man of shrewdness and determination, born with the unerring merchant instinct of the Northumbrian. At the age of 11 he was an apprentice aboard a Newcastle collier, was mate at 16, skipper at 17, and by the time he reached the age of 26 he was commander of his own clipper ship. From an early age Towns was prepared to try his hand at just about anything, and as a young shipowner he reputedly once said that he would 'sail to Hades and back if there was a profit in it'.

Towns settled in Sydney in 1842. Almost immediately he smelled an opportunity in the sandlewood trade, procuring that precious, fragrant wood from the islands of New Caledonia or the New Hebrides (Vanuatu) and shipping it to Asia for Chinese Buddhists to burn on religious and ceremonial occasions, or to be made into luxury articles such as inlaid boxes, fans and perfumes, or for medicinal preparations. It was an important export for the Australian colony, which had an insatiable thirst for Chinese tea and a nagging balance-of-payments problem. The knowledge gained about the natives of the western Pacific during Towns' years in the sandlewood trade enabled him to be the first to successfully import island labourers—*kanakas* as they were called— initially to work on his cotton plantation near Brisbane (in 1863) and later to work Queensland's cane fields. Towns, by the 1860s, had a fleet of ships and significant property holdings in Sydney, as well as interests in the expanding frontier in northern Queensland. He was to play the central role in establishing Townsville, which was proclaimed a port of entry in 1865 and which was to quickly establish itself as the northern cattlemen's port of choice. Most of the heavy work of clearing and building the new city was done by Towns' *kanakas*.

In the early days Townsville's main street was a rough track full of tree stumps, one side lined with bark huts, the other flanked by the Ross River, its banks lined with large salt-water crocodiles which basked fearlessly in the afternoon sun. Today that street, where it traverses the centre of the city, is a landscaped pedestrian mall, lined with Townsville's smartest shops. The city has some examples of Queensland Victorian architecture at its best.

Townsville itself is as flat as a tack with the exception of one dominating bare granite hill, Castle Hill, which provides an excellent vantage point from which to survey the city and the surrounding hilly country. It is the closest of all Australian cities to the outback, which begins 135 km south-west at the historic gold-mining town of Charters Towers. The unofficial capital of northern Queensland with a population of about 120,000, Townsville exports over 1.5 million tonnes of minerals, sugar and meat each year, serving the farms of the Burdekin and the Mt Isa mines in the far west of the State, where some of the world's richest deposits of copper, silver, lead and zinc are found. Townsville is the site of major army and air force bases; it is the centre for Australian tropical and marine research, being the home of the James Cook University of North Queensland, the CSIRO's Tropical Agriculture Research Station,

COLFELT

Above:
The Townsville landscape is dominated by a bare granite hill, Castle Hill, seen here as a backdrop to Ross Creek. Great Barrier Reef Wonderland, the world's largest living coral reef aquarium, is in the grey building in the right foreground. Townsville is not a city of skyscrapers, and the Townsville International Hotel (left) is a distinctive landmark, designed to look like a giant sugar shaker, a reminder of the importance of sugar to the port and reminiscent of structures, such as 'giant pineapples and peanuts', found elsewhere in Queensland, a State very dependent upon primary production and, increasingly, on tourism.

and the Australian Institute of Marine Science. The Great Barrier Reef Marine Park Authority, which manages and monitors The Reef, is located at Flinders Street East, on the Ross Creek next to the world's largest living coral reef aquarium, Great Barrier Reef Wonderland.

How to get to Townsville

By road. Townsville is about three hours' drive from Proserpine, the next gateway to the south, and about 17 hours from Brisbane. From Cairns it takes about four hours. Townsville is served by all the major bus companies; travelling straight through, it takes 18 to 21 hours by bus from Brisbane, about four and a half hours from Cairns.

By air. Townsville is an international airport. It is 1 hr 45 mins non-stop from Brisbane (with Ansett or Australian Airlines), and Sunstate Airline's Coastal Connection, which links the coastal cities, has one flight to and from Townsville every day.

By rail. It is 26 hours from Brisbane on the weekly tourist train, the Queenslander (which offers 'motorail' service), and the Sunlander commuter train (five days a week) takes 27 hrs 15 mins. It's about six and a half hours by train from Cairns.

Townsville weather

Townsville is located in a 'rain shadow' and boasts the highest number of sunshine hours of any Australian city, an average 282 sunny days a year, according to one set of figures, although recent tourist literature credits Townsville with an average eight hours of sunshine a day, 365 days a year (statistics which may be just a 'little bit pregnant').

	Jan.	Apr.	July	Oct.
Avg. Daily High	31°C	29°C	25°C	29°C
Avg. Daily Low	24°C	20°C	13°C	20°C
Days Rain (over 0.2 mm)	16	8	3	5
Normal Rainfall	230 mm	34 mm	2 mm	15 mm
Mean Sea Temp.	27°C	26°C	22°C	24°C
Normal Annual Rainfall = 1106 mm				

GBRMPA

Tourist information
The Magnetic North Tourism Authority (and its 'copper top' kiosk) is in Flinders Mall not far from the post office—the Denham St end of the mall—Townsville, Qld 4810. Telephone (077) 71 2724.

Accommodation
Townsville's rapidly developing tourist industry has prompted the building of a number of new hotels and motels in recent years. The centrepiece is the five-star Sheraton Breakwater Casino Hotel, and there are a few others in the very-good-to-good category, such as the Ambassador, the Reef International Motel, and the Townsville International Hotel. The city also has a few old-style Australian hotels (pubs), a broad range of run-of-the-mill motels, and two hands are needed to count the backpackers' inns, including several very smart new ones. Townsville has holiday apartments, four caravan parks, and several 'resorts'.

Great Barrier Reef Wonderland
One of the most exciting new tourist attractions for Townsville is Great Barrier Reef Wonderland, at Flinders Street East, the redeveloped end of Flinders Street right next to the Ross Creek. Wonderland's central attraction is a live coral reef aquarium, the largest of its kind in the world and one which has carried technology, developed by Dr Walter Aidey, of Washington DC's Smithsonian Institution, to new heights.

The aquarium provides an opportunity to see a living coral reef and its associated life with a wealth of interpretive material to explain the fundamentals of reefs and their marine life. Its main tank, 17 m x 38 m x 4.6 m deep, contains a transplanted coral reef, for which coral rock substrate was obtained from Hayman Island when its new boat harbour was created, the live coral from Flinders Reef, 149 nautical miles north-east of Townsville. The aquarium's reef includes all organisms that normally play a role in maintaining a balanced reef community, in about their normal numbers.

To keep a reef alive in a tank is no trifling matter. Oceanic conditions are mimicked by an artificial wave generator—a bank of high volume fans which pressurise chambers at the base of the tank, forcing air out and creating waves. Currents are induced in the tank, and high and low

Above:
The Wonderland Aquarium's walk-through tunnel of 65 mm acrylic plastic separates the main tank, with its living coral reef, from the predator tank, giving visitors a real underwater perspective. Other displays at the aquarium complex also give a good introduction to The Reef, its origins and its diversity of marine life.

Note on aquarium photography
Water clarity in the Reef Wonderland aquarium is probably better earlier than later in the day. Maximum light is available at noon, although this may not necessarily be the most pleasing light for photography. The predator tank is always on the dim side, so very high-speed film may give best results. A polarising filter is useful to cut reflections if photographing down into the tank from above. The best lenses for 35 mm cameras are those with a focal length of 28 mm or 35 mm.

COLFELT

Above:
Fantasy Island was to be the Barrier Reef pontoon of the future, an idea from the fertile imagination of Doug Tarca, creator of the pioneering Reef Link cruise from Townsville to John Brewer Reef. A hexagonal, doughnut-like floating pontoon, Fantasy Island had a restaurant, bar, tables and chairs, central swimming area, showers—even palm trees—and it provided all comforts for Reef Link day-trippers. It was also a place for guests at the floating hotel to get away from their own fantastic island. Towed into Brewer lagoon and anchored there in May 1988, only ten days later Fantasy Island was sunk by a storm and consigned to the ranks of nautical relics in Davy Jones' Locker. It has since been removed from the floor of the lagoon.

tides can be simulated. The chemistry of the water is maintained by 87 'algae turf scrubbers', shallow tanks with wire screens that have living algae in the mesh, through which all of the aquarium water is circulated every 24 hours. The algae simulate the conditions on a reef, helping to keep the water oxygenated and removing wastes and excess nutrients.

The Wonderland reef has about 100 different species of hard corals, 30 species of soft corals and more than 1500 fish of 300 different species. A smaller tank contains reef predators, and this is separated from the main tank by a transparent walk-through tunnel, constructed of 65 mm acrylic plastic; visitors standing (literally underwater) between the two tanks are able have a life-like view, with a reef lagoon on one side and predators hovering behind as if on the reef's outer margin. Other displays include numerous small tanks of living reef curiosities, and there are static exhibits, videos, and a theatrette that shows a film on the origins of the Great Barrier Reef. One exhibit which is especially enjoyed by children is a 'touch tank', representing a typical reef flat (inter-tidal zone), with the animals that normally inhabit this part of the reef, all of which may be touched.

The aquarium provides an introduction to coral reef ecology, an excellent way to prepare for a first visit to The Reef. Allow at least two hours to see it properly. Flash photography is not permitted, so load your camera with a medium- to high-speed film (see note on page 153).

Also part of the Wonderland complex is an Omnimax theatre, with its domed ceiling (screen) and seats tilted back so that spectators can watch without craning their necks. Omnimax is reputedly the best visual display system in the world and projects its large-format image (ten times the size of ordinary 35 mm film) through a fish-eye lens giving a picture that extends 180° laterally and 130° vertically. Viewers are given the feeling of being part of the action on the screen. Tip: the best seats are in the middle of the theatre. Several different shows are screened each day, lasting about one hour each.

Reef trips from Townsville

Townsville's Reef Link was the first Barrier Reef trip to offer its patrons the chance to view a coral reef from a semi-submerged coral-viewing 'submarine', and its founder, Doug Tarca, heightened the sense of fantasy by painting the unique vessel yellow. This pioneering day-trip, which goes to John Brewer Reef (74 km NNE of Townsville), proved so popular that it was emulated up and down the coast, and such partly submerged vessels are now commonplace along the Barrier Reef. A man of irrepressible ideas, it was Tarca who dreamt up the idea of a floating hotel, the one now anchored in the lagoon at Brewer Reef. His *Reef Link II*, a 400-passenger catamaran, does a daily passenger run to the hotel and at the same time takes day-trippers out for a day of snorkelling, diving and coral viewing in the yellow submarine.

John Brewer Reef was one of those badly damaged by the plague of crown-of-thorns starfish in the mid-1980s, and while it is now on the road to recovery, it has not yet returned to its full Barrier Reef glory. *Reef Link II* departs at 8.30 a.m. from the jetty right next to Reef Wonderland. The trip out takes 90 minutes; lunch is provided, and the boat returns about 5.00 p.m.

Islands cruises

About 65 km north of Townsville is a cluster of continental islands called the Palm Islands, a beautiful group of 11 islands very much favoured for their unspoilt beauty and sheltered anchorages. In spite of being rela-

tively close to the mainland, they have some of the best fringing reefs to be found in Australia, with the richest diversity of corals in the Reef Region. The largest of the group, Great Palm Island (5666 ha), may play some part in this, by deflecting the sediment-laden outflow of mainland rivers (which runs northwards) away from the islands to its north. The Palms can therefore offer tourists a high-quality 'Barrier Reef' experience relatively close to the mainland.

When Cook sailed by the Palm Group on August 7th, 1770, natives were seen on a number of the islands, but it was the palm trees on one that particularly attracted the *Endeavour's* crew; Cook's journal notes: 'a few of these nutts would have been very expectable [*sic*] to us at this time'. So he sent a shore party to collect coconuts. The men, unfortunately, returned empty-handed, the palms being of the rather unexpected 'cabbage' variety; but that's evidently how the Palm Group got its name. All but two of the Palm Group are today Aboriginal Reserves, Great Palm Island having a major settlement. Fantome Island was, until 1973, an Aboriginal leper colony run by the Catholic Church. Permission to go to any of the Reserve islands must be obtained from the Aboriginal Council on Palm Island and/or through the Department of Community Services.

There are two day-trips from Townsville to the Palm Group. Pure Pleasure Cruises' 15 m catamaran departs most days of the week from the Breakwater Marina, bound for Orpheus Island, where the company has a pontoon and jetty at Yankee Bay. Guests have lunch on the pontoon and can swim, snorkel, go coral viewing in a glass-bottom boat or dive in the bay, which has some good coral, or go ashore to get some sand between their toes

Below:
The view from Orpheus Island, looking south-east towards the massive silhouette of Great Palm in the far distance. Like most of Queensland's coastal continental islands, Orpheus is rugged and rocky; these islands are, after all, the tops of a coastal range of yesteryear.

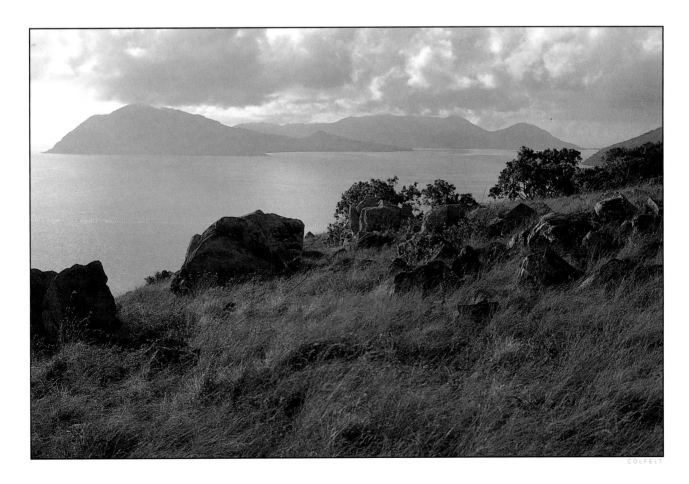

or go bushwalking. *Pure Pleasure* departs at 9.00 a.m. and takes two and a half hours to get to Orpheus; it is back at the marina by 5.00 p.m.

Westmark Cruises also does a day-long 'Palm Island Cultural Cruise' in its 140-passenger catamaran several days a week, a cruise through the Palm Islands stopping at Great Palm Island to witness Aboriginal and Islander dancing. Passengers rejoin the boat for a seafood smorgasbord lunch, and then go on to Falcon Island for one and a half hours of swimming and snorkelling on the fringing reef. This trip leaves from Westmark's Wonderland jetty at 9.00 a.m. and is back at 5.00 p.m.

Extended cruises operating from Townsville include one on a new 54 m catamaran, the *Coral Princess*, which can accommodate 54 guests in air-conditoned twin cabins or staterooms, and which does a three-day cruise to Cairns, departing Tuesdays at 1.30 p.m. and arriving in Cairns Friday at 3.30 p.m. The *Princess* goes via the Palm Group, overnighting at Orpheus, then proceeding to Pelorus Island, through the Hinchinbrook Channel and on to the Family Group, stopping at Dunk Island for the night. Next morning *Princess* heads off early for the outer Reefs, visiting a number of reefs and overnighting there. The last day is spent at The Reef and then getting to Cairns.

Westmark also offers extended cruise itineraries (three to seven days) in its luxury liner, the 60 m MV *Louisanda*. This air-conditioned vessel has 18 suites, each with well-appointed private facilities. *Louisanda* departs Thursday evenings from Townsville bound for the Whitsundays, with a mixture of day-time and overnight stopovers at Hayman, South Molle and Hamilton Islands and visits to the Barrier Reef and island beaches. It returns to Townsville on Monday morning, and then sets out again, that afternoon, on a three-day segment which overnights at Great Palm Island, proceeds to Dunk Island for the day, then an overnight voyage to Cairns, where passengers spend the day. The return to Townsville is via Orpheus Island research station.

Diving

Townsville has long been a destination for scuba divers, with one of the world's best wreck dives (the *Yongala*) and one of the Barrier Reef's longest established dive organisations, Mike Ball Watersports, with its modern (PADI five-star) diver training complex complete with three-metre-deep pool and eight-metre-deep diving well. The Ball organisation has four high-speed, completely air-conditioned catamarans, *Spoilsport* (30 m), *Supersport* (27 m), *Watersport* (20 m) an da new one, *Scubasport* (15 m), which do two- to ten-day dive excursions to the Barrier Reef, to reefs well out in the Coral Sea, and to the wreck of *Yongala*. A progressive marketer, Mike Ball has put together dive packages, such as his eight-day special, which does one day at The Reef, five days in the Coral Sea (at Flinders Reef, 245 km north-east of Townsville), and two days at *Yongala*—an itinerary with a range of diving experiences hard to beat anywhere in the world. The Coral Sea is renowned for its clarity of water and excellent 'wall' diving, with large predator fishes; the Barrier cannot be bettered for its variety of corals and reef fishes; and divers come from everywhere to dive on the wreck of *Yongala*, a 100 m ship that sank with the loss of over 100 lives in 1911. The wreck lies in 30 m of water on sand and is alive with fish and marine life.

All of Ball's vessels that do overnight trips are air-conditioned throughout and provide an on-board film processing service (E-6 process, for transparency film), and a full range of equipment is available

for hire, including Nikonos cameras, underwater flash units and diver propulsion vehicles. Beginning 1989 Ball Watersports will also be offering daily diving to the Great Barrier Reef in *Scubasport*.

The Dive Bell, whose dive shop is located on the highway to Ingham just past the Townsville showgrounds, offers regular week-end dive trips in the Townsville area with its 20 m monohull, *Hero*. This vessel has air-conditioned cabins and, with its Lloyds survey, can take 10–14 day trips to Coral Sea destinations, such as Flinders and Lihou Reefs, the latter some 500 km offshore. These long voyages set off throughout the months of October and November, the period of transition between the south-easterlies and the onset of the summer northerlies, when the conditions are usually at their quietest in the Coral Sea. Dive Bell also offers diver training (up to assistant instructor level).

Fishing

Townsville has an established reef-fishing charter fleet and a rapidly growing number of game-fishing vessels. Fast day-charter boats take parties of 8–12 anglers out in search of bottom-feeding fishes, such as coral trout and sweetlip, that are caught around the local reefs off Townsville. The city is also becoming known internationally as a light-tackle game-fishing centre following the discovery a few years ago of aggregations of small black marlin off Cape Bowling Green (C 21–22) about 55 km to the south-east, which can be caught year-round. Records for catches of small black marlin and sailfish have tumbled to Townsville charter boats in recent years. Light-tackle fishing charters usually cater for a maximum of four. From September to December heavy-tackle game-fishing charters head out to Myrmidon Reef, 125 km to the north-north-east, going after giant black marlin, dogfish and yellowfin tuna.

Below:
Orpheus Island has very well-developed fringing reefs, with a great diversity of corals and reef fishes.

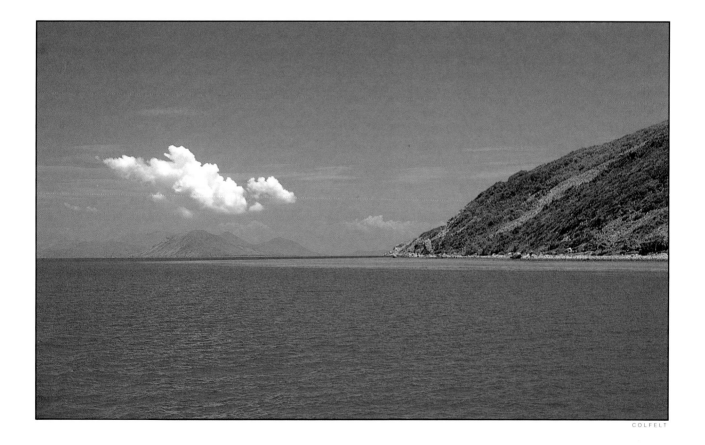

COLFELT

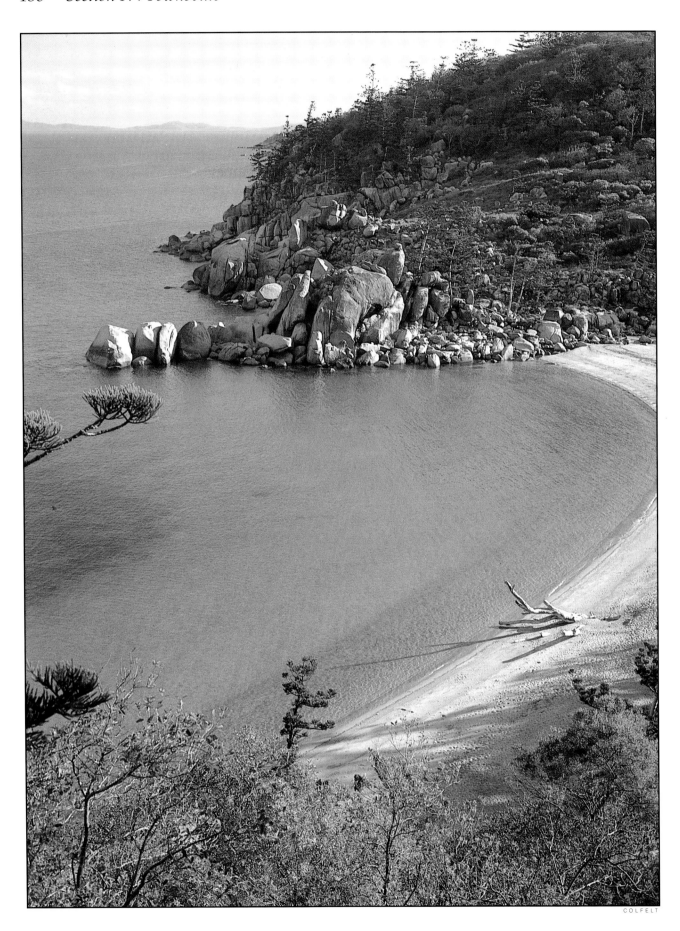

MAGNETIC ISLAND

Magnetic Island is a continental island located 8 km off the coast from Townsville. Rather than a resort island, it is an island of resorts, and holiday flats, and it is also a dormitory suburb of Townsville with a permanent population of over 2000. Magnetic has a sense of yesterday about it has traditionally been a place for informal, low-key family holidays or for those travelling on a budget, with plenty of secluded beaches and unspoilt natural surroundings. Several large new tourist developments are planned, but the island is large, too, and will probably take these in its stride, still providing escape for those who prefer a slower lane.

When Cook arrived at Townsville and Magnetic Island in 1770, he described them as 'the most ruged, rocky and barrenest surface of any we have yet seen', a description that, from seawards, quite befits Townsville, with its barren Castle Hill, but which is too harsh for the majestic, blue island that lies not far offshore. Cook was uncertain as to whether Magnetic was an island, and in writing up his journal he first gave it the name of 'Barren Head', later changing it to 'Magnetical head or Isle' because his compass, for some reason, 'would not travis well when near it'. Today's nautical charts show no such magnetic anomaly in the area (there are other locations along Cooks' trans-Pacific route where his compass, which was primitive by today's standards, went haywire, and the reason for this is not apparent today).

The name, since Cook, has been abbreviated, and its original meaning has been subverted by modern-day promoters, who use it to suggest the attraction of the island, but it is also appropriate in that this massive granite isle has seemingly entrapped time, drawing it in and recurving it amongst its massive boulders; time on Magnetic seems to be in an eddy, and the island has a quiet peace that one usually associates with days gone by.

Residents and tourists reach the island by fast ferry (regular catamaran services are offered by two companies) which go mainly to Picnic Bay, one of the principal settlements at the southern end of the island, or to Arcadia, another settlement on Geoffrey Bay where there is a jetty for unloading vehicles. A sealed road traverses the east coast from Picnic Bay to the beautiful, secluded Radical Bay, and along this road are a series of bays—Nelly, Geoffrey, Alma, Arthur, Florence, etc.—names belonging to the children of a family of Pearces who lived in Townsville in 1886, when J. G. O'Connell surveyed and named many parts of Magnetic Island in the vessel *Radical*.* Some of these have sand beaches, fringing coral reefs, and all have a feeling of wilderness which will probably be changed in years to come, one hopes not too radically. A bush road runs along the western side of the island from Picnic Bay to West Point. About one-half of the island is National Park, and there is an abundance of wilderness and native wildlife which attracts many to the island.

Accommodation

Magnetic has not traditionally been an international tourist destination, and its existing accommodation caters largely for families and back-packers, although there are two three-star resorts, the largest being the

COLFELT

Above:
Large granite boulders glow in the late afternoon sun at Geoffrey Bay. Like ancient ruins weathered by the eons, they have captured time on this island and slowed it down, imparting a sense of quiet and permanence.

Opposite:
Arthur Bay, on the east coast, is just one of many peaceful and secluded inlets around the shores of Magnetic Island.

* Nelly Bay is also said to have named after Ellen ('Nell') Butler, born 1872, the daughter of the first permanent white settler (1877) on the island, Harry Butler; moreover, it is also claimed that Nelly Bay is named after Nellie Bright, adopted aboriginal daughter of William and Mary-Ann Bright, the first successful farmers at Nelly Bay (around 1900), after whom Bright Point is named.

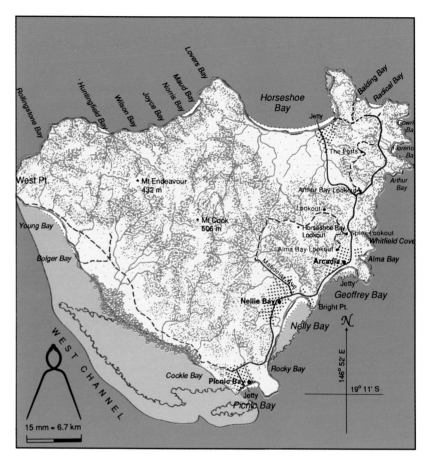

ISLAND SUMMARY
Magnetic Island

Location: 19° 08'S 146° 50'E
Gateway: Townsville (9 km)
2090 km N of Melbourne
1698 km NNW of Sydney
1123 km NW of Brisbane
271 km SSE of Cairns

Island details

Large, rocky continental island (5184 ha) separated from the mainland by the 8 km-wide, shallow West Channel. Roughly triangular in shape, it is thickly wooded with primarily open eucalypt forest; there are patches of rainforest and extensive mangroves at Missionary Bay and along its wester side; hoop pines line the headlands and granite ridges. Magnetic is studded with peaks (the highest, Mt Cook 506 m) covered with huge granite boulders. The island has 40 km of indented coastline with many secluded, sandy bays, some with fringing reefs. Approximately one-half the island is National Park, and there are numerous leases and freehold lots. It supports a permanent population of over 2000, with settlements at Horseshoe Bay, Alma Bay, Geoffrey Bay, Nelly Bay, Picnic Bay, Bolger Bay and West Point.

Access

From Townsville: chiefly by passenger catamaran (20 mins) or vehicular ferry (55 mins); helicopter landing facilities available for private charters. Two companies operate ferry services. Magnetic Marine, departing from the terminal at 168-192 Flinders St. East or from the Breakwater Marina and going to Picnic Bay and/or Arcadia Bay, has 10 daily passenger services on weekdays (9 on weekends and public holidays). Magnetic Marine also operates a vehicular ferry, departing from Ross Creek (south side) and going to Arcadia Bay only; there are 3 services daily (2 each day on weekends). Westmark's catamaran ferry service departs from the Reef Wonderland terminal and goes to Picnic Bay, with 10 daily services on weekdays, Sundays and public holidays (there is 1 extra, late-service Friday and Saturday night) and 9 services on Saturdays.

Accommodation

Magnetic Island is different from most Queensland islands in that it is not just a single resort but a local community, an island suburb of Townsville with accommodation ranging from conventional resorts (such as Latitude 19 Resort and Arcadia Holiday Resort) to budget-priced backpackers' resorts (Geoff's Place at Horseshoe Bay, Shark World at Nelly Bay), backpackers' hostels (Woody's Foresthaven hostel at Arcadia, Centaur House at Arcadia, Hideaway hostel at Picnic Bay), to a range of self-contained holiday units/flats. There are shopping centres and pubs at Arcadia and Picnic Bay. Magnetic Island is destined to have a number of new tourist developments, including a large resort, condominium development and marina, called Magnetic Quay, at Nelly Bay, a new resort and condominium development at Radical Bay, redevelopment of the Arcadia Holiday Resort, and a proposed resort for Florence Bay.

Activities

Virtually all holiday activities such as those found at any resort are available at Magnetic, including scuba diving, snorkelling, swimming, water sports equipment for hire, golf, and the generally unspoilt island environment lends itself ideally to lazing on deserted beaches, bushwalking (with magnificent views from lookouts on National Parks graded walks), wildlife watching. Mini Mokes, motorcycles and bicycles are available for hire. Other attractions include Koala Park Oasis at Horseshoe Bay and the Shark World marine display at Nelly Bay. The island has a bus service, and 4-wheel-drive tours to out-of-the-way spots are offered.

Reef trips and island cruises

Townsville-based operators doing trips to The Reef and to the Palm Group of islands call in at Picnic Bay to pick up passengers.

96-room Latitude 19 Resort, set back from Nelly Bay on the south-east side of the island, the next largest the 27-room Arcadia Holiday Resort, just across the road from Geoffrey Bay. There are several quite large backpackers' hostels/resorts, and camping is offered at one or two of these (no camping is permitted within the National Park). Magnetic also has a number of smaller 'resorts' and holiday units.

Over the next several years the island is to undergo significant development. There is to be: a large condominium-resort-marina complex at Nelly Bay, called Magnetic Quay; a new 250-room three-plus to four-star resort, with 15 condominiums, at Radical Bay; redevelopment at Arcadia Holiday Resort; a new 339-room four-star resort ('low-key, low-rise') at Florence Bay. All of this sounds as though it may jolt Magnetic sufficiently that it may lose some of its existing magnetism, but the tourist authorities assure that the ambience of the island will not be destroyed.

Activities

With its many bays and beaches, water activities, including snorkelling at some good fringing reefs in the eastern bays, are an important part of a Magnetic holiday. The fringing reefs at some of Magnetic's eastern bays have a good diversity of coral, and when it isn't too windy the visibility is good enough to enjoy snorkelling. Geoffrey Bay has a guided trail for reef-walkers at its the southern end. All those who swim or snorkel at Magnetic Island should note that the island is large enough and sufficiently close to the Queensland mainland to be a potential habitat for dangerous marine stingers, and entering the water without some protection from stingers is not a good idea during the November–April stinger season (although there are those on the island who swear that some eastern and north-eastern bays are stinger-free). During the stinger months visitors should plan to swim in a resort pool or at beaches where there may be a stinger enclosure (the pool at Arcadia is open to the public). Scuba diving is available on the island, including PADI tuition up to Divemaster level, at present conducted by Magnetic Diving at the Arcadia Hotel complex. This organisation also arranges diving at several backpackers' resorts, and it offers tuition packages which include five days' free backpacker accommodation with its Open Water Diver certificate course.

Being a National Park, Magnetic has a number of graded walking tracks, with splendid views from lookouts along the way, which can offer an opportunity to see koalas and other wildlife. The island was sentinel to Cleveland Bay and Townsville during World War II and was the site of the Port War and Signal Station, with observation and command posts and two large guns and searchlight batteries. 'The Forts', which can be reached from one of the walking tracks and which offers spectacular views, is the remains of this emplacement.

Those who prefer to explore the island on wheels can rent a Moke, motorbike or bicycle from several agencies at Picnic and Nelly Bays.

Reef trips and island cruises

Townsville operators going to the Barrier Reef and to the Palm Islands stop off at Picnic Bay to pick up passengers.

Above:
There is much to explore on the hilly island, and renting a Moke for the day is one way of getting around to see it all. National Parks tracks also provide panoramic views for those who wish to go on foot beyond the sealed road that traverses the eastern side of the island.

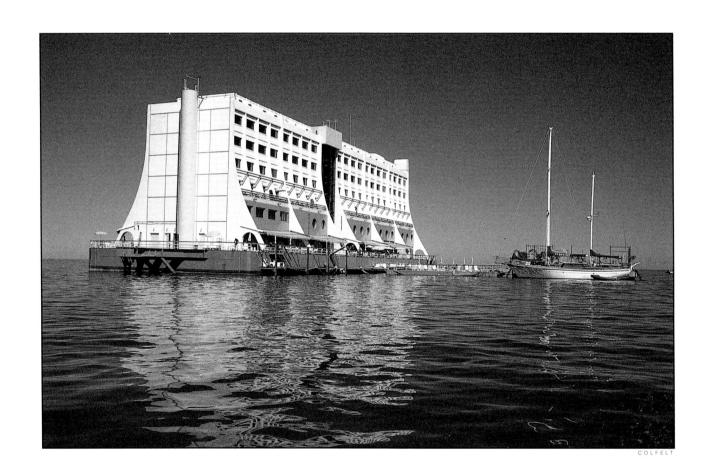

COLFELT

THE BARRIER REEF RESORT

The Barrier Reef Resort, said to be the world's first floating hotel, is a stylish, up-market resort anchored 74 km offshore in a Barrier Reef lagoon. It offers a novel experience and will appeal especially to those who enjoy having 'been there and done that'. The hotel offers The Reef right at the doorstep, and while this has obvious advantages, in practice the benefit is sometimes diminished by the facts of weather and wind at an offshore reef; not infrequently water-based activities must be cancelled because it is choppy in the lagoon. On a calm evening, however, the experience of being, for all intents, out in the middle of the ocean, watching a fiery sunset and dining on five-star cuisine in the middle of a reef lagoon, is unique for most tourists.

Barrier Reef Holdings Pty Ltd's prospectus for the world's first floating hotel read like a bit of fantasia when it was issued in late 1985. To sceptics the whole idea seemed a tribute to man's indominability if not to his grip on reality. A little over two years later, when the incredible seven-storey structure was deposited in the lagoon at John Brewer Reef, 74 km north-east of Townsville, the new resort became, simply, a wild dream come true.

However, for Barrier Reef Holdings, the owner of the resort, 1988 unravelled like a nightmare. Soon after it arrived, the hotel and its multi-million dollar anchoring system were to be tested by tropical cyclone Charlie, with 100 km winds, an event anticipated by the engineers and one which the structure weathered without event. A more severe trial was to be posed by Brisbane's Expo '88. Instead of a healthy rush of patrons to the luxurious and novel hotel, there was a deathly quiet (which was also experienced at other north Queensland resorts). The floating hotel also had a few to-be-expected teething problems, plus a few unforeseen by armchair planners who had never been near a Barrier Reef lagoon and whose designs for some of the floating attachments proved unequal to the task. Within a few months of its opening, the hotel, which was positioned at 'the upper end of the tourist market', was offering half-price specials to the citizens of Townsville in order to get some bodies into the empty beds and to give the staff something to do. Six months after the opening, the resort owners were at war with their own professional resort managers, Four Seasons Hotels.

Barrier Reef Holdings, late in 1988, accepted an offer from a large Japanese hotel/resort company, EIE International, to purchase 51% of the shares, and when the tourist season gets underway again in 1989 the resort will no doubt be re-launched under new professional management with a renewed determination to fulfil the original dream plan.

The 'floating hotel' is a brave idea, and it is never going to be totally without its own special problems. The structure is physically very stable and protected from big waves by the reef itself, and only the slightest movement is detectable; in this respect the resort is more like a traditional hotel than a ship. However, when sitting in a Barrier Reef lagoon, one has little option but to take what comes, and at times of brisk trade winds, guests will be reminded that they are at sea and that they can forget about playing on a floating tennis court.

Opposite:
The world's first 'floating hotel' anchored within the lagoon at John Brewer Reef, 74 km out in the ocean north-east of Townsville.

REEF SUMMARY
John Brewer Reef

Location: 18° 38'S 147° 04'E
Gateway: Townsville (74 km)
2148 km N of Melbourne
1746 knn N of Sydney
1156 kn NW of Brisbane
236 km SE of Cairns

John Brewer Reef and Barrier Reef Resort details

John Brewer Reef is a lagoonal platform reef (1750 ha) 74 km NNE of Townsville; approximately 7 km long and 3 km wide, the reef has a large lagoon with average depth of about 8 m which provides shelter for fishing vessels and a mooring site for the world's first 'floating hotel'.

Access

From Townsville: via *Reef Link II*, high-speed catamaran departing daily from the Reef Wonderland terminal at 8.30 a.m. (90 mins); via Lloyd's Helicopter Service at Townsville airport, on demand, during daylight hours only (20 mins).

Resort capacity, accommodation and facilities

Total capacity about 400 guests, in 7-storey floating hotel. **Accommodation:** 175 standard and deluxe twin/double rooms and standard and deluxe 2-room suites (deluxe are on 2nd floor and have balcony); all are air-conditioned, with private bath, colour TV, direct-dial phone, mini-bar and fridge. **Resort facilities:** Floating tennis court; underwater viewing chamber; library; gymnasium and sauna; nightclub; resort shop; dive shop; conference room; water sports equipment.

Eating and drinking

Reef Room restaurant, *haute cuisine*, (6.00 p.m. to midnight); Marina Café (6.00 a.m. to midnight). Verandah Bar (10.00 a.m. to midnight); Lobby Bar (10.00 a.m. to 10.00 p.m.); Boiler Room nightclub/disco (8.00 p.m. to early morning). 24-hour room service is available.

Tariff

Room only (but including use of tennis court, gym, sauna, snorkelling and some water sports equipment).

Activities

Aqua scooters, badminton, baseball, board games, carpet bowls, cougar cats, cricket, deck quoits, exercise classes, fish feeding, fishing charters (game and reef), glass-bottom paddle boards, gymnasium and sauna, paddle-wheel boats, sailboards, scuba diving (and instruction), snorkelling, tennis, video movies, water polo.

Barrier Reef Resort, John Brewer Reef, via Townsville, Qld 4810. Telephone: (077) 70 9111. FAX: (077) 70 9100. Telex: 47054.

The resort

The 90 m (295 ft) long, 27 m (89 ft) wide, seven-storey structure, which from the outside looks, end-on, not unlike a giant chimney with windows, cannot fail to impress for its engineering, high standard of construction, its complex range of plant and equipment and for its luxurious appointments. Based upon experience in building accommodation for workers on offshore oil rigs, it is virtually a completely self-contained ship, with water-tight bulkheads, a power-generating and air-conditioning plant, a desalinator which makes fresh water from the sea, a sewerage plant and solid wastes incinerator. Built and engineered in Singapore by a company owned by the American Bethlehem Steel and by the Singapore government, the construction had to satisfy both the rigid safety standards applied to such offshore housing as well as the constraints laid down by the Great Barrier Reef Marine Park Authority to insure that no damage was done to the Reef environment. For example, sewerage is processed on board, with the water component treated and held in tanks, later to be taken by barge out to sea; all solid waste is burned in a smokeless incinerator and the ashes removed to the mainland. Unburnable waste is also returned to the mainland.

The hotel floats on a rectangular base, and its wide, laid wooden deck and wooden hand rail remind arriving guests that they are stepping aboard a ship. On the lee side is a series of ramps and floating pontoons—a floating tennis court, a helipad, a deck with deck chairs, a floating marina, a water sports platform and a swimming enclosure. The spacious ground-floor lobby, with lobby bar, shops and reception area, is crisp and chrome, with potted palms and cane furniture; it is encircled by a mezzanine, above which a highly polished ceiling, with chandelier, reflects images of all below. The mezzanine offers uninterrupted views of the surrounding ocean through large round port holes, and on this level is a bar, lounge and library.

Accommodation and tariff

The resort has 175 twin/double rooms and two-room suites; the rooms on the second level have a balcony. Those who like fresh air may find that a balcony is worth the little bit extra that is charged, as the room windows cannot be opened by guests, evidently because this makes it difficult to keep the air-conditioning balanced throughout the hotel (which needless to say has no shade, and the rooms tend to be either slightly too warm or too cool at different times of the day). The rooms are just slightly smaller than a normal hotel room, as one might expect on a ship, tastefully decorated in coral and turquoise, with bleached woodwork and black lacquer furniture, a well-stocked mini-bar, colour TV and international direct-dial phone. The bathroom, with shower stall, is small but quite adequate and is equipped with a novel toilet that operates on a vacuum system (to conserve water).

The hotel tariff is room-only, although included in the price is the use of the gymnasium and sauna, library, glass-bottom paddleboards and underwater observatory (the latter was not yet functioning when this was written).

Eating, drinking, and entertainment

The Barrier Reef Resort is a five-star hotel, with the obligatory 24-hour room service found at such establishments. It has two restaurants: the Reef Room, which serves dinner only, *haute cuisine*, in elegant surroundings; the Marina Café, open all day until midnight, where anything from

COLFELT

Above:
The 'yellow submarine' which operates in the lagoon at John Brewer Reef was the first such coral-viewing craft on The Great Barrier Reef.

Opposite:
The world's first floating tennis court provides a unique experience for tennis enthusiasts. But when the south-east trades pipe in fresh, players facing the wind need a powerful stroke just to get the ball to the net.

COLFELT

Above:
Sunset over Hinchinbrook Island is an evening bonus for those sipping a drink on the deck of the Barrier Reef Resort. The trawlers at the right are anchored behind the leeward edge of the reef, a favourite sheltering spot for fishermen in this area.

hamburgers and snacks to a sumptuous seafood buffet is offered. There is a bar in the lobby, one on the mezzanine, and the restaurants both serve drinks and wine. Watching the sun set over Hinchinbrook Island from the mezzanine bar or from the deck, sitting out in the middle of the ocean, is an unusual experience, as is dining with the waters of John Brewer lagoon lapping virtually under the table. On the level below the lobby, where the gym and sauna are located, is the Boiler Room, a nightclub with elaborate lighting and sound system, providing disco-style entertainment till the early hours of the morning.

Activities

Activities at the Barrier Reef Resort are largely orientated towards the water (including the novelty of tennis on a floating court). Games (some organised, some not) are also offered. One of the rationales of the resort was to make it possible to see The Reef without having to undertake a sea journey, that is, to be able to stay right on The Reef overnight. Scuba divers have the comforts of a five-star hotel instead of the rigours of life aboard a dive vessel; game fishing enthusiasts, too, can enjoy their daily sport without, always, the need to commute a long distance to the fishing grounds. Needless to say all of these benefits cannot be guaranteed, and when the south-east trade winds are fresh in the lagoon, most water activities at the resort have to be cancelled. One cannot play tennis with 20 knots of wind and spray across the court, either. Weather limits activities at any resort, the difference being that guests here are much more confined. The resort does have a library and gymnasium, and in-house videos are shown during the day, but stir-craziness could easily set in after a few days of bad weather.

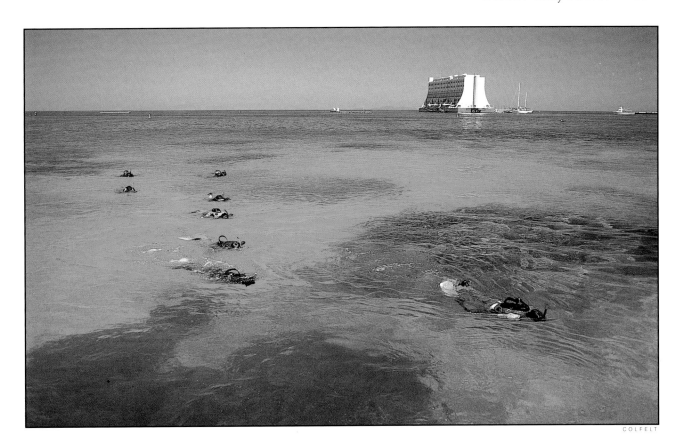

COLFELT

Diving and snorkelling

Diving at the resort is conducted by the experienced Townsville-based Dive Bell, and certificate courses are available from qualified instructors. Those who are already qualified may be well advised to take their own regulator, buoyancy compensator and wetsuit, especially if they intend diving more than once or twice, to save on equipment hire fees. Diving and snorkelling trips to sites around John Brewer Reef are available daily (weather permitting). The local reef does not offer the most spectacular diving and snorkelling available on the Barrier Reef due to damage by infestations of the crown of thorns starfish, but the reef is regenerating, and fish life is quite plentiful. In the immediate vicinity of the hotel the coral is very unspectacular, although the resort has spoken of plans for a coral transplant programme for the benefit of those who do not wish to venture away from the hotel. Reef Link's yellow coral-viewing submarine operates in the lagoon not far from the hotel, and guests are able to join this coral-viewing trip.

Fishing

The resort has access to one of Townsville's well-known charter operators, and game- and reef-fishing charters are available. The Townsville area offers some excellent light-tackle game fishing, particularly in the Cape Bowling Green area, which is about 1 hr 45 mins by launch from the hotel. Heavy-tackle fishing is also available (September to December) at Myrmidon Reef, about 1 hr 20 mins away, and reef fishing is offered. The hotel will prepare what you catch for your dinner, if you wish, at a small extra charge.

Above:
Snorkellers explore the lagoon at Brewer Reef.

COLFELT

ORPHEUS ISLAND

When Orpheus Island resort re-opened in 1981, it set a new pace on the Queensland coast for elegant relaxation. Conceived by two Italians and put together with an unmistakable continental flair, the resort has won numerous accolades in Australia and abroad over the past five years. Although close to the coast, Orpheus is a bit off the beaten track, and access for resort guests is either by amphibious aircraft (or helicopter) or by cruise boat operating out of Townsville, which heightens the sense of remoteness and adds a touch of romance to the journey. Billed as being 'for discerning people who really want to escape', Orpheus indeed offers refined simplicity, an opportunity to feel quite at home doing absolutely nothing but rejuvenating the spirit and indulging in good food and wine. The island is an unspoilt National Park, with some hilly walks, beautiful vistas, and seven beaches to get lost on. Orpheus also has some of the best fringing coral reefs to be found anywhere in the Barrier Reef Region, and the snorkelling, on the right day, is as good as can be found.

Apollo was the god of music and song, and his son, Orpheus, so the story goes, played the lyre so beautifully that wild things in the wood crept out to listen to the music that he made. Best known for his unsuccessful attempts to bring his lover, Eurydice, back from the underworld, Orpheus was also one of the Argonauts who sailed in search of the Golden Fleece, and Orpheus' songs aboard the ship *Argo* tell of the adventures of these mythical sailors. His beautiful melodies saved them from many a peril, lulling monsters to sleep and keeping the infamous Sirens at bay. The Orpheus for which the Queensland island was named, by Lieutenant G.E. Richards of the survey ship *Paluma*, in 1886, was no myth, but a British ship that was wrecked in New Zealand in 1863, apparently not having aboard an Orpheus of its own.

Orpheus, like many of the continental islands of the Queensland coast, was a favoured haunt of Aborigines, who moved from one island to another taking advantage of the seasonal availability of food (a midden at Pioneer Bay is tangible evidence). Of the 11 islands of the Palm Group, Orpheus and Pelorus (immediately to its north) are the only two that are not today back in the hands of their Aboriginal owners.

In the past, Orpheus has been used to run sheep, as a mackerel fishermen's base, and for oyster farming. Yankee Bay, on the south-western end of the island, had a degaussing station (for demagnetising ships) during World War II, and a small resort has operated at Hazard Bay since the mid-1940s (the resort today is not the original one). James Cook University operates a marine research station at Pioneer Bay, its location being suggested both by its proximity to Townsville and because Orpheus (and some other islands of the Palms) have excellent fringing reefs, with a richness and diversity of corals and fishes not exceeded anywhere in the Barrier Reef Region, the marine environment is an excellent place for study.

The history of the resort on Orpheus today begins in 1981, when it re-opened after being completely overhauled by its new owners, two expatriate Italians, Carlo Cobianchi, an ex chief of Pirelli Australia, and

COLFELT

Opposite and above:
The Orpheus resort faces west and looks out over Hazard Bay towards the mainland, opposite the sugar town of Ingham. Bougainvilleas and other colourful vines tumbling from pergolas add to the atmosphere of an intimate, private residence.

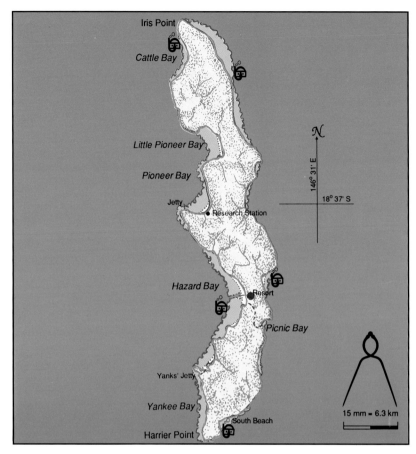

ISLAND SUMMARY
Orpheus Island
Location: 18° 37'S 146° 30'E
Gateway: Townsville (78 km)
2145 km N of Melbourne
1762 km NNW of Sydney
1190 km NW of Brisbane
204 km SSE of Cairns

Island and resort details
A long, narrow continental island 11 km x 1 km (1376 ha), second largest of the Palm Group, 16 km off the coast adjacent to Lucinda (B 19). It is composed largely of granite with some volcanic rock and covered with dry eucalypt and acacia woodland, small areas of grassland, and some rainforest (best developed on the western side of Iris Point). The island has many indentations and bays on both sides, with excellent fringing reef development and some good beaches. Orpheus is a National Park, and camping is permitted near Yanks' Jetty and at Little Pioneer Bay. James Cook University operates a research station at Pioneer Bay.

Access
From Townsville: Seair Pacific amphibians fly to the resort at Hazard Bay 5 days a week (2 flights on 3 days) departing from the Breakwater Marina (30 mins); *Pure Pleasure* Cruises' catamaran takes day-trippers to Yankee Bay on 6 days (2 hrs 20 mins) departing at 9.00 a.m. from the Breakwater Marina (resort guests can come to the island this way and will be met by a resort boat). Helicopter charters may be arranged with Lloyd Helicopters at Townsville airport. From Cairns: Seair Pacific amphibian (via Hinchinbrook Is.) (1 hr 35 mins) three days a week. From Taylor's Beach, near Lucinda: the research station can arrange transport, usually for scientists going to Pioneer Bay, with its own vessel (30 mins).

Resort capacity, accommodation, facilities
Maximum 74 guests. No day-trippers to resort.
Accommodation: Three standards: Studio units (23); Bungalows (2); Villas (6) . Studios and Bungalows have private bath, air-conditioning, ceiling fan, fridge and mini bar, sound system and radio, tea/coffee-making facilities. Bungalows have addition of king-size bath tub and private courtyard garden off the bathroom. Villas are completely self-contained, luxuriously appointed with 2 bedrooms, 2 bathrooms, living room, piazza, kitchen, laundry. **Resort facilities:** Fresh-water swimming pool; spa; tennis court; water sports equipment; resort shop; conference facilities. Laundry service available.

Tariff
All inclusive (except alcohol, and extras such as waterskiing, diving, fishing charter, cruises). Children under 12 are not catered for.

Eating and drinking
In the resort restaurant and bar next to the beach (breakfast from 7.30 a.m. to 10.00 a.m.; lunch, 1.00 p.m. to 2.00 p.m.; dinner from 7.30 p.m. onwards).

Activities
Tennis, walks to beaches with picnic, catamaran sailing, coral viewing, dinghies with outboard motor, diving (non-certificate course), fishing charters, island and sunset cruises, paddle boards, sailboards, snorkelling and snorkel trips, swimming, trips to research station, waterskiing. The island has some excellent fringing reefs, and snorkelling is very good in Cattle Bay, Little Pioneer Bay, Yankee Bay and (weather permitting) on the fringing reef off the north-east end of the island.

Anchorage
The resort does not cater for casual visitors. If anchoring in Pioneer Bay be sure to keep at least 50 m from the edge of the reef as clam mariculture is carried out in this bay.

Orpheus Island Resort, PMB Ingham, Qld 4850. Telephone (and FAX): (077) 77 7377. Telex: 47434.

Gino Pucci, an exporter. With unmistakable Mediterranean know-how they created an intimate resort for a maximum 25 couples. The travel writers who came to the island used terms such as 'civilised', 'sophisticated', and 'sizzling with savoir faire'. Travel writers are known to carry on a bit, but it is true that the small size of the resort, its completely peaceful atmosphere (it has studiously avoided *organising* fun for guests), the simple elegance of its decor, the fetish that it makes of food and wine—in all, the continental approach to the good life that pervades the resort—did put Orpheus in a class all its own on the coast during the first several years of its operation. It has since been much emulated.

At the time of writing, the resort is up for sale, making it difficult to say with certainty what the Orpheus of the future may be. Institutions, once in motion, however, do tend to develop a mind of their own, habits and practices being passed on as if by genetic code, and it would seem probable that the simple, successful formula of this resort will not invite much tampering by the next owner. Six villas have been added to the accommodation, each with a maximum occupancy of four people; these villas are up for private sale, but some or all of them will probably be used for guests from time to time, increasing the total capacity of the resort by a small number.

The resort

The resort is in Hazard Bay, on the western side of the island, just at the top of a long crescent coral sand beach. Hazard Bay has an extensive fringing reef that dries at low tide, except for a narrow channel that allows all-tide access to the jetty. As is true with many Barrier Reef island resorts, swimming is better in the pool when the tide is out. Snorkelling out by the edge of this reef at low tide will reveal a bounty of coral (particularly the soft varieties) and colourful fishes, although the visibility and coral diversity may not be as good as at some other bays around the island.

The central resort complex consists of several open-sided buildings linked by timber decks, simple and attractively furnished. The lounge, with its cane armchairs, sofas and tables and bamboo hanging chairs, is a cool place to relax with a book, undercover but you might as well be outside. The dining room and bar area is open, with high ceiling, wooden beams and cane furniture; the tables are elegantly set, adorned with flowers and large wine goblets. The fresh-water pool and spa overlook the beach just beyond the open-air lounge.

Accommodation and tariff

The main accommodation is in 23 individual Studio units and two Bungalows, spread well out at the top of the beach along a grassy verge punctuated by she-oaks. With tumbling bougainvillea vines and white stucco walls, the Studios and Bungalows give the appearance of stylish, private holiday houses rather than resort units. The interiors are spacious, with white walls, natural timber, cool tiles on the floor, roomy cupboards. Each has its own fully tiled bathroom. Ceiling fans and billowing white mosquito nets over the queen-size beds enhance the tropical atmosphere (the rooms are also air-conditioned). The Bungalows are slightly larger than the Studios and they also have a few dividends, such as a private courtyard and large round sunken bath, for which guests pay slightly more.

Orpheus has six new, self-contained, two-bedroom villas, up on the hill behind the resort. Designed by Florentine architect Marco Romoli, these are elegantly finished with high ceilings, natural wood beams of

COLFELT

Above:
The resort's dining pavilion, surrounded by lush plants, has a pleasant open-air feeling, and glorious sunsets are often a feature of pre-dinner drinks; the leisurely evening meal is spiced with heady tropical fragrances.

Right:
The resort is just behind the casuarinas and palms
at the top of the beach in Hazard Bay.

Below:
The fresh-water swimming pool is surrounded with timber decking
and lush planting; behind is the airy lounge, with its hammocks,
hanging chairs and cool cane furniture—a place
to relax in the shade with a book.

Centre below:
The beach faces the west and is protected from the prevailing
south-east trade winds. Orpheus enjoys fiery sunsets, particularly
when the sugar cane is being burnt prior to harvest on the mainland
and smoke thickens the western sky in the evening.

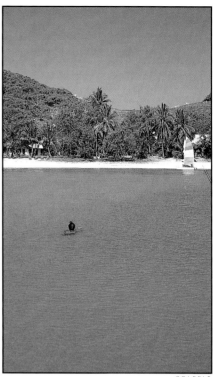

COLFELT

COLFELT

COLFELT

Left:
Orpheus's Studio and Bungalow units are well separated and, with their tumbling bougainvilleas and white stucco walls, are more like private holiday houses than hotel suites. The interiors are elegantly finished, with cool tile floors, white walls and natural timber.

Below:
Timber decking, which is gentle to bare feet even on hot days, surrounds the pool and connects the various elements of the central resort complex.

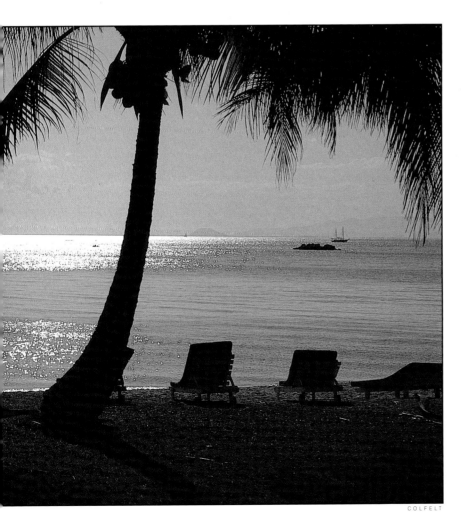

COLFELT

COLFELT

Queensland silky oak, white walls, floors of Italian ceramic tile, white cedar venetian blinds—obviously inspired by the best ideas of Sardinia and southern Italy for survival in a warm climate. They are simple but luxurious. The living rooms can be opened completely to a piazza, the internal and external spaces thus becoming indistinct, as is true of much of this resort. The Villas are not air-conditioned and don't really need to be, with their position on the hill, their large doors and high roofs helping them to collect cooling breezes and disperse warm air. They have fully equipped kitchens, two bathrooms, and they can accommodate up to four people.

Orpheus's tariff is all-inclusive except for alcohol and extras such as game-fishing charters, scuba diving, Reef trips and sunset cruises.

Eating, drinking, and entertainment

Orpheus provides no entertainment, its hallmark being its relaxed, informal, unhurried pace, an atmosphere that can best be provided by a small resort with relatively few people to fuss about. Entertainment is conversation at the bar before dinner, or relaxing with a brandy after an indulgent meal. The resort makes a fetish of its food, which becomes an important part of days where time drifts slowly by. Meals are served at times that will suit the guests rather than the kitchen; breakfast is *à la carte*; lunch is buffet or from a blackboard menu; dinner is *à la carte*, long and leisurely, from 7.30 p.m. till late. Emphasis is on fresh tropical fruits and seafood, the style continental and plentiful, and a good selection of local and imported wines is available. The kitchen will pack picnic lunches for those who want to take an outboard dinghy and go off to a quiet beach.

Activities

Orpheus is a place where guests can feel completely relaxed about doing nothing. The resort does not organise activities, but it does have an assortment of beach equipment, sailing craft and dinghies with outboards for those who wish to take a picnic and explore a remote beach. There are various boat trips to bays around Orpheus and neighbouring islands, for snorkelling, picnic lunches, sunset cruises. Orpheus is a National Park, and it has some walking tracks over its rocky hills; the views from on top of the island are magnificent.

Equipment is available for certified divers, and those interested in being introduced to the sport can take a non-certificate 'fun' course. Game fishing has become increasingly popular in recent years in waters off Townsville, and Orpheus has one or two charter boats on call for light-tackle fishing (and heavy-tackle fishing during the season, September–December). The nearest reefs of the Great Barrier are about one and a half to two hours away, although with the very good fringing reefs of the Palm Islands right at hand there is less incentive to travel out to The Reef to see good coral.

Camping

Orpheus is a National Park, and camping is allowed (with permit) both at Little Pioneer Bay and at Yanks' Jetty, where there are picnic areas and toilets. Campers must take all their water, food and equipment to the island. Pure Pleasure Cruises offers commercial camping and tent hire at its Yankee Bay facility.

Orpheus Island Research Station

James Cook University's research station at Pioneer bay is a place for

COLFELT

Above:
Giant clams (*Tridacna gigas*) are the focal point of activities at the Orpheus Island research station, where a programme is underway to perfect methods of farming this species, now extinct on many Pacific reefs. Breeding stock is brought ashore from Pioneer Bay and placed in tanks, where the clams are artificially induced to spawn. The fertilised eggs are then kept in tanks until the juveniles are large enough to survive (in cages) in the sea. Giant clams have been given an (undeserved) evil reputation by 'B' grade adventure movies, which have shown divers entrapped in their clutches. The fact is that these clams can close their heavy shells only very slowly, and the soft, fleshy mantle around the edge of the shell prevents the clam from shutting tightly; researchers say it is possible to remove an arm even from a completely closed shell, and they thus pose little threat to snorkellers.

scientists to conduct marine research, with laboratory and residential facilities, and it has become almost a tourist destination in its own right, being the base for a pioneering research programme into the farming of giant clams.

Giant clams, particularly the largest species, *Tridacna gigas*, are threatened or extinct on many Pacific reefs primarily due to over-fishing. These clams, which can grow to over one metre in length, are highly sought after in parts of Asia for their adductor muscle (the large muscle that closes the shells); this is dried and shaved into wafer-thin slices and sold as a flavour enhancer in cooking. Like so many exotic foods, the clam muscle is also reputed by Asians to have aphrodisiac properties. For centuries the people of that continent have devoured the most unlikely creatures and their parts, from shark's fins to sea cucumbers, in search of eternal youth, and for this reason the dried adductor muscle of *Tridacna gigas* fetches a very handsome price, upwards of $US100 retail per kilogram. Elsewhere in the Pacific all of the clam is eaten except for the shell and the kidney (the latter concentrates heavy metals and therefore tastes bad).

The Orpheus research programme has already produced a crop of giant clams which has been sent to Fiji to restock some of that country's denuded reefs, and research is continuing to examine the potential for commercial clam farming. The research station has become a popular tourist venue, with day trips and extended-cruise ships calling in almost daily. (See also 'Clams' in 'Notes for Reef Travellers'.)

Below:
The Orpheus Island resort has a small jetty at Hazard Bay. An all-tide access channel provides boats (and snorkellers) with a route to the outer edge of the fringing reef, where fascinating hours may be spent drifting amongst colourful fishes and corals in warm shallow water. Dinghies are available for those who wish to explore further afield.

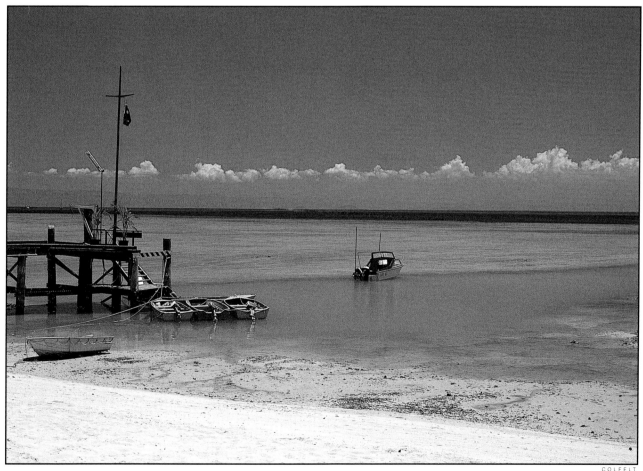

COLFELT

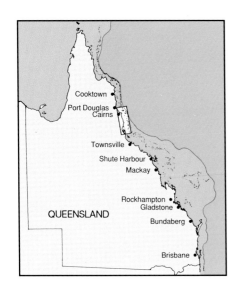

Principal destinations of this section

From Cardwell
- Hinchinbrook Island and the Hinchinbrook Channel
- Goold Island
- The Brook Islands

From Mission Beach
The Family Islands, including
- Bedarra Island
- Dunk Island
- Beaver Cay

From Cairns
The Barrier Reef and cays, including
- Agincourt Reefs
- Green Island
- Hastings Reef
- Low Islets
- Michaelmas Cay
- Moore Reef
- Norman Reef
- Upolu Cay

The continental islands
- Fitzroy Island
- The Frankland Islands

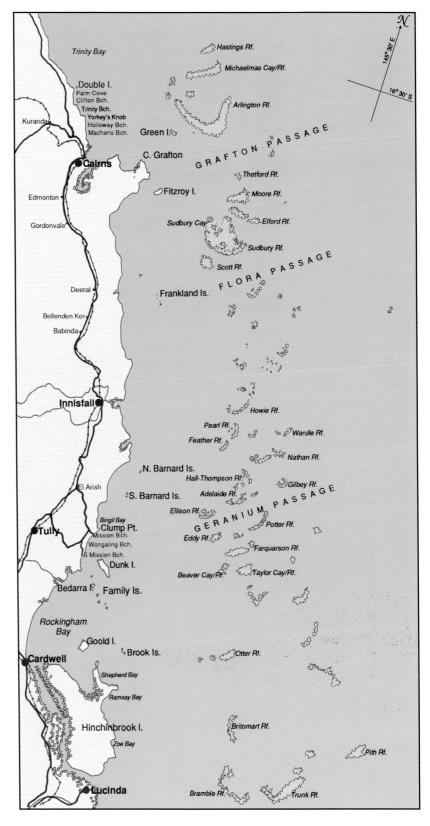

HINCHINBROOK TO CAIRNS

The coastal gateways of Cardwell, Mission Beach and Cairns;
Hinchinbrook, Bedarra, Dunk, Fitzroy, and Green Islands

As the traveller progresses north from Townsville, the landscape along the coast becomes increasingly lush, and one begins to get a real sense of the tropics. About one hour north by car is the rural town of Ingham (AB 19), set amidst green cane fields and with jungle-clad mountains at its back. Ingham is a sugar town, with two sugar mills, one of them the largest, the other the longest-operating in Australia. It is the home of the 'pub with no beer', renowned in Australian folk song. Off the main highway 28 km to the north-east on the coast is Lucinda (B 19), where the sugar is stored and then loaded onto ships, via what is reputedly the longest bulk-loading jetty in the world (almost 6 km long). Lucinda is also a minor gateway to the Palm Islands and Hinchinbrook area, with one or two vessels providing access to the Palm Islands and the southern end of Hinchinbrook.

CARDWELL

A further half hour up the main highway from Ingham lies the historic, sleepy coastal town of Cardwell (B 18), one of the earliest of north Queensland settlements. Its original purpose was to be the seat of the Port of Hinchinbrook, proclaimed in May 1864, a port badly needed at the time by settlers of the upper Burdekin valley who then had to trek all the way south to Bowen. Cardwell never became a very popular port; access from inland over the mountains was difficult, and when Townsville was established a year later it quickly became the preferred gateway. Cardwell, named for Edward Cardwell, Secretary of State for the Colonies in 1865, is the town where for the first time the railroad and highway come together right on the coast. It is the principal gateway for the spectacular, unspoilt Hinchinbrook Island and the protected Channel of the same name that lies between it and the mainland.

How to get to Cardwell
By road. Cardwell is 150 km north of Townsville, just under 2 hours by car (2 hours by bus). From Cairns to Cardwell it takes about 2 hrs 15 mins by car (2 hrs 30 mins by bus). From Brisbane it is 20 hours on the bus.

By rail. The Queenslander (tourist service) and Sunlander (commuter service) stop at Cardwell if there are passengers or freight to unload; Cardwell is about 29 hours from Brisbane by train, about 3 hrs 30 mins from Cairns.

Hinchinbrook area tourist information
Queensland National Parks and Wildlife Service has an information centre on the highway by the Cardwell jetty, PO Box 74, Cardwell, Qld 4816, telephone (070) 668 601. This office also issues permits for camping. Travel information and bookings are available from: Hinchinbrook Travel, 91 Bruce Highway, Cardwell, telephone (070) 668 539, which operates a ferry service to Hinchinbrook and other islands; and Cardwell Travel/Tekin Cruises Pty Ltd, 141 Victoria St, Cardwell (opposite the National Parks centre), telephone (070) 668 661.

Cardwell weather

Cardwell has one of the highest rainfalls of Queensland and has a warm tropical climate.

	Jan.	Apr.	July	Oct.
Avg. Daily High	32°C	30°C	25°C	30°C
Avg. Daily Low	23°C	23°C	18°C	22°C
Days Rain (over 0.2 mm)	15	14	6	7
Normal Rainfall	374 mm	159 mm	20 mm	37 mm
Mean Sea Temp.	28°C	26°C	22°C	25°C
Normal Annual Rainfall = 2111 mm				

Accommodation

Cardwell has several two-star motels, two caravan parks and some holiday units. It is the proposed site of a major tourist resort and marina complex, the Hinchinbrook Harbour Resort, which will begin to take shape in 1990. The proposed complex is to have of a 210-berth marina, with all associated facilities, shopping, a 434-room resort with hotel, townhouses, cottages, and terrace units. The resort will be three-to-four-star, aimed at local (Australian rather than international) tourists.

Cardwell environs

Highlights of the Cardwell area include the protected Hinchinbrook Channel, with its potential for aquatic recreation, including fishing and sailing. A scenic lookout on the low range of hills just behind the town offers beautiful views of Hinchinbrook Island and the Channel. About 1 km north is a fauna park, with crocodiles, snakes, goannas, kangaroos and other Australian curiosities. Mariculture (marine farming) is a coming industry.

Reef trips and island cruises

Hinchinbrook Travel operates high-speed catamarans which do daily runs to various parts of Hinchinbrook Island. These also transport campers to Goold Island and to some islands of the Family Group. Tekin Cruises operates a 160-passenger catamaran which does Hinchinbrook Channel cruises, departing from Cardwell jetty or Lucinda (these cruises are primarily geared to tie in with bus and rail groups; for information check with the booking agencies (see 'tourist information' page 177). The Channel and islands to the north and south are a good bareboat yacht charter venue, although at the time of writing there is only one company offering one 8.5 m yacht for hire (Hinchinbrook Rent A Yacht, [070] 668 007).

Camping

Camping is permitted on several of the National Parks islands in the area, including Hinchinbrook Island (see discussion later in this section), Goold Island, and at Bowden and Coombe Islands in the Family Group further north (which may also be reached via Mission Beach). Goold has two campsites, the main one being on the western spit, where there are bush amenities (toilet, tables and fireplaces). Campers must take all their food and water to the islands. It is also necessary to obtain a permit from the QNPWS office near Cardwell jetty (for more information on camping, see 'Camping on the Islands'). Transport and arrangements for carrying water may be made in Cardwell with Hinchinbrook Travel and with Tekin Cruises.

Opposite top:
The Brook Islands, a group of three continental islands 9 km north-east of Hinchinbrook Island, have extensive fringing reefs which lend a certain cay-like quality to their beaches. Pictured is the northern end of North Brook Island, with its deep coral sand beach, looking back towards Cardwell and the mainland.

Opposite bottom:
A misty sunrise over Hinchinbrook Island (right) and Goold Island as seen from the shores of Cardwell.

COLFELT

COLFELT

COLFELT

HINCHINBROOK ISLAND

Hinchinbrook is a majestic continental island, a National Park with towering granite mountains, cascading waterfalls, a lush cloak of tropical vegetation and sweeping sand beaches. It is a favourite haunt of international trekkers, naturalists, campers and escapists of all kinds, some of whom opt for the comforts of the island's small, informal resort. The island (and resort) are for those who delight in the unembellished, who enjoy simple pleasures in natural surroundings.

James Cook thought that Hinchinbrook Island was part of the mainland when he sailed past in June 1770, naming two easterly projections of the island, Point Hillick and Point Sandwich*. It was a mistake that is easy to understand, for from seawards it is almost impossible to discern that a narrow, mangrove-fringed channel separates the island from the mainland. Hinchinbrook's mangroves, which blurr its edges, are the richest and most diverse in Australia; they add perhaps another 25% to the total area of the island, and some 29 species are represented. These communities support a super-abundance of marine fauna. Many thousands of years before Cook, the Bandjin people had discovered the riches of life here, and when Cook passed, the island may well have been supporting a permanent population of 500. Remains of elaborate stone tidal fish traps, with their loops, pools, breakwaters and funnels, can be seen today at Scraggy Point. These effective 'automatic seafood retrieval systems' trapped substantial quantities of fish and molluscs as the tide receded, and the traps were still found to be working effectively years after the Bandjin had retreated, in the face of advancing whites.

Today Hinchinbrook is the largest island National Park in Australia, if not the world, about 344 sq km (if the mangroves are included). Hinchinbrook's lofty profile completely protects the 33 km long and moderately deep channel formed by the island and the mainland, a much favoured waterway with yachtsmen and with salt-water crocodiles (swimming on this side is not recommended because of crocodiles and, during November–May, possibly box jellyfish). The eastern side of Hinchinbrook is characterised by expansive bays and sweeping sand beaches. The island has several National Parks campsites, some graded tracks in the north, and an 18 km, rough bush track, blazed with triangular markers, from southern Ramsay Bay right down the eastern side to Mulligan Bay, a three-day walk each way. At the tip of Cape Richards is a minute holiday resort.

The resort
At a time when many Australian resorts were luring guests with promises of lots of good company, entertainment, and the opportunity to carouse all night, Hinchinbrook Resort was advertising 'MAX. POP. 30' and 'a million miles from the nearest disco'. It assured that there was no 'entertainment director' that there were miles upon miles of beaches where the only footprints to be seen were one's own. This unpretentious resort has now gained a loyal band of followers, many of whom return year after year, all of whom shun the glitter of 'resort life' and proclaim the glories of the island's unspoilt beauty, its miles of bush tracks. They are the sort of people who will be found down on Orchid Beach below

* Sandwich was John Montagu, 4th Earl of Sandwich, a First Lord of The Admiralty, supporter and admirer of Cook, a man also of many vices who once spent 24 hours at the gaming-table without food other than pieces of beef between slices of bread, giving birth to today's 'sandwich'. Hinchinbrook was the name of Lord Sandwich's home in Huntingdonshire, and this name was given to the island by Phillip King during his coastal survey of 1819, calling it 'Mt Hinchinbrook'. Its status as an island was confirmed by the naturalist Jukes in 1843.

Opposite:
Hinchinbrook has an abundance of sand beaches, such as that at Macushla Bay, with mountainous back-drops.
Below:
The island's mangroves are the richest and most diverse in Australia, supporting an abundance of marine life.

COLFELT

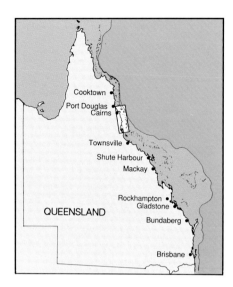

ISLAND SUMMARY
Hinchinbrook Island

Location:18° 21'S 146° 15'E
Gateway: Cardwell (4–10 km)
2173 km N of Melbourne
1798 km NNW of Sydney
1229 km NW of Brisbane
167 km SSE of Cairns

Island and resort details
Large, mountainous continental island (39 350 ha) separated from the mainland by the narrow Hinchinbrook Channel; the island lies quite close to the coast between Lucinda (B 19) and Cardwell (B 18) providing a long protected stretch of water, a favoured cruising area for yachts. There are extensive mangrove estuaries on the western side and long, sweeping sand beaches and bays on the east. Vegetation ranges from mangrove swamps to dense tropical forest, eucalypt forest and scrub heaths, fine examples of varied forest communities, unexplored, offering naturalists a rare experience. Hinchinbrook has a number of craggy peaks, one of which is the third tallest in Queensland (Mt Bowen—1142 m). Said to be the largest island National Park in the world, it has some graded walking tracks in the north (connecting the principal camping area at Macushla Bay with the beach at Shepherd's Bay and the small resort at Cape Richards); there is a rugged bush trail that goes from the southern end of Ramsay Bay all the way to Mulligan Bay. The island is rich in wildlife, including salt-water crocodiles that frequent the western estuaries, and it is popular with backpackers, bushwalkers and nature-lovers from around the world.

Access
From Cardwell: Catamaran ferry departs from the jetty for the resort or Macushla Bay (35 mins) daily at 9.00 a.m. (except Mondays that are not public holidays), returns to Cardwell at 4.30 p.m. Another catamaran departs for the boardwalk to Ramsay Bay daily (except Thursday) at 10.00 a.m. (45 mins), then goes to Macushla, on to the resort, returning to Cardwell at 4.30 p.m. From Townsville: Seair Pacific amphibians fly to the resort via Orpheus Island 5 days a week (2 flights on some days) (60 mins).

From Cairns: via Seair Pacific amphibian 3 days a week (60 mins). From Lucinda: Charter boat available to George's Point and Mulligan Bay.

Resort capacity, accommodation, facilities
Max. pop. about 50 guests; infrequent day visitors and the occasional visiting yacht/trawler. **Accommodation:** 15 free-standing bungalows (some additional new bungalows are being built) with private bath, fridge, tea/coffee making facilities, ceiling fan, verandah. **Resort facilities:** Fresh-water swimming pool; dining room/lounge/bar area; small shop; laundry; water sports equipment; outboard dinghies for hire. The island has one telephone, at the bar.

Tariff
All inclusive (except for alcohol, hire of outboard dinghies, and excursions).

Eating and drinking
All meals are served in the resort dining room (breakfast 8.00 a.m. to 9.00 a.m.; lunch 12.30 p.m. to 1.30 p.m.; dinner 7.30 p.m. to 8.00 p.m.). Picnic lunches and continental breakfasts in the room may be arranged. The resort bar is open as long as there is demand.

Activities
Beach activities, single surf skis, sailing dinghies, a canoe, windsurfers, outboard dinghies for hire, fishing, island walks, an abundance of nature. *Island Venture*, which ferries guests to the resort, does a variety of day trips for guests, such as to Ramsay Bay via the boardwalk, to the Brook Islands, and, occasionally, to Zoe Bay.

Hinchinbrook Island, PO Box 3, Cardwell, Qld 4816. Telephone (070) 668 585. Telex 148971.

the resort, watching the sun rise over the Brook Islands, and their silhouettes can be seen on the jetty against the setting sun, anxiously peering over the edge to see what's coming up on the end of their line.

There really isn't much to the resort. The central facility consists of a small, friendly dining room, predictably festooned with fishnets, cane baskets and lanterns. It is partly enclosed on three sides by waist-high latticework, so the surrounding jungle becomes part of the decor. There is a tiny bar, small lounge, a shop where postcards, stamps, suntan cream, insect repellent and the like are sold. Just outside is a terrace and fresh-water swimming pool surrounded by shady trees.

Accommodation and tariff
The resort has 15 unpretentious, free-standing units (they look like olive-green cargo containers on posts) hidden in the forest on either side of a circular track. Through the thickness of trees one can just see down to Orchid Beach, with its protected crescent bay, at the north-eastern tip of Cape Richards. From the beach the units are invisible. Fifteen new units are under construction, further up the hill 'in the tree-tops'. These will be round, with shingle roofs, more aesthetic in appearance, being the design of an architect.

COLFELT

The existing units have a wooden verandah with corrugated fibre-glass roof, a bedroom/living room, small bath with tiny, triangular, plastic shower stall; the walls are pseudo wood panelling, the floor covered with linoleum. Each has a clothes cupboard, fridge, tea/coffee making facilities, sink, ceiling fan, and dustpan and broom. They are perfectly adequate if not opulent—but at Hinchinbrook no one except honeymooners spends very much time in their room. They are serviced daily. The units are perhaps 300–400 m from the dining room, a five-minute walk along a forest path covered with leaves and criss-crossed by tree roots. At night this path is only dimly illuminated by infrequent electric lanterns, which cast eerie shadows, and the calling of tropical birds and frogs, and the skuttling of small marsupials in the dark, lend a touch of the exotic to the business of getting to and from the dining room. Hinchinbrook's tariff is all-inclusive (except for alcohol, hire of outboard dinghies and extra excursions).

Eating, drinking and entertainment
All meals are served in the dining room, which is intimate without being crowded. Tables are shared; seating is (mercifully) not assigned; those who cannot face polite conversation at breakfast will, at the morning meal, usually find a table to have to themselves; for those who like to sleep-in or who feel completely anti-social at breakfast, the kitchen will put together a continental breakfast which is taken to the room the night before. Because the resort is small (normal 'max. pop.' is actually somewhere around 50), guests tend to mix easily and informally. To comment on the food at a small resort such as this one is fraught with danger, for the chef may leave tomorrow and staff are not thick on the ground; during our visit the meals were surprisingly good.

Entertainment at Hinchinbrook resort is what you make it. No attempt is made to jolly-along or to organise. Evening entertainment is nattering on at the table after dinner, or sitting around the bar, or a moonlight walk on the beach. There is no radio, no TV, no movies, no disco. The island has one telephone, right on the bar.

Above:
Yachtsmen anchored at Orchid Bay enjoy a sunrise over the Brook Islands. The Hinchinbrook area is a popular yachting haven because of its protected waters and many quiet anchorages.

COLFELT

COLFELT

Top: Orchid beach, protected and hospitable, is just below the Hinchinbrook resort.
Bottom: Anglers work the evening rising tide on the jetty.

PETER LAVARACK

PETER LAVARACK

Above: Hinchinbrook's bush trails traverse creeks, follow water courses through dense vegetation and lead across vast stretches of golden sand beaches. The diversity of scenery and richness of nature make the island an attractive destination for seasoned trekkers.

COLFELT

Above:
Wallaby tracks in virgin sand,
Hinchinbrook Island.

Activities

Orchid Beach, as resort beaches go, is almost ideal, a few steps from the rooms, completely screened from the resort by thick vegetation, a long crescent of golden sand, completely protected from most weathers and a hospitable spot for sun-baking, early morning jogging or photographing the sunrise, swimming, windsurfing, surf skiing or sailing in one of the dinghies. Because it is so protected, novice windsurfers do not have to contend with blasts of wind that flatten them and exhaust them; nor need they fear being swept out to sea. Young paddlers are not bowled over by surf.

On the western side of Cape Richards is the jetty, a favourite haunt for anglers who seem content to while away the hours from morning till dark. Dinghies with outboard motor are available to hire for those who wish to take their fishing exploits further afield.

Walks

From the resort a well-marked, graded walking track meanders southwards through thick forest, over a 100 m hill, crossing several bush bridges. About 2 km long, it takes about 45 minutes to walk this track to North Shepherd Bay, where there awaits a yawning and inviting expanse of sand. At low tide the slope of this beach is barely discernible, and at its seaward edge a thin glaze of water always remains on the sand, reflecting the images of the green, cloud-covered mountains in the distance. Millions of ghost crabs scuttle along leaving tiny beads of sand in strange patterns on the beach behind them. Because of the towering scenery to the south of it, which diminishes the foreground, North Shepherd Beach is deceptively long; it takes another 30 minutes to walk to its southern end, where a graded track leads 2 km west (another 45 minutes' walk) to Macushla. At Macushla there is yet another golden sand beach, by the still waters of Missionary Bay. The resort packs picnic lunches for walkers; take plenty to drink, and don't forget the insect repellent, for millions of mosquitos lie in ambush in Hinchinbrook's damp forests, and there are other sorts of biting things around the mangroves.

Cruises around Hinchinbrook and the islands

Reef Venture, the 15 m catamaran that brings guests and campers across the Channel to the resort, does a number of day-trips to various locations around Hinchinbrook and to the Brook Islands, 7 km to the north.

Ramsay Bay. Deep in one of the mangrove creeks in eastern Missionary Bay the boat pulls up beside a boardwalk that materialises from under a vibrant green canopy. Passengers climb up onto the boardwalk and walk for a 100 metres, above slurping, popping, clicking mangroves, to Ramsay Bay, with its 9 km expanse of sand beach. Beachcombing, fossicking for shells and petrified crabs, swimming and lunch are the order of the day.

Zoe Bay. A trip around the eastern side of the island to a beautiful bay, with deep creeks at either end, waterfalls and mountain backdrop.

Brook Islands. A short trip to a pretty group of continental islands (which were used for weapons testing during World War II), with their fringing coral reefs. Snorkelling at Middle Brook Island, and then on to lunch on the northern side of North Brook Island, with its deep coral sand and shingle beach, and vegetation very like that of a true coral cay.

Camping and trekking on Hinchinbrook

There are two principal National Park campsites on the island, one at 'The Haven' (Scraggy Point), a short 4 km across the Channel from Cardwell, the other in eastern Missionary Bay at Macushla, 10 km from Cardwell. Hinchinbrook travel operates a daily taxi service to Macushla (see 'Access', page 182). These campsites have one or two toilets, tables, and tank or stream water is available; Macushla has a shelter as well. Macushla is the more popular site, perhaps partly because there are fewer mosquitos there and less worry about crocodiles.

Trekkers who want to walk the bush trail that runs all the way down the eastern side of Hinchinbrook, from southern Ramsay Bay to Zoe Bay and perhaps on to Mulligan Bay, get transport to the boardwalk and walk to the southern end of the beach where they pick up the track (to the right of a prominent granite slab). This is a real bush-walking track, beautiful, rugged, steep in places, and it occasionally traverses ankle-deep water. It is for those who are healthy and fit and, perhaps, who have some bush experience. It takes about two days to get to Zoe Bay. QNPWS provides a pamphlet with map and appropriate instructions, including recommended places to pitch a tent along the route.

Permits for camping and bush-walking are required prior to departure and are issued by QNPWS in Cardwell (or Ingham for those going to south Hinchinbrook from Lucinda). Permits for Macushla cost $5 per site per night; permits for camping elsewhere on the island are $2.00 per person per night. Camping is permitted for a maximum of seven days. Campers must be ready to be picked up at Ramsay Bay boardwalk at 11.00 a.m.

Below:
The sunrise from Orchid Beach.

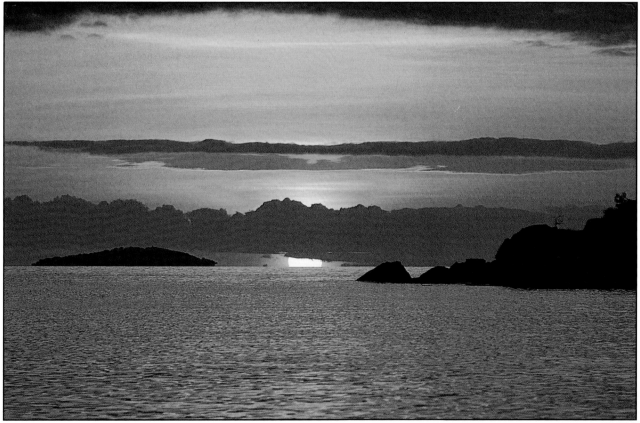

COLFELT

COLFELT

Above:
Catamarans lined up on the beach in front of Castaways resort, Mission Beach. Just offshore lies a group of tropical continental islands, the Family Group, which includes the best known of all Australian islands, Dunk (pictured), immortalised by the writings of the beachcomber, E. J. Banfield. Only 33 km further offshore lies The Great Barrier Reef, which is closer to the mainland here than it has been anywhere further to the south; The Reef continues to close with the mainland as the continental shelf narrows to the north.

MISSION BEACH

Mission Beach (B 18) is roughly half-way between Townsville and Cairns, 14 km east of the main highway right on the coast. It is a broad, shallow bay and beach located between Clump Point in the north and Tam O'Shanter Point in the south, a 13 km stretch of golden sand lined with palm trees. This area has been (so far) spared the intrusion of major tourist development, and it has a quiet, undiscovered feel, a green backwater where tropical rainforest meets the sea. Jungle-clad hills stand between Mission Beach and the main stream of traffic. The nearest town to the south on the main highway is Tully (B 17–18), which has the highest annual rainfall of anywhere in Australia, an average 4.3 m (168 inches). A lot of this rain falls between January and early April, and this whole section of the coast, from Hinchinbrook to Cairns, has a very moist, tropical climate, with luxuriant vegetation to prove it.

Mission Beach got its name because of the Aboriginal mission that existed about the time of World War I; along with much of the Queensland tropical coast, it was flattened in 1918 by 'the cyclone of the century' and was moved to Palm Island.

Today's traveller to Mission Beach will be spared confusion upon arrival by knowing that the name is now used in a collective sense, incorporating the communities (from south to north) of South Mission Beach, Wongaling Beach, Mission Beach and Bingil Bay, the latter being immediately north of Clump Point.

How to get to Mission Beach
By road. Mission Beach is about 2 hrs 45 mins from Townsville; turn right off the Bruce Highway at Tully and follow on for about 20 km. From Cairns turn off the highway to the left at El Arish and proceed 15 km to Bingil Bay, a drive of a little under 2 hours. By bus it's 24 to 25 hours from Brisbane, 3 hours from Townsville and just over 2 hours from Cairns. The Mission Beach 'detour' is taken by the major bus companies, so there is a regular service.
By rail. The nearest train stop is at Tully.

Accommodation
The Mission Beach area has three resorts, several holiday apartments, motels, three hostels and a number of caravan parks. Castaways Resort is attractively presented and centrally located right on the beach at Mission Beach, with self-contained penthouses, one- and two-bedroom suites, motel rooms, dining room, barbecue/informal restaurant; a complete range of water sports equipment is available to guests. Not far south is Mission Beach Resort hotel/motel, nestled in 18 hectares of dense trees, shrubs and lawns. At the extreme south, on the beautiful Tam O'Shanter Point, is The Point, a recently renovated resort motel with a superb position and glorious views over Rockingham Bay out to the islands. The hostels are: Tree Tops, a YHA hostel located in rainforest at Bingil Bay; Mission Bay Hostel, opposite the pub at Mission Bay; and Scotties' Mission Beach House at Wongaling Beach.

Mission Beach and environs
Within easy striking distance of the Mission Beach area there is a variety of diversions for tourists, including sugar mills, banana and tea plantations, white-water rafting on the Tully River, wildlife parks, such as the 30 ha Dundee Park, with its crocodiles, yabbie farm, reptile house and

the 'largest walk-through aviary in Australia'. Two scenic bush walks, one at Tam O'Shanter Point, the other at Clump Point, offer an opportunity to see real rainforest and perhaps catch a glimpse of the rare southern cassowary, a flightless, feather-duster of a bird, a smaller and more decorative cousin of the emu. Edmund Kennedy Adventure Cruises offers riverboat excursions up the Hull River, which runs parallel to the coast behind Mission Beach; this trip includes a tropical barbecue and night-time journey in search of the secrets of the waterway. Bingil Bay has become a centre for arts in north Queensland, with a number of well-known and accomplished artists, potters, wood sculptors, jewellers, tapestry artists and cane weavers displaying their work at the Bingil Bay Gallery—well worth a visit.

Barrier Reef and island cruises

Trips to the Great Barrier Reef are offered by two operators, both departing from Clump Point Jetty and both going to Beaver Reef and its associated cay, 41 km due east. Friendship Cruises, one of the longest-established Reef trips on the coast and operated by Captain Perry Harvey and his daughter, has a budget-priced, bring-your-own-lunch, all-day cruise in the 14 m fast catamaran *Flyer*, which departs daily at 9.00 a.m. and goes direct to Beaver Cay. For years Harvey has been protecting his own patch of reef from the invading crown-of-thorns starfish, and his guests have a day of coral viewing in glass-bottom boats, snorkelling and swimming right from the shores of the cay. Friendship Cruises also offers a cruise to Dunk Island and the Family Group daily, which includes a barbecue lunch at Bowden Island, then back to Dunk for a while before returning to Clump Point.

MV *Quick Cat*, a 140-passenger high-speed catamaran, departs daily at 10.00 a.m. for Dunk Island and then goes on to Beaver Cay, where the operator has a pontoon and coral-viewing sub. Lunch is provided, and scuba-diving facilities are available.

Two water taxis operate throughout the day to Dunk Island, one from Wongaling Beach and the other from South Mission Beach.

Below:
Castaways resort in Mission Beach is virtually right on the beach, a narrow strip of green lawn and palm trees separating it from the waters of Rockingham Bay.

COLFELT

COLFELT

COLFELT

BEDARRA ISLAND

Bedarra is a pretty continental island, one of the Family Group, just off the greenest section of Queensland's tropical coast midway between Townsville and Cairns. It has rainforest, numerous small bays, sandy beaches, and two small resorts, Bedarra Bay and Bedarra Hideaway, on opposite sides of the island. Both resorts are operated by Australian Airlines, each catering for a maximum of 32 guests in beautifully designed private villas hidden in their natural surroundings. These resorts specialise in passive holidays of total relaxation; the ambience is one of casual, refined elegance. Guests, treated as members of a small, private club, are pampered and indulged.

All of the Family Islands had Aboriginal names when the English chartmakers sailed through, giving them the titles of the English gentry and those of officers aboard the survey ships. The famous beachcomber, E. J. Banfield, who lived on Dunk Island for 25 years from 1897, recorded all of these Aboriginal names, although there is some question as to whether he got them all down correctly. Bedarra, it is said, was really 'Biagurra', which meant 'place of perennial water', one of the reasons why the island was popular both with the Aborigines and, much later, European men. In the dry season, when water stops running elsewhere in the Family Group, it continues to issue from one or two springs on Bedarra—something of a mystery, for Bedarra is not a large island. Perhaps it has some underground continuity with the adjacent mainland, where the highest rainfall in Australia is recorded.

Most of the Aboriginal names* for the islands, which were much more musical than the English ones, have been all but forgotten now. Bedarra is one exception. Although known as Richards Island on the charts (named by Lt G. E. Richards of the survey ship, *Paluma*, in 1886), Bedarra has retained its identity because it has been a relatively popular island since the early 1900s, with a succession of settlers, some of whom have stayed a long time, and they have kept the memory of the original name alive. Captain Henry Allason was the first white man to live there. In 1913 he came out from England, thoroughly infected by Banfield's *Confessions*, and he met the beachcomber, who introduced him to Bedarra. Allason bought the island, and built a house, but he lived there only a short time, being recalled to British military service when World War I broke out. Allason was injured in the war and was never to return to the island of his dreams.

Bedarra's first really permanent white settler was the artist Noel Wood, who in 1936 bought a 6 ha piece of land overlooking Dorilla Bay, and he still lives on the island. Quite a few settlers have lived on Bedarra at one time or another since Wood took up residence, and some have operated small resorts. But the contemporary history of the island, as far as today's tourist is concerned, begins in 1980 when the then Trans Australian Airlines bought the small Hideaway Resort, a low-key establishment nestled among dense tropical vegetation on the north-western side of the island. Hideaway in its day was a much-loved escape, but it inevitably became more and more run-down, and with the changing expectations of tourists, it had to be renovated. Today the

COLFELT

Above:
Fishermen on the jetty, late afternoon, Bedarra Bay.

Opposite top:
The view from the terrace at Bedarra Bay, looking across the lawn to the beach and a tranquil Hernandia Bay.

Opposite below:
Cool, overhanging gardens surround the path that winds past Bedarra Hideaway's villas just at the top of the beach.

* There are 14 or so islands and rocks (depending upon what is counted) in the Family Group, a few of which still have their original names on today's nautical charts. They are, from north to south, with Aboriginal names in parentheses: Mound (Purtaboi); Dunk (Coonanglebah); (Mungumgnackum); (Kumboola); (Wolngarin); Thorpe (Timana); Richards (Bedarra); (Peerahmah); Wheeler (Toolghar); Coombe (Coomboo); Smith (Kurrumba); Bowden (Budjoo); Hudson (Coolah).

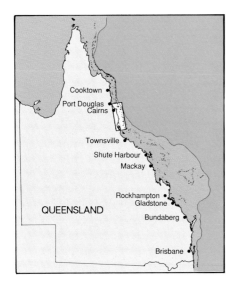

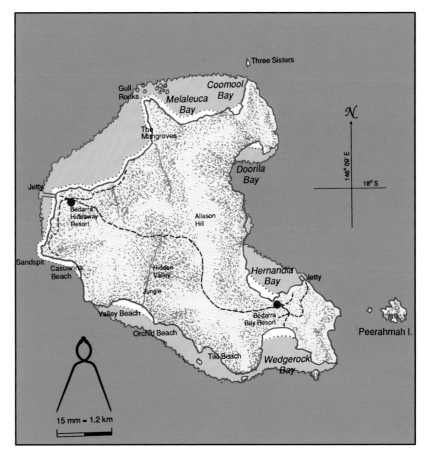

ISLAND SUMMARY
Bedarra Island

Location: 18° 00'S 146° 09'E
Gateway: Dunk Island (8 km) or
Mission Beach (8 km)
2211 km N of Melbourne
1838 km NNW of Sydney
1268 km NW of Brisbane
127 km SSE of Cairns

Island and resort details

A high continental island (86 ha) close to the coast opposite Tully, where the highest rainfall in Australia is recorded. The island has many small bays and sand beaches; vegetation is tropical, predominantly thick vine forest. Bedarra (today known officially as Richards Island) is one of a handful of Queensland islands to be privately owned (by freehold title), 93% belonging to Australian Airlines Resorts, which operates two small resorts there. Noel Wood, a well-known artist, also owns land and has resided on the island since 1936, something of a record for continuous white habitation of a Queensland island.

Access

From Dunk Island: via resort launch (15 mins). From Mission Beach: via water taxi (15 mins).

Resort capacity, accommodation and facilities

Bedarra has two resorts, Bedarra Bay and Bedarra Hideaway, with identical levels of service, at opposite ends of the island. The following details apply to each resort.
Total Capacity 32 guests (15 years and up). No day visitors.
Accommodation: Individual villas with split-level accommodation, balcony, bathroom w/tub and shower, writing desk, fridge, air-conditioning, ceiling fans, ISD direct dial phone, radio, bathrobes, beach towels, hair drier, ironing facilities. **Resort facilities:** Floodlit tennis court; fresh-water swimming pool and spa; lounge with TV and video; bar; water sports equipment; laundry. Laundry service available.

Tariff

All-inclusive, including all alcoholic drinks (except for private charters and Barrier Reef excursions).

Eating and drinking

Resort dining room with outside terrace (breakfast 8.00 a.m. to 9.30 a.m.; lunch 1.00 p.m. to 2.00 p.m.; dinner 7.30 p.m. to 8.30 p.m.). Picnic lunches prepared on request. Resort has 'open' bar (help yourself to anything, 24 hrs a day).

Activities

Tennis; catamarans; dinghies w/outboard motor; fishing; paddle skis; sailboards; snorkelling; rainforest walk, with lookouts, to resort at other end of the island. Private fishing charters and Reef trips may be arranged. The island launch is available on demand to take guests to Dunk Island, where they have use of all facilities or may join the MV *Quick Cat* Barrier Reef trip.

Bedarra Bay Resort, Bedarra Island, via Townsville, Qld 4810. Telephone (070) 688 233. FAX: (070) 688 215. Telex 46150.

Bedarra Hideaway Resort, Bedarra Island, via Townsville, Qld 4810. Telephone (070) 688 168. FAX: (070) 688 552. Telex 46151.

airline owns all but Noel Wood's piece of the island and has built two resorts, one on the hilly neck between Hernandia Bay and Wedgerock Bay (called Bedarra Bay Resort), and another completely new one on the site of the original Hideaway (called Bedarra Hideaway).

The resorts

Both places offer an identical level of service and amenities, the only difference being the style of the architecture and the slightly different feel of each location. Both were designed by architect Christine Vadasz, whose name was originally chosen from among eight or nine when the airline set out to build what was to be the 'crown jewel' of its resorts. Christine Vadasz brought with her a design philosophy that is on the increase among contemporary Australian architects; in a few words it may be summed up as 'keeping harmony with nature'. Buildings are placed so that they have minimum adverse impact on the land. To follow this concept throughout the Bedarra Bay project created no small number of problems, and at frequent meetings where escalating costs were anxiously discussed, Vadasz refused to budge from the original concept of her design. To its great credit the resort company never lost its nerve, and in the end the fortitude of both parties has paid off handsomely.

To the guest arriving at either resort, peaceful coexistence of the architecture and the environment instantly creates a feeling that, at this resort, there will be no compromise in the quality of life; here, privacy and tranquillity are paramount. Guests receive a very personal level of attention because, for one thing, there are very few of them. The manager, in so many words, explains to new arrivals: this is home for the duration of your stay, so behave as though it were. There is no bar tender; it is always open; please help yourself to whatever you want, whenever you want it. If there is anything that you require, just ask.

Bedarra Bay

Bedarra Bay Resort is surrounded on three sides by forested hills and looks out over Hernandia Bay, with its beach just at the bottom of a sloping lawn. The villas have the appearance of tree houses, set as they are in steep terrain, and they grow organically out of the site, in some cases with a tree growing right up through a verandah. A unifying theme is their spiralling roofs, reminiscent of the whorls of a shell, and this motif is most pronounced in the central resort complex, with its two interlocking spiral roofs, joining the reception, lounge and bar area with the kitchen, dining room and adjacent terrace.

Bedarra Bay accommodation

The 16 villas are constructed in lapped timber, a forest-green colour. Some have a level entry from a hilltop; some are entered by a spiral staircase ascending to the unit which appears to hang from the side of the hill. Inside they have split levels, with a living area below and a bedroom loft, sharing the same ceiling which spirals upwards with radiating timber beams. The floors are polished timber planks of blonde, red and rich brown colours, laid in random stripes. The walls are lined with timber, fastened with copper nails. Through a sliding glass door is a sundeck balcony, from which patches of blue water and white sand can be seen through the overhanging trees. The furniture is cane, with woven panels; the soft colours of shells are employed in the geometric designs of the fabrics. The bathroom, which looks out through a full-length window to a fern garden, has a sunken, oval bathtub surrounded by green slate. There are two air-conditioners, two ceiling fans, a writing

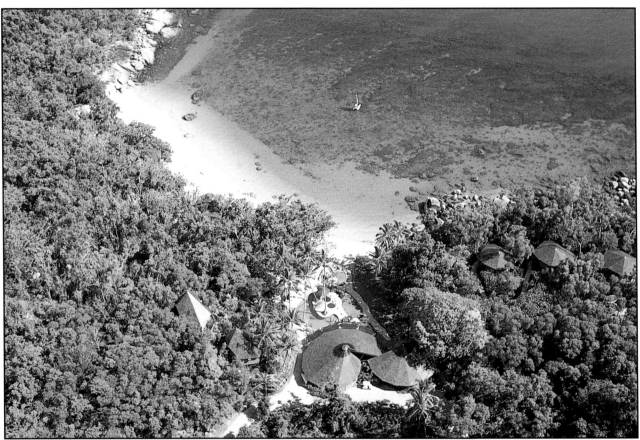

Above:
Bedarra Bay's villas are scattered and well hidden among the trees, their little shell roofs echoing the larger shells of the central resort complex.

Opposite top left:
The tree houses blend into the surroundings, becoming almost a part of the island.

Opposite top right:
The dining room at Bedarra Bay opens out to a terrace, giving an uninterrupted view of peaceful surroundings.

Opposite below:
The central resort complex, Bedarra Bay.

desk, direct-dial international phone, fridge, several full-length mirrors, bathrobes, beach towels, iron and ironing board.

Bedarra Hideaway

Bedarra Hideaway Resort is located on the western side of the island with its villas peeking out through dense jungle onto a sand beach. This is a slightly less hilly part of the island and has a more tropical feeling. It was the site selected by Captain Allason for his house, in 1913, and it was also previously the location of a small resort. Over the years a profusion of tropical vegetation has been planted here, now supplemented by the extensive landscaping that took place when the new resort was built.

Bedarra Hideaway accommodation

Bedarra Hideaway villas are little rainforest houses with oriental overtones—yellow bamboo sunburst motifs under their upturned, gabled roofs, wide, wood-framed glazed sliding doors painted an earthy red—there is a hint of Gauguin in their colours. The furniture is black lacquered cane; blue-black rafters contrast starkly with the white vault of ceiling and are echoed in the spectrum of blues and blacks of the fabrics; the bedside lamps have black bases with white pergoda-like lamp-shades. These villas are split-level like those at Bedarra Bay, with the bedroom a loft above the living area. At one end of the bedroom a translucent Shoji screen slides back to reveal the bathroom below, with its sunken tub surrounded by grey slate tiles. The full-length bathroom window looks directly out into a garden; inside on the sill is a miniature garden. As at Bedarra Bay, there are two air-conditioners, two ceiling

COLFELT

COLFELT

COLFELT

fans, writing desk, international direct-dial phone, ample cupboard space for clothes, ironing board and iron, two fluffy bathrobes and beach towels.

Tariff
Part of making guests feel at home is the elimination from the holiday of any thoughts of money. The tariff at Bedarra is all-inclusive of air fares, accommodation and meals, alcohol, dinghies with outboard, beach equipment, tennis court. The only extras are for private fishing charters and Reef excursions, phone charges and laundry service.

Eating and drinking
Food at Bedarra is of great importance, and it is prepared by cordon bleu chefs. Guests have a choice of dining in the open air on the terrace or in the adjacent dining room. Breakfast is buffet-style, cereals and fruit, and cooked breakfast may be ordered (there are often daily specials, such as fresh reef fish, or eggs Benedict). Lunch is typically two courses followed by cheese and fruit.

Guests tend to wander into the bar before dinner, and because the resort is so small, first names are used naturally and effortlessly. The atmosphere is that of pre-dinner drinks at someone's house where friends have been invited for dinner. New arrivals have a tendency to dine by themselves, but after a day or so mix easily if they are so inclined. Guests who decide to dine together never need worry about matching tit for tat when it's their turn to get another bottle of wine; the very best bottle in the house is absolutely 'free'. Dinner is three courses with cheese and coffee to follow.

The kitchen prepares a sumptuous picnic basket, complete with champagne or chardonnay, for those who wish to take one of the outboard dinghies and escape to their own private beach.

Activities
Bedarra is about relaxation rather than activity. There is no such thing as an activities board (other than a notice on the desk that a few guests have chartered a launch to go to The Barrier Reef and there is room for two more if someone would like to join in). The island has any number of beaches scattered around its circumference, and there are large rocks close by that invite investigation on a surf ski or by dinghy. Catamarans, sailboards, paddle skis, snorkelling and fishing equipment are available. There are areas of fringing coral reef around the island, although Bedarra's coral by no means offers the best snorkelling on The Barrier Reef, and those keenly interested in looking at good coral should go out to The Reef itself. The tennis court is lighted and may be used at any time of the day or night, without disturbing anyone. For those who want to stretch their legs, there is a track through rainforest from one side of the island to the other, a pleasant walk of about 45 minutes each way, which provides an opportunity to see how things look on the other side. Bedarra is one resort where, when it rains, there simply isn't a problem. Rainy days are very relaxed days; lunch trails off into the afternoon, champagne corks continue to pop. Nobody minds the rain at Bedarra.

The resort launch is at the disposal of guests who wish to go to Dunk Island, where they have free run of the island (including free lunch or a game of golf, if they wish) or can join excursions departing from Dunk, such as The Barrier Reef trip with *Quick Cat* to Beaver Cay.

COLFELT

Above:
Outboard dinghies offer escape to private beaches around the island.

Opposite top left:
Bedarra Hideaway's villas, little rainforest houses, have a decidedly oriental feel, with wide, sliding doors and sunburst motifs under the gable of their upturned roofs.

Opposite top right:
The jetty at Bedarra Hideaway is quite long, as it must traverse a flat expanse of fringing reef and sand before it reaches water deep enough for vessels to approach.

Opposite bottom:
The main resort complex at Bedarra Hideaway, shrouded in lush tropical growth.

COLFELT

COLFELT

COLFELT

COLFELT

DUNK ISLAND

Dunk Island is possibly the best known of all Australian islands, immortalised by the writings of the beachcomber, E. J. Banfield. It lies among a group of islands close to the coast in an area which receives very high annual rainfall, and of all the continental island resorts in Queensland which advertise themselves as 'tropical' Dunk probably fits the description best. Its forests are festooned with clinging vines, its air heavy with moist perfumes. Dunk for years was the only island to have a medium-sized resort of its standard, and this, along with the unmistakable charm of the island itself, made it very popular with Australians and international visitors alike. Extensively renovated in recent years, Dunk today caters for a broad spectrum of guests and offers a wide selection of activities and entertainment. It also seems to hold something for those who, like Ted Banfield, simply have a passion for fresh air.

'Coonanglebah' (meaning 'peace and plenty') is what the Aborigines called the island, a name far more lyrical that James Cook's stodgy 'Dunk' and one which pre-dates English discovery of the island by more years than western civilisation has existed. When Cook named the island he was paying homage to the George Montague-Dunk, previously a First Lord of the Admiralty but, in 1770, Lord Privy Seal. He called the group of islands to which Dunk belongs the Family Islands, possibly because they were in a close group and perhaps to suggest the family association between Dunk and the names 'Halifax' and 'Sandwich' which he had put on the chart earlier that day, Friday, June 8th, 1770.* Coonanglebah at one time probably supported a permanent population of Aborigines, who were able to thrive on the abundant fish, dugong, turtle and bêche-de-mer that abounded in the island's waters.

The first white inhabitant of Dunk was Edmund J. Banfield, a Liverpool-born immigrant who was two years old when he came to Australia with his mother, brother and two sisters, in 1855. During his adult life Edmund was to follow a career in journalism. Immediately before his dramatic change in lifestyle Banfield was with the Townsville *Daily Bulletin*; he retired from that paper in 1897 at the age of 44, evidently in a state of nervous exhaustion, and with his wife, Bertha, began a new life on Dunk Island. In 1908 Banfield's *Confessions of a Beachcomber*** was published in England, an idyll that captured the imagination of would-be drop-outs all over the world. In Australia, many of Queensland's pioneer island settlers have confessed to being strongly influenced by this book. Banfield lived on Dunk Island until his death in 1923. Both he and his wife are buried on the island.

Dunk was a radar station during World War II, its antenna placed on the highest hill, Mt Kootaloo (271 m), from which beautiful views are available to walkers. A small resort operated and changed hands a number of times before the title was acquired by P&O and Australian Airlines in 1978, who built the present resort. Today it is owned and operated exclusively by Australian Airlines Resorts, one of six operated by this experienced company (the others are Lizard, two on Bedarra, Brampton and Great Keppel Islands). The island has its own airstrip, and Australian Airlines De Havilland Twin Otter aircraft bring guests

*Halifax refers to George Montague, 2nd Earl of Halifax, who married Elizabeth Dunk (and thereafter changed his title to Montague-Dunk). Their daughter subsequently married a son of the 4th Earl of Sandwich, First Lord of the Admiralty from 1771 (whose name, co-incidentally, was Montagu (no 'e'). Cook called the bay just to the south of Hinchinbrook Island, which he had passed six hours earlier, 'Halifax', and he named that island's easternmost point 'Sandwich'. So there was both a family connection and a naval association between these names, and Cook must have thought he had done rather well. Dunk Island is in Rockingham Bay, possibly by mistake. This name is that of the 2nd Marquis of Rockingham, who was no relation of Halifax or of Sandwich. In the various manuscripts of Cook's journal there is evidence that the great navigator switched the names of these adjacent bays, Halifax and Rockingham, back and forth several times before finally settling on them (in the wrong order?), indicating his confusion about this family matter. Banfield (and others) have since taken the family association further, referring to Dunk Island as 'the father', Bedarra 'the mother', and other islands and rocks in this group as 'the twins', 'three sisters' and 'the triplets'.

**Confessions of a Beachcomber* is available in Australia in an Arkon paperback edition released by Angus and Robertson. In this and several subsequent books, Banfield set down many observations about the Aborigines, the flora and fauna of Dunk and the surrounding islands, and these are now a useful part of the literature and history of the Queensland coast. Of a different era, Banfield's style is perhaps a trifle turgid by today's standards, but his books abound with enthusiasm, which no doubt contributed to their being widely read and to making Banfield something of a celebrity. An example of text from Banfield's own 'Foreword' to his *Confessions*: 'My chief desire is to set down in plain language the sobrieties of everyday occurrences—the unpretentious homilies of an unpretentious man—one whose mental bent enabled him to take but a superficial view of most of the large, heavy and important aspects of life, but who has found light in things and subjects homely, slight and casual; who perhaps has queer views on the pursuit of happiness, and who above all has an inordinate passion for freedom and fresh air'.

ISLAND SUMMARY
Dunk Island
Location: 17° 56'S 146° 09'E
Gateway: Mission Beach (4 km) and
Clump Pt (10 km)
2218 km N of Melbourne
1843 km NNW of Sydney
1272 km NW of Brisbane
122 km SSE of Cairns

Island and resort details
Continental island (890 ha), the largest of the Family Group, 4 km from the mainland, in a high rainfall area which gives this island a lush, tropical nature. Vegetation is predominantly open eucalypt forest, with areas of rainforest, but there are many rainforest species throughout. About 80% is National Park. Extensive fringing reef extends along the western side which, because of proximity to turbid mainland waters, is not readily appreciated by visitors. The island has a number of sand beaches. In the National Park are 13 km of graded walking tracks.

Access
From Townsville: by Australian Airlines, 2 flights daily, 3 on weekends (45 mins). From Cairns: by Australian Airlines, 1 flight daily (40 mins). From Mission Beach: by MV *Quick Cat* departing Clump Point at 10.00 daily (15 mins); by water taxis, which operate throughout the day from South Mission Beach and Wongaling Beach (15 mins).

Resort capacity, accommodation, facilities
Maximum capacity about 375, with numerous day-trippers.
Accommodation: 153 units of 3 standards: 50 Beachfront units along front of Brammo Bay; 47 Garden Cabana units situated throughout richly landscaped resort area; and 56 Banfield units along periphery of resort area. All are air-conditioned, with private bathroom, refrigerator, ceiling fan, tea/coffee facilities.
Resort facilities: 2 fresh-water swimming pools; spa; 2 outdoor lighted tennis courts; 1 undercover tennis court; 2 air-conditioned squash courts; 6-hole golf course; gym; large lounge/disco; boutique and shop; laundry; hairdressing salon; dairy farm; complete range of water sports equipment. Free child supervision

daily with Children's Club (activities for 3–13 year-olds) and children's dinner (3 years and up) 5.00 p.m. to 9.00 p.m. daily. Babysitting available (at normal rates). Public phones only.

Tariff
All-inclusive (except alcohol, water sports requiring petrol, excursions/cruises, golf balls, clay-target shooting, horse riding).

Eating and drinking
Resort dining room Beachcomber Restaurant (8.00 a.m. to 9.30 a.m., 12.00 noon to 2.00 p.m., 7.00 p.m. to 8.30 p.m.); Banfield's *à la carte* Restaurant (from 7.30 p.m. Monday through Thursday, and Saturday). Main lounge bar 9.00 a.m. to midnight; Banfield's Bar (before dinner); Pool Bar (10.00 a.m. to 6.00 p.m.); Jetty Bar (10.00 a.m. to 6.00 p.m.).

Activities
Aerobics, archery, clay-target shooting, cricket, garden walks, golf, horseback riding, indoor bowls and cricket, squash, tennis, volleyball (indoor and pool), aquarobics, catamarans, cruises (island and sunset), dinghies w/outboard, fishing (and charters), paddle skis, para-sailing, sailboards (and tuition), snorkelling gear (and tuition), waterskiing, water tobogganing. The National Park has 13 km of graded tracks. All-day trips to the Barrier Reef are available daily aboard MV *Quick Cat*, which goes to Beaver Cay (50 mins). Helicopter day-trip to Orpheus Island is available.

Anchorage for yachts
Brammo Bay, in the area off the jetty just north of The Spit, is a popular anchorage sheltered from SE trade winds. Yachtsmen may use main resort lounge bar and front pool area until 6.00 p.m. Restaurant bookings permitted if numbers allow.

Dunk Island, via Townsville, Qld 4810. Telephone: (070) 688 199. FAX: (070) 688 528. Telex 148851.

on a picturesque flight from Townsville over the Palm and Family Islands, or from Cairns.

The resort

Situated by the shores of Brammo Bay on the north-western side of the island, the resort looks northwards through palm trees over a wide crescent sand beach. The water here is very shallow at low tide, and most aquatic activities on the island take place on The Spit, a long projection of sand to the west of the airstrip. Behind the resort is a golf course and dairy farm, which produces fresh milk and cream for Dunk and the neighbouring Bedarra Island.

The resort has evolved over the years, and its layout betrays a process of adding-on rather than a well-conceived design executed all at once. The faults are disguised somewhat by the attractive landscaping, with manicured lawns and lush tropical gardens that break up the spaces and create many private enclaves. These gardens are lovingly tended by a full-time nurseryman and his helpers, who with obvious skill (and some help from nature) have created a floral extravaganza, in spite of the intervention of cyclones.

In the middle of Brammo Bay's sweeping curve and a pebble's throw from the beach is the small reception area, which has been overtaken by time and should be much larger for the size of the resort. Next door is the boutique and shop, and several metres further west, the large, open Beachcomber Restaurant and lounge/bar look out over a fresh-water swimming pool through waving palms to the beach. A little further back along a winding path there is a second, huge, fresh-water pool, a cascading affair in three tiers, with a pool bar. Close by, a large, unaesthetic structure houses the activities booking office, indoor tennis court, squash courts, gymnasium, games room, disco and, a little incongruously, Banfield's *à la carte* Restaurant and bar where, for some reason, to get from the bar to the restaurant one passes through the games room. On the slope behind the resort is the golf course and, further up the hill, the dairy farm.

Accommodation and tariff

Dunk has three standards of rooms. The Beachfront units are immediately behind the beach on both sides of the central complex. The newer of these are in two-storey blocks to the left of the dining room and lounge; these rooms are split-level, elegantly appointed, with white walls and decorated in cool pastel shades. Each has its own terrace or balcony. The older Beachfront units are further along towards the eastern end of the beach, surrounded by thick vegetation, with bougainvilleas tumbling down over their latticework—secluded and private. All Beachfront units are designed for couples, with queen-size beds; all look right out onto the beach. Set among landscaped gardens and lawns in the centre of the resort area are the Garden Cabanas, which can accommodate couples or a family. The Banfield units are at the edge of the landscaped resort area, are more basic in furnishings and will accommodate families of up to five people. All units at Dunk are now air-conditioned.

The tariff is all-inclusive, except for alcohol, water sports which require the use of petrol, extra excursions, horseback riding, clay-target shooting, and golf balls.

Eating, drinking and entertainment

All three meals are served in the large, open Beachcomber Restaurant, a colonial-style building, typically open for the tropics, a single room with a high ceiling and suspended fans, wooden floor and trim. The building

Dunk Island placenames
Many of the Dunk Island placenames come from Aboriginal words. These were recorded by the beachcomber, E. J. Banfield, who has given the meanings of some of them: *Coonana* (a bulky rock, isolated); *Moorinjin* (spangled drongo, a rainforest bird); *Muggy Muggy* (coral mushroom where crayfish lurk); *Pallkooloo* (group of isolated rocks perpetuating a legend of men who came across from the mainland to fight); *Pallon* (name of an Aboriginal gin); *Toogan Toogan* (shrub providing fish spears, twine for lines, and a cement); *Woolngarin* (palm with coconut-like fronds).

COLFELT

Above:
Visitors to Dunk and other islands of the Family Group may be lucky enough to see the beautiful, iridescent-blue Ulysses butterfly on the wing around the gardens or in the forest. It is the adopted emblem of the resort, adorning everything from T-shirts to the bottom of the swimming pool.

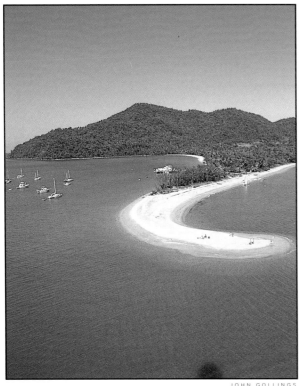

JOHN GOLLINGS

Left top:
The Spit, Dunk's water sports playground.
Left below:
Beachfront units.
Centre below:
The resort is set in the crescent of palm-fringed Brammo
Bay, on the north-western side of the island.
Right top and bottom:
Dunk has two fresh-water swimming pools, one in three
levels surrounded by gardens (top), the other in front of
the main dining room and lounge, with
views out over Brammo Bay.

COLFELT

COLFELT

JOHN GOLLINGS

COLFELT

has been enlarged beyond its original design, and with the numbers that now sometimes dine there, it has more the atmosphere of a refectory, or cafeteria, than a tropic isle restaurant; the sounds of clattering plates and cutlery dropped on the wooden floor reverberate throughout the hall. It is relaxed and informal, and there are plenty of tables of different sizes, so that those who wish to dine by themselves (if not exactly 'alone') may do so. Meals in the Beachcomber are both good and substantial, with occasional flourishes such as the seafood smorgasbord on Friday nights. Breakfast and lunch are serve-yourself. For those who want to get away to some romantic peace and quiet, there is Banfield's Restaurant, intimate and air-conditioned, and as guests at Dunk have already paid for all meals, the price of a full *à la carte* selection is less than one might normally expect. Dunk offers relief for parents in the form of children's dinner every night—free supervision of children three years and older from 5.00 p.m. until 9.00 p.m.

The large entertainment lounge and bar right next to the Beachcomber has after-dinner entertainment almost every night, with a resident band. There is also a disco, located well away in the activities centre, for those who want to stay up.

Activities

Dunk Island provides a diverse range of activities, something to entertain every age group throughout the day and into the night. There is a very wide variety of water sports, which are conducted from The Spit, where the day-visitor centre is located, just opposite the jetty. Sailboards, catamarans, and similar beach entertainments are available (instruction in many of these is available), and there is also para-sailing, waterskiing, and water-tobogganing. Water-sports equipment is free to guests and is hired out to visitors. Dunk has a six-hole, par-21 golf course. There is horseback riding at the farm, where guests are also welcome to watch the cows being milked at 5.30 a.m. or at 3.30 in the afternoon. A rather unusual addition to activities is clay-target shooting.

The resort provides a daily special children's activities programme (free child minding for 3–13 year-olds) all day during school holidays, otherwise morning or afternoon.

Walks

Dunk is one of a few continental islands on the coast to have real rainforest, and in the National Park there is a system of graded walks which offer a splendid opportunity to enjoy some magnificent views, tropical forest (and its occupants) and deserted beaches. The track from the resort to Mt Kootaloo is steep in places but not especially difficult if you take your time (recommended round-trip is two hours). From the summit one can either go back to the resort or continue on through the Valley of Vines (so called because of the profusion of tropical plants and vines, such as the lawyer vine (*Calamus*), or 'wait awhile', as it is sometimes quaintly called because it insists that one linger by snaring the clothing in its long tentacles with recurved hooks. The island has a wealth of bird life, and in the cool understorey of the forest, with luck you may see the Ulysses butterfly, a brilliant flutter of iridescent blue, now the symbol of Dunk Island resort. Emerging on Coconut Beach, the track follows the shoreline back to the airstrip, passing Bruce Arthur's Artists Colony, where the well-known wool tapestry weaver resides and has accommodation for visiting students of weaving, pottery and painting. His house is open to resort guests on certain days of the week, with

Below:
Dunk Island's rainforests, with their rich flora and fauna, invite exploration and adventure.

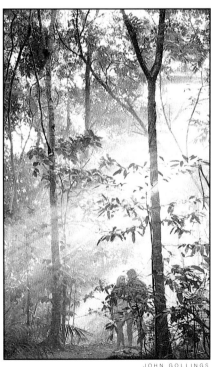

JOHN GOLLINGS

various works of art on display. Allow five hours to do the complete circuit in comfortable time. Walkers should remember to let someone at reception know that they are heading off. Remember, also, that in rainforest the light is dim, and dusk in the tropics turns to night very quickly. Take a drink and a piece of fruit.

Reef trips and island cruises

MV *Quick Cat* arrives daily about 10.15 a.m. with passengers from the mainland, and after picking up passengers from Dunk it continues on out to the Barrier Reef (to Beaver Cay, about 50 mins). There the cat ties up to a pontoon, and visitors may go coral-viewing in the sub or glass-bottom boat, snorkelling, swimming or can just lie in the sun. A marine biologist is on hand to take guided tours of the reef. Scuba diving is available, and introductory resort courses are offered for those who are not qualified. Lunch, morning and afternoon tea are served; *Quick Cat* returns at about 4.00 p.m. Dunk also offers guests an opportunity to take an all-day trip via helicopter to Orpheus Island, if enough people are interested.

For those who like sailing, the large and comfortable sailing yacht *Neptunius*, skippered by a real old salt, Harry Parsons, takes lunch cruises to the Family Islands as well as sunset cocktail cruises.

Camping

Dunk Island has a National Parks campsite on The Spit, with 13 sites that can accommodate a maximum of 30 campers. The camping area is adjacent to the day-tripper facilities provided by the resort, and the site, therefore, does not, by any stretch of the imagination, provide a 'wilderness camping' experience. It is a good base for those who want to explore the National Park, with the added convenience of toilets, showers, snack shop and bar close by. Permits for camping are issued by the Cardwell QNPWS office (see address on page 177), for a maximum stay of three days; they are free of charge.

Above:
Catamarans, windsurfers, dinghies and waterski tow boats ready for use on the northern side of The Spit.

COLFELT

Above:
The sun makes a spectacular beginning to the day as it melts its way through moist tropical air still laden with the smoke of last night's cane fires. The pall of these pre-harvest burns is a familiar part of the Queensland tropics during the sugar-cutting season, from June to December.

* The bay was named by Lt James Cook, who anchored there on Trinity Sunday, June 10, 1770 (the first Sunday after Whit Sunday on the Christian calendar).

CAIRNS

The city of Cairns lies at latitude 16° 55'S, almost 2000 km north of Sydney, on a mangrove-studded inlet in Trinity Bay.* It is today the tourist capital of north Queensland, a friendly, relaxed place and probably the city in Australia which best understands what tourism is all about. Cairns has a population of about 80 000 mostly concentrated in the suburbs, and the city itself is not unlike a large country town, laid out on a wide grid with predominantly single-storey buildings and a few high-rise hotels. Cairns has some lovely examples of early Queensland architecture. Esplanade, Cairns's pleasant waterfront promenade, looks out onto Trinity Inlet, whose waters recede at low tide, leaving a muddy fossicking ground for myriad waterfowl.

Cairns officially came into being in the goldrush days of 1876, when it was declared a port, to serve the Hodgkinson goldfield to the north-west. But teamsters and packers never liked Cairns because of the squelchy terrain between the waterfront and the foot of the mountains, and it was soon superseded by Port Douglas, 60 km further north. Named for Sir William Wellington Cairns, then Governor of Queensland, Cairns didn't really come into its own until after the Kuranda railway was completed in the 1890s. It was the most difficult railway construction ever undertaken in Queensland, the building of which cost 29 lives. Today tourists can ride this spectacular train, which climbs up through the Barron River Gorge and over the mountains to the Atherton Tablelands, passing through numerous tunnels and crossing dozens of high trestle bridges.

The Great Barrier Reef is closer to the mainland at Cairns than anywhere further south, the nearest part being Green Island, a coral cay

located only 27 km offshore. The edge of the continental shelf itself is only 60 km from Cairns. In this section of the Marine Park there are some 180 tourist operators offering Reef trips, scuba diving, island cruises, and scenic flights. Most of these adventures begin at the Marlin Jetty, at the southern end of Esplanade. Cairns has a good selection of shops, and there are lots of different places to dine.

The succession of sandy beaches stretching some 60 km north of the city make up what is called the Marlin Coast, a boast about Cairns being the world capital for giant black marlin fishing and the home of Australia's largest heavy-tackle game-fishing fleet. From September to mid-December record-breaking trophy fish are caught off the continental shelf further north.

To the west of Cairns the land rises steeply to the fertile Atherton Tablelands, where cattleman John Atherton first set up a homestead in 1877 and later discovered tin (one story says, exclaiming 'Tin, hurroo!' which is how the little lake town of Tinaroo got its name). The tablelands are the rich, green rolling country behind the coastal mountains, with volcanic lakes surrounded by rainforest, turbulent streams and cascading waterfalls. The air is cooler there and offers a respite from the heat and humidity of the tropical coast, and the tablelands are becoming an important tourist area.

Cairns is a gateway to many destinations further north, such as Port Douglas, Mossman, the Daintree River, Cape Tribulation, Cooktown and Lizard Island (these are discussed in the next section). Tours by bus, aeroplane, four-wheel drive vehicle and wavepiercer catamaran depart from Cairns for all of these destinations.

How to get to Cairns

By road. Cairns is about a four-hours-plus drive from Townsville, the next major city to the south, and about 21 hours from Brisbane. By bus (five companies go there) Cairns is 4 hrs 30 mins from Townsville and 23 to 26 hours from Brisbane.

By air. Cairns has an international airport with direct flights from a number of foreign counties. Three major domestic carriers go to Cairns; Ansett Airlines and Australian Airlines have most of the flights, and East-West has one daily service. From Melbourne, Cairns is about 3 hrs 15 mins non-stop; from Sydney, it is 2 hrs 50 mins; from Brisbane, it takes a little over two hours.

By rail. Cairns is 33 hours from Brisbane on the weekly tourist train, The Queenslander (which offers a 'piggy-back' service for cars); the Sunlander commuter, which runs five days a week, takes 35 hours.

Cairns weather

Cairns has a tropical climate varying from warm and humid to hot and humid. The 'green' season is December–April, when an umbrella often

	Jan.	Apr.	July	Oct.
Avg. Daily High	31°C	29°C	26°C	29°C
Avg. Daily Low	24°C	22°C	17°C	20°C
Days Rain (over 0.2 mm)	18	17	9	9
Normal Rainfall	374 mm	161 mm	20 mm	27 mm
Mean Sea Temp.	28°C	26°C	22°C	25°C
Normal Annual Rainfall = 1961 mm				

Below:
Cairns is Queensland's northern capital of tourism, a city much like a big country town, with some fine examples of an earlier architecture.

STEVE NUTT - QTTC

comes in handy. When it's raining on the mainland, it is not always raining at The Reef, however.

As is true in all of northern Queensland, swimming in the ocean close to the Cairns mainland is hazardous during the marine stinger season (October–April) because of the possible presence of the box jellyfish (see 'Notes for Reef Travellers'). A number of Cairns's northern beaches, such as Holloway Beach, Trinity Beach, Yorkey's Knob, Kewarra Beach and Clifton Beach, have stinger-protected swimming enclosures, and most of the hotels and motels have fresh-water swimming pools.

Tourist information

Tourist information is available at the Far North Queensland Promotion Bureau, on the north-east corner of Sheridan and Aplin Streets, Cairns, Qld 4870, telephone (070) 513 558. The Marlin Jetty Booking Office specialises in fishing and boating activities, and almost every hotel and motel in the area has a rack full of tourist literature.

Accommodation

In recent years Cairns has experienced a building boom. There are many new hotels and motels and more are under construction. Cairns has two new five-star international hotels, the Cairns Parkroyal and Hilton International Cairns, several four-star-plus and four-star hotels, such as the Pacific International, Cairns Quality Inn Harbourside, Tradewinds Esplanade, Four Seasons Cairns, and a host of three-star-plus to two-star hotels and motels. Cairns is a Mecca for backpackers, with some 15 hostel-type establishments of various sizes, and there are a number of small boarding houses. There are some beautiful old traditional hotels,

Below:
The James Cook Highway from Cairns to Port Douglas is one of the prettiest drives in Australia, following the shoreline closely and giving many splendid views.

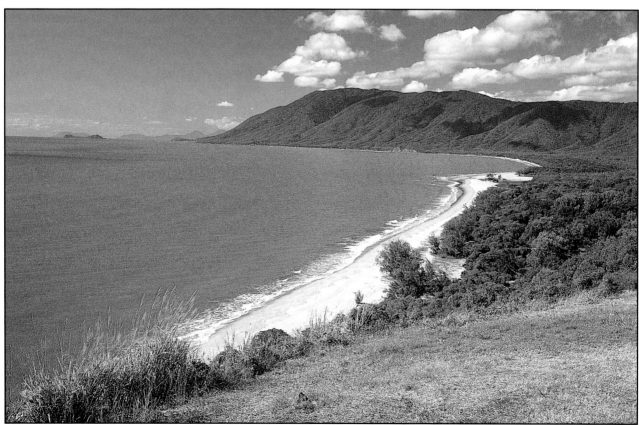

COLFELT

too (primarily for drinking), some of which are sadly defaced by gaudy 'Fosters' and 'XXXX' banners).

The beach communities to the north of the city are both dormitory suburbs as well as holiday venues. These have a variety of accommodation, from motels and holiday flats to very luxurious resorts, such as the Ramada Reef Resort at the premier northern beach suburb of Palm Cove.

Reef trips and cruises

Cairns is Australia's principal centre for Reef tourism and there is a wide variety of Reef destinations and choices of how to get there—something for everyone, no matter what their age or condition. There are numerous day-trips departing every day, and extended cruises of three to eight days are also available. Characteristic of the crews on board Cairns' tourists vessels is their infectious enthusiasm for The Reef, and they also have the Australian gift of friendly informality that puts even the most timid Reef explorer completely at ease. A representative sample of Reef trips and island cruises is provided in the box on page 210. Some of these are in large vessels which take several hundred passengers; others are in smaller vessels and take perhaps as few as 15–20. Details of trips change from time to time; for up-to-date information check with the tourist information office or booking offices.

Diving

Cairns is a major scuba-diving centre, and more divers are trained here than anywhere else in Australia. There are five or six companies in the city and on the resort islands offering certificate training, from introductory 'resort' courses on up to the level of Divemaster. A typical training programme for an Open Water Diver certificate is two or three days' lectures and pool work followed by a three-day, two-night trip to The Reef on a dive boat. Prospective trainees may do well to shop around and compare what is being offered. Scuba diving for certificated divers may be undertaken on the tourist catamarans, other day-trip vessels, or specialised dive boats which offer day-trips and three-day (two-night) trips. A number of vessels offer extended trips (3–9 days) going north to the Ribbon Reefs and the famous Cod Hole east of Lizard Island and, at certain times of the year, out to the Coral Sea. Connections can be arranged with dive boats operating out of Port Douglas, Cooktown and Lizard Island.

Game fishing

Cairns is the game-fishing capital of Australia and the giant marlin centre of the world. Each year, in late August to early September, black marlin swim into the Barrier Reef waters to spawn, just off No. 10 Ribbon Reef, in numbers unequalled anywhere. Trophy fish hunters from around the globe come to Australia in quest of a prize. During the season, which lasts until perhaps mid-December, the heavy-tackle fleet in Cairns numbers 30–40 boats. A small number of these do day-trips; the majority do extended trips and either provide accommodation themselves for the anglers or work from one of nine or so large 'mother ships' which stay anchored at The Reef throughout the season. Some game-fishing boats and anglers use Lizard Island as a base of operations during the marlin season. The resort on that island is heavily booked at this time, and special arrangements are made for game boats at the resort's day-visitor facility at Watson's Bay. Heavy-tackle game-fishing boats accommodate usually two, but up to four, anglers, and the sport,

COLFELT

Above:
Large clusters of coral in the lagoonal waters of Michaelmas Cay.

Visiting the Great Barrier Reef from Cairns

Day trips

Agincourt Reefs. A series of beautiful coral reefs 102 km north of Cairns. Access is by Quicksilver Connections of Port Douglas. This is considered one of the best Reef trips in Australia. Quicksilver has a fleet of buses that picks up passengers all around Cairns daily; the company also operates a wavepiercer catamaran departing from Cairns each morning bound for Port Douglas to connect with its Reef trips and which then goes on to Cooktown for the day. Helijet offers a helicopter connection with Quicksilver from Cairns airport daily. See next section (Section VI: The Far North).

Fitzroy Island. A very pretty continental island 29 km from Cairns just south of Trinity Bay. Coral shingle beaches; coral viewing; snorkelling; swimming and aquatic equipment for hire. Rainforest walks. Access is by Great Adventures' fast catamarans twice daily. This island has a resort and is discussed in detail later in this section.

Frankland Islands. A group of 5 continental islands, named by Cook after Sir Thomas Frankland, a British Navy admiral. The islands have extensive fringing coral reefs and thick rainforest. Day trips are operated, from Deeral Landing on the Mulgrave River (about 2 km off the main highway 40 km south of Cairns), by Banyandah Marine Tours. Its *Frankland Islander* takes a maximum of 40 passengers to Normanby Island for the day as well as a maximum 20 divers, who go on to Round Island for a day of diving. Normanby Island is 12 km offshore, a triangular-shaped, thickly rainforested continental island with coral sand beach, good fringing reefs with giant clams. Snorkelling, rainforest exploration, beachcombing, barbecue lunch. Banyandah Marine has a bus which picks up passengers daily from anywhere in the Cairns area.

Green Island. Coral island 27 km north-east of Cairns. Underwater observatory; snorkel trail; reef walking; day visitor facilities; museum of sea curiosities and marine miscellany. Nice beaches for swimming and sunning; beach equipment for hire. Green Island has a small resort and is discussed in detail later in this section. Access is by Great Adventures' fast catamarans twice daily, or, by Big Cat, a budget-priced day trip to the island via slow catamaran.

Hastings Reef. 52 km north-east of Cairns, Hastings is visited by the 18 m cruiser, *Sea Star*, which stops first at Michaelmas Cay. *Sea Star's* experienced operator, Ray Brooker, has been tending 'his own patch of reef' at Hastings for years, removing crown-of-thorns starfish to prevent damage. Diving, snorkelling, fish feeding, hand-feeding small reef sharks; a relatively inexpensive, no-frills trip (bring your own lunch) for a maximum 40 passengers.

Low Islets. A picturesque coral cay 63 km north of Cairns, with lighthouse, surrounded by reef. Trip operated by Quicksilver Connections in Port Douglas (see 'Agincourt Reefs' above and Section VI: The Far North).

Michaelmas Cay. A jewel of a coral island on a reef 42 km north-east of Cairns. Michaelmas is literally clothed in sea birds, a major nesting site for some 14 species. It is a National Park and access for tourists is restricted to the northern beach to prevent disturbance to the birds. Michaelmas's fine coral sand beach is surrounded by crystal-clear water and provides an excellent launching site for snorkellers, particularly the inexperienced. Coral-viewing subs used by 2 operators. Giant clams. Access is by: Great Adventures' catamaran daily (8.30 a.m.) going via Green Island (snorkelling, coral-viewing sub, walk on cay, lunch, and two hours at Green Island on return

trip); or, by the large sailing catamaran, *Ocean Spirit*, which goes direct to Michaelmas Cay daily from Marlin Jetty (8.30 a.m.), a full-day trip with lunch, scuba diving (introductory dives and diving for qualified divers), snorkelling, coral-viewing sub, walking on the cay; or, by *Sea Star*, 18 m trawler-cruiser which takes about two and a half hours to get to the cay, stops for awhile and then goes on to Hastings Reef.

Moore Reef. 49 km east of Cairns. Access is by Great Adventures' catamaran (8.30 a.m., combined with 2-hr visit to Fitzroy Island, or 10.30 a.m. with no stopover); pontoon, glass-bottom boats, coral-viewing sub, snorkelling, scuba diving (introductory dives and diving for certificate holders), buffet lunch provided.

Norman Reef. 59 km north-north-east of Cairns just south of the Trinity Opening and almost at the edge of the continental shelf. Access is by Great Adventures' fast catamaran (several variations available depending upon the season, e.g. direct to Norman Reef, or via Green Island with or without 2-hr stopover at Green Island). Departs Great Adventures' jetty (8.30 a.m. or 10.30 a.m.). Facilities at reef include pontoon, coral-viewing subs, glass-bottom boats, snorkelling; barbecue lunch on pontoon. Access is also by Jayrow Heliventure helicopter from Cairns airport, which links up with Great Adventures' catamaran at Norman Reef, offering option of a one-way trip (return via catamaran) or a round-trip in the helicopter. Schedule is variable,

Upolu Cay. A small, ephemeral, low cay 32 km north-east of Cairns, a day-visit destination for 1 or 2 small vessels.

Extended cruises

Cairns to Thursday Island and return with *Atlantic Clipper*, a luxurious new 43 m (140 ft) 35-passenger square-rigged motor sailer with air-conditioned cabins (2-, 3-, and (one) 6-person). Does a Sat.–Sat. cruise (7 nights aboard ship) departing every Saturday from Trinity Wharf at 5.30 p.m. Trip goes to Lizard Island and up through The Reef to Cape York (champagne at sunrise), to Thursday Island for most of the day, and then returns stopping at islands and reefs all along the way, with last day in Cooktown. Beach barbecues, fishing, snorkelling, swimming, beachcombing.

Cairns to Thursday Island and return with *Queen of The Isles*, a 48 m (157 ft), 78-passenger, air-conditioned, steel motor cruiser with 2-person staterooms to 4- and 6-person cabins. Does a Sun.–Sat. cruise (5 nights aboard) departing Sunday evening from Trinity Wharf. Trip goes to Restoration Island and up through The Reef to Cape York (champagne at sunrise), to Thursday Island for 4 hrs, then back, stopping at islands on the way. Depending upon weather, may stop at Cooktown before returning to Cairns. Fishing, snorkelling, swimming.

Cairns to Townsville with *Coral Princess*, a new 35 m (115 ft) 54-passenger luxury motorised catamaran with air-conditioned twin cabins, staterooms and deluxe suites all with private bath. Does a Sat.–Tue. cruise (3 nights aboard ship) departing every Saturday from Trinity Wharf at 10.00 a.m. Cruise goes to Reef, overnighting at Moore Reef, on to Dunk Island Resort for next night, then through Family Islands and through Hinchinbrook Channel to the Palm Group and Orpheus Island for the night. On to Townsville next morning. Fishing, snorkelling, scuba diving, swimming.

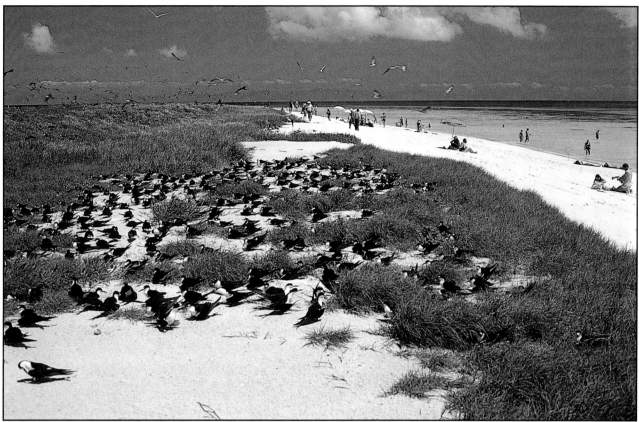

COLFELT

on a per-capita basis, is not inexpensive. It costs from $1200–$1800 per day for the boat, depending upon whether accommodation is also being provided. Anglers who wish to have the comforts of using a mother ship can expect to pay, on top of the price of the game boat, another $2200 per day. But, it's worth every penny to catch a 500 kg marlin.*

Light-tackle game-fishing is popular in Cairns throughout the year. This is a sport that can be enjoyed by people of ordinary means; light-tackle game boats can handle a greater number of anglers, and the charge per day, spread amongst perhaps eight anglers, is about $800.

Camping

Those intent on island camping in the Cairns area have two choices. Fitzroy Island has a commercial campsite operated by the resort (see discussion of this resort later in this section). Non-commercial camping is permitted on two National Park islands of the Frankland Group, 40 km south of Cairns, on Russell Island (toilets, picnic tables and benches, maximum of 30 campers) and on High Island (a 'wilderness camping' island with no facilities, maximum 15 campers). These are pretty islands, with good fringing coral, dense rainforest, and relative isolation. Transport and arrangements for water or equipment hire may be made with Banyandah Marine Tours, which leaves from Deeral Landing on the Mulgrave River. This company also operates a bus which picks up passengers from Cairns and the northern beaches. A camping permit is required and may be obtained from QNPWS, 41 Esplanade, Cairns, Qld 4870, telephone (070) 519 811.

Above:
Michaelmas Cay is a tiny coral island 42 km north-east of Cairns. A low, vegetated cay, it is home to thousands of ground-nesting seabirds. Day-visitors from Cairns have an opportunity to snorkel off the beach and to view colourful corals and giant clams which lie in clear shallow water close to the island.

* It is usually the case on Australian game-fishing boats to tag billfish and then let them go again. Exceptions may be (a) if it is the first fish that the angler has ever caught and (b) if it is a record-sized fish. (For more about fishing, see 'Fishing on The Barrier Reef' in 'Notes for Reef Travellers'.)

COLFELT

FITZROY ISLAND

Fitzroy is a high continental island quite close to the coast east of Cairns. It has a warm tropical climate, its hills cloaked in lush vine forests, its shores lapped by clear blue-green waters and fringed with coral reefs. A small resort caters for informal, inexpensive holidays, for families, backpackers, divers, honeymooners and those who just wish to enjoy the pleasant natural surroundings. Most of the accommodation is hostel-style, with a small number of two-bedroom villas. Fitzroy is a popular destination for day-trippers from Cairns, offering many beach activities, 'jungle' walks, snorkelling and diving.

COLFELT

James Cook passed between Fitzroy Island and the mainland on Trinity Sunday, 1770, later naming the island and the adjacent point of the mainland after the 3rd Duke of Grafton, Augustus Henry Fitzroy.* Aborigines, at this time, had already been using the island for millenia, periodically coming to gather its abundant food.

In 1819, Phillip Parker King, while surveying the Queensland coast in the cutter *Mermaid*, sheltered from a gale in the western bay of Fitzroy Island, now known as Welcome Bay. King noted the constant stream of fresh water running into a pool behind the present resort and also that the anchorage afforded plenty of timber. From the time King's observations were published Welcome Bay became a much visited anchorage by all manner of vessels on coastal voyages.

During the Queensland goldrush from the mid to late 1800s, when gold was found behind the coastal ranges all the way from Townsville to Cooktown, thousands of Chinese gold-seekers came into the State, both from New South Wales and Victoria and, later, in large numbers, directly from China. The Chinese, being very thorough prospectors, were content to rework ground already dug by the Europeans, and their meticulous methods brought them no small success. However, their alleged tendency to smuggle nuggets back to China instead of selling them locally, as well as their ever-increasing numbers, earned them the jealousy (and hatred) of colonial diggers. The Chinese Immigration Act of 1887 was one of a series of Acts designed to slow down the 'yellow peril'; it placed a heavy poll tax on these immigrants, and health authorities gazetted Fitzroy Island as a quarantine station where all Chinese (who might be carrying smallpox) had to stay for a minimum period of 16 days before setting foot on the mainland. If they showed any signs of sickness, they had to stay a further 16 days, and so on. It was almost a self-fulfilling regime; by April 1877 there were some 3000 Chinese living in intolerable conditions on the island. They ultimately revolted, and there was bloodshed. The graves of Chinese who died on Fitzroy may be seen by tourists today.

Fitzroy played a role as a radar and war signals station during World War II. On an eastern prominence stands a lighthouse with a red-white-green sector light that guides shipping through the Grafton Passage in the Great Barrier Reef.

The resort

The resort is situated at the edge of Welcome Bay. The beach, like all of the beaches on the western side of Fitzroy, is a steep bank of coral

Above:
A big cloud of atherinids (bait fish, or silversides) hovers in the warm shallow waters of Welcome Bay, one of many sights to delight and divert the snorkeller.

Opposite:
Large granite boulders on the coral sands of Nudie Beach illustrate the dual nature of Fitzroy Island, which is composed of mainland (continental) rock while its apron is of coral like that which makes up the Barrier Reef.

* Fitzroy was Secretary of State in the Rockingham administration (1765–66), was by far its ablest member, who 'gave to the turf and his mistresses the hours and the gifts which in politics might have achieved an enduring reputation'. (Robertson, Sir C. G.: *England Under the Hanoverians*, Methuen, London 1911.)

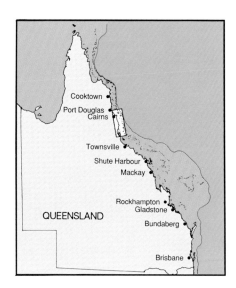

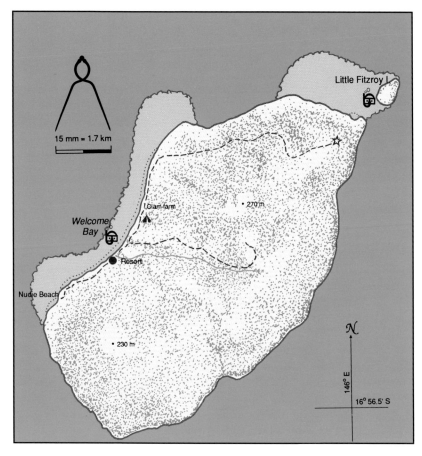

ISLAND SUMMARY
Fitzroy Island
Location: 16° 56'S 145° 59'E
Gateway: Cairns (33 km by sea)
2329 km N of Melbourne
1957 km NNW of Sydney
1378 km NNW of Brisbane
23 km E of Cairns

Island and resort details
An attractive high, rocky continental island (324 ha), with maximum elevation of 270 m, covered with eucalypt and tropical vine forest. A small islet situated off the north-east corner is a popular scuba-diving site. The island has a lighthouse which marks the Grafton Passage through the Great Barrier Reef. Fitzroy is almost completely surrounded by fringing coral reef, and it has a number of coral shingle beaches. A small resort, built in 1981 and later extensively modified, occupies 4.2 ha on western side, at Welcome Bay. Mulgrave Shire Council has a camping area, operated by the resort, located just north of the resort at Welcome Bay.

Access
From Cairns: by Great Adventures' catamarans departing from their Wharf St jetty at 8.30 a.m. and 10.30 a.m. (45 mins), returning 3.15 p.m. and 5.15 p.m.

Resort capacity, accommodation, facilities
Maximum 144 guests in resort accommodation, plus maximum 48 campers. Numerous day visitors.
Accommodation. Two standards: 8 Villa units, each with 2 bedrooms (1 double and 2 single beds), private bathroom, fan and patio; Beach House Bungalows, hostel-style accommodation, with total 28 units, each with 2 double-decker bunks (max. 4 persons) and individual lock-up cupboards. Beach House units have a separate toilet/shower block and separate kitchen and recreation room. The island has 12 campsites (max. 2 adults and 2 children per site).**Resort facilities.** Day-visitor area with freshwater swimming pool, Flare Grille restaurant, snack bar, boutique, full dive shop, Mango Bar, and separate Rainforest Restaurant and Cocktail Bar. Water sports equipment for hire. Coral-viewing sub.

Tariff
Guests staying in Villa units: tariff includes dinner, bed and breakfast. Everything else is extra. Guests staying in Beach House hostel-style accommodation: tariff includes room only and use of toilet/shower and kitchen facilities (bed linen and everything else is extra).

Eating and drinking
Rainforest Restaurant (breakfast and dinner, 8.00 a.m. to 9.00 a.m., 7.00 p.m. to 8.30 p.m.). Flare Grille (11.30 a.m. to 1.45 p.m.). Mango Bar (9.30 a.m. to midnight); Cocktail Bar (6.30 for pre-dinner drinks).

Activities
Aquabike, beachcombing, catamarans, canoes, glass-bottom paddle skis (for 1 and 2 persons), island and rainforest walks, powerboards, scuba diving, semi-submersible coral-viewer, snorkelling (and lessons), surf skis, swimming.
A trip to the outer Barrier Reef (to Moore Reef) is available daily, as is a cruise to Green Island.

Fitzroy Island, via Great Adventures, Wharf Street, Cairns, Qld 4870. Telephone: (070) 519 588. FAX: (070) 521 335.

shingle, finger-size fragments of *Acropora* which make a lovely tinkling sound when walked on—a bit uncomfortable under tender, bare feet, but, unlike fine coral sand beaches, you can lie on this one without getting coated all over (like a piece of crumbed fish) by tenacious fragments of shell and coral that refuse to be brushed off. The water is crystal clear, its colour vibrant aquamarine. Around the jetty and along the shore, millions of tiny bait fish hover in large clouds, the edges of which recede and reshape when approached by a snorkeller and which disperse in a sudden shimmering explosion when a pebble is thrown into their midst. Welcome Bay has living coral just a few metres from the shore and is easy for snorkellers to get to.

The central resort complex is built behind a large, landscaped fresh-water pool and consists of a charcoal grille restaurant, dive shop and school, boutique, snack shop, mini-mart, departure lounge and bar. A few hundred metres away, along a path through heavy tropical foliage, eight cedar-clad Villa units look out over the beach. Beyond them are two wooden hostels set organically amongst shady trees with coconut palms growing right up through the outside edges of the roof.

Accommodation and tariff

The Villas have two rooms, with a double and two single beds. They are simply furnished and have a private bath, ceiling fan and shaded patio. The tariff for guests in these units includes breakfast and dinner, which are served in the Rainforest Restaurant. Lunch may be purchased at the Flare Grille. The Beach House Bungalow units are attractive, typical hostel-style accommodation but constructed for the tropics—airy, with large open windows and shutters that swing down (and which stay propped slightly open at night to let air circulate). The pine rooms have two double-decker wooden bunks and four individual lock-up clothes cupboards. As is true in most hostels, the walls are thin, and you are aware what time the last person goes to bed. Bed linen may be hired. There is a large separate shower and toilet block. The kitchen, where Beach House Bungalow occupants do their cooking, is a large, open room with several large fridges, plenty of counter space, several sinks, and all cooking and eating utensils. The eating area extends outside onto a terrace.

Beyond the Beach House Bungalows there is a commercial camping area run by the resort, with 12 sites (maximum two adults and two children per site). A permit is required to camp, which may be obtained from the Great Adventures' booking office at the Wharf Street jetty in Cairns, telephone (070) 510 455.

Eating, drinking and entertainment

Breakfast and dinner is served in the Rainforest Restaurant, 100 m or so up the beach from the central complex. It is a pleasant dining room with tropical atmosphere, where the menu is *à la carte,* and a budget-priced *table d'hôte* selection is also available. Night-time entertainment is pro-vided at Fitzroy about once a week, a disco or band.

Activities

The beach is the centre of focus at Fitzroy. Welcome Bay lives up to its name, very protected and hospitable. All manner of beach equipment is available for hire, by house guests and day-visitors alike—canoes, glass-bottom paddle skis for one or two, motorised surfboards, catamarans, aquabikes, windsurfers. The resort has a coral-viewing sub, and a swim-ming platform with slippery slide is anchored in the bay. A good variety of hard and soft corals may be found not far offshore, and there are

Below:
Fitzroy's hostel-style Beach House Bungalows, set sympathetically in their surroundings under shady trees, are open and airy, designed for the tropics.

COLFELT

occasional giant clams and lots of fish.

A giant clam farming project has been underway at Welcome Bay for a number of years, and its large brood tanks are located just beyond the camping area. Juvenile clams are reared in these tanks until they are large enough to be placed on racks out in the bay.

Walks

Fitzroy has several walking trails through rainforest, with occasional signs along the way explaining something of the flora and fauna, for example, the mysterious mound which is the top of the scrub fowl nest buried deep in the friable rainforest floor, a marvellous piece of self-incubating engineering that liberates the bird from its hatching duties. One such track goes south through forest just behind the shoreline to a lovely and secluded beach (Nudie Beach), which is of finer coral sand than that of the resort. A trail behind the central complex leads up the hill to the Boulder Lookout, and more-intrepid walkers can scramble up to the highest point of the island, where there are 360° views (allow about 1 hr 30 mins to go up and back comfortably; early morning is the best time, before it gets too hot and before there is much haze). There is also a road to the lighthouse.

Scuba diving

Scuba diving and training (resort and certificate courses) is an important activity, and Fitzroy is increasingly becoming known as a diver training venue. A favoured dive spot is the excellent fringing reef around Little Fitzroy Island, where there is coral to rival that found on the outer reefs.

Reef trips and island cruises

Daily catamaran trips are offered, to Moore Reef, only 24 km east of Fitzroy, where Great Adventures has a coral-viewing sub and where guests get a taste of shallow snorkelling or diving in the pristine waters of the Barrier Reef. A catamaran goes to Green Island every day, providing an opportunity to visit and experience a true coral island.

Opposite and below:
Welcome Bay is well sheltered and provides a hospitable playground for swimmers and snorkellers of all ages as well as an ideal anchorage for vessels on coastal voyages. Fitzroy is a hilly island with dense tropical foliage. Its beaches of coral shingle have been created by the action of the sea over past several thousand years, piling up the dead skeletons of the limestone-secreting animals that construct its fringing reefs.

COLFELT

COLFELT

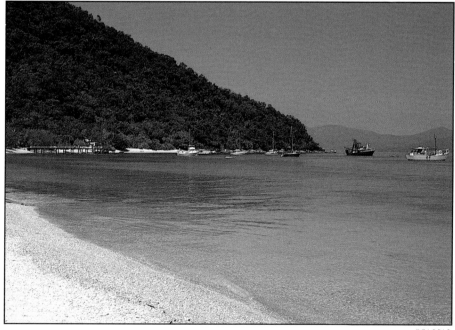

COLFELT

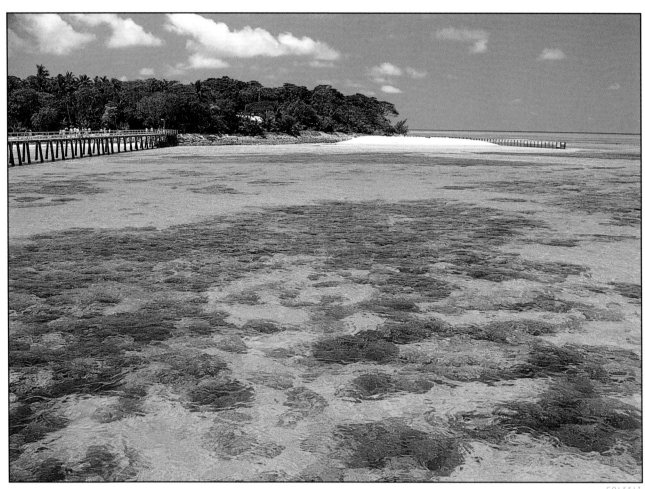

COLFELT

GREEN ISLAND

Green Island is probably the most-frequented location on the Barrier Reef, with perhaps 300 000 visitors each year, and in this respect it has been called a 'Reef supermarket'. The description is apt if it suggests that Green Island puts a variety of experiences into one place, with easy accessibility, and with a certain degree of aesthetic compromise that invariably is a part of dealing with large numbers. There is something for all ages at Green Island, an underwater observatory, a snorkelling trail, a beautiful, protected coral sand beach with crystal-clear water, a reef flat for fossickers, and other diversions such as Marineland Melanesia and a small film theatre. The island has a small resort, one of only three true coral island resorts in the Barrier Reef Region. House guests must share their 'desert isle paradise' with the many visitors during the day, but when 4.30 p.m. comes and the catamarans and tourists return to Cairns, Green Island totally changes character, reverting to that special condition unique to coral cays—the scent of salt and sea birds, the soothing sounds of waves on the reef.

Green Island was the first true Barrier Reef island to be seen by James Cook and the crew of the *Endeavour* when they did their coast-hugging journey of discovery in 1770. It was a precursor of the troubles which were to follow, and an indication of how much narrower the continental shelf has become, and how much closer the Barrier Reef is to the mainland, as one moves northwards along Australia's east coast. Green Island's proximity (27 km) contributed to its being one of the first of the islands to gain the attention of Europeans. At some time around 1856, a bêche-de-mer (sea cucumber) camp was set up there, at which time almost all of the trees were cut down to make fires to heat the boiling pots and to smoke the 'fish' (see 'bêche-de-mer' in 'Notes for Reef Travellers'). Green Island has once or twice been completely inundated during a cyclone, and today it has a rather unique flora, the result of both replanting since the late 1800s as well as the natural recolonisation of trees from seeds transported by birds.

In the late 1880s, amateur fishermen and groups of teachers from the mainland used to go over to the island to camp in grass huts for the weekend. To look after the simple facilities there, a caretaker was appointed—John Lawson, a character and renowned fisherman whose name was familiar to many, from Torres Strait to New South Wales. His nickname was Yorkey.* In 1922 the Hayles family of Townsville, who were pioneers in Queensland island tourism, built a jetty on Green Island, and in 1924 they commenced a regular fortnightly ferry service. In 1937 Green Island became a National Park. The underwater observatory was constructed in 1954, and in 1963 the Hayles opened the Coral Cay Hotel, which is today called the Green Island Reef Resort, operated by Great Adventures, a subsidiary of the owner, Dreamworld Corporation, one of Australia's most successful tourist operators. The company is about to embark on a $20 million programme to build a new, much larger underwater observatory, new day-visitor facilities and new resort accommodation. While all of this is going on, in stages, the management will continue to provide amenities for visitors.

Opposite:
Green Island's resort is on the western side of the island, with a long, dog-legged jetty extending over its reef into water deep enough for the ferries. The main attraction of the island is its reef and beaches, and visitors have the choice of coral and fish-viewing from the underwater observatory, glass-bottom boats or by snorkelling. The observatory gives those who wish to stay on dry land the opportunity to look at fishes and soft corals. Resort guests can occasionally visit the observatory at night, which can provide a whole new perspective.

* John ('Yorkey') Lawson lived on Green Island from the 1880s until he died on the island, in 1907. His name is best known today through 'Yorkey's Knob', a 40 m high hill on the end of a wooded point 15 km north of Cairns (also the name of the community there).
Professional fishermen, during the last century, often gathered their catch by dropping a stick of dynamite into the water. The story goes that Yorkey was, one day, using this sure-fire method of angling, and the explosive failed to detonate. In retrieving the dynamite from the water, Yorkey had his hand blown away. He was taken to the mainland and stitched up, but from that day onwards one of his arms was somewhat stump-like. It had a hook on the end, which from time to time gave him cause for worry (such as the time it got caught in the anchor chain when he threw the anchor over). 'Yorkey's Knob' is a bit of irony, inspired by this colourful character's misfortune.

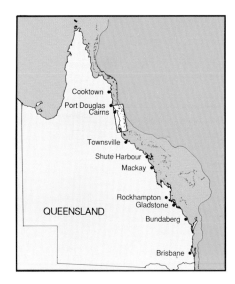

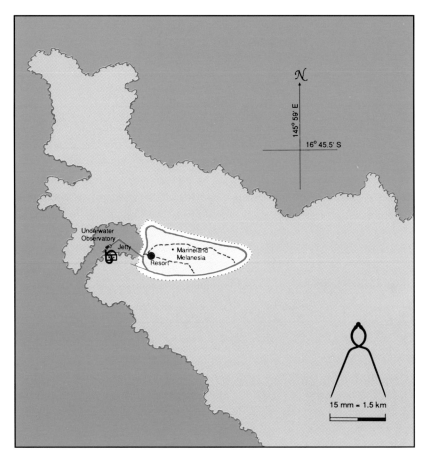

ISLAND SUMMARY
Green Island

Location: 16°46'S 145°58'E
Gateway: Cairns (27 km)
2347 km N of Melbourne
1978 km NNW of Sydney
1395 km NNW of Brisbane
27 km NE of Cairns

Island and resort details

Coral cay (area 12 ha; elevation 2.4 m) on north-west corner of a much larger lagoonal platform reef (1200 ha). Tropical maritime climate with warm to hot summers and mild winters. Average annual rainfall 2.2 m (86 in) 60% of it falling during the wet season (January–March). Vegetation is lush vine forest similar to north Queensland mainland forests with some typical cay species and a number of exotic species introduced over the past 100 years by man. Fine coral sand beaches and clear water make for good swimming, snorkelling and beach recreation. Two-thirds of Green Island is National Park. Its reef is not an outstanding example and has suffered from several infestations of the crown-of-thorns starfish in past decades, but it is showing excellent regrowth in some areas on the south-eastern end. The part of the reef seen by most casual visitors is visually attractive and provides a good, readily accessible reef experience. Other attractions are: underwater observatory and snorkelling trail; Marineland Melanesia (marine creatures, Pacific artefacts, crocodiles); small theatre. Most visited destination of the Barrier Reef, with some 300 000 visitors annually.

Access

From Cairns: by Great Adventures' catamarans departing from company's jetty at Wharf Road (next to Marlin Jetty) at 8.30 a.m. and 10.30 daily (45 mins), returning at 3.15 p.m. and 5.15 p.m.; by *Big Cat*, twin-hull cruiser daily from Marlin Jetty at 9.00 a.m. (90 mins) returning 5.30 p.m.; Great Adventures' *Mandalay* departing 9.00 a.m. (90 mins); via Aquaflite seaplane, on demand (10 mins).

Resort capacity, accommodation, facilities

Maximum about 80 guests, with a multitude of day visitors. **Accommodation:** 32 double and twin units of similar standard: 11 Tropical Villas which are slightly larger than the 21 Palm Villas, set behind central facility and along path under shady forest canopy. All have private bathroom, air-conditioning, ceiling fan, TV, fridge and mini bar, tea/coffee making facilities. **Resort facilities:** Underwater observatory and snorkelling trail; glass-bottom boats; water-sports equipment; snack bar; boutique; dive shop; laundry; public telephone.

Tariff

Dinner, bed and breakfast. Use of water-sports equipment free to guests.

Eating and drinking

Resort restaurant (breakfast 8.00 a.m. to 9.00 a.m., dinner 6.30 p.m. to 7.45 p.m.; morning tea 10.00 a.m. and afternoon tea 4.00 p.m.). Garden Grille and snack bar open (in day-visitor area) 10.00 a.m. to 4.30 p.m. Yorkey's Bar (day-visitor area) 10.00 a.m. to 4.30 p.m.; Sundowner Cocktail Bar 5.30 p.m. for pre-dinner drinks.

Activities

Beach volleyball, beach walking, bird watching, canoes, catamarans, coral viewing, fish feeding, guided reef walks, island walks, paddle skis, reef fossicking, scuba diving (and instruction), snorkelling, surf skis, swimming, windsurfers. Marineland Melanesia and Barrier Reef Theatre.
Barrier Reef trips (to Michaelmas Cay or to Norman Reef) available daily.

Green Island, via Great Adventures, Wharf Street, Cairns, Qld 4870. Telephone: (070) 514 644. FAX: (070) 513 624. Telex: 48322.

The resort

The central resort (day-visitor area) is a bit like a street café, a courtyard under a cluster of shady trees with many umbrella-covered tables and chairs, the Garden Grille, Yorkey's Bar, boutique, a small dive shop and snack shop. Almost immediately in front is a pleasant and protected sand beach, ideal for swimming and sunbaking, and the sand spit at its northern end is lined with catamarans and other beach equipment. The dining room, lounge and Sundowner Bar, which are for resort guests only, are a short distance away and look out towards the setting sun.

Accommodation and tariff

The 32 Palm and Tropical Villas are a short distance beyond the day-visitor area, extending north-east along a path under a shady forest canopy. This path traverses the island, emerging at several points to the beach. Green Island's units have all been improved in recent years; they are clean and comfortable. The 11 Tropical Villas are slightly larger (and slightly further away from the central complex) than the 21 Palm Villas. All have private bath, air-conditioning, ceiling fan, TV, tea/coffee making facilities, fridge and mini-bar. The tariff includes bed, breakfast, dinner, and the use of beach equipment and snorkelling gear.

Eating, drinking and entertainment

Breakfast and dinner are served in the resort dining room, which is small and informal; lunch may be purchased at the Garden Grille. There are two bars, Yorkey's in the day-visitor area, and the Sundowner, right next to the resort guests' dining room, the latter an excellent vantage point from which to watch the sunset as peace settles over the island in the evening. Green Island is about enjoying nature, and guests find adequate entertainment in the beauty of a coral island and its wildlife; videos and movies about The Reef are shown from time to time.

COLFELT

Above:
As the sun goes down, serenity returns to Green Island, where resort guests and other island residents enjoy the unique atmosphere of a coral island.

Activities

The main area of reef that is easily accessible to day-trippers is the reef flat in front of the resort and off the jetty. A snorkel trail along the outer jetty introduces an abundance of colourful soft corals and plenty of fish life. Fish-feeding takes place on the jetty each morning—quite a performance, as thousands of fishes vie for a hand-out, a ritual repeated each day for the past 30 years. A large expanse of reef flat (west of the groyne) dries at low tide; guided reefwalks provide an opportunity to learn about the mysteries of inter-tidal marine life on a reef. Green Island has a dive shop, and certificate courses are offered. The dive tender goes out twice each day for scuba diving on the island's reef. Marineland Melanesia, a short distance along the track beyond the accommodation units, has a potpourri of marine paraphernalia, with colourful fishes and other marine life in aquaria, small sharks in pools, some large saltwater crocodiles, Melanesian artefacts and articles of marine salvage. It is a popular addition to the island and is an inspiration to the beachcomber. The Barrier Reef Theatre next door screens some classic films about The Barrier Reef.

Reef trips and island cruises

Every day the Great Adventures catamarans depart for Michaelmas Cay, a beautiful coral island and seabird rookery 18 km to the north, where excellent snorkelling is available from the beach. There are daily trips, also, to Norman Reef, on the outer Barrier, where snorkelling, coral-viewing in semi-submersibles, scuba diving (for both the inexperienced and for certificated divers), swimming and a barbecue lunch are provided.

QUEENSLAND

Cooktown
Port Douglas
Cairns
Townsville
Shute Harbour
Mackay
Rockhampton
Gladstone
Bundaberg
Brisbane

Principal destinations of this section

From Port Douglas
- *Agincourt Reefs*
- *Low Islets*
- *Lizard Island*
- *The Ribbon Reefs*
- *Cormorant Pass*

From Cape Tribulation
- *Mackay Reef*

From Cooktown
- *Lizard Island*
- *Cormorant Pass*
- *The Ribbon Reefs*

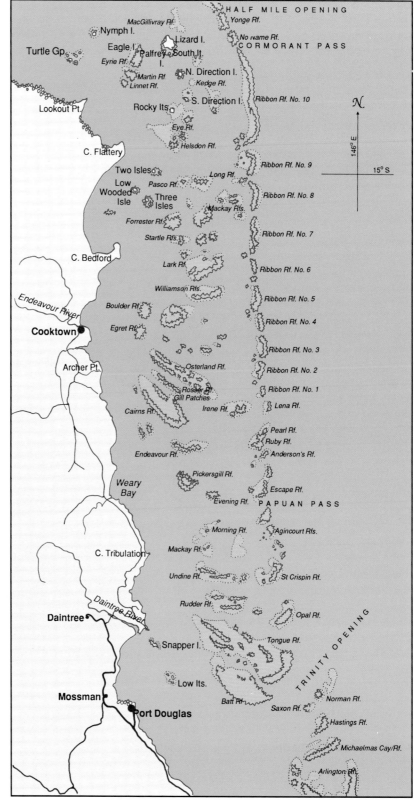

SECTION VI

THE FAR NORTH

Port Douglas, Mossman, the Daintree, Cape Tribulation, Cooktown;
the Low Islets, Agincourt Reefs, the Ribbon Reefs, Lizard Island

As James Cook sailed into coastal waters off Port Douglas (BC 115) he entered one of nature's minefields, which can be appreciated after only a brief glance at the map on the opposite page. Adjacent to Cape Tribulation* (C 14), the continental shelf is relatively narrow (about 41 km), and it is densely packed with coral ledges. At the edge of the shelf is an almost continuous line of ribbon-like reefs, with only relatively narrow gaps between them, and this stretches north for miles, bearing the brunt of the ocean's fury. The rampart which these reefs form no doubt suggested the term 'Great Barrier Reef' to the explorer Matthew Flinders who, in the early 1800s, first used this expression to describe the world's largest coral reef system. Just inside of the ribbons, the shelf lies at a depth of about 25 m; just outside, the clear waters of the Coral Sea plunge to over 1000 m. Cook said this:

> …we assended a high hill from whence we had an extensive view of the Sea Coast to leward; [which] afforded us a Melancholy prospect of the difficultys we are [to] incounter, for in what ever direction we turn'd our eys Shoals inum[erable] were to be seen.

> …we could see nothing but breakers all the way from the South round by the East as far as NW, extending out to sea as far as we could see, it did not appear to be one continued shoal but several laying detach'd from each other, on the Easternmost that we could see the Sea broke very high …

The latter part of Cook's observations were made during a southerly gale in June. As the year progresses, the south-easterly trade winds that fan the Queensland coast in winter give way to northerlies, and the Reef waters are often glassy-calm. This section of the coast is firmly in the tropics and has hot and humid weather for much of the year.

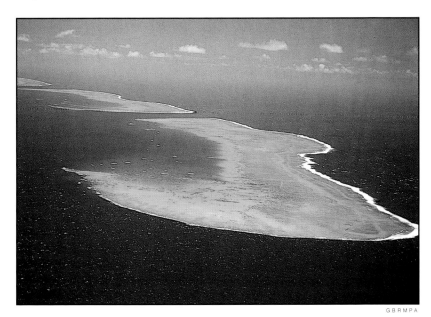

GBRMPA

Above: Yonge (foreground), Carter and Day are ribbon reefs north-east of Lizard Island. Cook found his escape between Carter and Day.

* 'Cape Tribulation' is one of a number of names on today's maps that were occasioned by the trials of James Cook's - *Endeavour*; it was after the ship passed this point that all the troubles began. At about 11.00 p.m. on a Sunday night in June, 1770, the ship struck Endeavour Reef, 35 km to the north-east of Cape Tribulation, and it was only supreme seamanship that enabled the crew to refloat her 24 hours later and make for a mainland refuge. Weary Bay commemorated their exhaustion from pumping the leaking ship. In the mouth of the Endeavour River a place to careen the ship was found, and Cooktown marks the spot where the crew camped for 48 days while repairs were carried out. No sooner had they set sail again, on August 4th, than they were for days hammered by south-easterly gales, the ship dragging her anchors and bringing them perilously close to grounding on the Startle Reefs. At Cape Flattery they were given a false impression of their prospects, at this point thinking they had at last gained open waters. They soon found themselves again surrounded by a maze of shoals. Point Lookout was the mainland prominence near where *Endeavour* anchored and which Cook climbed in search of a way through the labyrinth.

While on the subject of naming things, it was during their stay at Cooktown that *Endeavour's* crew made their first close contact with the natives of Australia, adding to the English language the word that is now 'kangaroo'. A myth has gained some currency in modern times, that kangaroo was not the name the natives used for the animal but rather was the utterance of a bewildered black interrogee—'I don't understand'—and that this was duly recorded by Joseph Banks. This explanation, for all its ironic charm, rests uncomfortably with other facts and gives scant credit to the intelligence of the Aborigines. Banks was meticulous in his recording of names, and although he admitted that his reliance on pointing at objects, to find out what the Aborigines called them, was open to error, he was careful to cross-check what he had recorded against the lists of two or three others. To suggest that the natives should have failed to understand what was being asked is hard to explain; the identification process was presumably by now a familiar, oft-repeated exercise. It would be even more unlikely to suggest that they didn't have a name for the kangaroo. A monograph published in 1901 by Ling Roth, *The Structure of the Koko-Yimidir Language*, about the language used by those natives around Cooktown, showed that Banks indeed had recorded many words correctly (and others very nearly so), and Roth suggests that the word used by these Aborigines and written down by Banks as *kanguru* was probably *ganguru*.

PORT DOUGLAS

The Captain Cook Highway is the last stretch of what may be called 'highway' in Queensland. Wedged between mountains and the Coral Sea, it follows the shoreline from Cairns to Mossman (BC 14–15), the latter being the northernmost sugar-town in Australia. This 75 km section of road takes about an hour by car, and it is one of the most scenic drives in Australia. About 10 km before Mossman is the turn-off to Port Douglas (BC 15), a sleepy fishing village for most of this century but today a rapidly expanding gateway to the Barrier Reef and the rainforest country to the north. Named after John Douglas, the Queensland Premier, Port Douglas was founded in 1877 to serve the miners of the Hodgkinson goldfields. In 1988 Port Douglas was transformed by the completion of the Qintex Mirage development, a project of major proportions, with a new five-star international hotel, condominiums, shopping centre, 18-hole championship golf course, country club, and a new marina.

How to get there

Coral Coaches of Cairns operates buses almost hourly throughout the day, starting at 7.00 a.m. Special buses also pick up Reef-trip passengers from their hotels, motels and resorts throughout the Cairns area. Quicksilver Connections has a wavepiercer catamaran leaving Cairns every morning at 7.30 a.m., a 1 hr 30 mins trip which connects with its Reef and Cooktown (C 12–13) trips. There are private limousines and taxis for hire, and Helijet offers helicopter service from Cairns airport.

Below:
The Sheraton Mirage Port Douglas rises from its surrounding lagoon like an illusion, a five-star hotel at the edge of Queensland's northern frontier.

COLFELT

Tourist information

The Port Douglas Tourist Information Centre is located at 27 Macrossan Street, Port Douglas, Qld 4871, telephone (070) 995 599. It is open all day, from 7.00 a.m.

Accommodation

Port Douglas has one five-star resort hotel, the spectacular Sheraton Mirage Port Douglas, which is located in the middle of Four Mile Beach. Concerned citizens of Port Douglas a few years ago made dire predictions that the Mirage would scar the landscape and spoil this beautiful beach. Today it is possible for the first-time visitor to Port Douglas to drive right past the hotel not realising that it's there. The hotel rises, like a mirage, from a huge salt-water lagoon. It has 300 luxuriously appointed rooms in a series of wings that overlook the beach, lagoon or the golf course and which are connected to the hotel by covered walkways. It is one of Queensland's finest hotels. On the opposite side of the road (right next to the golf course) is the new Reef Terraces, a 144-suite resort featuring beautifully appointed two-bedroom suites including kitchen and laundry. A new four-star Radisson Hotel, next to the Reef Terraces, will be open in June 1989. Port Douglas also has a number of three-star-plus motels, two caravan parks and one backpackers' hostel. This growing tourist town now has about 50 food outlets, among which are a handful of restaurants comparable with the good ones of Sydney or Melbourne—many are, in fact, run by southern 'refugees'. Among the best are Macrossan's (at the Sheraton Mirage), Catalina, Danny's, Sassi's and the Terracehouse (at the Reef Terraces resort). The Port also lays claim to being the home of the best meat pies in Australia (Mocka's).

Reef trips and cruises

Quicksilver Connections was first in Australia to take daily trips to the outer Barrier, and today it offers what is reputedly the best large-catamaran Reef trip in Australia. This progressive company, which runs something like a piece of Swiss machinery, began about 10 years ago taking day-trips to the Low Islets, in an old Tasmanian ferry boat. Today it has a fleet of sleek 300-passenger, air conditioned wavepiercers which depart daily to Agincourt Reefs, Low Islets and Cooktown. The company also has a fleet of air-conditioned coaches which pick up passengers from all around the Cairns area.

Diving

Port Douglas is the nearest gateway to Lizard Island and the famous Ribbon Reefs, which offer some of the most spectacular scuba diving along the Barrier Reef. Cormorant Pass (known as the Cod Hole) is possibly The Reef's best known dive today, with its giant, tame potato cod, giant wrasses and tame moray eels. Port Douglas has (at the time of writing) two companies offering diver training, Quicksilver Diving Services at the Marina Mirage, and Port Douglas Dive Centre. Diving is available on day-trips with Quicksilver (Agincourt Reefs). Extended dive trips (3–9 days) are also offered by several operators: Fantasy Dive Charters' well-known *Si Bon*, a 21 m Fairmile (converted navy patrol boat) departs every Saturday for a six-day cruise to the Ribbon Reefs (including the Cod Hole), Lizard Island (a barbecue on the beach) and returning to Port Douglas via various sites at the Ribbons, such as the famous Pixie Pinnacle, Giant Clam Beds, Manta Ray Point and others. This trip offers something of the order of 18–20 dives. From October to

Reef Trips from Port Douglas

Agincourt Reefs. Quicksilver has two pontoons at this group of pristine shelf-edge reefs located 66 km (1 hr 30 mins) from Port Douglas. There are two departures each day, at 9.30 a.m. and at 10.30 a.m., both returning at 4.30 p.m. Videos about the Great Barrier Reef are shown on the way, and marine biologists give an introductory lecture on snorkelling and sign up those who wish to take a guided snorkel-tour at The Reef (definitely worth doing). Scuba diving is available, conducted by Quicksilver Diving Services, and they have several sites at Agincourt offering a number of different types of diving experience. Underwater camera equipment (Nikonos V) and underwater flash is available for hire. The pontoons anchored at the reef have tables and seating under shade, underwater viewing chambers, and shallow platforms from which snorkellers and swimmers can launch themselves. There are coral-viewing subs which take 28 passengers on a guided underwater tour. Special services (including translators) are available for groups. Lunch is a lavish smorgasbord.

Low Islets. Low Islets consists of a small vegetated sand cay and a larger mangrove swamp both of which arise from the same coral reef 13 km north-east of Port Douglas. The cay, which has a lighthouse, has beautiful coral sand beaches with a lagoon for snorkelling; on its other side, a wide expanse of reef dries at low tide—ideal for reef fossickers. Low Islets was, in 1928, the site of the Great Barrier Reef Expedition, headed by C. M. Yonge, a year-long programme of scientific research which contributed much to advance understanding of The Reef. It is an important breeding site for a number of sea birds. The Quicksilver catamaran leaves the Marina Mirage daily at 10.30 a.m. for a whole day on the island. It anchors next to a 24 m pontoon, and passengers are ferried ashore in glass-bottom boats for snorkelling, swimming, sunning, coral viewing and reef walking (tide permitting). Lunch is served on the catamaran, and a guided environmental tour is available in the afternoon. It is also possible to go to Low Islets for a day-trip on *Hardy's Courier*, a 12 m sailing catamaran that takes a maximum of 20 passengers for a day of sailing, boom-netting and snorkelling at the island. *Courier* departs from the slipway (next to the marina) daily at 9.30 a.m.

Batt and Tongue Reefs. *Wavelength*, a 12m motorised catamaran, takes 20 passsengers out for a day of snorkelling and swimming at Batt or Tongue Reef, departing from the slipway (next to the marina) daily at 8.30 a.m. A marine biologist provides orientation and guided snorkel-tours (at no extra charge). Lunch is provided. A good, budget-priced trip.

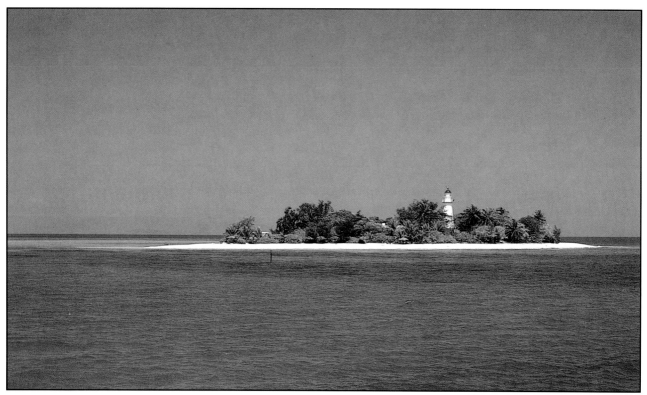

COLFELT

Above and opposite bottom:
Low Islets was the site, in 1928, of the Great Barrier Reef Expedition which did much to advance the knowledge of coral reefs. Today it is a popular day-visit destination reached from Port Douglas, offering snorkelling, swimming, reef fossicking and beachcombing.

Opposite top:
Quicksilver's daily excursion to the Agincourt Reefs offers a variety of experiences, including guided snorkel-tours of the reef with a marine biologist.

December, when the trade winds abate, there are opportunities for diving in the crystal-clear waters of the Coral Sea as well as at the Ribbons. Three-day trips to the Cod Hole are also available.

Fishing

Port Douglas is closer to Australia's famous marlin fishing grounds than any other gateway, and the advent of the new marina has seen a growing number of fishing charter vessels using this port for light- and heavy-tackle game fishing. Day trips and extended cruises are available with vessels such as *Chaelee, Doreen II, Bubbles and Stingray*. The situation is changing daily, and up-to-date information should be sought from the tourist information centre or the Port Douglas Game Fishing Club.

Port Douglas environs

Just at the turnoff from the Cook Highway is a nature park called Rainforest Habitat, which has a wealth of north Queensland flora and fauna, including butterflies, attractively presented in natural surroundings. Port Douglas's Four Mile Beach is renowned for its beautiful expanse of golden sand for sunning and swimming, and for safety in the summer months (November to April). There is now a stinger-resistant swimming enclosure, which incorporates the latest technology developed at James Cook University. On the end of the Port Douglas pier is Ben Cropp's Shipwreck Museum, a collation of marine salvage and oddments gathered over the years by this well-known underwater cameraman and wreck diver. Cropp, who lives right at the end of the pier behind the museum, has made scores of underwater films that have been shown on television around the world and which are constantly being screened in the museum.

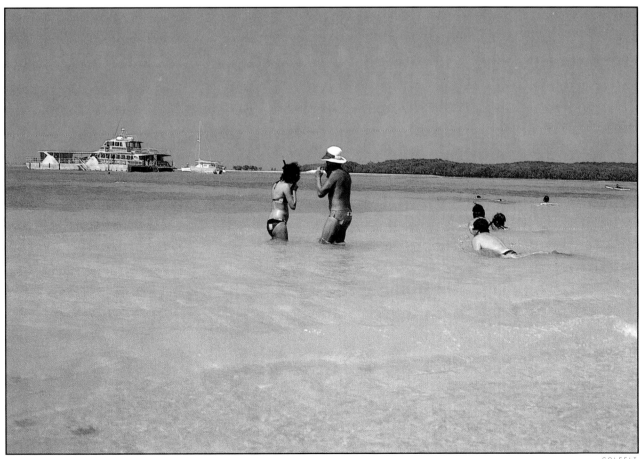

COLFELT

Above:
Silky Oaks offers peaceful accommodation in the wilderness at Mossman Gorge, with individual timber huts that look out into the tree-tops.

* The vestiges of the goldrush days are very much in evidence in this part of Queensland, the coastal cities and towns all having been created to serve the idol, gold. The name Daintree is that of Richard Daintree, who migrated to Australia in 1852, a geologist with a keen eye for prospecting who was surveyor of the Victorian fields in the early days of Australia's goldrushes. He later moved to Queensland and was responsible for that State's biggest goldrush, by predicting that the metal would be found between the Etheridge and Endeavour rivers. Not very long afterwards, the explorers who were sent out to investigate the prospects struck the rich Palmer River fields, which were to become known as the 'river of gold', which led to the founding of Cooktown.

Mossman

About 14 km north of Port Douglas on the Cook Highway is the green country town of Mossman. Mossman is joined to Port Douglas by the Bally Hooley railway, a steam-driven cane-gauge train that runs from the new Marina Mirage to St Crispins, an authentic re-creation of an old station near the Reef Terraces resort, and from there the tourist train goes on through the cane fields at Mossman, stopping to visit its computerised sugar-crushing mill. A short distance out of town is Mossman Gorge, with its waterfalls and river, where those who like peaceful hideaways may find Silky Oaks Lodge a good alternative to lodgings at Port Douglas. This small, private retreat, owned and operated by Moss and Terese Hunt, who managed the exclusive Lizard Island resort for many years, has 19 beautifully furnished timber cabins, each with its own verandah that looks out into tree-tops above the gorge, with nothing but the sounds of birds, and water cascading over rapids, to soothe and refresh the spirit. The Hunts also operate Australian Wilderness Safaris, which conducts two- and three-night safaris to the Daintree River (BC 14), Cape Tribulation (C 14), Cooktown (C 12–13) and other attractions of the rainforest north.

Daintree*

Where rainforest meets The Reef, the Daintree is Australia's last significant lowland tropical rainforest. Just north of the Daintree River, this closed-forest community merges with sandy beaches and a coast fringed with living coral reefs. The river, where crocodiles slither from the banks to thrill the tourists on river cruises (and occasionally eat those who don't heed the warnings not to swim there), is crossed by a punt that runs every ten minutes throughout the day. A number of day-trips from Cairns include Daintree River excursions in their itinerary. Daintree has one motel, the Forest Rest, which was started a few years ago by a local resident who wearied of putting people up for the night when they missed the last punt.

Cape Tribulation

Beyond the Daintree punt, the 34 km gravel road to Cape Tribulation winds its way through rainforest to the wilderness beaches of Cape Tribulation. Cape Tribulation was, until recently, a well-kept secret and a favourite retreat of international backpackers. It was an adventure to get there (by four-wheel drive only), and there was only one place to stay—at the Jungle Lodge, a relaxed hostel about 2 km south of the Cape with accommodation ranging from individual cabins to typical hostel rooms, a bar, small dining room, and cooking facilities. The Lodge continues to have a unique atmosphere and it is still the nerve centre of the Cape, arranging all manner of activities from horseback riding on the beach to Reef trips (for small groups) to Mackay Reef and its unvegetated cay 18 km offshore. But the road has been much improved, with concrete fords over the many streams, and there are now other hostels and a new resort. About 15 km south of the Cape, at Cow Bay, is the new Crocodylus Village, a tent-city hostel inside the rainforest, dark and dripping with atmosphere. And the new Coconut Beach Rainforest resort has just opened 10 km south of the Cape and just across a boardwalk from the beach. It has an attractive, pole-frame timber central complex including facilities for day-trippers, restaurant, bars, boutique, general store and swimming pool, and in the forest behind, it also has 30 well-furnished guest cabins, with private bath.

Cooktown

Cooktown is a picturesque village on the Endeavour River with a rich historical flavour, billing itself as the first white settlement in Australia (Cook and his crew camped there for 48 days in 1770). Established to provide a gateway for the rich Palmer River goldfields, by 1875 Cooktown was a bustling town of 30 000, many of which were Chinese. At that time it had 20 eating houses, six butchers, five bakers, and 65 hotels (pubs), one of which, the Sovereign, still stands and has been transformed into Cooktown's showpiece resort/hotel. When the Palmer River goldrush petered out after a couple of decades, so did Cooktown. By 1896 the population had fallen to 2620, and it has only just re-awakened with the boom in tourism. Cooktown has some lovely old buildings (such as the one currently occupied by Westpac Bank). There are two museums, The James Cook Memorial Museum (full of fascinating bits and pieces, ranging from old 'torture devices' (a bizarre collection of early dentistry tools) to a Chinese joss house, a reminder that Cooktown at one time was home to 18 000 Chinese), and the Cooktown Sea Museum. There are several motels, including a new one which has, by name, resurrected the 'River of Gold'; Cooktown also has a few guest-houses and a backpackers' hostel. This pioneer town is reached from Cairns and Port Douglas by the daily Quicksilver catamaran (the trip takes 1 hr 30 mins from Port Douglas), and there are frequent bus services from Cairns and Port Douglas. Numerous operators of safaris offer trips via both the inland highway and the rough and scenic four-wheel drive road, The Bloomfield 'Highway', through the coastal rainforest and across the mouth of the Bloomfield River. Cooktown has an airport, and several air operators in Cairns visit Cooktown.

COLFELT

Above:
The James Cook Museum, full of curiosities of Cooktown's past.
Below:
Cape Tribulation, where the rainforest meets The Reef, a wilderness still relatively undiscovered, as seen from the controversial Bloomfield road that provides a coastal route to Cooktown.

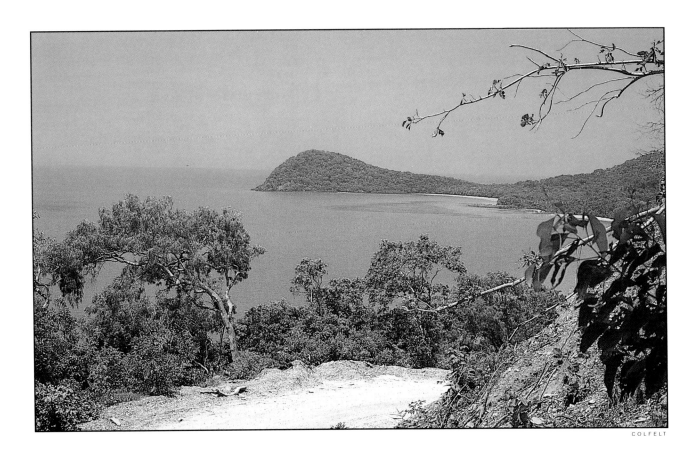
COLFELT

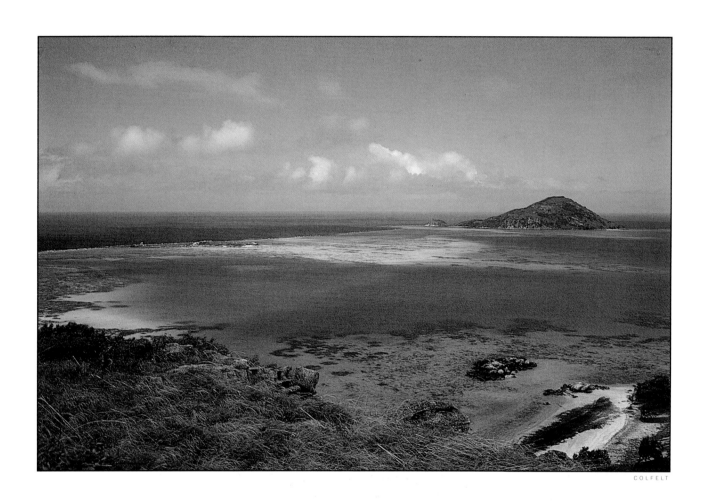

COLFELT

LIZARD ISLAND

Lizard is the most northerly resort island of the Barrier Reef Region, and it is known internationally as the world headquarters of giant black marlin fishing. By virtue of its small size, its remote location, and its association with movie stars engaged in the expensive quest for the big fish, Lizard Island Lodge has a reputation as 'exclusive', but it is at the same time a very relaxed and informal resort, one which offers a high standard of living to those who have taken pains to travel so far. Lizard is relatively close to one of the great Barrier Reef's most sought-after dive sites, the Cod Hole, at the top of Ribbon Reef No. 10. It has an extensive fringing reef of its own, and there are numerous white sand beaches scattered around its shores. During the marlin season, from September through November, the resort is very busy, particularly during the week of Hallowe'en (October 31st), when a game-fishing tournament is on. During this time the milieu is very much heavy-tackle fishing. But at all times Lizard will appeal to anyone looking for relaxation in comfort, a place to unwind by the sea in a warm tropical climate, with no organised entertainment and no distractions other than those provided by rich natural surroundings.

Lizard Island afforded Cook his chance to escape from the maze of coral that had closed in on him as he sailed further up Australia's coast. Hoping to get a better view of the surrounding ocean, he left *Endeavour* anchored at Point Lookout, and with Joseph Banks and a few of the crew, took the ship's boat one morning and sailed 30 km to the north-east, to a high island that stood boldly on the horizon. That afternoon, and again early the next morning, Cook and Banks climbed the eastern ridge of the island, over rough, grass-covered granite boulders, to reach the summit 359 m above the sea. From there they sighted a narrow channel through the long ribbon of reefs at the edge of the continental shelf.

For perhaps thousands of years before that Saturday in August 1770, Aborigines had been coming from the mainland to *Dyiigurra*, as they called it, towards the end of September, when the trade winds had abated and the seas were calmer, making travel by canoe less hazardous. They found a bounty of food on this island, and on the hills that overlook the lagoon they left vast piles of shells which are still in evidence today. Banks noted these in his journal, along with the presence of the frames of huts. He also observed that the island had many large, shy monitor lizards, which is how Lizard Island got its present name.

Many explorers, chartmakers and naturalists have followed Cook's steps to the top of Lizard Island, as, in recent times, have many guests of the Lodge. It is a 1.5 km pilgrimage from the northern end of Watson's Bay, over quite steep terrain, and having climbed it once, one has additional admiration, if that is possible, for Messrs Cook and Banks, who climbed up twice in 24 hours. Retracing the path of perhaps the greatest sea captain and navigator of all time, reflecting upon what must have been weighing on his mind, and then to see the glorious views that are available from the summit, cannot fail to make more than just a passing impression.* Today, there is a cairn on the summit, and a waterproof box in its base contains a log to which those who have made the journey may

*The early years of charting the Australian coast were principally directed at finding a safe route inside The Barrier Reef to Torres Strait. A number of surveyors and naturalists have sailed past Lizard Island over the years, and many have taken time to retrace Cook's steps to the summit.

Commander J. L. Stokes, a surveyor on HMS *Beagle*, 1839: *There is an inexpressible charm in thus treading in the track of the mighty dead, and my feelings on attaining the summit of the peak, where the foot of the white man had perhaps but once before rested, will easily be understood.*

Joseph Beete Jukes, naturalist aboard HMS *Fly*, with Capt. Blackwood, in 1843: *The night was clear and beautiful, and the hour passed quickly as I leant against a large block of rock on the border of a precipice several hundred feet high, looking down upon the motionless expanse of the surrounding sea, into which the setting moon was just descending in the west, the light of our fire glimmering on the rocks and bushes about, the utter silence in the air around. It was from this hill that Cook, after having repaired his vessel, came to cast a look on the dangers that yet surrounded him, and from which he hoped here to see a method of escape. How little could he have foreseen that in so short a time a British empire would be founded on the shores he had then first discovered, and that this reef-environed coast, dangerous though it be, should be in the daily track of vessels!*

Thomas H. Huxley, world-renowned philosopher, naturalist, biologist, who did much to advance Darwin's theories, was surgeon and naturalist on the survey ship HMS *Rattlesnake* under Capt. Owen Stanley in 1848: *The natural beauty of the scene was heightened by the recollection that one stood on ground rendered classical by the footsteps of the great Cook, who from this height sought some exit from the dangers which had so nearly put an end to him and his glory. I say 'was heightened'. Truth requires that I should substitute 'ought to have been heightened', for in fact, the sun had been pouring on my back all the way up and my feelings more nearly approached sickness than sublimity when I reached the top.*

Opposite:
View from Lizard Head looking south-west over the lagoon towards Seabird Islet (left) and South Islet. Lizard's lagoon is ringed with numerous secluded sand beaches, pleasant places to escape to with a picnic lunch.

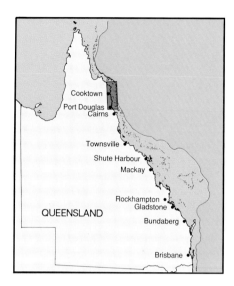

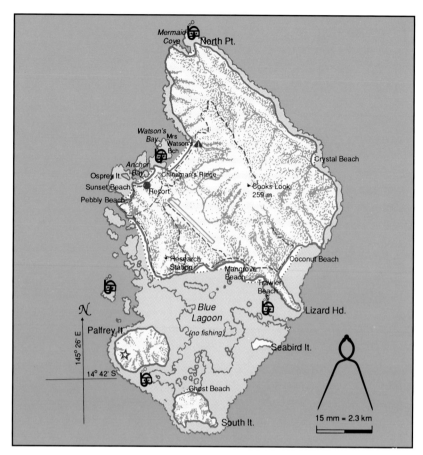

ISLAND SUMMARY
Lizard Island

Location: 14° 40'S 145° 28'E
Gateway: Cairns (252 km)
2579 km N of Melbourne
2215 km NNW of Sydney
1625 km NNW of Brisbane
252 km N of Cairns

Island and resort details

High, rocky continental island (1012 ha), Australia's north-ernmost resort island in the Barrier Reef Region. It has extensive fringing coral reefs, with a large deep lagoon surrounded by coral reef on southern side. Lizard has a slightly stark appearance with a dominating grass-covered granite ridge running SE–NW on its eastern side; eucalypt woodlands and heaths adorn the lower slopes, with small patches of rainforest in protected gullies. The island has numerous sand beaches including two long, sweeping all-tide beaches in the north-western side, at Anchor Bay and Watson's Bay. About 44 species of birds can be seen (14 sea birds and 30 land birds), many nesting on the island. Lizard has a sense of history, with large shell middens indicating previous seasonal use by Aborigines. It was the island from which James Cook saw his route of escape through The Barrier Reef, which can be seen from its summit, Cook's Look (359 m). A National Park campsite, with picnic table and toilet, is located at the eastern end of Watson's Bay. It is not much used due to the remoteness of Lizard and the expense of getting there, which for practical purposes today, is by air. Permits to camp are issued by QNPWS Cairns (see page 211). The Australian Museum has a scientific research station just above the western beach, with good field laboratory facilities.

Access

From Cairns: by Australian Regional Airlines Twin Otter service daily (1 hr); by private air charter (1 hr 30 mins). Various scuba-dive boats and extended-cruise boats operating from Cairns, Port Douglas and Cooktown often call in at Watson's Bay, but access by this means is dependent on a number of variables.

Resort capacity, accommodation, facilities

Maximum about 70 guests (children under 6 yrs not catered for). **Accommodation**: 32 units: 30 suites of similar standard (6 with twin queen-size beds and 24 with king-size bed), and 2 deluxe suites (with large separate bedroom and living room). All have private bathroom (with shower and bath), air-conditioning, ceiling fan, fridge and mini bar, ISD direct-dial phone, desk, private balcony, hair drier, iron and ironing board. **Resort facilities:** large fresh-water swimming pool, two tennis courts, dive shop, good range of water-sports equipment, boutique. Laundry service is available.

Eating and drinking

Resort dining room (7.30 a.m. to 10.00 a.m., 12.00 noon to 2.00 p.m., 7.30 p.m. onwards). Bar open as required.

Tariff

All inclusive (except for alcohol, Barrier Reef trips, scuba-diving and private charters).

Activities

Beachcombing, catamarans, fishing, game-fishing charters, glass-bottom boat, glass-bottom paddle skis, island walks, picnics, sail-boards, scuba diving (certificate tuition available), snorkelling, swimming, tennis, water-skiing. Lizard Island Lodge is a centre for marlin fishing during the season (September to November). Barrier Reef snorkelling and scuba-diving trips to Cormorant Pass (the Cod Hole) and to reefs nearby the island are available.

Anchorage

Watson's Bay is a popular anchorage for many itinerant vessels, particularly during the marlin season.

Lizard Island Lodge, Lizard Island, via Cairns, Qld 4870.

add their names.

There is speculation that Lizard Island may have had more significance to the Aborigines than just being a food-gathering ground, as evidenced by stone formations found there, and this may explain an attack on the Watsons' bêche-de-mer camp in September 1881.*

The resort

Lizard Island Lodge is situated on the north-western side of the island on a grass-covered foreshore dune, and it surveys a wide, protected bay that is divided into two smaller ones by Chinaman's Ridge—Anchor Bay immediately in front of the resort, and Watson's Bay to the northeast. Anchor Bay is fringed by a broad sweep of sand, a beautiful beach that rivals the best in The Reef Region for the amenity that it offers—smooth, clear, warm water, at all conditions of the tide, for swimming, snorkelling, sailboarding, and water-skiing. The central resort complex is attractive and inviting, with an intimate lounge and bar, the walls adorned with stuffed billfish and varnished tablets bearing the names of anglers who have caught trophy-size fish. The adjacent dining room is light and airy, with terrace immediately outside, and it commands a view of the entire northern bight of the island.

The resort has a large fresh-water swimming pool, surrounded by an attractive timber deck, and there are two all-weather tennis courts.

Accommodation and tariff

Lizard's accommodation is spread out along the lawn on either side of the central Lodge, with views out over Anchor Bay. There are 16 duplex blocks, with clapboard exteriors, green corrugated-iron roofs, and each with a small verandah. Architecturally, they are not prize-winners, but they are very well furnished, with wall-to-wall carpet, twin queen-size beds (or one king-size bed), a desk with reading light, a dresser unit with

* Mary Beatrice Phillips Oxenham was married to Robert Watson in Cooktown on May 30th, 1880. Watson had a homestead on Lizard Island, and he and his wife lived there after their marriage with two Chinese servants, Ah Sam, the houseboy, and Ah Leong, the gardener. P. C. Fuller, a partner in the bêche-de-mer business, also lived on the island. There was a cottage, shack, smokehouse and store room, and they had a vegetable garden adjacent to a source of fresh water near the current airstrip. Mary Watson gave birth to a son, Ferrier, in June 1881. In September, Watson and Fuller left to go on a fishing trip, and when they returned several weeks later, the camp had been ransacked and Mrs Watson and the Chinese servants were gone. Part of Mary Watson's diary was found, and it revealed that two days after her husband had left, a party of Aborigines came over from the mainland. Ah Leong was killed by blacks down by the vegetable garden. A day later when natives appeared on the beach Mrs Watson fired a rifle and revolver, and they went away. But next day, Ah Sam was speared and badly wounded and Mary decided to leave the island by whatever means she could find. She took Ferrier and the wounded houseboy and 'set sail' in a large iron bêche-de-mer boiler. In January 1882 the bodies of the three were found, on an island in the Howick Group, 54 km to the north-west. Mary's diary again told the story, that they had landed at several reefs and islands before reaching the Howick Group, but were unable to find water. They apparently died of thirst.

Below:
The Lodge.

COLFELT

fridge and mini-bar underneath, large air-conditioner, and ceiling fan. Two deluxe units have a separate bedroom and living room. The bathrooms are spacious, with twin basins and large mirrors, ample clothes cupboards, shower and bath. The Lodge is awaiting a new ISD direct-dial phone service, and by mid-1989, all rooms should have telephones. Room servicing is impeccable, and ice is delivered to the verandah each afternoon at 5.30. Lizard's tariff is all-inclusive except for drinks from the bar, scuba diving and trips to The Reef.

Eating, drinking and entertainment

The cuisine at Lizard has always been of a very high standard, with three elegant meals served in the dining room or on the terrace. Breakfast is leisurely—no need to get out of bed with the birds—a selection of cereals and fruits or a hot breakfast of choice; reef fish is often available. Lunch and dinner are a *table d'hôte* selection, nicely prepared and presented, and the Lodge has a good wine list. The kitchen will pack a sumptuous picnic hamper for those who wish to spend the day exploring.

Entertainment at the Lodge is conversation at the bar before and after dinner. The small size of the resort ensures that everyone knows who the new arrivals are, and guests mix easily and informally.

Activities
Beaches and the fringing reef

Lizard Island, with more than 20 sand beaches, and with its large coral lagoon and adjacent islets on the southern side, has many natural attractions. Aluminium dinghies with outboard motors wait by the beach to be taken exploring. Corals grow just in front of the resort beach; schools of bait fish swarm along the shore (and to float through the midst of one of these clouds of flashing silver will make any snorkeller's day). There are soft corals undulating in the currents, and giant clams with colourful, fleshy mantles lie in shallow water.

Opposite top:
The dining room and terrace of the Lodge look out over the island's north-western bight, a broad expanse of still, blue water.

Opposite bottom:
Anchor Bay, immediately in front of the resort, is fringed by a long, white sand beach. The bay is very well protected and is ideal for windsurfing, swimming and snorkelling. Watson's Bay is further on, tucked under the tall granite ridge which runs along the island's eastern side.

Below:
Lizard has many land and sea birds, many of which nest on the island. Pictured is an osprey's nest atop a boulder on Lizard Head.

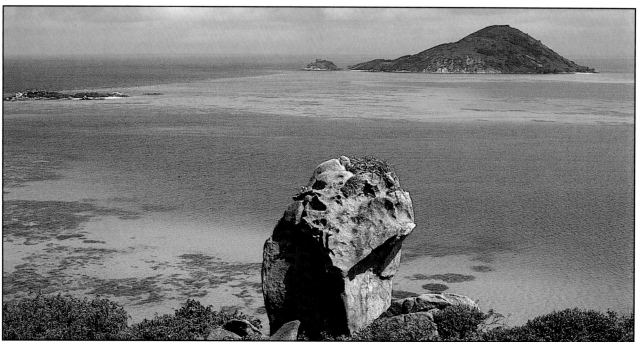

COLFELT

COLFELT

COLFELT

GEOFF FERGUSON

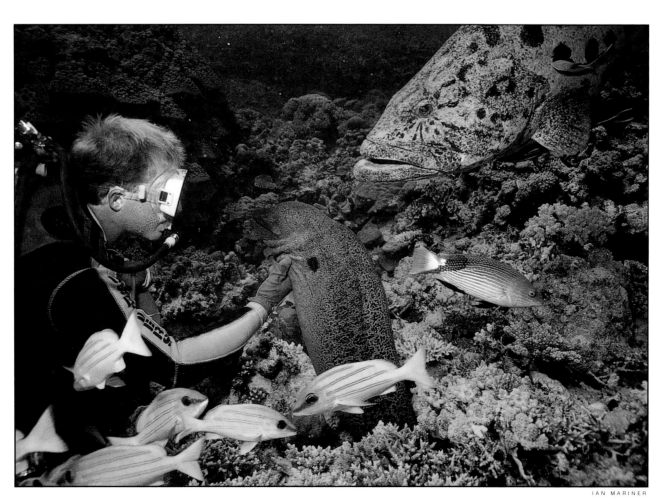

IAN MARINER

Walks

There are National Parks tracks to the lagoon, the research station, and to Cook's Look, the latter beginning at the north-eastern end of Mrs Watson's Beach. The ascent to Cook's Look is steep in places and is a demanding but rewarding trek. The view from the top is almost unlimited on a clear day, spanning from the mainland to the very edge of The Barrier Reef. For intrepid adventurers there is also a rugged path which ascends (almost vertically) this grass-covered ridge to Lizard Head. From the top there is a splendid view of the lagoon and of Coconut Beach, which lies on the south-east shore of the island just under the bald rock face of the headland. Bird life abounds, and chances are you will catch a glimpse of a monitor lizard scurrying, on long, swift legs, into hiding amongst the rocks.

Diving

Lizard has its own dive shop which is in the charge of a qualified dive instructor; certificate tuition is available. The dive boat *Volare* takes snorkellers and divers both to reefs in the vicinity of the island and to a site at the outer edge of The Reef that has become one of the most sought-after dives of The Barrier Reef, the Cod Hole. Officially known as Cormorant Pass, the Cod Hole has a resident population of huge, tame potato cod which can be hand-fed, and it is a dive never to be forgotten. Snorkellers can paddle happily around on the surface near the edge of The Reef, and watch all the action from above.

Fishing

Every year, in late August, giant black marlin swim into Coral Sea waters, just outside No. 10 Ribbon Reef, to spawn in numbers unequalled anywhere in the world. From September through November Lizard Island becomes the world headquarters of black marlin fishing, and many guests have bookings at the Lodge from year to year during this period, the height of which is in the week surrounding Hallowe'en at the end of October. The Lodge has several game-fishing boats available for charter, but most anglers make their own arrangements with heavy-tackle boats based in Cairns or Port Douglas, and the game boats use Lizard Island as their base. At the far end of the second resort beach is the Marlin Centre, a facility with an informal dining room, bar, showers and toilets; during the season it caters for the fishing fleet, and in the evenings around the bar the tallest tales in the world are told. The area around Lizard Island is excellent for all types of light- and heavy-tackle fishing, for billfish, sailfish, several species of tuna and mackerel.

Lizard Island Research Station

In 1974 the Australian Museum established a scientific research station on Lizard Island to provide facilities for study in the northern Great Barrier Reef, that part least affected by man. Today it provides accommodation for up to 15 scientists at one time and offers modern air-conditioned laboratory facilities with darkroom, radioisotope room, library, computers and a range of high-quality laboratory and analytical equipment (much of which has been generously donated by Australian and overseas companies). The station has scuba-diving facilities, and it has two vessels, a small outboard-powered catamaran and a larger auxiliary sailing catamaran, the *Sunbird*, which is capable of voyages to the extreme northern end of The Reef. Conducted tours of the research station take place several days a week.

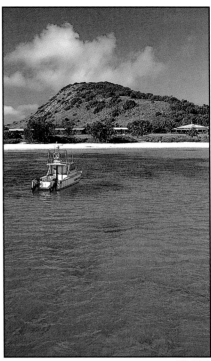

COLFELT

Above:
Looking towards the Lodge from Anchor Bay.

Opposite top:
A group of elated followers of Captain Cook celebrates a successful ascent to the Cook's Look (359 m), made early one morning before breakfast. They are welcomed to the ranks of the Cook's Look Club with a glass of champagne and orange juice.

Opposite bottom:
Merlin, a tame moray eel who lives at the Cod Hole, Cormorant Pass, gets his chin tickled by a Lizard Island divemaster. About ten years ago divers discovered a location at the top of No. 10 Ribbon Reef, east of Lizard Island, which has a resident population of giant potato cod. Now known as the Cod Hole, it has become one of The Reef's most popular dive sites. On entering the water divers are immediately surrounded by huge cod, up to a metre in length, as well as giant Maori wrasses and coral trout, all dashing excitedly about waiting to be hand-fed. Cormorant Pass is scoured by strong currents, and for this reason the fish life is a greater attraction than the coral, but it is a dive never to be forgotten; snorkellers enjoy it too.

The marine snail (Hexobranchus sanguineus) is a nudibranch whose undulating mode of swiming, reminiscent of the flambuoyant swirl of a señorita's skirt, has earned it the common name 'Spanish dancer'. Nudibranchs are molluscs, which are second only, in number, to the insects of the animlal kingdom. PHOTO: GARY BELL

NOTES FOR REEF TRAVELLERS

A few words of explanation; some bits and pieces that may be useful to Barrier Reef Travellers

Australia

'Australia' means 'southern' and the name first appeared on the maps of the early geographers as *Terra Australis Incognita*, a great, unknown southern land which, it was supposed, must exist in order to 'balance' the land masses of the northern hemisphere. Exploring for Spain in the 1660s, Pedro Fernandez de Quiros went in search of this southern land and thought he had found it when he arrived at Santo, the largest island of what is today Vanuatu (formerly the New Hebrides), about 2500 km north-east of Australia. He named his discovery *Australia del Espiritu Santo* (south land of the Holy Spirit). It wasn't until the voyages of James Cook over one hundred years later that the existence of *Terra Australis* was disproved. At the time of Cook's first voyage, the map showed Australia with no east coast, and it bore the name New Holland, which was given it by Dutch explorers. Cook named the part that he saw 'New South Wales', and 'Australia' first appeared on our maps about the time that the first accurate charts were produced by the early surveyors, Matthew Flinders and Phillip Parker King, during the first quarter of the 19th century.

The arrangement of the continents has not always been as it is on today's globe. Scientists know now that the continents float and move around on great plates of the earth's crust, and there is evidence that the earth's land masses have completely assembled and disassembled themselves several times since the planet was created. Australia's current position is vastly different from where it was at other times in history. Over the past 500 million years, the land that is now Australia has tumbled all the way from north of the equator to the south pole. It has been covered in ice, it has been covered in water, it has been a swamp. For a long time it was part of a great southern continent, Gondwana, which also included Antarctica, South America, Africa, India, and Papua New Guinea. About 60 million years ago Australia started its north-easterly migration to its present position, and during most of that time it has been an island ark, evolving a unique flora and fauna.

The shifting of land masses on the surface of the globe has influenced the earth's weather by changing the circulation of oceanic currents that redistribute heat around the world. Other factors, such as the slowly changing tilt of the earth's axis (and the effect that this has on the amount of solar radiation bathing northern hemisphere land masses), may have also played a role in changing the climate. In the last years of Gondwana, while Australia and the tip of South America were still connected to Antarctica, the temperature of the globe was relatively more uniform than it is today, with warm currents running down the eastern sides of the great continents in the southern hemisphere, transferring heat from the equatorial latitudes, and at that time there was no ice at the poles. The climate in Australia was warm and wet, and the continent was mostly covered by rainforest. The breakaway of Australia and South America caused a significant change in oceanic circulation; a current was now able to flow unobstructed along southern latitudes, creating a new weather regime, characterised by much less even global temperatures, setting the stage again for the formation of polar ice and cycles of glaciation that would cause wild fluctuations in the level of the sea in years to come.

Australia has had a long, relatively stable geologic history with not a great deal of volcanism and not many earthquakes. It has ancient, relatively poor soils, unrenewed by volcanic activity and leached of nutrients, and the climatic changes that followed its isolation promoted development of a distinctive sclerophyll flora—hard, leathery-leafed trees (the eucalypts, or gums) and plants that could survive in poor soils and which evolved strategies to cope with increasing fire as the rainforests receded. The isolation of Australia occurred before the arrival of the more advanced placental mammals, and the ark headed off with a load of marsupials, which evolved into forms unique to Australia, such as the kangaroo.

Australia is the smallest continent, and the flattest, gently rising in the east to what is called the Great Dividing Range, which visitors to this country would hardly call 'mountains'; it is a series of plateaus formed during the tectonic spreading of the Tasman Sea floor, an escarpment carved and eroded at the margin by rivers and creeks. As Australia moved gradually north-east (it is still doing so, at a rate of about one centimetre a year), the temperature of the waters off the Queensland coast got warmer and were hospitable to a group of marine organisms, called corals, which, of course, are credited with building The Great Barrier Reef.

Figure 1. *The Australian land mass 500 million years ago was in the northern hemisphere, rotated 90°. What is now the east coast was underwater.*

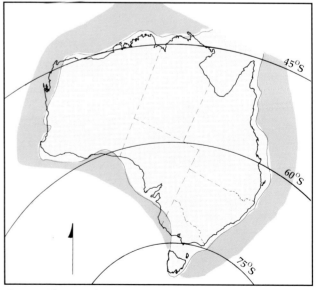

Figure 2. *The Australian land mass about 80 million years ago was located in high southern latitudes, still attached to Antarctica.*

Figures 1 & 2 are based on information from
the *Bureau of Mineral Resources Science Atlas* compiled by G. Wilford.

239

The Great Barrier Reef

The Great Barrier Reef has been called many things—'the largest structure on earth made by living creatures', 'the eighth living wonder of the world', 'the world's largest coral reef system'. Such superlatives obviously satisfy some urge, just as do cricket or baseball statistics, but they do little, really, to advance the argument. The Great Barrier Reef is not a single reef but a system of about 3000 reefs that stretches for 2000 km along the continental shelf of the Queensland coast and then north almost to New Guinea. The individual reefs are, indeed, composed of the dead skeletons of millions upon millions of tiny coral animals, but also those of millions of calcium-forming plants, all of which have been cemented together by calcareous algae, and there is a thin veneer of living corals on the surface. The Great Barrier Reef is the largest coral reef system to come under one nation's control and it is a complex system providing habitats for a wide diversity of corals and fishes. But it isn't really a barrier reef, in the sense that Charles Darwin first used the term.

'Barrier Reef' was first used by Darwin in his attempts to classify coral reefs. Barrier reefs were seen at mid-ocean islands around which they formed a close offshore barrier. This type of reef began life as a fringing reef, skirting the shores of an island that was slowly sinking into the ocean as a result of the tectonic movements of the earth's crust. Eventually when the island submerged, only a ring of coral with a central lagoon was left at the surface—an atoll. There are no atolls in Australia's reef system, which sits on our relatively stable continental shelf, although the term is used by some tourist promoters who are ignorant of its meaning but knowledgeable about promotion. 'Barrier' was probably first used to describe Australia's system of reefs by Matthew Flinders when he explored the coast in the early 1800s. The term had a certain logic, especially in the northern sections of the Reef Region, where the reefs form almost a continuous rampart, and in other parts, such as the Hard Line Reefs east of Mackay, are an impenetrable maze perforated by intricate channels. Throughout the Region they bar the incursion of huge oceanic swells from the east, rendering the waters behind them smooth in comparison with the ocean, and they certainly caused early ship's masters more than a little grief in negotiating them.

Australia's north-eastern continental shelf, the edge of which is generally defined as the 100 fathom (200 m) line, is relatively narrower and shallower in the north (only 28 km wide off Cape Melville at 14°10′S) and reaches its maximum width of 370 km east of Mackay (about 21°S). Reefs extend right across the shelf in the north, and some are quite close to the mainland; further south they generally occupy the outer third of the shelf.

The beginnings of today's Reef

The origins of The Barrier Reef go back several million years, but the living reef of today began in relatively recent geologic times. About 18 000 years ago one-third of the earth's land was covered with ice. The ice was so thick and had so much water locked up that sea level was perhaps 150 m lower than it is today. This glaciation was the most recent of ten ice ages in the past million years which have come, roughly, every 100 000 years. During the most recent ice age Australia's continental shelf was a vast coastal plain, and coral reefs from previous times, when the shelf was flooded, were high and dry. Water from the most recent thaw inundated the continental shelf about 12 000 years ago and the limestone hills of previous reefs were submerged 8000–9000 years ago. That event marks the beginning of what we now see as the modern Barrier Reef; the sea reached its current level about 6500 years ago.

All reefs today are a living veneer of coral that has grown up on the eroded hills and gutters of the previous reefs, and the shapes of today's reefs reflect the shape of their substrate as well as the effects of the seas and currents that impinge upon them.

All major reef areas of the world are found within the tropics, i.e. within a band on either side of the equator marked by the northerly and southerly extremes of the sun, about 23° north and south latitudes. Water temperatures in this band are always within a range of 20°–30°C. Maximum reef-building activity occurs in water shallower than 30 m.

What builds The Reef?

The first time you put your head underwater with a face mask on and look at coral growing on a reef, it will be plain to see why for so long man believed that these colourful growths were plants and, even in the face of evidence to the contrary, refused to believe that they were animals. Anchored to the bottom, with branch-like projections and little flower-like polyps that they extend for feeding, logic would say they were plants. They were named *zoophytes* in the 6th century by Sextus Empiricus, who pronounced them plants (although the name he chose might indicate that he was hedging his bets—see Footnote 1), and it was not until ten centuries later that Ferrante Imperato declared them animals. He was completely ignored. Then, in 1723 a well-respected French scientist, Jean Peysonnel, put it to his fellows at the prestigious Académie des Sciences that corals were in fact animals. Many colleagues thought Peysonnel had momentarily taken leave of his senses, and they tried to persuade him not to publish his findings lest he ruin his reputation. Science today has classified corals in the kingdom Animalia, phylum Cnidaria (from the Greek *cnidos*, nettle, named by Aristotle), which also includes jellyfish, anemones and hydroids (this phylum is also referred to as 'coelenterata'). The unifying theme in all of these animals is the presence of batteries of specialised stinging cells (cnidoblasts, or nematocysts) which contain coiled stinging threads that they inject into animal prey. Coral polyps feed mainly on zooplankton,[1] which they immobilise with their nematocysts.

The individual coral animal is not much more than a mouth surrounded by tentacles, for capturing food and for defence, and a cylindrical gut cavity divided by fleshy partitions, called mesenteries, which function as digestive organs and, during some months, also as sexual organs. The polyps of reef-building

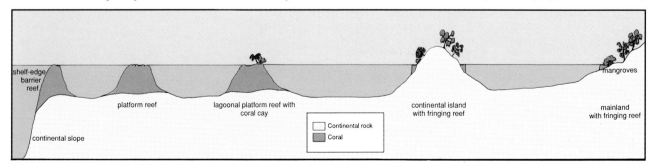

Figure 3. *Cross-section of the continental shelf showing different types of reefs.*

1 Plankton (Gr. *plagktos*, wandering) is a term that describes a general population of micro-organisms, both plant and animal, that drift at various levels in the seas. The *zoo*plankton community is animal; it consists, among other things, of eggs and larval forms of numerous sea creatures and reflects the economy of reproduction of sea life: out of many, a few survive. *Phyto*plankton (Gr. *phyton*, plant) consists mostly of minute single-celled algal protists, e.g. diatoms and dinoflagellates.

species rarely exist as individuals; they are colonising animals, their bodies joined together to form a wide variety of skeleton shapes and, in their ultimate opus, reefs. There are corals that resemble the antlers of deer, human brains, spilt cans of slime, mushrooms and bedroom slippers. Although the debate as to whether corals are plants or animals has been laid to rest taxonomically, in recent times, as more has been discovered about how coral reefs function, ironically there are grounds for seeing both points of view. For one thing, there is a very close relationship between corals and millions of minute brown algae that actually live within their tissues. And while the Great Barrier Reef has been called the largest structure on earth ever created by living creatures, the plants of the reef, the algae, play a very significant role in the construction, and some scientists say that the reefs, in fact, might even be called 'algal reefs' without really distorting the truth.

The intriguing relationship between coral and algae

The reef builders are called 'hermatypic'[1] corals. Probably the most significant fact about hermatypic corals is the presence in their tissues of minute, single-celled symbiotic[2] brown algae, called zooxanthellae. These resident algae, like all plants, have the ability to create food by photosynthesis; given the energy of sunlight to drive their engine, they turn basic nutrients (nitrogen, phosphorus, carbon dioxide) into chemical energy—carbohydrates and amino acids (the building blocks of protein and fats). They contribute 95% of their food production directly to their host coral, and this input of food satisfies from 30% to 90% of the coral's total requirements. In return, the algae receive from the coral what they need, nitrogen waste products and carbon dioxide, the result of the coral's digestion and respiration. Herein lies the secret of the reef-building corals' success; their symbiotic algae enable them to devote most of their energy to growth and the laying down of skeleton, at a rate two to three times faster than they otherwise could, a rate sufficient for them, in the past, to have kept pace with the rising sea levels of the past interglacial periods. The corals function like plants, and, philosophically, the early scientists who thought they were plants were in one sense correct. Quite apart from zooxanthellae, algae are the major source of food on reefs, and they also play a significant role in binding the reef together. While corals create the 'aggregate' of the reef with their skeletal remains, algae cement it all together. Certain types of algae make the principal contribution to sand production on the reef. In terms of total reef biomass the algae are very much more significant than corals. The algae are less

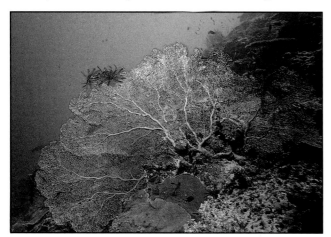

Plant or animal? It was a vexing question for centuries and put more than one scientific reputation at risk. Corals are today classified as animals, but they function very much like plants, with their resident symbiotic algae contributing the lion's share of their energy. PHOTO TONY FONTES

spectacular than the animals of the reef environment, which is why they have not rated a mention when we speak of 'coral reefs'.

How a reef begins

Coral polyps reproduce sexually and asexually. They can multiply asexually by a number of means, including fission, budding, branch-breaking/transplant, and, by 'polyp bail-out' (like a pilot deserting a flaming aircraft and which occurs under analogous circumstances, e.g. when the colony is under stress). Sexual reproduction occurs two ways: either a polyp in a male state issues a sperm which is ingested by a female polyp and fertilised internally; or male/female polyps issue sperm/eggs which become fertilised while free-floating in the water. Coral colonies are sometimes male, sometimes female, and often both (hermaphroditic). A large proportion of the corals on the Great Barrier Reef do their sexual reproduction simultaneously, over a period of several nights in early summer, about three to five nights after a full moon on a night when the difference between successive high and low tides is minimal and there is therefore minimal tidal flow over the reef. In what has been described as an 'upside-down snowstorm', they release multi-coloured eggs and sperm into the sea. A phenomenon confirmed only relatively recently, the mass spawning of corals is a strategy of immobile animals that cannot move into sexual contact with each other and which live in an environment of continuous water movement. It may also serve to 'overwhelm' predators, thus improving their survival rate. The individual fertilised coral larva (called a planula) joins the zooplankton community for a period of several days to perhaps several weeks. If it survives predation by any of the many plankton feeders, e.g. small fish, clams and other molluscs, even the corals themselves, it finds a clean substrate on which to settle. It then begins to secrete a cup-like skeleton at its base, into which it can retreat for protection; it can then get on with the business of budding and expanding itself. Coral colonies grow upwards and outwards seeking maximum light for the benefit of the coral's resident algae. Zooplankton, little fishes and other creatures seek protection among the growing branches, folds and sands of the reef. Algae become established here and there, and soon bigger fishes arrive looking for algae to graze on or for little creatures to eat. Some of the zooplankton grow up into shells and crabs and fishes. And so the fledgling reef, with all its inter-dependent creatures, is underway.

The reef continues growing upwards until it reaches the surface and can grow up no more (this is at low tide level, at which point the top of the colony will die) and further growth continues outwards. The reef is shaped by the forces of the water that impinge upon it. On the windward side it is pounded by waves, and bits of coral are broken off and tossed back to leeward where it accumulates in piles of rubble. Slowly the rubble is pulverised into sand and small fragments. Algae take over where the coral has been vanquished. There are calcareous algae that flourish in surf-battered conditions and which cement the dead fragments of the corals, shells, and other debris into a solid mass, and pounded by the sea it becomes a smooth ledge sometimes referred to as the 'algal rim' which, along with a rubble zone immediately behind it, is the highest point of the reef. This zone dissipates the energy of the waves, and behind it corals may again grow. Various physical conditions exist at various locations on the reef, producing zones that suit many different kinds of animals. A physical and biological pattern is established. Typical physical zones of a platform reef are illustrated in Figure 4, and those of a continental island fringing reef are shown in Figure 5.

How best to enjoy a reef?

The best way to really appreciate a reef is to be right in the water with it, snorkelling or scuba diving. Until you've actually done it there is no way of conveying the excitement of leaving the human

1 The origins of 'hermatypic' are in Greek mythology. Hermes married Aphrodite, goddess of love; their son, Hermaphroditos, became 'joined in one body with a nymph', from which our biological term 'hermaphrodite' is derived, meaning sexually both masculine and feminine. Most reef-building corals are hermaphroditic, i.e. have both male and female sex cells. Non-reef-building corals, which may be found at much greater depths, are called 'ahermatypic'.

2 Symbiosis is an arrangement in nature where animals live together for mutual benefit and without harm to one another.

world and heading off on a solitary adventure, to become a temporary member of another world which is silent, and blue, and full of strange and beautiful creatures, and they don't seem to mind the intrusion at all. There are separate notes on diving and snorkelling later in this section, but either of these activities may not necessarily suit all people, and there are a number of

alternatives, such as coral-viewing subs, glass-bottom boats, underwater observatories on islands or in pontoons anchored at a reef, and reefwalking (the latter is discussed in a separate note, also). If you've read something about The Reef you'll get much more out your visit, and some suggested reading may be found under 'Reading about The Reef' later in this section.

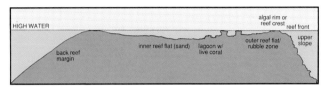

Figure 4. *Cross-section of a typical platform reef with central lagoon.*

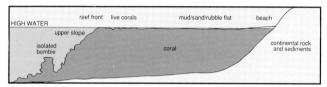

Figure 5. *Cross-section of a typical continental island fringing reef.*

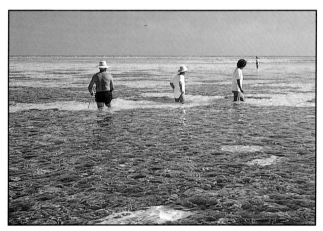

The lagoon usually has a sandy bottom with patches of virulent coral growth, creating a mosaic of shallow pools which can provide, towards low tide, some of the best snorkelling to be had—shallow, still, bright pools that are alive with small fishes and shells. PHOTO: COLFELT.

Continental island fringing reefs characteristically have a broad, muddy rubble flat with algae-covered dead coral. Tourists' expectations of a colourful reef are sometimes unfulfilled when, instead of 'the Garden of Eden' they find 'the back of the moon'. However, on closer inspection, most reef flats are alive with shells and marine life, with coral growing towards the edge and down the reef front. PHOTO: COLFELT.

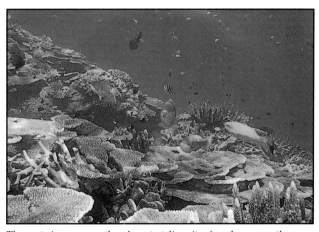

The most vigorous growth and greatest diversity of corals occur on the upper reef slope below low tide level and down to 20 m. PHOTO: LEN ZELL.

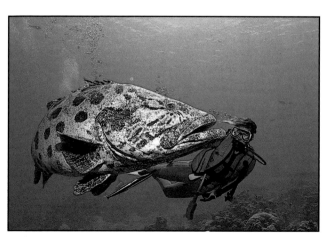

Scuba diving is the ultimate way to view a reef, just as the reef occupants see it, with complete freedom of movement and no interruptions to go up for air (see 'Diving' later in this section). PHOTO: GARY BELL.

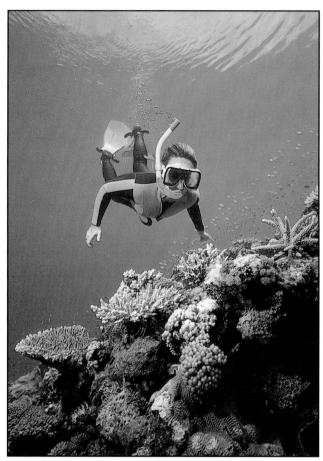

Snorkelling is an excellent way to enjoy a reef, from right in the water with the reef inhabitants. Snorkelling requires minimal equipment and, in most situations, affords almost as good a view as scuba divers get, especially for practised snorkellers who have mastered the art of the shallow dive. (See 'Snorkelling' later in this section.) PHOTO: TONY FONTES.

Underwater observatories are built on islands, and before the advent of the coral-viewing sub they provided the only means of getting a true underwater perspective without getting wet. Observatories are usually easy to get to and visitors have only to descend a flight of steps, which can be an advantage to some. Being next to land, visibility around observatories is often limited, especially when there are spring tides or fresh winds, which stir up sediments, and generally they offer a better view of fish life than of coral. There are currently three observatories in The Reef Region, at Middle Island off the Capricorn Coast (see Section II), Hook Island in the Whitsundays (Section III) and (pictured) Green Island off Cairns (Section V). PHOTO: COLFELT.

Reefwalking offers the chance to examine reef inhabitants at very close quarters. It is an occupation more frequently available at island locations than at outlying reefs. Good footwear is essential, and a pair of socks may help to protect ankles from scratches. Care should be taken to step only on sand patches or in places that appear 'cemented over' to avoid damaging live corals. A walking stick can be a valuable aid to balance. PHOTO: COLFELT.

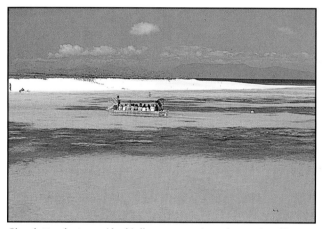

Glass-bottom boats provide a bird's-eye perspective and are preferred by some claustrophobes who like never to be underwater even in a watertight vessel. Photography with flash is usually difficult because of reflections from the glass floor. PHOTO: COLFELT.

Coral-viewing submarines give a real underwater perspective, allowing spectators to see the under side of coral ledges and down the sides of bombies. Photography with flash is possible if the camera is held right against the glass window. PHOTO: DEAN LEE.

Great Barrier Reef Marine Park

(See fold-out map between pages 16 and 17.) The Great Barrier Reef Marine Park covers most of Australia's north-eastern continental shelf, and it is quite different from a 'park' as in 'national park', where everything is totally protected. The Marine Park incorporates a vast area of water and islands, with a 'town plan' superimposed; it has various zones that cater for the equivalent of a town's residential, commercial, light-industrial, and recreational areas, along with areas that are off limits (which are usually for wildlife preservation). The Marine Park provides the framework for managing and preserving The Reef.

Within the boundaries, everything from low water mark to the edge of the continental shelf is under Marine Park jurisdiction; it is complemented and overlapped by a system of Queensland State Marine Parks which protect from high water out to three miles offshore. Above high water mark the islands are either Queensland national parks or are covered by State or Federal Government lease or, in a few cases, by freehold title.

In zoning the Marine Park, the Great Barrier Reef Marine Park Authority (GBRMPA) had to consider pre-existing activities on the continental shelf—for example, commercial and amateur fishing, tourist resorts, and shipping. It was apparent that a model much more flexible than a national park was needed. A zoning scheme was devised allowing different uses of the park to coexist without undue interference between them. It took about ten years to zone the entire Reef, section by section, a process only recently completed. A review of each section is undertaken every five years, with public involvement at all stages.

The Marine Park is managed on a day-to-day basis by the former Queensland National Parks and Wildlife Service—QNPWS—which comes under the State's Department of Environment and Conservation. Queensland Fisheries and Boating Patrol also has a role. Reef travellers can obtain extensive information about The Reef and the Marine Park, including some

Satellite imagery is used by the Great Barrier Reef Marine Park Authority to monitor The Reef. The image above, which was produced by the microBRIAN *digital image processing system, specially tailored for reef mapping, shows, among other things, chlorophyll 'A' levels in the northern Reef area. This information is sought to better understand how currents and nutrients in the Marine Park may affect the Reef system, and it also may contain clues to help explain the mysterious outbreaks of the crown-of-thorns starfish. The line of shelf-edge reefs opposite the eastern projection of the continent, Cape Flattery, is the Ribbon Reefs.* GBRMPA

Great Barrier Reef Marine Park: Summary of Zones and Activities

General Use 'A' Zone
An area where you can do just about anything, within reason, consistent with conservation of The Reef. Spear fishing with scuba is prohibited throughout the Park, as are commercial drilling and mining. Commercial trawling and shipping are permitted.

General Use 'B' Zone
Basically the same as General Use 'A' but with no trawling or commercial shipping.

Marine National Park 'A' Zone
This zone is similar in concept to a national park on land, that is, natural resources protected; but it is different in that some fishing activity is permitted, e.g. trolling (for pelagic fishes, such as mackerel), line fishing (with one hand-held rod or line used with one hook or lure), and bait netting.

This zone has been applied to protect significant areas from intensive extractive activities; for example, netting, collecting and spear fishing (without scuba) conflict with many tourist activities and have been excluded adjacent to resort and camping islands.

Marine National Park 'B' Zone
This is a 'look but don't take' zone; fishing of any sort and collecting are prohibited. The purpose of this zone is to protect areas of special value so that people may appreciate and enjoy them in a relatively undisturbed state.

Preservation Zone
The objective of this zone is to preserve areas of outstanding value in a totally natural state, undisturbed by man except for purposes of scientific research which cannot be carried out elsewhere. Important breeding and nesting grounds may be given this status.

Definitions of activities
Bait netting/gathering
These can be undertaken only in the General Use 'A', General Use 'B' and Marine Park 'A' Zones.

Recreational bait netting is the use of a cast net or a recreational bait net as defined by Queensland Fisheries Regulations.

Commercial bait netting is using a commercial bait net when used by a licensed commercial fisherman.

Bait gathering is taking of yabbies, eugaries (pippies), bait worms or crabs, when taken by hand or hand held implement.

Camping
Camping on Commonwealth islands and all Queensland National Park islands within the Marine Park requires a permit, which may be obtained from offices of the Queensland National Parks and Wildlife Service.

Spearfishing
Spearfishing may be undertaken in General Use 'A' and General Use 'B' Zones. Throughout the Marine Park the following are prohibited:

- commercial spearfishing
- spearfishing with scuba
- use of a powerhead

Collecting
The taking, by any means, of aquarium fish, most shell fish, other invertebrates and marine plants, whether dead or alive. Collecting may only be undertaken in General Use 'A' and General Use 'B' Zones.

Limited collecting
The taking of not more than five of a species (other than coral) in any 28-day period.

Commercial Collecting
The taking of more than five of a species in a 28-day period, and the taking of any coral. Commercial collecting requires a permit.

Crabbing and oyster gathering
Crabbing may be undertaken by a licensed commercial fisherman or a recreational fisherman in the General Use 'A' and General Use 'B' Zones.

Limited crabbing may be undertaken in Marine National Park 'A' Zone, using any combination of crab pots, dillies or inverted dillies that total not more than four devices, or a crab hook. Note: limitations apply on the apparatus used, and restrictions apply on the numbers, size and sex of certain species taken, in accordance with the Queensland Fisheries Act.

Oyster gathering may be undertaken in the General Use 'A' and General Use 'B' Zones. However, while commercial operations may be carried out in these zones, subject to provisions of the Fisheries Act, the construction of racks or other structures in the Marine Park requires a permit.

Limited oyster gathering is gathering of oysters for immediate consumption and may be undertaken in Marine National Park 'A' Zone.

Line fishing
Line fishing includes fishing by both recreational and licensed commercial fishermen. The term line fishing includes fishing with either a handline or rod and reel and includes trolling, bottom fishing, drift fishing or fishing with a floating bait. Tackle and equipment regulations are complementary to Queensland Fisheries Regulations: for example, no more than six hooks are to be used on one line.

Line fishing is allowed in the General Use 'A' and General Use 'B' Zones and limited line fishing is allowed in the Marine National Park 'A' Zone. Limited line fishing allows trolling for pelagic species, or fishing by a person using equipment comprised of either one hand-held rod or one handline attached to either one hook, one artificial fly, or one lure.

Tourist and educational facilities and programmes
The conduct and operation of any facility or programme for tourism (e.g. charter vessels, cruise boats, observatories, pontoons, etc.) or educational programmes may be undertaken in the General Use and Marine National Park Zones only with a permit.

Diving, boating and photography
These activities are considered to cause minimal disturbance to the Marine Park and its resources. For this reason they are allowed in all zones, with the exception of Scientific Research and Preservation Zones. Commercial operators have similar freedom of access within the conditions of permits granted by the Great Barrier Reef Marine Park Authority.

excellent maps which outline the various zones and explain the types of activities permitted, from the Great Barrier Reef Marine Park Authority, 1–37 Flinders Street East, PO Box 1379, Townsville, Qld 4810, telephone (077) 81 8811. QNPWS has regional offices all along the Queensland coast, which has literature about the local areas.

Great Barrier Reef Marine Park Authority

The Federal authority charged with overall responsibility for planning and management of the Great Barrier Reef Marine Park, GBRMPA (as it is usually referred to) is one of the happier chapters in the annals of Australian bureaucracy. From its inception this organisation attracted an unusually well-motivated and informed group of officers who have been responsible for working out a means of protecting The Barrier Reef for future generations while 'allowing life to go on' at the same time. Zoning has often been a balancing act and has been accomplished with imagination and a remarkable lack of conflict, considering the divergent interests that use Queensland's coastal waters. GBRMPA is responsible for examining all proposals that might affect the Barrier Reef and for issuing permits for all commercial operations and collecting within the Marine Park.

The Authority conceived and operates the Great Barrier Reef Aquarium, now a major tourist attraction of Townsville, a 'must' for visitors to that city and a place to get a good idea about the amazing scope and diversity of the Great Barrier Reef. The Authority has a wealth of information and printed material about The Reef.

Bêche-de-mer

Bêche-de-mer is a French corruption of what early Portuguese sailors of the Pacific in the early 16th century called *bicho da mar*, or 'worm of the sea', and which are today commonly called 'sea cucumber' or 'sea slug'. Bêche-de-mer are holothurians, part of the phylum of echinoderms (which also includes starfish, sea urchins, sand dollars, etc.) They are also called 'trepang', a corruption of the Malayan *teripang*, the name that the fishermen of

Holothuria leucospilota

Holothuria atra (*lolly fish*)

Thelenota ananas (*prickly red fish*)

Macassar, in southern Celebes, gave to them a long time ago. Long before white men came to the Pacific, every year, when the northerly monsoon set in, Macassan fishermen would set sail for the northern Australian coast in their praus, wooden vessels with high, square sterns and low bows, with bamboo cabin and large triangular sail (lateen rig). They spent the season harvesting trepang, which were highly sought after by the Chinese as a food flavourer and because of alleged aphrodisiac properties. The fish were cured by boiling for about 20 minutes; they were then split lengthwise and dried in the sun for a short time before being smoked for one day. In processing, bêche-de-mer shrink to half their original size and to less than one-tenth their original weight. Once smoked they must be kept absolutely dry, for in this state

they readily absorb moisture, and if they do, they become gelatinous and soon smell worse than last month's lobster shells. In Australia the industry had its best years from about 1896–1928; it was centred at Thursday Island, although the fishing luggers used to come well down the Queensland coast. At its height this export industry was worth annually perhaps £57 000.

Reef travellers mostly see bêche-de-mer lying lethargically in shallow water, where they appear to do very little. They are actually busy sifting through the debris on the bottom and pooping out sand. Bêche-de-mer range in size from 10 to 50 cm (4–19 in) and come in a variety of colours and shapes; some look like a loaf of bread and some like feather dusters; the trade has names for them, such as teat fish, prickly fish, curry fish, red fish, lolly fish, chalk fish, tiger fish, black fish. Teat fish (*Microthele noblis*) are among the most highly prized.

Bêche-de-mer are quite harmless to pick up, although when threatened they sometimes eject, from their rear end, milky coils of threads which are very sticky and difficult to remove.

Holothuria edulis

Stichopus variegatus (*curry fish*)

Stichopus chloronotus

Bahadschia argus (*leopard fish*)

Bombie

Pronounced (and sometimes spelled) 'bommie', bombie is short for the Aboriginal word 'bombora' which means submerged reef or rocks. On The Barrier Reef, bombie refers to large isolated lumps of coral, frequently of the massive type.

Box jellyfish (See 'Nasties'.)

Wilderness camping on islands in the Marine Park is a popular activity and provides a rare opportunity to shed the cares of civilisation and get back into rhythm with nature. Island campers live by the sun and the tide, and these holidays bestow a sense of adventure. Campers must arrange their own food, water and transport, and they are quite isolated while on the island. PHOTO COLFELT

Camping on the Islands

For campers, there is nothing quite like being on your own 'desert isle'—the stars hanging out of the sky at night, the sounds of water lapping at the beach or surf crashing on the reef, the calling of sea birds; when the sun is up you are surrounded by an empty blue horizon, uninterrupted except perhaps by a white sail, or the pale profile of a distant island. Camping away from the mainland is endless days of sun, peace and solitude. The Barrier Reef Region offers a host of potential 'desert islands', most of them national parks and many of them available for campers seeking this special form of holiday escape.

The islands are of two different types: continental islands, which are similar to the mainland in vegetation and wildlife and which are usually relatively easy to get to; and coral cays, which are quite different in their feel, vegetation and wildlife—they have a certain magic about them—and which are much further offshore. At some times of the year coral cays may be alive with sea birds, and these can set up an unbelievable cacophony at night—music to some ears, torture to others. When the wind comes up suddenly and blows the baby noddy terns out of their nests, the world is at an end (or so it may sound). It all adds to the adventure.

Some islands have developed campsites, with toilets, fireplaces picnic tables and (infrequently) water; others may have no facilities or water. On some islands it is permissible to have motor-driven compressors, generators and other such trappings, while others have been set aside for 'wilderness' camping for those who want no reminders of civilisation. As a general rule, fewer campers are permitted at any one time on wilderness islands.

Camping can be done on your own or, on some islands, with a commercial camping operator. Private campers must arrange to get themselves, their equipment and their food to the island, and when they arrive (exhausted) they have to set up camp. For their troubles they may be rewarded with relative solitude and a sense of having had an adventure. Commercial camping operators do most of the worrying for you, but you will not be on your own. (For names of commercial camping operators, get in touch with the QNPWS

regional office in the area nearest where you wish to camp.)

The major considerations of camping are permits, transport and water, and what to take.

Permits and charges

A permit is necessary for camping on any national park island and may be obtained from the various regional offices of QNPWS (part of the Queensland Department of Conservation and Environment); the office closest to the island in question is where to apply. Bookings are accepted on a first-come first-served basis upon receipt of the full camping fee. Telephone bookings may be made if payment is by credit card. Charges vary, depending upon the amenities provided at the site (e.g. toilets, picnic tables, water, fireplaces); however, a single, flat rate applies to camping on the coral cays of the Capricorn and Bunker Groups ($2.00 per person per night). Charges for other islands range from $2.00–7.50 per site per night. It is essential to book well in advance, particularly if you plan to go to an island during Queensland or New South Wales school holidays. Payment may be by cash, cheque, credit card authorisation (Bankcard, Visacard, or Mastercard only). Permits are issued for varying periods, ranging from 3 to 28 days depending upon the island.

Transport and water

Transport to some islands may be arranged with day-trip operators, either those who make scheduled visits to the islands or those who operate somewhere in the vicinity. In other cases special charters must be arranged. Departure time (for charters) will usually depend upon the state of the tide at the time of arrival; on many islands (particularly where there is a surrounding reef) it isn't possible to land other than at high tide. When arranging transport ask about the type of vessel and the method of landing gear on the beach. If you have a choice, vessels that can land right on the beach, such as a barge, make the whole operation very much easier. Ask whether the charter operator will supply water and containers and whether a charge is made for

this. Most islands do not have a guaranteed water supply, and on coral cays there is, for practical purposes, never any water. If water is to supplied in large drums, be sure the equipment you take includes a 2 m length of 25 mm diameter plastic hose to use as a siphon; a few small containers will also be necessary for decanting. As a rule of thumb, campers should take a minimum of three litres of water per person per day, plus two days' spare water, in case your return is delayed due to bad weather. This is adequate, provided everyone does not use the water for showering. Bathe in the ocean (using any good quality shampoo for soap—it will lather quite adequately, even in salt water) and use fresh water (in a solar shower) to rinse off afterwards.

What else to take

The usual equipment for mainland camping will be necessary with a few additional items (see box for a suggested basic list). Gas cooking equipment is strongly recommended, as fuel for fires is non-existent on the islands (even dead wood may not be collected on national park islands, particularly coral cays, as it is an important part of the island ecology). Those who wish to have camp fires must take firewood with them from the mainland; charter operators can usually make arrangements to have wood delivered to the boat.

If camping on a coral cay, be sure to take extra-long sand pegs; 1.2 m (45 in) hardwood tomato stakes will do for small tents, but for the major pegs for larger tents, similar lengths of 30 x 40 mm hardwood are much better; this length and diameter is very helpful in getting a decent grip in soft coral sand, particularly if it's windy.

Plan each meal for the duration of your trip and cater accordingly; remember, also, that appetites increase by an order of magnitude when camping on islands. Procure your meat in the port of departure and ask the butcher to freeze it for you before you pick it up. Do not depend upon being able to catch fish because (a) fishing may not be permitted (in Marine Park 'B' zones), or (b) you may not succeed in catching fish even if they are there (particularly if you haven't a dinghy). If you do have a dinghy, remember to tie it up well at night (see note on 'Tides' later in this section).

Keeping food fresh on an island can be a challenge, particularly if the weather is hot and you're staying for more than a week.

Take as many insulated chests as you can get your hands on. Ordinary ice will last for three days only; dry ice wrapped in newspaper to supplement ordinary ice will make it last longer. Your butcher may be prevailed upon to freeze your milk for you, and take it with you frozen. Pack food in waxed fruit boxes, which do not melt when they get wet. Cockroaches are in plentiful supply on most islands, and an old-fashioned bush meat safe (or two) is an invaluable item; hang it from a tree near the kitchen area and use it for opened packages of cereals, dried fruits, and anything else that ants and cockroaches love. If you erect a tarpaulin on poles over the kitchen area you will further increase the time that food stays frozen and fresh.

Rubbish

There are no rubbish bins or disposal services on the islands, and QNPWS policy is 'to ship it in and ship it out'. Visitors should have an ample supply of heavy-duty garbage bags and must take all rubbish back to the mainland. Nothing may be buried on the islands, and edible food scraps may be dumped at sea (at least 500 m from the edge of any reef). Fish scraps may be dumped anywhere but it is not advisable to throw these anywhere near where swimming is taking place.

COLFELT

Fires

On islands with no fireplaces, fires must be lit only where there is a least one metre of cleared sand around the fire. Where fireplaces are provided, these must be used (fires are also permitted on the beach. On coral cays, it may be advisable at night to set up a barricade of a kind close to the fire on the seaward side—perhaps several camping chairs—to prevent accidental intrusions. The light can attract the odd mutton bird on its way home from a hard day at sea, and on rare occasions one may fly straight into the fire (mutton birds are magnificently deft at sea, notoriously daft on dry land). Watch the rear side of the fire, too, for the occasional baby mutton bird that may be wandering around drunkenly at night.

Safety

Most of the islands are close enough to civilisation that, in an emergency, help is not too far away. Many islands are regularly overflown by helicopters and local air operators or are passed regularly by yachts or ships. If you are concerned about being able to communicate, consider taking a hand-held marine citizen's band radio.

A good first-aid kit is essential, including plenty of liquid antiseptic ('Metaphen', mercurichrome, 'Betadine') and antiseptic powder to apply to cuts immediately (see note on 'First aid' later in this section). Obtain prescriptions from a doctor for antibiotics to treat different types of infections (along with some instructions about which antibiotic to use for which infection, e.g. middle-ear or upper-respiratory vs. infected toe).

Continental islands generally have the same wildlife as is present on the mainland (including the possibility of poisonous snakes). Coral cays are generally devoid of all terrestrial nasties

Suggested basic camping equipment list

air mattresses and pump	food wrap	shower, solar
aluminium foil	frypan, heavy	sieve
bags, sturdy plastic	garbage bags, sturdy	sleeping bags
barbecue, gas	gas lights	snorkel
billies, several	gas light mantles	snorkelling fins
boiler, heavy	gas bottles (LPG)	snorkelling mask
bowl, mixing	hammock	spades, small
bowl, salad	hat, broad-brimmed	spoons, serving
bowl, washing up	hose, plastic 2 m (25 mm)	stove, LPG gas
bowls, eating	insect repellent	string
bucket	knives, forks, spoons	sunglasses
can opener	mallet or stout hammer	sunscreen
chairs and/or stools	matches, waterproof	table[4]
chopping board	mugs	tarpaulins
clothes pegs	music (radio/cassette)	tea towels
container, water 2 litre	oven mits	tent pegs, sand[5]
containers, water 4 litre	petrol (for outboard)	tents
dinghy, w/ anchor/rope	plates	toilet paper
dish cloths	poles, 2 m (12)[1]	tongs, barbecue
dishwashing detergent	pot scourer	tools (basic selection)
egg flip	ropes, extra	torches and batteries
'Eskies' (insulated chests)	sacks, hessian (8)[2]	
first aid kit	scissors	
fishing gear	shirt, long-sleeved, light[3]	

1. Extra poles (bamboo or any small-diameter poles readily obtained from a hardware store) are extremely useful for erecting a roof over the kitchen area with a tarpaulin. This reduces heat and will reduce problems keeping food. Poles can also be useful for erecting extra fly-covers over leaking tents, and for other miscellaneous duties.
2. Hessian sacks are excellent for carting things such as barbecues and other difficult-to-pack items; they make excellent mats to sit on.
3. For wearing while reefwalking or snorkelling (after several days of too much sun!)
4. A table can raise the standard of camping, and everything needn't take place at ground level. A trestle-table with folding legs is ideal, but any flat board placed on crates or drums will suffice.

except those of nuisance value; centipedes (*Ethmostigmus rubripes*) are present on all of the cays and, while not poisonous, can be quite large (20 cm (8 in))and can give a painful nip; keep your tent zipped up at all times, and watch out for centipedes especially after rain or if the ground around the tent is disturbed. As a general rule, dangerous marine stingers (box jellyfish) are not found at the islands off the Queensland coast; however the western bays of islands close to the mainland (within 10 km), particularly large islands with mangroves, may not be stinger-free, and it is advisable to wear a stinger suit when swimming at these islands during the stinger season (November–April). (See also notes on 'First Aid' and 'Nasties' later in this section.)

Camping philosophy

To preserve the natural value of the islands of The Reef, campers should adopt an attitude of 'minimum impact camping'. No matter how considerate of nature, campers do have an impact, and if this is kept to the absolute minimum the islands will continue to be pleasant places to go when future generations come along. The aim should be to leave everything exactly as it was found. Campers can expect a visit from a Marine Parks Ranger at some time during their visit. The Rangers are always well-informed and willing to answer questions about park flora and fauna.

COLFELT

Brief summary of camping on The Reef

Section I: The Southern Reef.

Permits: QNPWS Gladstone District Office, Roseberry St (PO Box 315, Gladstone, Qld 4680, telephone (079) 76 1621.

In the southern Reef area are the beautiful coral cays of the Capricorn and Bunker Groups. Camping is permitted on four of these cays; Lady Musgrave (see pages 52–54), North West Island (page 70), Mast Head Island (pages 69–70), and Tryon Island (page 71). Lady Musgrave may be reached via Bundaberg with the MV *Lady Musgrave*, which does day trips to the island, or via Gladstone (private charter). Mast Head and Tryon Islands are reached by private charter only, from Gladstone. They are 'wilderness camping' islands, more remote, relatively more difficult to get to and much more difficult to land on than are Musgrave and North West.

Section II: The Capricorn Coast

Permits: QNPWS Central Regional Office, Royal Bank Building, 194 Quay St (PO Box 1395), Rockhampton, Qld 4700, telephone (079) 27 6511.

Camping is permitted on several islands of the Keppel Group (see page 75). Great Keppel Island has a camping resort with facilities ranging from tent cities to ordinary campsites behind the dunes. North West Island, the largest cay of The Reef Region, in the northern Capricorn Group, is visited by the high-speed catamaran *Capricorn Reefseeker* several days a week departing from Rosslyn Bay, and individual campers can arrange transport on this vessel. There is also a commercial camping operation on North West, operated by Yeppoon Backpackers, which has a site for a maximum 15 campers, with two-man teepee tents and a large communal tent.

Section III: The Whitsundays

Permits: QNPWS Mackay District Office, 64 Victoria St (PO Box 623), Mackay, Qld 4740, telephone (079) 57 6292.
QNPWS Proserpine District Office, Conway Ranger Station, Shute Harbour Road (PO Box 332), Airlie Beach, Qld 4802, telephone (079) 46 9430.

The Whitsunday Islands are the largest group of islands on the Queensland coast, and most of them are national parks. There is a broad range of island campsites, from reasonably large, developed sites (with pit toilets, water tanks—which may not have anything in them in the dry season—fireplaces and picnic tables) to completely undeveloped sites for wilderness camping. Access for the southern islands in the Group is from Mackay; Shute Harbour is the principal departure point for the central and northern·islands. Transport may be arranged with a number of day-cruise boats or with the water taxi at Shute Harbour. The high tidal range in the Whitsundays means that the tide must be considered when planning a landing at most beaches. At the Conway Ranger Station about 1.5 km from Shute Harbour, there is a campsite which is often used as a staging ground by campers bound for the islands, and there are commercial camping grounds and caravan parks in the Airlie Beach area.

Section IV: Townsville

Permits: QNPWS Great Barrier Reef Wonderland Office, 1–37 Flinders St East, Townsville, Qld 4801, telephone (077) 21 2399.
QNPWS Hinchinbrook District Office, 2 Herbert Street (PO Box 1293), Ingham, Qld 4850, telephone (077) 76 1700.

Camping is available at Orpheus Island in the Palm Group, where some of the best fringing reefs in the whole Reef Region may be found. Orpheus has a resort and research station operated by James Cook University, where a project on giant clam farming has been underway for several years. Access is with Westmark-Pure Pleasure Cruises, whose vessels depart from the Breakwater Marina.

Section V: Hinchinbrook to Cairns

Permits: QNPWS Cardwell Office, Bruce Highway (PO Box 74), Cardwell, Qld 4816, telephone (070) 66 8601.
QNPWS Far Northern Regional Office, 41 Esplanade (PO Box 2066), Cairns, Qld 4870, telephone (070) 51 9811.

This section of the coast offers a number of options for campers, including the wild, rugged Hinchinbrook Island (pages180–187), the largest island national park in the world, and Goold Island (see note on page 178). Access is from Cardwell. Camping is permitted on Coombe, Bowden and Dunk Islands in the Family Group, which may be reached from Cardwell or Mission Beach. Further north are the Barnard Islands, but access is difficult (by private craft only—there are no commercial services). Camping is permitted on two national park islands of the Frankland Group, 40 km south of Cairns—Russell Island, which has a developed site, and High Island, which is a wilderness island; access is from Deeral Landing with the water taxi. Fitzroy Island (pages 212–217), which is reached from Cairns, has a campsite a short distance from the resort. This island is currently under the jurisdiction of the Mulgrave Shire Council, and arrangements for camping are made through the resort.

Section VI: The Far North

From QNPWS Cairns (see above).

There are a number of islands between Cairns and Lizard where camping is permitted, but access becomes increasingly difficult as one moves north. These include Snapper Island (access via day trip operating from the Daintree River), West Hope Island, Three Isles, Two Isles, Rocky Islets, the Turtle Group and Lizard Island (access to most of the latter is by private vessel or charter from Cooktown). Lizard Island has a good campsite, with permanent water, and the island has an abundance of natural attributes. It is remote and not inexpensive to get to.

Cans

The way Australians pronounce Cairns (see page 206).

Ciguatera

Ciguatera comes from a Spanish word, 'cigua', and was coined by a Cuban ichthyologist, F. Poey, in 1866. Cigua is the name for a small mollusc (*Livona pica*) which causes digestive and nervous disorders when eaten. Ciguatera is usually acquired by eating predatory tropical reef fishes, or reef-feeding pelagic fishes, that have accumulated a toxin through eating smaller fishes which contain the toxin. Ciguatoxin is believed to originate from a dinoflagellate (phytoplankton) Gambierdiscus toxicus which is passed along the food web via small herbivorous fishes; the toxin is firmly tissue-bound, very little being excreted, and thus it can reach high concentrations in larger carnivorous fishes.

Juvenile chinaman fish (Symphorus nematophorus).

Gambierdiscus toxicus proliferates around coral reefs where the coral has been killed either by storms or by the intervention of man, or by silting or heavy rainfall. Thus, from time to time many different species of fishes may be affected by ciguatoxin, and the list of fishes that have been implicated at one time or another reads like a peerage, including everything from coral trout to scallops. The list is of little practical value as a guide to which fish to avoid eating. The best thing is to check with local fishermen as to which fishes to avoid, as this varies from time to time and from area to area. Certain species of fishes in Queensland are reputed to be frequently toxic, and these should always be avoided. They are: Chinaman fish (*Symphorus nematophorus*); paddletail or red snapper (*Lutjanus gibbus*); red bass (*Lutjanus bohar*); and moray eel (Gymnothorax sp.). Large fishes (over 4 kg) are much more likely to have accumulated ciguatoxin than smaller ones, and the cautious may wish to avoid eating any fishes over 4 kg. In any event, never eat repeated meals from the same large fish. If there are more than the usual number of dead sea birds around, don't eat *any* fish for several weeks.

Because of the cumulative nature of the poison, it is possible that one may on one occasion ingest a dose which is not sufficient to produce symptoms and then on a subsequent occasion develop a full-blown case after eating what would normally be a

Adult chinaman fish (Symphorus nematophorus)

sub-clinical dose of toxin. Several members of Cook's crew got ciguatera in the New Hebrides (now Vanuatu), and a pig on board which was fed some of the suspect fish died the next day, in spite of the fish having been cooked together with a silver spoon. Other folklore heard even today says that ciguatera may be avoided by boiling the fish together with a coin, and perhaps both of these fables have a common origin; there is no fact known to support either notion. Ciguatoxin is heat stable and is not destroyed by cooking. While the water-soluble fraction may be reduced by repeatedly soaking fillets and discarding the water, this will not prevent poisoning by the insoluble fraction. The broth of boiled ciguatoxic fish is very poisonous.

Paddletail or red snapper (Lutjanus gibbus)

Symptoms of ciguatera develop between two and 12 hours after ingestion (usually in about five hours); initially there is abdominal pain, nausea, vomiting and diarrhoea, then numbness or tingling about the mouth and in the extremities develops, and victims experience a characteristic inversion of hot and cold perception (ice cream and cold drinks burn the mouth and throat, and a cold can of beer feels hot). Muscle aches and pains are common. Sometimes victims say their teeth feel like they're falling out of their mouth. Rash is common. Recovery usually occurs in 48 hours to one week. Tingling and disturbance of temperature perception may last much longer. A good dose of poison may produce subsequent allergic reactions, particularly to fish.

First aid: If the victim is conscious, induce vomiting by sticking the fingers down the throat or administering an emetic (syrup of ipecac). If a large amount of toxin has been ingested, symptoms can be life-threatening, and medical attention should always be sought.

Clams

Giant clams of the family *Tridacnidae* are the most spectacular shells of The Reef. Six species[1] of these giant clams are found in Queensland waters, ranging from the massive *Tridacna gigas*, which lies in shallow reef waters (good places to see them are Lizard Island and Michaelmas Cay) to the smallest *Tridacna crocea*, the burrowing clam that can be seen throughout The Reef Region 'smiling' from within solid coral boulders, leaving the observer wondering both at the improbability of a 'rock with many mouths' and as well as how the clam got there. *Tridacna gigas* is known to many who have never even seen a reef, particularly watchers of late-night 'B'-grade movies, who have seen hapless pearl divers struggling underwater to free themselves from the vicious clutches of one of these ogre-clams. That is a whole lot of hooey.[2] Another myth is about their age. Large specimens are often claimed to be 200 years old, which is highly doubtful and which probably came from projecting their early

1 The six species, from the largest to the smallest, are: *Tridacna gigas* (80 cm, or 32 in);*Tridacna derasa* (40 cm, or 16 in); *Tridacna squamosa* (35 cm, or 14 in); *Hippopus Hippopus* (25 cm, or 10 in); *Tridacna maxima* (20 cm, 8 in); *Tridacna crocea* (15 cm, or 6 in).

2 There is no question about the power of the clam adductor muscle, with which it closes the shell and keeps it closed, but there is also no reason to fear giant clams. The largest species, *gigas*, usually depicted as the culprit, can close their shell only slowly. It contains a huge volume of water that has to be exhaled as it closes, and one would have to stand in the shell for several seconds to get a leg caught. Even when the shell is closed, researchers say that it is possible to remove an arm from between the soft folds of the mantle, which prevent complete closure of the shell. But entrapment makes a good story, and of course, there is always the exception to the rule. The smaller species of giant clams *can* close their shells completely; *Hippopus hippopus*, which has a sharp, curved shell, does not extend its mantle past the edges, and this is one clam not to get a finger caught in. It, nevertheless, does not close with trap-door rapidity. Reef visitors are advised not to go sticking their hands into any of the species of giant clams, but there is nothing to fear (except, perhaps, the possibility of being squirted).

growth rate in a linear fashion; clams grow more rapidly in their early years than later on, and James Cook University's clam expert, John Lucas, says that the oldest clam he's yet seen on the Great Barrier Reef was probably about 50 years old.

The giant clam is prized on many counts. Its shells may be found in churches throughout the world, used as baptismal fonts; the shells are not an uncommon sight on suburban lawns, being used as bird baths. The natives of the Pacific eat the meat, and the Chinese prize the adductor muscle as a flavourer for food and an aphrodisiac. The meat, when dried and shaved into flakes, commands about $50 per kilo (wholesale) in Asia. The obvious attractions have lead to the clam's undoing as it is now extinct on many Pacific reefs, due to over-fishing.

The giant clam (Tridacna gigas)

Travellers frequently encounter the two smallest species, *maxima* and *crocea*, when reefwalking. *Crocea*, the burrowing clam, is seen imprisoned in large lumps of coral rubble. It gets there by rocking back and forth; the projections (scutes) at the base of its shell erode away the coral substrate until all that can be seen are the 'lips' of the mantle. It may also secrete a little acid to help dissolve the limestone. The clam continues to grow, eroding its shell to make room, until it is completely imprisoned.

The fleshy mantles of giant clams contain symbiotic algae (zooxanthellae), which is why these clams are all found in shallow water. As with reef-building corals, the zooxanthellae supply a large proportion of the clam's food, and light is needed to keep this food factory going. This explains how the clam has managed to attain such a large size while sitting immobile on top of the reef. Clams also filter sea water, removing phytoplankton, but this is only a fraction of their diet. Unlike corals, clams can 'harvest' their symbiotic algae, transporting them via the blood stream to the gut. Giant clams have structures in the mantle (hyaline organs) which increase the translucency of the tissue; the brilliant, iridescent blue and green spots on the mantles of some of them are due to a physical aspect of the mantle's construction, not due to the zooxanthellae, as is sometimes said (see 'Colour on The Reef' below). Clams have light-sensitive organs in their mantles, and they close their shells when a shadow falls over them. They have a powerful excurrent siphon through which they can deliver a very powerful squirt; even from beneath the surface, they can raise a column of water as much as 40 cm in the air. This is used for defence, to disperse eggs and sperm, and to frighten reefwalkers. Clams, like hermatypic corals, are hermaphroditic.

Giant clams have been completely protected in Barrier Reef waters for some years, in an effort to avoid the extinction that has

taken place elsewhere in the Pacific. At Orpheus Island research station, a giant clam farming project is underway, and clams from Orpheus have already been exported to re-stock depleted Fijian reefs. Visitors are welcome at the station, where you can watch giant clams being stimulated to eject sperm and eggs (those with cameras should beware of being soaked with a jet of water from the bottom of the tank—ogre-clams!).

Colour on The Reef

'Colourful corals and fishes' are words often written about the Great Barrier Reef, and the colour of the reef and its inhabitants is certainly one of its attractions. Many Reef travellers arrive, however, with their imaginations fired with images from glossy books and tourist brochures, expecting to see corals growing like so many blazing petunias in a garden on top of a reef. It is understandable that photographers and book editors wish to display their most dramatic photographs, but many of the images are collected in circumstances that the average Reef visitor will not encounter. The Reef, in daytime, is a mixture of myriad textures and muted colours. Water, being a selective filter of sunlight, removes first the colours at either end of the spectrum— the reds and the violets. As depth increases, only the middle wavelengths—the blue-greens—remain. At a depth of 20 m, red light has been almost entirely filtered out; a lot of it has been removed at shallower depths. Fish that are bright red at the surface are, when seen at depth, almost invisible, a dusky green shadow moving across the sand.

Corals have a reputation for being colourful, and they fooled men for years into thinking of them as flowering plants of the sea. The most colourful part of corals is their polyps, and most reef-building corals have their polyps retracted inside their skeleton during daylight hours, extending them to feed at night when the zooplankton come out of hiding. These colours are captured by photographers with underwater flash on cameras fitted with close-up lenses, and the photographs do resemble flowers with brilliantly coloured and intricate petals. If you carry a torch underwater you can re-introduce red light, but snorkellers and those in coral-viewing subs or glass-bottom boats must usually rely on incident light only, and what they see are attractive, subtle yellows, oranges, greens, purples and browns, all with a gentle overlay of blue.

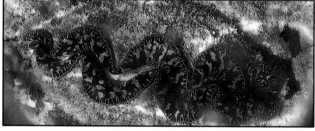

COLFELT

The colour of any object or animal is the colour of light that is *reflected* from its surface. The other colours, all of which are present in the white light that falls on an object, are not seen because they have been selectively absorbed. Thus, a red fish is reflecting red wavelengths and absorbing all the rest. What causes animals to absorb certain wavelengths of light is both the *physical* nature of its surface and the *chemical* nature of its surface. Colours caused by physical factors are called 'structural' colours, and those due to the chemical makeup are 'pigmentary' colours.

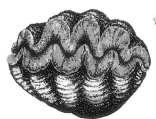

Giant clam (Tridacna maxima)

Burrowing clam (Tridacna crocea)

Horseshoe clam (Hippopus hippopus)

Bait fish caught in the polyps of Tubastrea sp. PHOTO GARY BELL

Structural colours can produce iridescent hues. Pigmentary colours are more uniform reds, yellows, browns, purples, greens. Sometimes colour is due to a combination of the chemical and physical factors.

Structural colours are caused by (a) scattering of light (Tyndall effect), (b) light interference, and (c) by diffraction.

Scattering, according to Tyndall, is why the sky its blue and why some eyes are blue. In the case of the sky, the blue is caused by particles in the atmosphere which are smaller than the wavelength of red and yellow light; these reflect and scatter more short-wavelength light (at the blue end of the spectrum).

Interference is what causes the rainbow effect in a soap bubble or oil spilled on water; light is reflected from two surfaces, causing cancellation of some wavelengths, and the resultant wavelengths produce the colours that the eye perceives. These colours change constantly as they are viewed from a different angle. Interference is what is chiefly responsible for iridescent colours, the blue wings of the Ulysses butterfly, or the tail of the peacock, the bright blue spots on the blue-ringed octopus and the iridescent greens and blues sometimes seen in the mantle of giant clams.

A few animals, when viewed from one specific angle, have iridescent colours caused by what is called a 'diffraction grating'; this produces the colours of mother-of-pearl.

Pigments are chemicals that perform many functions in addition to imparting sometimes brilliant red, purple, yellow, green, brown hues. Melanin is what gives white skin its tan (and protects white people from harmful ultraviolet radiation from the sun). Haemoglobin contains a pigment complex that both imparts the red colour to lips, gills and tongues and enables oxygen to be carried by blood. Carotenoids are pigments that

produce an array of reds, yellows, oranges (and other colours when combined with proteins), such as the red of lobsters and the brilliant yellows and reds of some reef fishes. The subdued yellow-brown colour of many corals, as they appear in the daytime, are caused by pigments of their zooxanthellae. Pigments also produce the bright colours of the polyps.

Corals

Corals are the animals associated with building the Great Barrier Reef, but the name really covers a number of different types of animals including reef-building corals and non reef-building corals (see 'Great Barrier Reef' earlier in this section), plus soft corals, and in addition, a group of animals called hydrozoans which look just like corals to a layman but which scientists tell us are not. To add to the confusion, corals which belong to the same genera sometimes have wildly different appearances, so knowing their scientific name (for example, *Acropora* sp.) does not necessarily help get things straight as far as the casual coral reef observer is concerned. Species of the genus *Acropora* sometimes look like a deer's antlers, and they sometimes look like a garden gnome's table. Possibly it is more satisfactory for the tourist to know that reef-building corals generally fall into the following categories: branching, columnar, encrusting, foliaceous (leaf-like), free-living, laminar (table like), and massive. Bringing things down another rung, these include things that Reef travellers will hear described as staghorn corals, plate corals, brain corals, mushroom corals, slipper corals, micro-atolls, etc. Coral taxonomy is well beyond the scope of this book and the capability of the authors. Those interested in expanding their knowledge will find some suggested titles in 'Reading about The Reef' later in this section.

Crown-of-thorns starfish

The crown-of-thorns starfish (*Acanthaster planci*) has become a major worry for The Reef because in the past three decades it has swarmed over reefs (primarily from Lizard Island to Townsville) in plague proportions causing a significant amount of damage to corals. It is a normal part of The Reef community and is but one of a number of coral predators and parasites, which include a variety of fishes, crabs, nudibranch and gastropod molluscs, worms, an encrusting sponge and one other starfish. However, it is the only one that is known to cause physical damage on such a large scale.

Population explosions of the crown-of-thorns may have occurred periodically throughout history and in recent times throughout the Indo-Pacific region. The first of recent outbreaks on The Barrier Reef was first noticed in the 1960s. It began at Green Island, off Cairns, where there is a tourist resort and where thousands of people get their first look at a coral reef. Green Island's reef was devastated. *Acanthaster* attacks particularly staghorn corals, the fastest growing and most plentiful species. These starfishes have no table manners; they lie on top of the coral, turn their stomach out through their mouth and release digestive juices, and then slurp up the 'polyp soup'. One starfish can wipe out an area the size of a dinner plate a day, leaving nothing but a bleached white skeleton. In aggregations of millions, they can devastate an entire reef in a matter of months.

By 1976 the crown-of-thorns started to disappear as suddenly as they came. An advisory committee that was convened to study the problem concluded that there was no evidence to suggest that the starfish posed a real threat to The Reef.

In 1979 the crown-of-thorns returned with a vengeance, and some people began predicting 'the end' for The Reef, that it would crumble and be destroyed by the sea (which wouldn't happen, as the living coral of any reef is only a thin veneer, the rest being limestone). The media panicked, there were loud calls of 'Somebody do something', and criticism was levelled at the Marine Park Authority for 'not doing anything', although without understanding the cause of the phenomenon, it is difficult to see just what the Authority could do. Practical field work suggested that the cost of killing the starfish, if carried out on a meaningful scale, would soon bankrupt the country. One reef

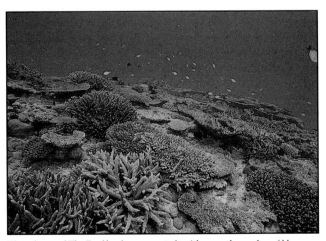

The colours of The Reef by day are muted, with a gentle overlay of blue.
PHOTO LEN ZELL.

may have starfish in the millions, and estimates put the cost at about $10 per starfish killed. Small-scale eradication on parts of reefs used for coral viewing—done by injecting starfish with small amounts of copper sulfate, a poison—have proved more feasible but still expensive and time-consuming. Other methods of control suggested so far, such as dusting reefs with lime, are neither ecologically sound nor feasible.

The reason for population explosions are not yet known. The starfish is extremely fecund, one female producing 10–40 million eggs per year. That sort of population economy is known in other animals, such as giant clams, and the strategy is definitely *e pluribus unum*—only a few are intended to survive. Anything that tips the balance in favour of survival of the millions of larvae, even if only by a minute percentage, can result in a plague.

Several theories have been advanced to explain the plague. One is that man is responsible, because he has removed in great numbers one or more natural enemies of the crown-of-thorns, particularly the triton shell and, more recently, some species of fishes. Some scientists haven't given the triton theory much credit, holding that the triton would be an insignificant factor in controlling populations, particularly plagues. On the other hand, some feel that with normal starfish populations, tritons may have kept the crown-of-thorns thinned out enough so that its blitz spawning strategy was kept under control. Man has also been implicated by his activities on the land—clearing and agriculture—which have increased run-off of nutrients, fertilising and increasing the phytoplankton population upon which the crown-of-thorns starfish larvae survive. The other argument holds that starfish plagues are a natural phenomenon, recurring from time to time, part of the random variations of nature. It has even been suggested that they might play some role in maintaining ecological balance, by pruning the virulent staghorns and allowing other coral species to establish themselves.

Researchers now mostly agree that the crown-of-thorns phenomenon cannot be explained by a simple cause-effect relationship. There may be many reasons for the outbreaks, per-

Reefs that have been attacked by crown-of-thorns starfish can have a desolate appearance and may take years to recover. PHOTO PETER MORAN

haps even a combination of natural and man-induced factors. The managers of the Marine Park have taken the position that, until most crown-of-thorns experts can agree that the infestations are unnatural, measures to control them should be limited to areas of scientific importance or important to tourists.

Skeletal remains of the crown-of-thorns have been found, in core samples taken from reefs, in sediments which can be dated back thousands of years; the outbreaks may not be just a recent phenomenon. This evidence may indicate that nature is taking its course; however, since man's effect on nature is now being felt more regularly, what used to be an infrequent natural disaster may have become a more frequent, unnatural one. Science is, by definition, conservative, so the final proof may not be available until after the truth is apparent. Even so, no one has yet come up with a practical way to deal with the problem. The Reef Authority is following the situation closely and a multi-million dollar research effort has been gathering data for several years. While significant new sightings of crown-of-thorns should be reported to GBRMPA, and the Authority is also interested in negative reports from the more infrequently-visited reefs.

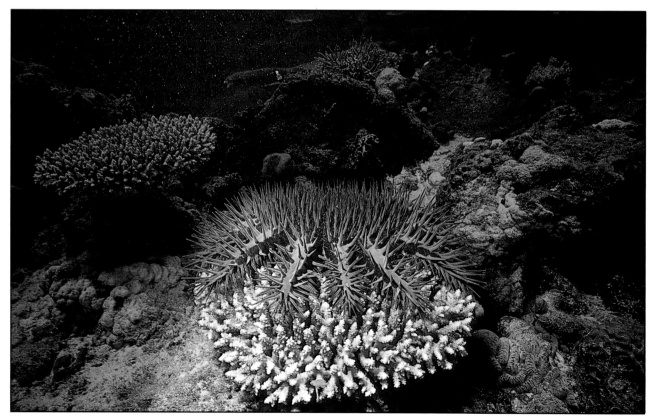

*The adult crown-of-thorns starfish (*Acanthaster planci*) feeds on coral, particularly the staghorn variety, and when it's finished it leaves behind a bleached white skeleton. The starfish's spines are toxic and can inflict a painful wound.* PHOTO PETER MORAN

Diving, the ultimate way to see The Reef. PHOTO GARY BELL

Diving on The Barrier Reef

I'll never forget that first dive on the Great Barrier Reef. Gliding easily down the coral-clad slope, I had passed over a shelving terrace of sombre green plate corals, a forest of giant staghorn coral, here blue, over there a creamy brown. I was drawn to a giant brain coral, standing clear of the slope on a white sandy floor, and as I approached, teeming masses of tiny fish parted before me. I finned gently around the coral wall, and was startled by a face-to-face encounter with a bug-eyed fish finning in the other direction. A flick of his tail, and he was off, joining a dozen of his companions hovering in loose formation at the edge of my vision. I exhaled and allowed myself to settle under the overhanging base of a giant brain coral, the bubbles from my diving cylinder becoming trapped like flattened quicksilver among the myriad encrusting life forms which clad the cavern's shaded roof. My flashlight revealed their unbelievable colours and forms: rich purples, reds, yellows, and orange in an infinity of shades and shapes. I felt the touch of my companion's hand on my arm, and following his beckoning, swam upwards to join a pair of graceful manta rays circling the giant coral. We swam together for fully five minutes. They effortlessly manoeuvred their giant, flattened bodies through sweeping arcs and curious about these unusual-looking intruders to their world, allowed themselves to be stroked as they passed nearby. They departed, and we made our way slowly up the slope in a state of gentle euphoria. Sitting there in our little dive boat, I resolved to do this much, much more often.

— Terence Done

Few who experience the excitement of being underwater on The Great Barrier Reef come away unmoved, the words above being those of a man who went on from that first experience to pursue a career in coral reef research with the Australian Institute of Marine Science. Fortunately, at almost every Reef gateway along the Queensland coast there is some provision for scuba divers, so there is no shortage of choices. The travel budget will obviously

be a consideration, but aside from that, the following are a few other questions worth considering: (a) Is time a constraint? (b) Is a particular type of diving sought, for example, wall diving with maximum visibility and large predator fish, or is the prime aim to see a high diversity of coral and reef fishes? (c) Is the objective diving, diving and more diving, or is diving to be mixed with other holiday activities and pleasures? (d) Is commuting to The Reef from the mainland every day acceptable, or would it be preferable to stay right at The Reef, for example, at one of the three resorts on a Reef cay, or at the 'floating hotel'?

If your time is strictly limited, then it may be best to consider going to an area where there is maximum availability of services so that, for example, if you're an experienced diver, you can get out to The Reef by any of several means on any day of the week, or if you're a beginner, you can start a course at several different times during the week and not just, say, on Saturdays. Not all areas offer this flexibility. If diving is the sole criterion, then perhaps an extended cruise on a purpose-oriented dive boat will be most satisfactory, taking in some exotic diving in the Coral Sea or at the Ribbon Reefs in the far north. For those who dislike commuting, there are three coral cays with resorts, Lady Elliot Island, Heron Island, and Green Island, and a fourth, Lady Musgrave Island, on which, at certain times, it is possible to join a commercial diving safari. One of these options may suit perfectly, with the added benefit of experiencing the magic of living on a coral cay. Perhaps the family also needs to be considered; maybe no one else is interested in diving, in which case it might be better to choose a location, such as the Whitsundays or a mainland centre, where there are lots of other activities for all the family and where creature comforts may be enjoyed by all.

Diver training

It is always a good idea to become acquainted with what is offered in a particular area by talking with several of the dive

operators and, as well, with someone from the local tourist information centre; weigh up what each has to say. There is no such thing as a 'free lunch', and if one dive course costs very much less than another, there must be an explanation. It may well be that an operator who trains many divers can operate efficiently at a low unit cost, but there may be differences in the length of the course offered, the number of days of pool and classroom theory provided, the amount of open-water time, and the amount of individual attention given. Find out where the open-water part of the course is conducted, what sort of dive boat the operator uses, what, if any, extras are charged for, and the answer to these questions may help to decide which course offers the most.

Training is available at almost every gateway and every island

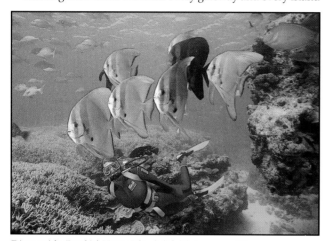

Diver at 'the Bombie', Heron Island; fish life is very prolific.
PHOTO: GARY BELL.

resort in the Reef Region. The heaviest concentration of training facilities is in the Cairns–Port Douglas areas (Sections V and VI), where there are seven or eight companies, each starting courses perhaps three times a week. This area also offers the greatest variety of opportunities to get to The Reef each day. From the standpoint of numbers of divers trained, the next-largest centre is the Whitsundays (Section IV); Airlie Beach and its adjacent communities have a wide range of accommodation, from resorts to holiday flats to backpackers' hostels, and there are five or six dive operators, including one of the few schools in the country which offers instructor-level certification. Almost all of the Whitsunday Island resorts have resident diving instructors. Townsville (Section V) has three or so dive operators, one large, long-established firm which has one of the best physical facilities for training in the country and another which has some staff with very high qualifications. Don't forget to arrive with a diver's medical certificate to avoid any delays. Certified divers need to show their 'C' card, and most dive operators ask you to give a brief, verbal summary of recent diving experience to help them assess your current capabilities. Those who are not sure whether or not they're really interested in getting into scuba diving can take an introductory course (sometimes called a 'resort course'), which involves a few hours of pool instruction and then a shallow dive with an instructor. These are very popular and can be a good way of testing for real interest before much time or money is committed.

Other general considerations

Australia's position in the Indo-Pacific region is not far from where modern reef-building corals evolved several hundred million years ago, so when the Australian continent moved into the tropics, the Queensland coast started out in life with a 'silver spoon in its mouth' as far as coral diversity is concerned. The Barrier Reef has since grown up on Australia's shallow north-eastern continental shelf, over the past two million years. The proximity to the coast means that The Reef is affected, to varying degrees, by sediments, nutrients and fresh water from the mainland. The individual reefs are found in a wide range of habitats, from high-energy environments in clear waters at the edge of the

shelf, to relatively protected shallow habitats in sometimes murky waters adjacent to the mainland. The many factors have played a role in contributing to the very high diversity of marine species found in the region—about 350 different reef-building corals, 1500 different kinds of fishes, and 4000-odd species of molluscs. Divers have a wide variety of diving sites to choose from and an abundance of marine life to amuse them in the water.

Visibility varies from location to location, chiefly a function of proximity to the mainland or to neighbouring islands and reefs, but it is also affected by a combination of water depth, tidal range, state of the tide, and wind conditions. The sheer size of the Reef system means that a measure of self-generated plankton is added to the equation. As a very rough rule of thumb, visibility increases by one foot for every one mile travelled away from the mainland. There are local anomalies, such as in the Whitsundays, where the high tidal range in the area adversely affects visibility, especially at times of spring tides combined with fresh winds, but the Whitsundays nevertheless offer some excellent diving. Visibility is by no means the sole criterion of good diving, but it is best to understand that, with south-east trade winds blowing fresh, visibility at mid-shelf reefs will not always be the theoretical maximum 60 m (200 ft) that one may find in distant oceanic situations (where, incidentally, there is usually much less diversity in corals and reef fishes to provide entertainment for the diver).

The part of The Barrier Reef discussed in *Barrier Reef Traveller* covers about 7° of latitude along the Queensland coast, and water temperature varies by a few degrees from one end to the other; for comfort as far as temperature is concerned, in the winter-time a full, heavy wet suit is required in southern areas; a lightweight or short wetsuit may suffice in the far north). Obviously a full wetsuit provides some added protection, irrespective of temperature, and if diving close to the mainland during the stinger season (November–April), it provides protection from box jellyfish.

Diving on The Reef is generally undertaken in one of two ways; by dive boat, i.e. a boat specifically operated for scuba divers; or

Mean sea temperatures in the Barrier Reef Region (°C)				
	Jan.	Apr.	July	Oct.
Bundaberg	26	24	21	22
Capricorn Coast	27	25	21	23
Whitsundays	27	25	21	23
Townsville	27	26	22	24
Cairns	28	26	22	25
Cooktown	28	27	23	26

The nudibranch Phyllidia ocellata *is pretty to look at and unpleasant to eat. Hardly camouflaged in its outrageously colourful garb, this snail can emit toxic chemicals when disturbed, suffiicient to deter attack.* PHOTO: TONY FONTES.

by one of several different types of vessels offering day-trips and catering for general tourists, snorkellers, beachcombers, sun-worshippers, swimmers and others. Purpose-oriented dive boats have diving as their sole *raison d'être*; day-trips cater for a broad range of interests. Some divers feel that they get better value for money with dive boats, but it is only fair to say that some day-trip operators do take diving seriously and provide separate facilities and a separate programme for their divers. Here again, a bit of prior research may help.

All of the latest equipment is available in Australia and may be hired. Many operators also have a wide range of ancillary equipment, such as diver propulsion vehicles, underwater cameras (Nikonos V), 35 mm camera housings, underwater flash. The amount of diving one plans to do may dictate whether it's worth bringing your own equipment.

The anemone fish lives with impunity among the stinging tentacles of the anemone, an example of the many strange adaptations that occur in the richly diverse life of The Reef. PHOTO GARY BELL

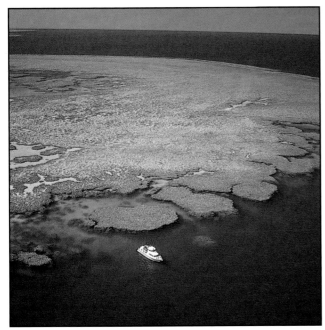

The 'stepping stones' bombies at Bait Reef, north-east of the Whitsunday Islands, with Hayman Island's state-of-the-art dive vessel, Reef Goddess.
PHOTO TONY FONTES

Brief summary of diving on The Reef

Section I: The Southern Reef: *coral cays and emerald reefs, nesting sea birds, turtles, manta rays, whales; generally good visibility.*

The southern section of The Reef is characterised by the well-developed lagoonal platform reefs and the beautiful coral cays of the Capricorn and Bunker Groups. It is a delightful part of The Reef with equable climate year-round. A full, heavy wet suit is required in winter. Visibility averages 15–20 m (50–65 ft), often up to 30 m (100 ft). Reef destinations are quite a long way offshore and access is relatively difficult for casual divers. Two coral cays, Lady Elliot Island and Heron Island, have resorts which provide the opportunity to stay right on The Barrier Reef and to dive every day (these resorts, and access to them, are discussed in detail in Section I). At Lady Elliot diving is done right from the beach on the north-western side, divers wheeling their gear across the cay in a barrow. This coral island has a good diversity of sites, something to suit everyone, from coral gardens to canyons, a shark cave, the now-famous 'Blow Hole'. Visibility is generally very good (average 21–24 m, sometimes 30 m). Commonly sighted are manta rays, moray eels, leopard sharks, shovel-nose rays, schools of trevally. Heron Island and its surrounding reef, and the adjacent Wistari Reef, have some excellent diving and the island is a renowned diving destination. Heron's famous 'Bombie' reputedly being the one of the 'largest collections of tame fish in the world', including a tame moray eel. Visibility is occasionally reduced around Heron, at times of brisk

trade winds and spring tides, when sediments get stirred up from the large lagoons of the island and the adjacent Wistari Reefs.

From Bundaberg, at the bottom of the Reef Region, diving is available with the MV *Lady Musgrave* which takes day-trippers to Lady Musgrave Island, a vegetated coral cay with large lagoon 94 km (about 2 hrs 15 mins) north of Bundaberg. Lady Musgrave offers some very attractive diving. It is occasionally used by a commercial operator who takes one- and two-week diving safaris to the island, and Musgrave is also a favourite haunt for university research groups. Bundaberg also has some good fringing reefs accessible from the mainland. At this writing there is also one private charter operator in Bundaberg offering extended charters to the Capricorn and Bunker Groups for divers. Gladstone has several dive charter operators doing extended dive trips, for example, to the Swain Reefs (such as Ron Isbel's *Tropic Rover* and John McGregor's *Calypso Kristie II*). The Swains are a vast complex of reefs and cays, quite a distance offshore, with shallow lagoons and sparkling clear water—territory that still awaits exploration. They are a major breeding ground of sea snakes. Gladstone is also a gateway to the Pompey Complex, a remote, relatively unexplored area about 230 km to the north-north-east, a region swept by strong tidal currents that cut deep, sheer-sided channels between the reefs. This is where the spectacular 'blue holes' may be found, deep, circular lagoons, some 300 m across and 33 m deep, which it is believed are created by the collapse of cave systems eroded in the limestone substrate during a period of lower sea level. From Gladstone, week-end and week-long trips to coral islands and reefs of the Capricorn and Bunker Group are also available, on a varying schedule, with Calypso Cruises's *Calypso Kristie II*.

Section II: The Capricorn Coast: *continental islands with fringing reefs; olive sea snakes; the northern islands of the Capricorn Group.*

Rosslyn Bay provides access to the northern section of the Capricorn Group of coral islands and to the Keppel Group of continental islands. Great Keppel has two resorts of very different styles, as well as a camping ground and youth hostel. Haven Diving on Great Keppel Island offers certificate courses and daily diving around Keppel and outlying islands with their fringing reefs; this area also provides an opportunity to see sea snakes. Diving is generally shallow (maximum depth 28 m), and the area is subject to large tides; visibility in winter averages 15–20 m (50–65 ft) and in summer is 6–9 m (20–30 ft). Divers are catered for on a day-trip from Rosslyn Bay which visits a large coral cay in the northern Capricorn Group.

Section III: The Whitsundays: *mountainous islands sitting like pyramids with aquamarine margins on a shimmering horizon; excellent fringing coral reefs; the mid-shelf platform reefs of the Hook/Hardy complex, with deep channels providing exhilarating*

drift diving; huge bombies and caves at pristine Bait Reef.

The Whitsundays are a major diver training centre and offer good opportunities to mix diving with other holiday pleasures, such as restaurants, night life, sailing, and resort life. The reefs of the Barrier system are about 2 hrs offshore by catamaran. In almost all weather conditions, there is somewhere that diving can be conducted throughout the many islands, 365 days a year. There are five or six dive operators, including Barrier Reef Diving Services, the senior dive team in the area and one of the best schools on the coast (and one of two which offer instructor-level certification). There are eight island resorts in the Whitsundays, almost all of which have resident instructors. Hamilton Island, a centre in its own right, has an experienced dive team in H20 Sportz. Hayman Island also has a comprehensive diving facility and a dive boat that, along with most other things on that island, is the best money can buy. A regular programme of island and diving at Bait Reef is offered there. The mainland resort town of Airlie Beach and neighbouring Cannonvale have a wide variety of accommodation. High-speed catamarans depart from Shute Harbour on most days for the outlying reefs of the Barrier system 60–70 km to the north-east; the trip takes about 1 hr 30 mins.

The Whitsundays have some of the best fringing reefs of the coast with a great diversity of corals, and some excellent diving is available around the islands, particularly on the northern side of Hook Island and southern bays of Whitsunday Island. The area is subject to very strong tides (almost the highest on the east coast), and visibility is sometimes limited. The average is 6 m (20 ft); it can be as good as 15 m (50 ft) and as poor as 1.5 m (5 ft). The compensating factor is that the waters around the islands carry a relatively high load of terrestrial sediments, giving them a brilliant turquoise hue and also fostering excellent variety in corals. This is an area where marine scientists often come to do coral research. The effect of decreased light penetration due to

Soft corals and turtle weed in an underwater reef garden. PHOTO GARY BELL

suspended sediments has also compressed the vertical stratification of corals, the result being that many different corals grow within a relatively narrow vertical zone—a bonus for snorkellers. Divers who want to 'dive, dive, dive' in the Whitsundays have to orchestrate their dive programme, as (at the time of writing) there is no single dive boat operator providing a daily schedule of Reef or island diving. Large tourist catamarans, such as those of Hamilton Island Cruises, Fantasea Cruises and South Molle Island, depart several days a week for the outer reefs, and diving is available from these vessels. The nearest reef of the Barrier is 63 km from Shute Harbour, Bait Reef, a small, pristine reef which offers a good variety of sites including large bombies and a drop-off with deep caves. Hook, Hardy and Sinker Reefs offer a variety of wall dives with swift currents. Visibility at the outlying reefs averages 20–30 m.

Section IV: Townsville: *gateway to the Coral Sea; the wrecks of Yongala and Foam; the world's first floating resort in a Reef lagoon;*

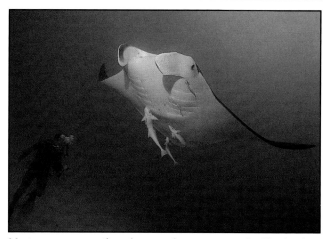

Manta rays are among the reefs spectacular creatures, soaring like giant bats. They are quite playful and like having their bellies tickled. Note the sucker fish hitching a ride on this manta. PHOTO GARY BELL

gateway to the Palm Islands, with their magnificent fringing reefs.

Townsville has two or three dive operators, two of which have been operating successfully for some time. Mike Ball Watersports is a progressive company with four air-conditioned high-speed catamarans and a modern diver training facility complete with deep-diving well. Ball offers two- to ten-day dive excursions to the Barrier Reef, to reefs in the Coral Sea, and to the well-known wreck of the *Yongala*. He has recently commenced day diving trips, too. The Dive Bell of Townsville offers diver certification and is staffed by highly qualified instructors. Its dive vessel *Hero* does week-end and extended dive trips, some as far out as Lihou and Flinders Reefs way out in the Coral Sea; the latter are available beginning about October, when the trade winds have abated. Diving in the Coral Sea is spectacular for its visibility and excellent wall diving with large predator fishes. The Dive Bell also conducts dive operations at the Barrier Reef Resort, the 'floating hotel' permanently moored in the lagoon at John Brewer Reef 74 km north-east of Townsville, where it is possible to stay at a five-star hotel literally right on The Reef. Townsville was an area worst affected by several infestations of the crown-of-thorns starfish in the past two decades; some reefs, including John Brewer Reef, are in the process of recovering, some showing good re-growth, and there are some that escaped starfish damage entirely. Local operators know where there are good sites at many reefs lying off Townsville. Westmark Cruises runs day trips to several of the Palm Islands, where the best fringing reefs of the coast may be found. Diving can be arranged on these day trips.

Section V: Hinchinbrook to Cairns: *a wide variety of reefs relatively close to the mainland off Cairns, the dive capital of Australia, with extended diving cruises to the Ribbon Reefs, Cormorant Pass and the Coral Sea; Michaelmas Cay; Beaver Cay, reached from Clump Point, Mission Bay.*

Diving opportunities in the Hinchinbrook area are limited and no operator caters specifically for divers, although it may be possible to make arrangements to dive. The Brook Islands, just north-east of Hinchinbrook Island, have some excellent fringing reefs, but at this writing no operator is taking day visitors to the Brooks; it may happen soon.

The coastal town of Mission Beach (B 18) serves as gateway to the popular resorts at Dunk and Bedarra Islands. There is not much diving around these near-offshore islands, but Reef trips depart daily from Clump Point (see page 189) bound for Beaver Reef and its cay, and these trips do cater for divers.

Cairns is the epicentre of diving in Australia and offers the greatest range of opportunities for divers of anywhere along the coast. The city has a complete range of accommodation from five-star international hotels to numerous good motels and a host of backpackers' hostels. There are some six dive operators and a number of independent dive boats departing daily and on ex-

tended trips to reefs, ranging from 45 km offshore to No. 10 Ribbon Reef, 250 km north. Diving is available daily with any of several dive boats that take students out to reefs south-east of Cairns. Diving is also available with many of the catamarans taking day trips to Moore Reef, Green Island, Michaelmas Cay and Norman Reef.

Section VI: The Far North: *densely packed reefs quite close to the mainland; the Ribbon Reefs and Cormorant Pass (the Cod Hole).*
Port Douglas is a growing tourist centre and currently has two dive companies offering certificate training. Quicksilver Dive Services, at the Marina Mirage, operates in conjunction with the famous Quicksilver Connection catamaran Reef trip to Agincourt Reefs, and Quicksilver Dive has several different types of sites at Agincourt and a programme specially for divers on this excellent day trip. The Port Douglas Dive Centre also does certificate training. There are one or two single-purpose dive boats in Port Douglas, such as *Si Bon*, which does six-day extended dive cruises to the Ribbon Reefs (including the Cod Hole, Pixie Pinnacle, Giant Clam Beds and Manta Ray Point). The Ribbons offer spectacular diving right at the edge of the continental shelf, and from October onwards when the trade winds abate divers have the opportunity to dive the outer wall of these reefs, where the 'bottom falls out of the ocean'. Here one may have the opportunity to see large predators patrolling, and during the spawning season large aggregations of fishes may be encountered. The Cod Hole at Cormorant Pass, right at the top of No. 10 Ribbon Reef, is one of The Reef's most sought-after dives, with its giant tame potato cod, moray eels, and giant wrasses. Inshore from Lizard Island northwards are extensive seagrass beds, the favoured haunt of dugong, and this area is also home of many large salt-water crocodiles.

Dugong

Possibly the most memorable words ever written about dugong were those of the beachcomber, E. J. Banfield, who in his *Confessions of a Beachcomber* said:

Reddish grey, sometimes almost olive green in colour, with white blotches and sparse, coarse bristles, the animal has no comeliness, and yet when a herd frolics in the water, rising in unison with graceful undulatory movements for air, and the sunlight flashes in helioscopic rays from wet backs, the spectacle is rare and fine. Rolling and lurching along, gambolling like good-humoured, contented children, the herd moves leisurely to and from favourite feeding grounds, occasionally splashing mightily with powerful tails to make fountains of illuminated spray—great, unreflecting, sportful water-babes. Admiration is enhanced as one learns of the affection of the dugong for its young and its love for the companionship of its fellows. When one of a pair is killed, the other haunts the locality for days. Its suspirations seem sighs, and its presence melancholy proof of the reality of its bereavement.

For some time after birth the young is carried under one or other of the flippers, the dam hugging it affectionately to her side.

As the calf grows, it leaves its mother's embrace, but swims close beside, following with automatic precision every twist and lurch of her body, its own helplessness and its implicit faith in the wisdom and protective influence of its parent being exemplified in every movement.

Mermaids have been a common myth among all sailors since the earliest times. Part woman, part fish, they appeared to mariners who had often been long at sea. The Sirens were mermaids of Greek mythology, who sang so enchantingly that sailors were compelled to stop and listen, and when they did, they were never heard from again. Ulysses had himself lashed to the mast and the

Dugong dugon

ears of his crew filled with wax so that they could sail past without being tempted.

Dugong dugon is of the order Sirenia, and it is said to be the mammal that gave rise to the mermaid myth. With a passably-human expression, a Dugong seen rising to the surface with a baby 'clutched to its breast' might well fire the imagination of any homesick mariner.

Dugong, from a Malayan word *duyong*, is a mammal that probably descended from a terrestrial herbivore. Adults may be up to 3 m long and weigh about 400 kg; they are a grey to bronze colour on the back tending to blonde on their bellies. Commonly seen in herds, dugong may be found in The Barrier Reef Region all the way from Moreton Bay to Cape York, feeding where there are sea grass beds, and they are therefore most often seen at: Moreton Bay; Shoalwater Bay; Cleveland Bay; around Hinchinbrook Island; at the mouth of the Starke River north of Cooktown (the highest population of anywhere along the coast); Princess Charlotte Bay; Shelbourne Bay. Dugong have traditionally been a favourite food of Australian Aborigines and Torres Strait Islanders, who hunt them using a spear with a detachable head secured to a rope. The meat is supposed to taste like pork or veal, and an average adult yields 100–150 kg of meat, and 5–8 gallons of oil which is supposed to have medicinal and aphrodisiac properties. Dugong tears are sold as an aphrodisiac in the Aru Islands.

Dugong are considered vulnerable to extinction in the Great Barrier Reef Region and are a protected species in Australia. The population here is estimated to be 11 500. They are today still of great significance in ceremony, economy and culture of certain Aboriginal and Torres Strait Island societies, and a limited amount of traditional hunting by native peoples is permitted.

Reef travellers interested in seeing dugong will probably have the greatest success if they charter a plane or helicopter; the best place to look would be Moreton Bay

First Aid

The greatest hazards faced by Reef travellers and the things most likely to spoil a holiday are utterly avoidable—sunburn, infected coral grazes, and other cuts and scratches received on beaches. There are a few much more remote hazards, such as stings by jellyfish and stepping on poisonous fishes, which can usually be avoided by preventive steps.

Sunburn

Queensland sun is very much stronger than many visitors realise. To substantiate this statement, it can be cited that Australians (and particularly Queenslanders) have the highest incidence of skin cancer in the world. Those who do not already have a base tan when they arrive for their Reef holiday should go very slowly at first on the suntanning. Untanned skin begins to burn after only 20 minutes in Queensland sun, and a broad-brimmed hat, lightweight long-sleeved shirt, and plenty of sunscreen should be part of every traveller's kit bag. For Reef holidays, a water-resistant grade 15+ sunscreen is advisable (the grades refer to the amount of extra protection given, the higher the number the greater the protection; anything less than grade 8 is approaching 'cooking oil'). Even if you don't use the highest grade all the time, it is a good idea to have some available for when you've overdone it.

Coral grazes and oyster cuts

Reef travellers should take seriously any cut or scratch received in the water or on the beach. Tropical waters are alive with *Vibrio* organisms and other marine bacteria which are accustomed to a salty environment and which multiply extremely rapidly in salty human blood, and any cut you receive in the water is guaranteed to be infected within seconds. If not treated promptly, it can develop into a major infection and a course of antibiotics will be required. *Immediately* after getting out of the water apply an antiseptic (in a tincture, or liquid, form, such as 'Betadine', 'Metaphen', mercurichrome, but *not* an antiseptic cream, which is unsuitable for the humid tropics). Antiseptic powders are suitable for use under dressings. It is best to subsequently keep a

wound dry until it is healed; however, if this is not possible, be sure, whenever leaving the water, to immediately dry off and again liberally apply antiseptic.

In the case of oyster wounds, it is particularly important to insure that the wound is cleaned out; if your injury is more than a graze and if it's early days in the holiday, go to a doctor and get the wound cleaned out properly. Oyster shells disintegrate as they cut; they're like shale, in layers, and they shatter leaving mica-like slivers in the wound, and it's very difficult to do the job properly yourself. The incidence of complications is virtually 100% if they're not dealt with properly.

Ear infections

Inflammation of the external ear, or 'tropical ear' as it is referred to, spoils more holidays than just about anything else on the list. It is caused by too much water in the ears too frequently; the ear gets waterlogged, never dries out, infection (bacterial or fungal) sets in. It occurs most frequently in people who have a tendency to 'waxy ears'. Before going to the topics, if you have a tendency to get ear trouble, see your doctor and make sure your ears are clean. A chemist may also be able to supply a pair of mouldable ear plugs which are quite comfortable to wear.

Minor barotrauma in divers

Pressure-induced ear problems are very common in divers. If you have difficulty with your ears on the plane going to The Reef, you will probably have a problem if you go scuba diving or duck-diving while snorkelling. Don't dive if you have any difficulty equalising the pressure.

Venomous sea creatures

There are a number of beasts found in tropical waters which have devised diabolical means of protecting themselves or of acquiring food (human beings are never the preferred food, but they sometimes get in the way).

Jellyfishes

There are several types of jellyfishes in Queensland waters which can give a painful sting, and one which can be lethal (box jellyfish *Chironex fleckeri*, or 'sea wasp' as it has been called). The most worrisome jellyfishes are principally a mainland phenomenon which occurs seasonally (generally November–April). During this time mainland swimmers should use stinger-resistant enclosures or swim in a fresh-water pool. If swimming in the ocean adjacent to the mainland, always wear protective clothing (a stinger suit, such as the lightweight 'Lycra' suits that many Queenslanders wear). The box jellyfish is not normally found around islands (although large continental islands very close to the mainland may have box jellyfish, particularly if they have large mangrove estuaries).

First aid for jellyfish stings is to immediately liberally anoint the affected area and any adhering jellyfish tentacles with vinegar (this is provided on all patrolled Queensland beaches) before attempting to remove any adhering tentacles. Jellyfish nematocysts cannot sting through clothing. Box jellyfish stings should be treated as serious; try to keep the victim calm to prevent systemic spread of the venom, and get medical assistance. (See 'Nasties' for more details about jellyfishes.)

Stonefish; stingrays; cone shells; other venomous beats

Prevention is eminently preferable to first aid, and these animals are discussed in more detail under 'Nasties'.

First-aid in envenomation: Pressure-immobilisation

Pressure-immobilisation is the standard first-aid in most cases of envenomation, recommended in all cases of snake bite, cone shell stings, and blue-ringed octopus bite; pressure bandaging is *not* recommended in fish envenomations (e.g. stone fish), and it is not always possible with box jellyfish stings that cover a large area.

- Apply a broad crêpe bandage (or any flexible material) over the site of the bite as soon as possible. Don't struggle with removal of pants or shirt if this requires a lot of movement of the affected limb. In cases of bites to the trunk, administration of pressure-bandages is more difficult but may be used if it doesn't impair breathing. In bites to the groin and neck it is probably not feasible.
- Bandage first over the wound and then upwards (away from the toes or fingers) as tightly as you would bind a sprained ankle, extending the bandage as high as possible. If the victim complains of discomfort it probably means that the bandage is too tight and should be readjusted.
- Bind a splint firmly to as much of the limb as possible (up to the elbow in the case of an arm).
- Reassure the victim and keep the victim calm. Seek medical assistance. Bandages should be left in place until the victim is in professional hands and emergency resuscitation measures have been prepared.

Fishing on The Reef

Fishing is Australia's most popular sport, and Barrier Reef waters provide a wide variety of fishing grounds. The coast has extensive areas of mangroves, virtual fish nurseries for coastal species and very fertile territory for anglers. The many reefs of the Barrier system attract reef fishes in abundance. And among the outer reefs of The Barrier and off the edge of the continental shelf, game-fishermen may pursue the king of game species, the giant black marlin, with hopes of landing a record-sized fish. Fishing of one sort or another is available from virtually every gateway city.

Blue tuskfish (Choerodon albigena).

Queensland anglers recommend that the best times to fish in the Reef Region are the five days leading up to the full moon (for demersal species) and the five days leading up to the new moon (for pelagic species)[1]—in other words, the two periods of waxing spring tides.

Strangers to Queensland will be a little bewildered by fish names, which to the outsider appear to be somewhat interchangeable, but whatever they are called, there are many fine-eating fishes to be caught, and local fishermen will be able to sort out the names. Among the popular pelagic species are Spanish mackerel (*Scombromorus commerson*)—known in international game-fishing circles as the tanguigue and a close cousin to the American king mackerel—giant trevally (*Caranx ignobilis*), queenfish (*Scomberoides commersonianus* and *S. lysan*), several types of tuna (*Thunnus* sp.), dolphin fish (*Coryphaena hippurus*)—like the American

1 Demersal fishes are those associated with the bottom or structures such as reefs; they tend to stay put in one general location; pelagic species are generally found in open water, tend to move around and are hooked nearer the surface.

2 The names of Queensland fishes are confusing for the uninitiated. For example, red emperor is also known as government bream, king snapper, queenfish and red kelp. Queenfish is also known as leatherskin or giant dart. Scarlet sea perch is known as red emperor, red jew, red snapper, red bream, and large-mouthed nannygai. Red bream is another name for saddle-tailed sea perch, moses perch, mangrove jack, spotted-scale sea perch, and snapper. Red snapper, on the other hand, is another name for paddle tail, one of the poisonous species. There are more sweetlips around than you would find at a high school dance. You can get some assistance from a volume entitled *Guide to Fishes* by E. M. Grant and published by the Queensland Department of Harbours and Marine. This book, which is available at most books stores in Queensland, has a wealth of pictures which will help sort your fish out even if the names don't agree with what the fishermen in the local area are calling them. It makes very good bedtime reading. For those seeking taxonomic precision, most libraries will have *The Fishes of New Guinea*, by Ian S. R. Munro, Department of Agriculture, Stock and Fisheries, Port Moresby, 1967.

dorado, or mahi mahi)—black marlin (*Makaira indica*) and sailfish (*Istiophorus platypteris*). Demersal species include the coral trout (*Plectropomus* sp.), sweetlip (*Lethrinus* sp.), grunter (*Pomadasys hasta*), (red) emperor (*Lutjanus sebae*), bream (*Acanthopagrus* sp.), dart (*Trachinotus blochi*)—brother of the American green pampano—and mangrove jack (*Lutjanus argentimaculatus*). Coral trout are the pride of Queensland reef fish, beautiful to eat and pretty to look at, and because of its great popularity it appears on restaurant menus perhaps slightly more often than it actually makes it to the table. A few other Queensland fishes are somewhat similar in appearance, which no doubt is why this happens.

An invaluable publication for anglers is the *Queensland Official Tide Tables and Boating Guide*, published each year by the Queensland Department of Harbours and Marine. It is available from most bookshops or marine chandleries. An inexpensive book, it has a wealth of information about the all-important tides, but also a great deal about fishing in general, including regulations and minimum fish sizes.

Brief summary of fishing on The Reef

Section I: The Southern Reef
Gladstone is the centre of fishing charters in the southern Reef area, and it has a sizeable fleet of vessels. It is the undisputed capital in Queensland of recreational 'reef fishing'. The fleet works the Capricorn and Bunker islands and reefs, but also makes regular week-long (and longer) trips to the Swain Reefs, some 200 km offshore. The Swains have some of the largest populations of coral trout in the whole of the Reef Region. They are a maze of hundreds of reefs and shoals, where navigation is difficult, and charter skippers usually arrange their departure times to arrive well before dark. On the way out and back anglers troll for pelagic species. The boats always come home with a load of happy customers.

Parrotfish (Scarus rivulatus)

Section II: The Capricorn Coast
Rosslyn Bay is a gateway for the northern Capricorn cays and the Keppel Islands, the latter which lie quite close offshore, with extensive fringing reefs. There are several charter operations based at neighbouring Yeppoon which make extended fishing trips to the Swain Reefs.

Section III: The Whitsundays
Mackay and the sleepy little fishing village of Seaforth just to its north are jump-off points for the southern islands of the Cumberland Group, where one can fish for both demersal and pelagic species around the continental islands and reefs. A number of charter vessels operating from Mackay take parties on extended charters to the Hard Line Reefs, which like the Swains, are excellent coral trout grounds. Airlie Beach and Shute Harbour are the gateways to the central and northern islands of the Whitsundays, the largest group of islands on the Queensland coast. This area offers some excellent fishing for pelagic species, and one or two charter boats operate from Airlie and Shute Harbour. Fishing charters are also available from Hamilton Island and Hayman Island.

Section IV: Townsville
The reefs of the Barrier system are about 70 km offshore from Townsville. The fishing fleet consists both of fast boats that cruise at 20 knots and take 8–12 anglers on day reef-fishing trips, and also slower, displacement-hull vessels that do extended charters.

The reefs of Townsville are among the most productive along the central and northern coast. Townsville is also the home of a rapidly growing fleet of game-fishing vessels which use the famous Cape Bowling Green billfishing grounds, now considered among the best light-tackle fishing areas of the world and where record catches of sailfish and small black marlin have been recorded. In this area, two or three fish per day is considered average, six to ten fish in one day is not uncommon, and most weigh in about 10–20 kg. Rib Reef, about 95 km north of Townsville, is the site of one of the largest aggregations of Spanish mackerel along the coast; in October and November it is not unusual to catch 20 per day, most weighing 10–20 kg. Myrmidon Reef lies 125 km north-north-east of Townsville, right on the edge of the continental shelf in crystal-clear water, and from September–December these are excellent pelagic fishing grounds—giant black marlin, dogtooth and yellowfin tuna, wahoo, dolphin fish, Spanish mackerel.

Section V: Hinchinbrook to Cairns
The Hinchinbrook Channel provides the small-boat angler with one of the largest expanses of mangrove creeks and estuaries on the coast, all well protected from any weather. Access to the channel for small boats is (in the south) from Lucinda (Dungeness ramp), or (in the middle) from Fishers Creek ramp, or from Cardwell in the north channel area.

Cairns is the centre for big-game-fishing in the Reef Region, home of the giant black marlin fleet. Here the Barrier Reef is only 30 km offshore, and there is a large range of charter vessels equipped for both one-day and extended fishing charters. Reef-fishing trips are conducted in both fast, planing-hull vessels, such as those used by the game-fishing fleet, or by a number of displacement-hull vessels. The planing vessels take one-day or overnight trips, and the larger, displacement vessels do extended trips. Overnight or extended expeditions allow time to fish a

Coral trout (Plectropomus leopardus)

number of reefs and to go further afield. At night anglers can fish the deep water for the highly prized red emperor. Cairns offers excellent light-tackle fishing around the many reefs in the area, too.

The giant black marlin season is from the middle of September to the middle of December, the height of it being around the end of October. To book one of the top game boats at this time one needs to start 18 months in advance. The number of vessels operating out of Cairns doubles at this time of the year as the charter game boats from Brisbane, Sydney and other ports come north for the season.

A number of game boats operate on a daily basis from the Marlin Jetty during the season, but most of the fleet is spread from Jenny Louise Shoals, off Cairns, up to No. 10 Ribbon, Yonge and Carter Reefs. Many of these vessels operate in conjunction with a 'mother ship', a development of the early 1970s which came about as a result of searching for giant black marlin further afield from Cairns. Most game boats have limited ability to remain at sea for protracted periods because they need to refuel and take on water. Mother ships act as floating hotels, providing accommodation for anglers, and they are also a refuelling station for the game boats. Many mother ships provide five-star facilities and cordon bleu meals; they are air-conditioned, with luxurious cabins complete with queen-size beds and private bath. Most

Coral trout are among Queensland's prized reef fishes. There are several species, which all make good eating. PHOTO: COLFELT

mother ships support one or two game boats only; they vary from 15 m cruisers to multi-deck catamarans well over 30 m. Travel to and from these vessels is normally by sea plane, as the game boats and their attendant mother ships usually remain at sea for the duration of the season, following 'the bite' from reef to reef.

Marlin fishing is one of the most expensive of sports. The angler is paying for perhaps two boats, the cost of the game-fishing charter and also that of the mother ship. Mother ship costs are split equally between the charterers on the two game boats using it. If only one boat is using the mother ship, the charterer has to cover the full cost. Mother ships cost about $2200 per day, and game boats $1200–1500 per day during the big-fish season.

A number of game-fishing boats operate from Lizard Island each season, and one of these can provide a cheaper alternative to using a mother ship and allow the fisherman to have the comfort of a good resort at night-time. Anglers book into the Lizard Island Resort and either arrange a game boat through the resort or, more often, make their own arrangements with the charter boat of their choice. Some boats work out of the resort on a daily basis, too, so guests at the Lodge can share the cost of a boat. Lizard Island acts as a weigh station for many game boats and mother ships, and numerous world records have been weighed-in on the beach in front of The Lodge.

Section VI: The Far North
Port Douglas is rapidly developing as a tourist port, and with the advent of the new Marina Mirage an increasing number of boats are beginning to use it as a base. It is a little closer to the marlin grounds.

Fish poisoning
Illness after eating tropical fishes is mostly due to three types of poisons: (a) Tetrodotoxin, extremely toxic and often fatal poison ingested by eating puffer fishes (see discussion of toadfishes under 'Nasties'); (b) scombroid poisoning, which comes from eating certain pelagic fishes such as tuna, bonito and skipjack which have not been properly refrigerated after being caught and which have become infected with *Proteus morganii*; (c) ciguatera poisoning, generally caused by eating certain reef fishes on a known poisonous list and sometimes by eating large fish which have accumulated ciguatoxin (see 'Ciguatera'). Some fishes are rendered 'poisonous' by virtue of their behaviour as far as man is concerned (these are discussed under 'Nasties').

Nasties
The title of this entry is somewhat tongue-in-cheek; it is pejorative and laden with human bias. All of the creatures discussed hereunder are fellow inhabitants of the earth who go about their own business very much less intrusively than does man. They cross paths with careless humans who step on them or dive upon them, and the damage they inflict on humans is almost always in self-defence. Most of them will never be encountered by Reef travellers, and they are discussed in some detail here both to pander to morbid curiosity as well as alert the traveller as to how they can best be avoided.

Badjellies
All the stinging jellyfishes are evil if one takes a one-eyed perspective, that of the summer swimmer, and it is ironic that the worst of these, the infamous box jellyfish (cubo, sea wasp), is also one which does its damnedest to avoid humans if given the chance to. However, because of its potentially lethal sting, the box jellyfish has been the bogeyman of Queensland's mainland beaches for years. Today, many Queensland beaches have stinger-resistant enclosures for swimmers, which are basically systems of nets anchored to the bottom. The older ones, which were originally designed to exclude the dangerous sizes of box jellyfish, had 50 mm mesh which did not prevent the smaller irukandji jellyfish from getting in. The latest models are exclude irukandji with their 8 mm mesh. It probably should be noted that these stinger nets are called 'stinger-resistant' and not 'stinger-proof', although they are improving all the time.

Box jellyfish
Box jellyfish (*Chironex fleckeri*)[1] are a worry for Queensland swimmers inshore north of the tropic of Capricorn from November through April but are not a problem at islands well offshore or at coral reefs. *Chironex* is an almost clear, box-shaped jellyfish, very difficult to see in the water, with many stingers trailing from the four corners of its 'bell'. It appears characteristically after the first summer storms, which probably relates to the presence of calmer seas, warmer water, and the first migration of small shrimps, particularly *Acetes australis*, which swarm into coastal waters about this time and which is *Chironex's* favourite food. Box jellyfish are often numerous after rain in the vicinity of creek outlets; they are also usually absent when the seas are rough. They particularly love calm, glassy weather after a northerly wind; they like sandy beaches that have fresh-water outlets nearby, beaches with no offshore obstructions like fringing reefs or growths of marine vegetation. If the water is smooth they are present within a few feet of the beach; if there is a slight swell they may be seaward of breaking waves. They patrol parallel to the shore gathering shrimps and small fishes beneath the surface, periodically dropping to the bottom to eat their catch, then bobbing up again, breaking the surface with a characteristic oval ripple, which is the most obvious sign of their presence.

Box jellyfish are agile swimmers and could maintain a pace of

1 There are two species of box jellyfish, the other being *Chiropsalmus quadrigatus*, which is smaller and which hasn't definitely been associated with deaths; it packs a nasty sting, and it may have been responsible for less serious incidences of 'box jellyfish' stings.

3–4 knots all day; they are capable of 5 knots at a sprint. They have four sensory organs that register posture/attitude, change of direction, change of light intensity, and one of their 'eyes' has a convex lens capable of forming crude images. When approached slowly at an oblique angle (not directly ahead or behind) they will move away, and they tend to avoid dark objects in the water. Many stings have occurred when swimmers have rushed headlong into the water and dived on top of one, not giving it a chance to get out of the way. The nematocysts are triggered by both chemical and physical receptors, and a thin layer of clothing, or even hair, can offer protection for swimmers. Pantyhose have been used by surf lifesavers in Queensland for years, and these days colourful 'stinger suits' are frequently seen on beaches in the summer.

Box jellyfish stings are accompanied by immediate agonising pain. One with a 75 mm (3 in) diameter bell will be potentially lethal to children; one with a bell 115 mm (4.5 in) bell can kill an adult. Children are more vulnerable because their surface-area-to-weight ratio is much higher, and they get a relatively much bigger dose. The jellyfish tentacles, when extended for feeding, may be 2.5–3 m (8–10 ft) long. The welts produced have a characteristic ladder-like, frosted cross-hatch pattern.

Box jellyfish (Chironex fleckeri) *are difficult to see in the water, although they are very agile and will attempt to avoid swimmers.* PHOTO ROBERT HARTWICK

First aid: The first step is to get the victim out of the water; this is not usually a problem with adults, who characteristically bolt up the beach in agony, but children may stay and tug at the tentacles, which may further endanger them, particularly if the jellyfish is still attached. Only those nematocysts in direct contact with the skin will have fired, so it is important to inactivate the remaining tentacles by dousing them liberally in household vinegar for 30 seconds before attempting to remove them (vinegar is present in large containers at most Queensland beaches during the summertime). Be prepared to resuscitate the victim. There is an antivenom available, which can reduce the incidence of scarring, and medical assistance should be sought for all box jellyfish stings.

Other badjellies

There is a variety of other jellyfishes which may cause problems for swimmers, and listing all of them becomes a rather confusing jumble. One in particular, the irukandji (*Carukia barnesi*), is worthy of singling out for mention, as it causes a delayed and sometimes baffling symptom complex. No deaths have been reported, but this small jellyfish (usually about 2 cm diameter) initially causes only mild pain. After 20–40 minutes victims develop symptoms of backache, abdominal pains or chest pains, headache and nausea, which have sometimes been diagnosed as appendicitis or heart attack, and some people have even had their appendix whipped out. If someone develops these symptoms within an hour of swimming in the summertime, the possibility of irukandji sting should be considered.

First aid: Reassurance and rest is frequently enough, although there have been cases with serious after-effects. Medical assistance may be required.

Blue-ringed octopus

Australia is known for some of its venomous creatures and can boast some of the world's most deadly snakes, spiders, jellyfishes—and the world's only lethal octopus—the blue-ringed octopus (*Hapalochlaena maculosa*). This small (20 cm from tip to tip) dark-brown-to-ochre coloured octopus has blue rings which 'glow' when it is angry, making it sometimes fatally attractive to children. It is found in shallow rock pools, frequently after stormy weather, fossicking for crabs. The octopus has a small beak at the junction of its eight arms, and unlike many other octopuses, it manufactures a venomous saliva rather than ink. The toxin closely resembles tetrodotoxin (TTX), and its bite can produce flabby paralysis very much more rapidly than after puffer fish is consumed (which also contains TTX) because the poison is injected rather than absorbed from the gut (see 'Toadfishes' later in this section). The bite may be almost imperceptible, many victims having been unaware that they were bitten except for a tiny drop of blood at the site. Bites have occurred always when the creature is handled, as in picked up and draped over an arm, hand or shoulder. Like tetrodotoxin, the poison is neuromuscular and produces muscular weakness and, ultimately, respiratory depression. Warn children to leave them alone, irresistible though they may be with their glowing blue circles.

First aid: Speed of action is important; apply pressure-immobilisation. Get medical help.

Poisonous cones, left to right: C. mamoreus, C. geographus, C. textile.

Cone shells

Cone shells (*Conus* sp.) are numerous (some 70 species); in Australian waters, and perhaps seven of them are potentially dangerous to man. They have beautifully patterned and coloured shells, although their beauty is not always immediately obvious due to a thick green covering of slime. Cones are carnivorous gastropods which inhabit shallow inter-tidal waters of coral reefs, where they remain buried under a rock by day and come out at night to do their marauding. They eat worms, fish, other gastropods and octopuses, all of which they immobilise with a poisoned 'harpoon'. This barbed tooth, up to 1 cm long, is firmly held in the end of the proboscis and is jammed into their prey while venom is squeezed through the tooth cavity. Each barbed tooth is used only once, and cones have a quiverful of them in reserve. Cones can distend their proboscis to envelop an object about their own size. They have an acute sense of smell.

The species that eat fishes are most potentially dangerous to man, but since you cannot ask them what they eat it is best to assume that, whatever the cone is that you shouldn't have in your hand, it may be lethal. A myth has been perpetuated that cones can safely be held by the thick end; alas, they can reach either end

The cone shell, with its armoury of arrows.

from the cleft in their shell, so don't pick them up without barbecue tongs, and don't slip one into your pocket.

The sting is sometimes very painful, and it progressively leads to incoordination and muscular weakness, blurred vision, difficulty in swallowing, and, ultimately, respiratory paralysis. There have been at least 16 reported fatalities.

First aid: Pressure-immobilisation. Keep bandages in place until medical assistance and resuscitation equipment is available.

'Poisonous' fishes

Certain fishes are poisonous if eaten (see also 'Fish poisoning'), and others are rendered poisonous by their 'behaviour'. Some are poisonous either way.

*Butterfly cod (*Pterois volitans*) are curious and will approach divers fearlessly, with colourful lances waving. They are not aggressive but can give a painful sting.* PHOTO GARY BELL

Butterfly cod (Lionfish, Fire Cod)

Butterfly cod (*Pterois volitans*) are found around coral reefs and are curious creatures, so they sometimes will approach divers in the water, pointing their dorsal spines in front of them as they get near. These spines have glands which produce venom that is akin to one species of stonefish. It produces a severely distressing sting, which usually subsides within a couple of hours (although it can last for several days). Local effects of the sting are usually the most significant. You needn't fear these fish, but treat them with respect. They are very pretty to look at.

First aid: Immerse the wound in hot water.

Stingrays

Stingrays are, biologically, 'flattened sharks' which patrol sand flats looking for molluscs to crunch up with their pavement-like teeth. They flick sand onto their backs to make themselves hard to see, and very often the first hint of their presence is when one 'explodes' from the sand immediately in front of or just between the feet. Rays are timid, and given the chance will move away; a foot planted on their back makes this very difficult to do. If stepped on they may lash out and up with their tail, which is

armed with venomous, serrated spines, and they can inflict a nasty, painful wound. The wound is bound to be contaminated with animal tissue and other foreign matter and will usually need to be cleaned out by a doctor. The moral is, if walking along sand flats in shallow water, always shuffle your feet, or carry a stick and regularly test the ground in front of you. If diving or snorkelling over sandy shallows, be wary of cruising too close to the bottom.

First aid: With all venomous fishes, pressure-immobilisation is *not* recommended. Hot water may be useful to control pain. Seek medical attention to insure that the wound is properly cleaned.

Stonefishes

There are two species of stonefishes in Queensland, the estuarine stonefish (*Synanceia horrida*) and the reef stonefish (*S. verrucosa*), the former being more common although both are poisonous. They are of potential concern to reefwalkers because they lie in slime-covered rubble and are very difficult to detect; if stepped on, they can inflict an unbearably painful wound (no deaths have been reported in Australia, although they have been elsewhere in the Indo-Pacific). The moral is: always wear good solid footwear when reef-walking, and always tread cautiously—never run on a reef.

Stonefishes are about 20 cm (8 in) long, scaleless, and their skin is covered with covered with 'warts', and slime which is toxic to small marine animals and which evidently tastes bitter (the mind boggles at the desperate hunger of the man who established this fact, and his bravery far exceeds that of the man who ate the first oyster). They lie on the reef, looking just like any other piece of algae-covered rubble, and they absolutely defy detection. Stonefishes have thirteen spines along their back, fitted with venom sacks, which become erect when the fish is on alert; when stepped on, the skin of the spines presses down over venom sacks, causing toxin to explode upwards along the sheath of the spines and into the offending foot. It is a completely passive act, if that is any comfort to the victim.

*Estuarine stonefish (*Synanceia horrida*)*

First aid: Control of pain is most important. With venomous fishes, pressure-immobilisation is *not* recommended because most of the damage is done at the site of the wound rather than systemically. Hot water (but not scalding hot) may help relieve pain and will also denature the protein of the venom. An antivenom is available, and because these wounds can be quite debilitating for months, it is advisable to seek medical attention.

Toadfishes

Toadfishes are poisonous to eat, and large ones can be poisonous in behaviour. Toadfishes belong to the order of tetraodontiformes, a mouthful which describes their four (tetra) large fused teeth (odontiformes). Toadfishes lurk around shallow coastal estuaries and inlets; they lie waiting for passing crabs which they crunch up with their beak-like teeth. They are normally only about 13 cm (5 in) long, but certain species grow as big as 96 cm (38 in), with teeth to match, capable of shearing through a number 4/0 hook. Giant toadfish have from time to time on the Queensland coast conducted campaigns of terror. For example, in the Whitsundays during the Easter weekend of 1979, six-year-old Margaret Lewis had two toes bitten off at the first joint while wading barefoot in Shute Harbour. Some time later that year a toadfish removed a walnut-sized chunk from the leg of a boy wading at Cid Harbour, Whitsunday Island. In October that year, Richard Timperley was fishing in water about 35 cm deep near the Shute Harbour ramp when a 65 cm toadfish came like a torpedo for his sneakered feet. Undeterred by jabs from a fishing rod, the toadfish pursued the rapidly retreating fisherman until

it had almost beached itself, and it was subsequently dubbed 'Thomas the Terrible', and toadfish in that area are now colloquially known as 'toe fish'.

Toadfishes are members of the family of puffer fishes which are capable of inflating themselves like basketballs, a practice which evidently intimidates would-be predators, or at least makes the puffers jolly difficult to swallow. Puffers were known to be poisonous well before the time of Christ. Hieroglyphics of 2700 BC mention the toxicity of Red Sea puffer fishes, and there are biblical warnings against eating fish with no scales (puffer fish have no scales). The Greeks and Chinese knew of the danger; and it is surprising that neither James Cook nor his cook were aware of it, for the great explorer was poisoned by a puffer in New Caledonia on his second voyage of discovery in 1774. The Japanese play a form of culinary Russian roulette with puffer fish, and they carry it to the extremes of art. Fugu, as it is called, is a prized delicacy which may be prepared only by licensed fugu chefs, who have gone to school and taken exams on the subject of its preparation. These chefs create *tours de forces* in their restaurants, laying out thin slices of the fish in delicate floral patterns. Traces of tetrodotoxin (TTX) produce a pleasant tingling sensation which has been likened by enthusiasts to a white Burgundy of a good year. The sense of danger obviously heightens the experience, and it is said that to eat fugu liver, in which the concentration of toxin may be very great indeed, is the ultimate in fugu culture; even trained chefs are prohibited from serving it. TTX is one of the most poisonous toxins known. James Bond, at the end of *From Russia with Love*, was left for dead on the floor after being kicked in the leg by a poison-tipped boot tainted with fugu poison. Nine millionths of one gram per kilogram of TTX, administered intravenously, will kill 50% of mice so injected.

Left:Toadfish (Spheroides hamiltoni)
Right: Stars and stripes toadfish (Arothron hispidus)

Symptoms of puffer poisoning are relatively rapid in onset (10–45 mins), the speed of onset and severity being relative to the amount of poison ingested. Symptoms begin with a tingling sensation and numbness about the mouth and lips; sometimes there is nausea, but seldom vomiting. Symptoms progress to numbness of the tongue and face, followed by slurred speech and progressive muscle paralysis with, ultimately, respiratory paralysis and death, which occurs in about 60% of cases. TTX is said to be used by voodoo specialists in Haiti to create their 'zombies', the walking dead who survive being buried alive. Other medical reports indicate that, in some serious cases where patients have apparently been unconscious, they have recovered and reported being mentally alert right throughout the ordeal.

First aid: For conscious victims, induce vomiting. Medical assistance should be sought.

QNPWS

Queensland National Parks and Wildlife Service, as it used to be known, is part of the Queensland Department of Environment and Conservation. QNPWS looks after day-to-day management of Queensland National and Marine Parks and has regional offices right up the Queensland coast. It is a service of genuinely dedicated people who go out of their way to be helpful.

Reading about The Reef

The following is a short selection of suggested further reading about The Barrier Reef and its islands.

Banfield, E. J., *Confessions of a Beachcomber*, Arkon paperback edn 1980, Angus & Robertson, Sydney, (1908).
The famous beachcomber's view of his tropical island paradise, Dunk Island, with many observations about wildlife, in fulsome style.

Giant toadfish can grow to almost 1 m in length, and with their large fused teeth can be formidable to crabs, and to humans. This one, measuring 65 cm, was dubbed 'Thomas the Terrible' by the fisherman whom it chased from shallows at Shute Harbour. PHOTO RICHARD TIMPERLEY

Basuttin Windsor, V., *Island That We Knew*, Valda Basuttin Windsor, Mackay, Qld 1982.
The story of the pioneering Basuttins on Brampton Island.
Bennett, I., *The Great Barrier Reef*, 1986 impression, Rigby-Lansdowne, Sydney, (1971).
The Barrier Reef through the loving eyes of a biologist, with lots of photographs depicting the reef as ordinary Reef travellers will see it. Very readable.
Byron, T., *Scuba Divers Guide, Australia's Southern Great Barrier Reef*, Aqua Sports Publications, Sydney, 1987.
Practical information about the diving in the southern Reef area, with good photographs.
Colfelt, D., *100 Magic Miles of The Great Barrier Reef – The Whitsunday Islands*, 2nd edn, Windward Publications, Sydney 1988 (1985).
All about Queensland's most beautiful group of islands, the Whitsundays and their magnificent anchorages.
Covacevich, J., Davie, P., amd Pearn, J. (eds), *Toxic Plants & Animals, a Guide for Australians*, Qld Museum, Brisbane, 1987.
The latest information on all of Australia's nasties, what they can do to you and what to do about it, written by the experts in their fields.
Cribb, A.B., and Cribb, J.W., *Plant Life of the Great Barrier Reef and Adjacent Shores*, University of Queensland Press, Brisbane, 1985.
All about the plants of Barrier Reef islands, with lots of interesting observations including the origins of some plant names.
Discovering Coastal Queensland, Queensland University Press, Brisbane, 1988.
Excellent maps of the Queensland coast with summary comment about gateways and tourist attractions.
Endean, R., *Australia's Great Barrier Reef*, University of Queensland Press, Brisbane, 1982.
Another look at The Reef in general, in a quite readable style and presentation.
Grant, E.M., *Guide to Fishes*, 5th edn, Queensland Department of Harbours and Marine, Queensland, Brisbane, 1982.
All of Queensland's fishes in readable text and colour photographs and illustrations; also available in waterproof edition.
Heatwole, H., *A Coral Island, the Story of One Tree Island and its Reef*, Collins, Sydney 1981.
A close look by a scientist at one southern Reef coral cay; good background information about coral islands.
Mather, P. O. and Bennett, I. (eds), *A Coral Reef Handbook*, The Australian Coral Reef Society, Brisbane, 1984.
A listing with comments about the various forms of life on a coral reef. Good line illustrations.
McLean, G. T., *Captain Tom*, (ed. C. Davis), Boolarong Publications, Brisbane, 1986.
Thoughts of a tourism pioneer, Tom McLean, who founded Roylen Cruises of Mackay; observations about Brampton Island.
Mead & Becket (ed), *Reader's Digest Book of the Great Barrier Reef*, Reader's Digest, Sydney, 1984.
Excellent pictures and authoritative discussion of The Barrier Reef and its marine life, written by experts in their respective fields.
Porter, J. G., *Discovering Magnetic Island*, Kullari Publications, Tully, Qld, 1983
Some history and background of Magnetic Island, off Townsville.

Porter, J. G., *Discovering the Family Islands*, Kullari Publications, Lutwyche, Qld, 1983
Background and history of the Family Island, which includes the beachcomber's Dunk Island and Bedarra Island.
Queensland Official Tide Tables and Boating Guide, Government Printer, Qld, 1988.
The tide tables and lots of information about fishing in Queensland.
Veron, J. E. N., *Corals of Australia and the Indo-Pacific*, Angus & Robertson, Sydney, 1986.
The definitive word on taxonomy of Indo-Pacific corals, with some lucid comments about Barrier Reef origins and geography.

Reefwalker with coral-viewing tube, which is simply a bit of PVC pipe with glass fixed in one end. PHOTO COLFELT

Reefwalking

Reefwalking provides an opportunity to become totally absorbed in the marine life that lives on top of a reef, in what is called the inter-tidal zone, the area that becomes exposed when the tide goes down. This is a whole new dimension of a reef, and while in some respects it is not as 'pretty' as the growing edges of the reef—lots of sand and algae-covered coral rubble—it is nevertheless alive with shells, millions of crabs, small fishes and corals that can survive being exposed to the air. Reefwalking is most readily available on continental islands with fringing reefs or at coral cays, which are islands that have grown up from reefs. There are a few mid-shelf platform reefs where reefwalking is conducted, but this is obviously subject to tides and may not be possible on some days.

A few hints may make reefwalking more enjoyable.

• Good solid footwear is essential. Any pair of old sand shoes or running shoes with good thick sole will do. Sandals, thongs and bare feet are not suitable. A pair of socks can give added protection from scrapes for the ankles.

• A walking stick is useful for balancing, as it is frequently necessary to step awkwardly over clumps of coral to obtain solid footing.

• Walk slowly and be careful where you step. Try to walk on sandy areas or places that appear 'cemented over' to avoid damaging live coral (and yourself).

• Watch the tide. When the tide comes in over the reef crest, which is the highest part out towards the edge, the water covers the reef quite rapidly, and one can get caught unawares. It is just not possible to run on a reef, and walking over a reef in thigh-deep water is difficult.

• Wear a broad-brimmed hat, put plenty of sunscreen on the back of your neck and shoulders (and on the tops of your feet if not wearing socks); a long-sleeved lightweight shirt will provide additional protection if needed. Gloves are a good idea if you intend to pick anything up (don't pick up any cone shells without tongs (see 'Nasties').

• If you pick up a coral boulder to see what is underneath, be sure to put it back exactly as it was; this is the home of a number of creatures, and they may not survive the intrusion if the boulder isn't put back where it was.

• In most areas shells are protected and may not be collected (even dead ones) without a permit. The reason is primarily to leave

something for others to see when they come reefwalking, but dead shells are also used by reef animals, such as hermit crabs, and they eventually make a useful contribution to the reef substrate.

• Almost all corals lose their colour soon after being removed from the water, and dead coral smells absolutely dreadful for months. Those who want a coral souvenir will do very much better at a souvenir shop than on a reef.

Sailing The Barrier Reef

Old salts say that the thrill of spending the night in a reef lagoon is one that a sailor will never forget—anchored in the middle of the ocean, with stars dropping out of the sky. Sailing amongst coral produces its anxious moments, too, as reefs can be very difficult to see (especially on cloudy, still days at high tide), and if the weather turns bad, navigation can be hazardous. Until recent times, sailing The Barrier Reef was only for those who owned their own yacht and had lots of time on their hands. When the south-east trade winds become established in April or May, they blow consistently until perhaps October. It's easy enough sailing north with the winds at your back, but it's a tough slog going back the other way, and most don't attempt it until the trades ease up and the northerlies become more frequent. This fact was one reason for the success of the bareboat yacht charter business in the Whitsunday Islands. It provided the opportunity for yachtsmen with limited time to sail a boat without having to sail back home. For those unfamiliar with the term, 'bareboat' means bare in the sense of 'boat only', without skipper or crew. It is the nautical equivalent of the rent-a-car, and the yachts are anything but bare, with equipment such as stereo tape decks, ovens, electric windlasses, even fire hoses. Survey requirements are rigid, and bareboats are more sturdily built than are many private yachts. Bareboat means 'you are the skipper, your friends the crew', although it is also possible to arrange a professional skipper and guide.

At this time the Whitsundays are the only location in the Reef Region where sail-it-yourself boats are available on any scale. The business has flourished in that area for several reasons, not the least of which is that it is an ideal cruising area, with lots of sheltered anchorages among many islands, each within a short sail of the next. The islands are almost all national parks, still in their natural state. Navigation is 'by eyeball', and the fringing coral reefs of the Whitsunday Islands provide the thrill of cruising in coral and opportunities for excellent snorkelling and scuba diving. There are about five bareboat charter companies in the Whitsundays, with a total fleet of about 150 yachts, ranging from 7 m (23 ft) to 15 m (50 ft), and which can accommodate up to 12 people (although eight is the maximum number permitted unless there is a professional skipper aboard). The Whitsunday area is well geared for tourism. Yachtsmen can sail themselves to a number of island resorts, where moorings are provided and they are made welcome. Scuba diving can be arranged, either

The Whitsundays are now home to a number of Australia's well-known, retired ocean racing maxi yachts. They provide a taste of exhilarating sailing in the Whitsunday Passage. PHOTO COLFELT

island diving or at the outer reefs of the Barrier; it is even possible to arrange for scuba instruction right on your yacht. The Whitsundays' air taxi service has float planes that can pick up yachtsmen from several anchorages and take them out to the Barrier Reef.

Qualifying for bareboat charter is not difficult as long as someone in the crew knows something about handling a boat and the charter can demonstrate to the company that the crew can manage the yacht. If not, arrangements can be made to take a professional guide or skipper. An excellent cruising guide to the area is available, *100 Magic Miles of The Great Barrier Reef – The Whitsunday Islands*, which gives thorough sailing directions for all anchorages and information about the Whitsunday area in general.

Sailing The Reef can also be experienced on day cruises from a number of gateway cities, the Whitsundays and Cairns in particular, and there are week-long cruises from some gateways, such as from Cairns to Thursday Island and return, on sailing ships. The Whitsundays also have a number of grand old dames of Australian ocean racing, such as the 12-metre class *Gretel*; the maxi *Apollo* is in retirement there, and other smaller sailing yachts take passengers for day sailing through the islands.

The Hinchinbrook Channel and islands to the north and south are another good cruising area, and no doubt there will one day soon be a bareboat industry based near Cardwell. At this time there is one bareboat for hire in that area.

Sea birds

On the Barrier Reef islands are found some 35 species of sea birds and over 30 species of waders. The birds are attracted to the region for its plentiful food, and the islands, particularly the cays, make good nesting sites, away from mainland predators. Reef travellers who visit a coral cay during the nesting season, from October to February, cannot ignore the birds; tens of thousands of shearwaters, boobies, noddies, gulls, terns and gannets set up a din that goes on morning and night. Among the best places for sea bird watchers are the cays of the Capricorn and Bunker Groups, such as Lady Musgrave Island, Heron Island, North West Island, and at Michaelmas Cay, which is north of Cairns.

Sea birds are vulnerable to disturbance during the nesting season, and Reef travellers should heed the advice of the park rangers to avoid unwittingly upsetting the birds, which are coming under increasing pressure from tourism. The feeding of gulls is discouraged, as it tips the natural balance of bird populations and may pose a threat threat to other species, such as turtles, whose babies may be eaten by gulls. QNPWS regional offices usually have informative literature available for travellers.

The wedge-tailed shearwater (*Puffinus pacificus*), also called the mutton bird, is among the more common and engaging species of the southern cays. This species nests in burrows on the friable floor of the pisonia forests. They are amazingly graceful birds at sea, but on land, it's another story. Campers have many comical stories to relate about the hapless landings of mutton birds, but it would be difficult to find better words to illustrate the point that those of Elliot Napier, who learned something about them while on holiday on Lady Musgrave Island in the late 1920s.

The pairing and nesting season was on when we were at the island, and from the moment of their arrival to the hour when they departed these wretched amorists kept up a Pandemonium which for variety and concentration would leave a sports-meeting hopelessly beaten. The lyre-bird is said to be our champion mimic; but at best he can only imitate what he hears. The mutton-bird, on the other hand, can mimic anything whatever, whether he has heard it or not—and does it for eight hours on end, without a pause for a 'smoke-o'. For instance, I feel sure that there have never been any motor cars on Lady Musgrave Island. Yet every note on the whole gamut of the motor-horn, from the alluring squeal of the siren to the hoarse grunt as of a consumptive elephant in extremis, is reproduced by these extraordinary birds with a fidelity quite unnatural.

…You can imagine—or, rather, you can not imagine—what two million odd mutton-birds are capable of doing in the way of weird music when each single one of them—and the majority of the married ones too—are joining in the chorus. At some distance it sounds like an organ, if you can imagine the organist to break out every now and then into a fury of discords and frantic pedallings which no sane organist could ever compass. One brave romanticist among our party even said it reminded him of community singing. If so, all I

can say is that the sooner he removes from the society of such a community the better for his reputation. For it must be composed of tenors who suffer habitually from the d.t.'s, and sopranos in a permanent state of hysteria.

…Nor is this all that I have to set down in my indictment of these avian clowns. They are tame with an idiotic tameness which annoys me. They suddenly appear 'out of the nowhere into the here', with a softness and an eeriness that makes one jump; and then they run along in a silly manner and suddenly stop, and squat down, and look aimlessly around as if they were mechanical toys, which needed rewinding. Then, just as suddenly, they will fly up and hit you in the face or light on the table; and if you pick them up—as you may do with ease—they will merely wait patiently until you put them down, when they will run along and squat again in the same ridiculous fashion. Friendly; well, I suppose so; but it is a blundering stupid sort of friendliness, which rather annoys than endears.

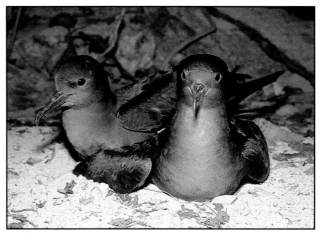

Wedge-tailed shearwaters (Puffinus pacificus) nest in the friable ground beneath the pisonia forest. PHOTO: GARY BELL

I remember one evening we were sitting round the mess-table after tea, listening to Galli-Curci on the gramophone. Right in the middle of the song a mutton-bird came up to hear what was doing, and blundered into the arm of the machine, adding to the song a gurgle and a glissade which the composer never dreamed of. Then he fluttered on to the butter, and sat there with an air of calm content that was infinitely exasperating. After a pause, Galli-Curci took up the song again, pretending she didn't notice the interruption. But you could see that she was annoyed—and I don't wonder.

It is another peculiarity of the male mutton bird to sidle up to anything in the shape of a hen-bird they may see, and gurgle out to her their amorous sighs. But their sight being bad, apparently they sometimes mistake the object of their affection with rather ludicrous results. One of our camp-followers—who…was very much annoyed about this one night. 'I don't mind these 'ere butcher-birds knockin' out me teeth,' he said, 'or shootin' sand all over me bed; but when it comes to makin' love to me boots, I reckon it's over the odds.'

Elliot Napier, *On the Barrier Reef*, Angus & Robertson, Sydney, 1928.

Sea snakes

Sea snakes are a phenomenon of tropical Indo-Pacific waters and probably descended from a family of Australian land snakes; like their ancestors, many have a highly toxic venom. Thirty-two species have been recorded in Barrier Reef waters. They may be found throughout the region, but the areas particularly noted for sea snakes are the Swain Reefs, where they are numerous at some reefs, and around the Keppel Islands, where the olive sea snake (*Aipysurus laevis*) is a familiar sight. Sea snakes have specialised flattened tails for swimming and valves over their nostrils which are closed when they are underwater. Not to be mistaken for eels, they have scales and they do not have gill slits. Because of their need to breathe air they are found in relatively shallow water, where they lie on the bottom feeding largely on eels, fish and fish eggs. One species, the yellow-bellied sea snake (*Pelamis platurus*) is planktonic, and in parts of the eastern Pacific is sometimes seen floating in massive aggregations, or 'slicks', on the surface. Fish that come up to shelter under these slicks get eaten. Individual yellow bellies may be seen on beaches along the Australian east coast, after storms; children have stepped on them occasionally and have been bitten.

Many divers say that sea snakes worry them more than do sharks, not that either beast causes much trouble for divers on the Barrier Reef. Sea snakes are seldom aggressive (except possibly

during the mating season, in winter) but they are very curious, and they are fascinated by elongated objects and will sometimes entwine themselves around divers' equipment, such as their auxiliary breathing hose, and this is somewhat un-nerving. The advice given is simply to inflate your vest a little so that you lift off the bottom, and the snake will usually go away. It is not advisable to provoke sea snakes, for they can become aggressive, and then they are extremely persistent. Their swimming changes from leisurely and undulating to very rapid, their head hardly moving at all, and they come spearing in. The usual defence is to kick them off with your fins, which is quite effective, provided you can keep it up for long enough, because they don't always go away after the first pass.

Olive sea snake (Aipysurus laevis). PHOTO GARY BELL

Many myths persist about sea snakes. It is often heard that, because they have short fangs (2.5–4.5 mm) and (usually) small mouths, they can't bite very effectively. The truth is that their fangs are adequate to penetrate the skin, and they can open their small mouths wide enough to bite a flat table-top. Even a small snake can bite a man's thigh. Sea snakes can swallow fish that are more than twice the diameter of their neck.

Sea snake venom is highly toxic and appropriate for the job it is intended to do—to immediately immobilise fish so that they can't swim away and to make them completely relax so that the snake can swallow them easily with dorsal spines flattened.

Most sea snake bites occur on trawlers, when the snakes are sometimes hauled in with the catch. Only a very small percentage (4–5%) of sea snake bites are fatal to man, probably because the snakes voluntarily control the injection of venom, and they don't always choose to inject any. If they do not intend eating something, they often don't bother to waste venom on it. This fact probably explains why, amongst the islands of the Pacific, there are so many different folk cures for sea snake bite, all of which are claimed to be 95% effective. An Australian authority on sea snakes, Colin Limpus, when collecting venom for research, had to devise a special means of getting these snakes to release venom; the normal biting techniques employed for land snakes didn't work.

Unlike most envenomations, intense pain is not obvious at the site immediately after being bitten by a sea snake; 30 minutes after a severe envenomation, muscle aches, stiffness and spasm of the jaw may be present, leading to moderate to severe pain in the affected limb, with progressive central nervous symptoms of blurred vision, drowsiness and, ultimately, respiratory paralysis. A specific antivenom is available, and Australian tiger snake antivenom, or even polyvalent snake antivenom, can also be used.

Sharks

Sharks are the subject of much irrational fear, largely on the part of strangers to The Reef, those who may have never seen a shark

Black tip reef shark (Carcharhinus melanopterus)

other than in one of the 'Jaws' movies. Sharks which inhabit the shallow waters of Australia's nor-eastern continental shelf are well fed, and the three reef species most commonly encountered—the black tip (*Carcharhinus melanopterus*), the white-tip (*Triaenodon apicalis*) and the epaulette shark (*Hemiscyllium ocellatum*) are all quite timid. Species such as the whalers (*Carcharhinus brachyurus*) and tigers (*Galeocerdo cuvieri*) do engender more respect among divers, but not a great deal of worry. Attacks on divers and snorkellers in the Reef Region are almost unknown, and those that have occurred have usually been on divers with speared fish dangling from their belts. Shark attacks have occasionally occurred off Australia's beaches, some of them, it is suggested, the result of mistaken identity. Surfboard riders have been among those attacked south of the Reef Region, and it is speculated that as they sit astride their boards beyond the breakers, waiting for a wave, with their legs dangling down, from underwater they may appear much like seals, with white belly and flippers, and sharks do enjoy eating seals. There have been, over the years, rogue shark attacks in harbours, which defy explanation.

White tip reef shark (Triaenodon apicalis)

Sharks have been around for more than 100 million years and today are largely unmodified from their original design. They have proved to be able survivors. They are very sensitive to vibrations in the water, have excellent vision (their eyes are have special adaptations for gathering maximum light in dim situations), and they have special organs for sensing electrical potential. They are also exceedingly cautious, a true mark of the survivor. Humans are not preferred food, and when one considers the hundreds of thousands of snorkellers, divers, and swimmers in Barrier Reef waters every year, the incidence of shark problems is infinitesimal. Some Reef-trip operators feed sharks by hand for the benefit of the tourists; two of Australia's best-known underwater identities, Ron and Val Taylor, have been filmed 'hitching rides' on sharks. Neither of these pastimes is recommended to novices, and the purpose is simply to demonstrate that the most experienced practitioners of The Reef are really not worried about sharks.

When in the water, it is prudent not to attempt impersonations of wounded fishes by splashing and creating vibrations, and one should simply employ the good sense that is used when crossing the street—the chances of getting hurt are far less.

Snorkelling on The Reef

One of the best ways to appreciate The Barrier Reef is to be right in the water with it—snorkelling, in shallow water, where the

Epaulette shark (Hemiscyllium ocellatum)

light and the colours are brightest. Snorkelling involves a minimum of fuss and equipment and provides freedom to explore. Guided snorkel tours are available on most reef trips, where a marine biologist takes a group of snorkellers off for a paddle, pointing out reef curiosities that otherwise might be overlooked.

There is nothing quite like sliding into a shallow reef pool at low tide, or slipping over the edge into the lagoon, where you enter a silent new world; you can hear only your breath sighing in the snorkel, and perhaps occasional dull 'clicks' coming from the bottom. Looking down, you discover the source of these clicks—a bright green and red parrotfish rasping away at a piece of coral with its beak-like teeth, scraping off fine threads of algae to eat. Taking in the scene, you drift with the sun warm on your back, floating in a light blue dream, ripples of golden light undulating across the bottom. One by one the local residents come out of hiding. A school of iridescent blue fish swims up from a coral thicket and hovers between blue-tipped antlers. On a patch of white sand a trochus shell sits like a miniature pyramid; suddenly it begins to move, the inhabitant peering up with eyes on stalks. Out from under a coral ledge a tiny red fish, no bigger than one segment of a finger, darts up to challenge you, stopping centimetres from your nose and staring straight into your mask; for a moment you both hang there, wondering at each other. For the next half hour, time will become lost as a fantasia is acted out by the inhabitants of this silent world. Realising that you are beginning to feel a chill, you start finning your way back to the boat or the beach, excited about new discoveries. During this brief visit to another dimension, you cannot escape a vague sense of the oneness of all nature, a feeling that another piece of the puzzle of life has just fallen into place.

Equipment
Snorkelling is a skill that is easy to learn and requires very little equipment, the basic requirements being mask, snorkel and fins. The mask is to see underwater; the snorkel allows you to keep your face down without having to lift up your head to breathe; the fins let you move effortlessly and quietly through the water. Depending upon how much snorkelling is to be done, perhaps a few extras, such as gloves, a wetsuit and weight belt can be added—gloves and a wetsuit for protection when snorkelling in shallow water over rough coral, and the wetsuit for warmth. The weight belt helps overcome the buoyancy of a wetsuit when diving.

Fitting a mask
It is so important to get a mask that fits snugly and comfortably that, if you will be doing more than just a little snorkelling, you should seriously consider purchasing one of your own. There is no guarantee that you will find a perfect fit amongst the equipment offered on a reef trip, and having travelled that far to see The Barrier Reef it seems silly to leave that to chance. A mask that leaks because it doesn't fit well will rob you of much of the pleasure. The best masks today are made of silicon rubber, which is a transparent, pliable compound that moulds comfortably to the face, making a good seal. These masks are more expensive than conventional black rubber ones, but they fit better (and they also last longer). Modern masks also have individual eye chambers, and a separate chamber for your nose (which allows you to pinch your nose to equalise pressure when diving.) Optically corrected lenses are available with some masks (they're not much help if you have astigmatism); before going to the added expense of buying special lenses, remember that, because the index of refraction of water is different from air, everything appears 25% bigger underwater anyway.

To check that a mask fits properly, put the strap in front of the face plate, out of the way, and with one hand hold your hair back away from your face and put the mask into place. Holding it lightly against your face with your index finger, breathe in gently through your nose. When you take your finger away, the mask should stay in place by suction, and no air should get in around the seal. Shake your head gently from side to side; the mask should still stay in place. If it does, you've got a good fit.

Snorkel and fins
Forget about extra-long snorkels or those with attachments, such as cages with ping-pong balls on the end. A snorkel is a simple device not much improved by embellishment. Buy a plain one, which should have a tube of about 20 mm diameter. It may have a flexible curve and adjustable mouthpiece, and it should come with a simple rubber keeper for attaching it to your mask.

Fins are either full-foot or have an open heel with adjustable strap. Those with an adjustable strap allow you to wear wetsuit boots, which can be useful if you have to walk over rough territory to get to the edge of a reef. Full-foot fins, which are worn over bare feet, should fit snugly, not too tightly.

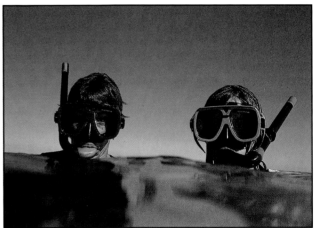

COLFELT

Other equipment
Snorkellers frequently find themselves in shallow water, pulling themselves along over the coral with their hands, and gloves can be an asset. You should wear gloves if you plan to go around picking things up. A wetsuit provides extra protection against scrapes, and also it will allow you to stay in the water longer without getting chilled. Wetsuits with half-length sleeves and legs are available and are less expensive than full wetsuits. You can also get very lightweight, full-body suits—very popular in north Queensland—which are quite colourful and stylish and which double as 'stinger suits' during the warm summer months. Without a wetsuit, as a rule of thumb, 20–30 minutes is about as long as most people can snorkel without starting to get chilled. A wetsuit increases buoyancy, and a weight belt may be necessary for diving. Those who shun extra gear may be perfectly happy in a pair of long cotton pants and a long-sleeved shirt; any clothing provides some protection and also helps prevent loss of body heat; moreover, the shirt will protect the middle of the back, and pants the back of the legs, which can easily get sunburnt.

Gearing up
The mask strap should be adjusted so that it just holds the mask comfortably in place; the pressure of the water does most of the work of holding it on. To prevent fogging, just before getting into the water, apply spit to the inside of each lens, and then give the mask a quick rinse. New masks sometimes fog up because they have a protective coating on the lenses; this is easily removed by scrubbing the inside of the lenses with toothpaste and toothbrush. The strap is adjustable on either side. The snorkel is attached to the left side of the mask by passing the strap through the keeper on the snorkel. Your snorkel should sit at about a 45° angle so that when you are face down in the water it is pointing more or less straight up.

If entering the water from a beach, wait until it's deep enough to float before putting on your fins. It is very difficult to walk forwards with fins, and you look like a goose; walking backwards isn't easy but is more possible. If snorkelling from a ramp or pontoon, put on your fins before stepping feet-first into the water (hold your mask in place with one hand, and if you start kicking the minute you step off, you won't go completely under).

Mastering the basic technique
The secret of snorkelling is learning how to relax with your face in the water. Breathing *easily* and *normally* is the key; it may take a few moments to overcome the natural anxiety that most people have when their mouth and nose are underwater. Spend a little time in a pool, or in shallow water by the beach, where you can stand up immediately if you feel the need to. Legs and feet should float out straight behind you. Once you can control your breathing you will feel confident to deal with the odd bit of water that gets into your snorkel, for example, when a wave slops over the top, or you put your head in too deep. Small amounts of water in the snorkel will be trapped in the U-bend under the mouthpiece and will gurgle as you breathe in. To clear this, inhale *slowly and gently* (so as not to draw in this water with the air) until you have a deep breath, then exhale sharply into the mouthpiece. Remember, never inhale sharply through your snorkel—always slowly and gently.

Finning is almost a straight-legged action, with the knees slightly bent. Some people say it helps to imagine having splints on your legs; it may be easier to get the hang of it on your back.

Snorkeller at Erskine Island in the Capricorn Group. PHOTO DEAN LEE

More-advanced technique
When you're happy about snorkelling on the surface, you may wish to try some shallow diving. The first thing to remember about diving is that you will need to equalise the pressure in your ears from the very moment you start to go down. Pressure increases rapidly as you descend. Everyone is familiar with equalising—'popping' their ears—when landing in a plane; the principal in diving is the same. Divers should start equalising from the moment they are beneath the surface and should keep equalising all the way down. Pinch your nose and and exhale gently with your mouth blocked. You shouldn't wait to actually feel the pressure coming onto the eardrums; if you wait until you feel it, you may not be able equalise. If you feel pain, go back up.

'Duck diving', as it is sometimes called, is done from a position flat on the surface with arms by your sides. Take a deep breath and swing your arms straight down and forward, which will force your head and trunk down. As you go head down, point your legs straight up in the air. The weight of your legs above water will force your body down, and you can begin finning downwards.

Stingrays (see 'Nasties')

Sugar
Reef travellers driving along Queensland's Bruce Highway from Bundaberg to Cairns pass through miles of billowing green sugar cane fields, hectare upon hectare of tall (2–4 m), green stalks with flowering heads, called 'arrows', undulating in the breeze. Travellers will also become familiar during the June–December harvesting season with raging cane fires in the afternoon and evenings, and the pall of smoke that produces spectacular sunsets and sunrises. Queensland's warm climate suits sugar, which also prefers an annual rainfall of 1500 mm or more (although it is grown in areas with lower rainfall, under irrigation). The cane fires get rid of weeds and trash that impede harvesting and milling, although in days when sugar was harvested by hand the fires also served to clear out rats and snakes and reduce the incidence of skin complaints by cane cutters. Immediately after firing, mechanical harvesters move in, cutting off the leafy tops and cutting the stalks into short lengths called 'billets' which are loaded into bins and transferred to the picturesque cane cars of the narrow-gauge sugar railways seen throughout Queensland cane country. At the local mills, which operate only during the harvesting season, the cane is crushed between rollers and the juice extracted, purified and, finally, raw sugar crystals are grown. Bi-products of milling include 'bagasse' (crushing residue) which is burned to produce electricity for the mill, 'mill mud', which the growers use for fertiliser, and molasses, which is converted, among other things, to rum. About five crops can be obtained from one planting of green stalks, which sprout from 'eyes' (like sections in bamboo). Tours of sugar mills are available throughout Queensland, from Bundaberg to Mossman (and at Bundaberg, travellers may visit the rum distillery).

Tide
Tides have been of keen interest to European Reef travellers since James Cook grounded *Endeavour* during a June night in 1770. Cook found that the high tide the next morning wasn't sufficiently high to float the ship, illustrating the inequality of the two daily tides in the Barrier Reef Region.

Tides are produced by the gravitational effect of the moon, which 'lifts up' the oceans as the earth rotates each day, setting in train a complex series of water movements all over the globe. Twice each month when the moon and the sun are lined up (full moon and new moon), their gravitational fields are in conjunction, and the lifting of the oceans is greater. Tides at these times are called 'spring' tides (tides of greater range, or difference between the level of water at high and low tide). Neap tides occur twice each month, too, when the moon and sun are pulling against each other and their combined lifting effect is less. Tides are influenced in different localities by land masses and the shape and slope of the sea floor, and tidal range varies enormously. The highest tides along the Queensland coast are in the vicinity of Broad Sound, south of Mackay, where the maximum range is about 7 m (23 ft). North and south of this point, tide range is less.

Tides interest today's Reef travellers for many reasons. Fishermen know that there are best times each day and each month to be angling for different fishes. Reefwalkers get the best look at a reef top during spring low tides. Campers need to know when the tide will be high, and sometimes just *how* high it will be, in order to make arrangements to be landed and picked up from the islands, where landing may be possible only at high tide, and because tide determines whether beaches are swimmable. The same is true for guests at island resorts. Divers know that the water will usually be clearest during periods of neap tides, and also each day just before the tide is at its lowest. Snorkellers enjoy paddling around reef pools when the tide is low and the big fish have left the reef until the tide floods the reef crest again. Yachtsmen in the Whitsundays plan their itineraries taking note of the high tide ranges in that part of the Reef Region, for when wind and tidal streams oppose each other, the seas become rough.

Tides are important to corals, too. In early summer, about five days after a full moon (on the neap tide), a large percentage of the reef-building corals of the Barrier simultaneously release their

eggs and sperm in mass reproductive orgy. They pick this time because it is when there will be least movement of water over the reef, and they thus maximise the chances of successful reproduction and recruitment of new corals. Many primitive cycles in nature are lunar-based, which for creatures in the oceans, is the same as saying that they are based on the tides.

Trade winds

Global weather is dominated by several principal pressure systems, and the movement of air within and between these systems is responsible for the trade winds that fan the Queensland coast for about six months each year, from about April through September (more or less). The origin of the trade winds is a belt of low pressure, referred to as the 'uniform equatorial low', which lies about the equator (within this belt are the fabled mariners' *doldrums*). On either side of the equatorial low are belts of uniform high pressure. The south-east trade winds are part of a generalised movement of air northwards (in the southern hemisphere) from the subtropical high pressure belt to the equatorial low. The northerly-moving air stream is deflected to the west by rotation of the earth (Coriolis force), and it becomes a north-westerly flow. Mariners have traditionally named winds for the direction *from* which they blow, hence the *south-east* trades. A procession of high-pressure systems parade across the Australian continent in winter, their axis centred about 25°–30°S, producing ridges of high pressure along the Queensland coast; these can be seen as isobars on a weather map with narrow ends pointing up the coastline. The wind blows along the isobars at an average 15–20 knots, sometimes for weeks at a time. It keeps the climate fresh. The winds also affect sea conditions within the Barrier Reef lagoon. Reef fishing and diving excursions, for example, may be cancelled when the wind gets above 20–25 knots.

Turtles

There are seven known species of sea turtles, six in Barrier Reef waters, three of which are 'reef' species and others nest on mainland or continental islands. Reef species are: green turtle (*Chelonia mydas*), loggerhead turtle (*Caretta caretta*), Hawksbill turtle (*Eretmochelys imbricata*). The others, which live in near-mainland waters or off the continental shelf are: leatherback turtle (*Dermochelys coriacea*), flatback turtle (*Chelonia depressa*), olive ridley turtle (*Lepidochelys olivacea*). Sea turtles are large, weighing 90–140 kg with an average length of 1 m. Some, such as the green turtle, migrate vast distances from their feeding grounds to breeding rookeries—1000s of kms—from Torres Strait, Vanuatu, and New Caledonia to the Great Barrier Reef. Some sea turtles have become extinct in parts of the world, and Barrier Reef waters are one of the world's significant remaining breeding grounds for some species. While turtles used to be harvested in Queensland,

they are now totally protected, and an intense turtle research and tagging programme has been underway since 1968.

Turtle watching is best in the southern Reef area, where there are both mainland and island beaches used by sea turtles. Males and females congregate at their southern Reef rookeries for intense courtship (August to early September) prior to nesting.

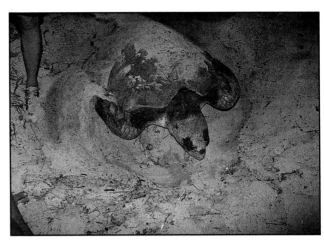

After a strenuous scramble up the beach the female sea turtle excavates a body pit with all four flippers. PHOTO: CARLO GROSSMAN

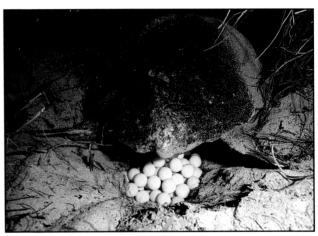

The eggs are deposited in an egg chamber which is dug out with the hind flippers. Females lay several clutches of ping-pong-ball sized eggs during the nesting season (loggerhead turtle pictured). PHOTO: DEAN LEE

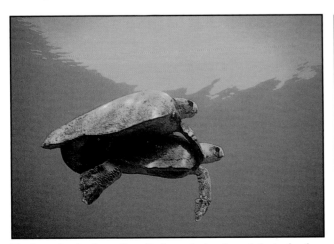

Turtles gather in the southern Reef area during August–September for a furious bout of mating, after which the males of some species return to distant feeding grounds, and the females stay on to lay their eggs. PHOTO: DEAN LEE

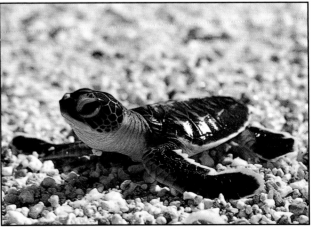

The hatchlings emerge after about nine weeks. They scramble down the beach and over the reef flat, after which they just disappear for several years. Mortality can be very high during the first hours of life. PHOTO: GARY BELL

Mating reaches its peak in October. Males leave after the courtship period and some return to their traditional feeding grounds perhaps 1000 km away. Females remain close to the nesting ground for the next two months or so during which time, depending upon the species, they may lay 4–8 'clutches' of eggs. They lay perhaps four times, beginning in late October and finish about mid-February (a little later in the case of greens). Laying takes place normally 1–2 hrs before the top of the tide. More turtles can be expected on nights when the high tide occurs near midnight than when it occurs near dawn or dusk. The female struggles up the beach to the sandy dunes above high tide level where she digs a body pit with all four flippers; she then excavates an egg pit with her hind flippers, perhaps 50 cm under the surface, and lays a clutch of 50–120 billiard-ball to ping-pong-ball sized eggs depending upon the species; the process takes about 45 mins. She covers the eggs and crawls back to the sea.

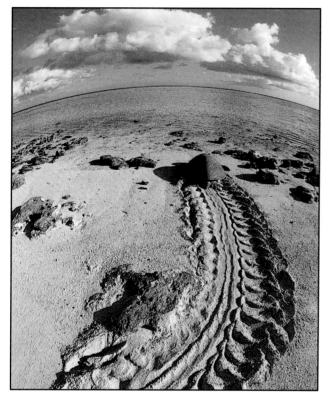

The eggs take about nine weeks to mature, and then one night, usually from about 5.00 p.m. to midnight on the islands, the hatchlings will explode from the sand and race down the beach towards the setting sun or the moon. The hazardous trip across the beach and reef takes a heavy toll; ghost crabs may kill many before they even reach the water. The young turtles who do make it over the edge of the reef will then mysteriously disappear, to swim with the oceanic plankton community for several years, and then reappear in Reef waters about the size of a dinner plate.

Mon Repos, a few kilometres north-east of Bundaberg, is the best mainland site for turtle-watching, and Heron or North West Islands of the Capricorn Group are excellent island sites. Turtle nesting starts in late October and continues into March, for some species; hatchlings may be observed from mid-January till late March.

Green turtle *Loggerhead turtle*

Hawksbill turtle

Rangers are present at Mon Repos and Heron Islands throughout the nesting season and are happy to give hints on how to find nesting turtles; QNPWS has also produced a pamphlet which includes a few cautions to avoid disturbance to nesting turtles.

- Walk the beach about high tide mark, looking for tracks. These will be about 1 m wide.
- Lights can disturb turtles, so keep lights off while walking the beach. Turtle tracks are easily seen without lights.
- Follow the tracks carefully and quietly onto the dune to find the turtle; try to avoid excess movement, especially in front of her. Don't approach closely or shine lights on the turtle as it comes up the beach.
- Wait quietly, sitting behind the turtle until it has started laying eggs, i.e. when it is sitting still after a long period of throwing sand forward off the hind flippers. Once laying, the turtle is not normally disturbed by lights, gentle touching or noise, and spectators may dig gently behind the turtle to observe the eggs as they drop. Light may now be used to examine the turtle closely, and flash photography is all right.
- Lights may confuse and attract hatchlings away from the sea and increase mortality.

Whales

Of the 50 species of whales in Great Barrier Reef waters, the spectacular humpback (*Megaptera novaeanglicae*) is perhaps the one most often seen by Reef travellers. Humpbacks travel along the eastern Australian coast, heading north in June from Antarctic feeding grounds to the warm Reef waters, where they breed and give birth to their pups. Whaling decimated the humpback population as late as the 1960s, but they are now totally protected in Australian coastal waters, and it is even an offence to 'harass' them in a boat. Now, it is not uncommon to see these massive, acrobatic cetaceans, which can attain a length of 15 m (50 ft) and which weigh some 40 tonnes, from Stradbroke Island to the Whitsunday and north, leaping completely out of the water ('breaching') or breaking the surface emitting a massive puff of spray ('blowing'). They are commonly seen from sea planes and helicopters that take tourists from the Whitsundays to Bait and Hardy Reefs, and guests at Heron Island resort, having drinks by the pool, see them cavorting among the islands of the Capricorn Group. Come early summer they head south again to the Antarctic, the number of sightings increasing each year. Whale-watching as a tourist activity is becoming popular, particularly in the Hervey Bay area (FG 36–37).

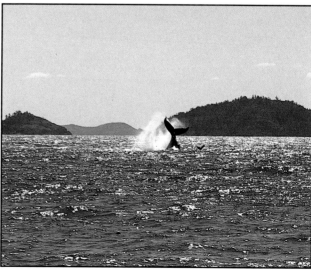

A humpback cow in the Whitsunday Islands engages in some antics, her calf by her side, like a ditto mark, learning how it's done. PHOTO COLFELT

Leatherback turtle